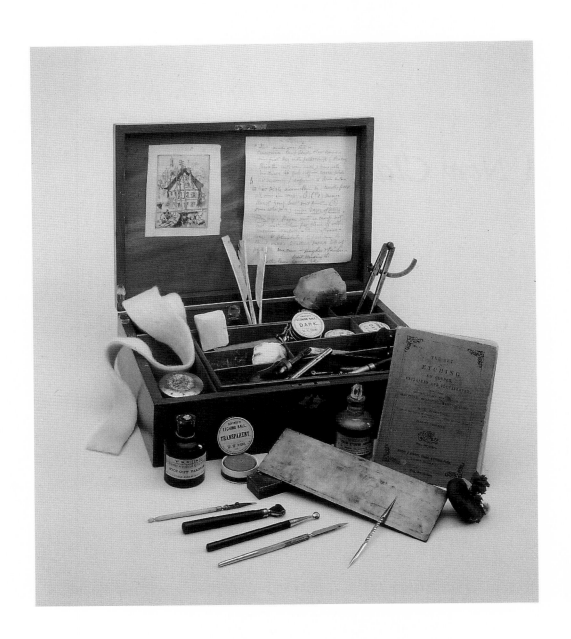

H. Ivan Neilson's etcher's box
National Gallery of Canada
Gift of Marjorie Neilson, St-Lambert,
Québec, 1986

A New Class of Art

The Artist's Print in Canadian Art, 1877–1920

Rosemarie L. Tovell

NATIONAL GALLERY OF CANADA, 1996

Published in conjunction with the exhibition *A New Class of Art: The Artist's Print in Canadian Art, 1877–1920*, organized and circulated by the National Gallery of Canada.

Itinerary

National Gallery of Canada, Ottawa
27 June – 2 September 1996

Art Gallery of Nova Scotia, Halifax
16 November 1996 – 12 January 1997

Vancouver Art Gallery
26 February – 27 April 1997

Art Gallery of Ontario, Toronto
30 July – 19 October 1997

This catalogue was produced by the Publications Division of the National Gallery of Canada, Ottawa.
Serge Thériault, *Chief*
Lynda Muir and Myriam Afriat, *Editors*
Colleen Evans, *Picture Editor*
Jean-Guy Bergeron, *Production Manager*

Designed and typeset by Associés libres, Montréal, using Bembo, Galliard and Futura Condensed. Printed on Phoenix-Imperial dull cream paper. Film and printing by Gilmore Printing Services Inc., Ottawa.

Available through your local bookseller or from: The Bookstore, National Gallery of Canada, 380 Sussex Drive, Box 427, Station A, Ottawa K1N 9N4

Photograph Credits

Photographs have been provided by the owners or custodians of the works reproduced, except for the following:
National Gallery of Canada pl. 1; fig. 31, 35, 37, 38, 39, 47, 50, 52, 60, 61, 62, 63, 65, 145, 146, 147, 157, 158, 159, 164, 166, 167, 168, 169, 170, 171, 172, 173, 175.

Front cover: Clarence Gagnon, *En novembre*, 1904–05 (cat. 37 and pl. IV)
Back cover: Homer Watson, *The Pioneer Mill*, state II/III, 1890 (cat. 121 and pl. III)
Elizabeth Armstrong Forbes, *The Bakehouse*, c. 1886–87 (cat. 33 and pl. II)

Canadian Cataloguing in Publication Data

Tovell, Rosemarie L.
A New Class of Art: The Artist's Print in Canadian Art, 1877–1920.
ISBN 0-88884-655-X

Issued also in French under title: Un nouvel art : l'estampe originale au Canada de 1877 à 1920.
Exhibition catalogue.
1. Etching, Canadian – Exhibitions.
2. Prints, Canadian – Exhibitions.
3. Etching – 19th century – Canada – Exhibitions.
4. Etching – 20th century – Canada – Exhibitions.
5. Prints – 19th century – Canada – Exhibitions.
6. Prints – 20th century – Canada – Exhibitions.

NE55 .C3 T68 1996 769.971
 CIP 96-986000-5

Contents

Foreword

Canadian art has been chiefly described and celebrated through the history of its paintings: the history of Canada's prints has been relatively ignored. No more than a dozen exhibitions with publications have been devoted to the subject, and as a result, Canadian printmakers and their societies have not received adequate credit for their important contribution to the visual arts of the nation. The current exhibition and its catalogue are the first to document from a Canadian perspective that momentous period in the nineteenth century when artists began to reclaim the print media as techniques for original artistic expression. In Europe and North America, Canadian artists joined the front ranks of this international movement commonly referred to as the "etching revival." Canada's printmakers had to struggle against institutional indifference and public apathy, yet they managed, over a span of forty years, to create and establish their new art form and their own art associations. The nationalism promoted and practised by the printmakers and their societies played a vital role in defining the movement of Canadian art from Victorian parochialism towards that nationalistic ideal we now often identify only with the Group of Seven and their associates.

When Rosemarie Tovell, Associate Curator of Canadian Prints and Drawings, first contemplated undertaking this project, little was available on the topic, save for the occasional listing in the catalogues of the Canadian art society exhibitions, a handful of unresearched prints acquired by the National Gallery of Canada between 1909 and 1917, and isolated references in a limited bibliography. With no specialists and collectors in the field and only the infrequent interest of dealers, her work progressed slowly. By first combing through all exhibition records both in Canada and abroad,

she was able to establish the existence of a considerable body of work by a number of Canadian artists, as well as the framework of a chronology for the growth of the movement in this country. This was followed by a careful survey of newspapers and magazines, for reviews, announcements, and the rare contemporary article on the subject of Canada's printmakers. The scarcity of archival papers made them treasured discoveries. Patient sleuthing located prints with descendants of the artists or their associates. Many of the prints thus unearthed entered the National Gallery of Canada's collection, and a surprising number of prints were found in archival, museum, and art gallery collections.

Throughout, Rosemarie Tovell was encouraged by the enthusiasm of colleagues in Canada and the United States, who readily came forward with crucial information. The very recent, growing interest of private collectors and dealers dedicated to Canadian prints has uncovered much new material. Only after many years of consistent effort has it been possible to offer this presentation of a pivotal period in the history of Canadian art and printmaking.

It is interesting to note the leading role the National Gallery of Canada has had in this story of Canadian printmaking. Once the Gallery had the means to support the fledgling Canadian etching revival, it did so in a manner that legitimized the art and artists on a national scale. As early as the 1880s, there was an interest in creating a print collection. Unfortunately, this dream could not be realized until 1909 when, fittingly, the first prints acquired for the collection were by the internationally recognized Canadian painter-etcher Clarence Gagnon. The purchase was not just the beginning of an acquisitions policy that included Canadian

printmakers, it was the first known instance of Canadian artist's prints being purchased by any public institution in the land. By 1914, curator Eric Brown's enthusiasm for the Canadian etching revival prompted him to propose to Sir Edmund Walker, chairman of the government's Advisory Arts Council and a knowledgeable print collector, that the National Gallery should acquire an impression of every print produced by a "recognized artist." While their ardour was to be tempered by the reality of budgets and the need to be selective, it nevertheless led Brown and Walker to commission etchings and lithographs depicting Canadian activity during the Great War for the Canadian War Memorials Fund collection. During the lean wartime years and displacement to accommodate a homeless Parliament, the National Gallery fostered printmaking by mounting Canada's first travelling print exhibitions. However, the Gallery did not stand alone in its support of a home-grown movement. Its efforts were handsomely complemented by the Art Museum of Toronto (now the Art Gallery of Ontario), which from 1914 to 1917 organized an important series of exhibitions devoted to Canadian etchers from across the land. Consequently, we are pleased that the AGO will present this exhibition in Toronto. Above all, we must salute the courage, determination, and creativity of Canada's printmakers; for they, and the societies they founded, beginning with the Association of Canadian Etchers in 1884, and leading up to the Graphic Arts Club and the Society of Canadian Painter-Etchers in this century, did the most to bring "a new class of art" to Canada.

The National Gallery of Canada's mandate is, in part, to support the visual arts of Canadians. It is in this tradition of advocacy of Canadian art in all its guises that the Gallery undertakes projects which allow full exploration and explanation of our heritage. This principle is also endorsed by those Canadian art galleries who requested to host this exhibition. The nature of the material – light-sensitive works on paper – meant only a limited tour was possible. The Board of Trustees and the staff of the Gallery join me in welcoming Canadians to visit the exhibition in Ottawa, as well as at the Art Gallery of Nova Scotia, the Vancouver Art Gallery, and the Art Gallery of Ontario.

Dr. Shirley L. Thomson
Director
National Gallery of Canada

Acknowledgements

To put together a publication and exhibition of this scale has required years of research and the assistance of many individuals and institutions. While it has often been lonely work, I have been blessed with the unwavering support and encouragement of colleagues, among whom I would single out Mary Allodi, Curator Emeritus at the Royal Ontario Museum, Christine Boyanoski, Associate Curator of Canadian Art at the Art Gallery of Ontario, and Patricia Ainslie, Director of Collections at the Glenbow Museum. I also owe a special debt to Rona Schneider, scholar, collector, and former editor of *Imprint* magazine.

I would like to acknowledge the assistance I received from Jan Johnson of Montreal. Her research on the Québec printmakers H. Ivan Neilson and Herbert Raine could not be ignored, and she has generously written biographical and stylistic descriptions of both artists for this catalogue.

Given the strong links between the Canadian etching revival and its American counterpart, the earliest part of our movement's history can largely only be traced in American libraries, archives, and public collections. Among the many helpful individuals in the United States, I would mention Thomas P. Bruhn, Director of the William Benton Museum of Art, who was ever willing to share his knowledge of the North American etching revival; Sinclair Hitchings, Keeper of Prints, Boston Public Library; Sue Welsh Reed, Curator of Prints, Museum of Fine Arts Boston; and Elton Hall. Of particular assistance were Wendy Shadwell, Curator of Prints, New York Historical Society; and Robert Rainwater, Roberta Waddell, and Nancy Finlay of the New York Public Library. My sincere thanks to Maureen C. O'Brien and Alicia Longwell at the Parrish Art Museum in Southampton; and to Helena E. Wright, Curator of the Division of Graphic Arts, National Museum of American History in Washington, D.C. Robert Getscher, professor of Art History at John Carroll University, Cleveland, was among the first to lend his support.

In Canada, there are many to whom I owe a debt of gratitude, including Patricia Bovey and Ann Tighe of the Art Gallery of Greater Victoria, and John Bovey at the Provincial Archives of British Columbia. Further thanks go to Ian Thom at the Vancouver Art Gallery, and Karen Henry and her staff at the Burnaby Art Gallery. A special thank you to Susan Moogk for ferrying me around the region on very wet days. Bryan Klassen at the Centennial Museum and Exhibition Centre in Fort Langley, B.C., was most cooperative. Carolyn MacHardy at Okanagan University College in Kelowna, B.C., was an excellent sounding board. My thanks to Susan Kooyman, archivist at the Glenbow-Alberta Institute, and E.T. Harbert of Calgary. I greatly appreciate Andrew Oko, Regina, for allowing me access to the Art Gallery of Hamilton's important collection of prints when he was curator there. In Winnipeg, I must thank Elizabeth Blight, Manitoba Provincial Archives, as well as Michel Chef, Gary Essar, Karen Kisiow, and Margot Rouset at the Winnipeg Art Gallery. I would also like to thank Bob and Margaret Hucal, who came forward on their own account to lend to the exhibition, and Virginia Berry, who showed particular generosity towards this project.

I also wish to acknowledge Ted Pietrzak, Tobi Bruce, and Joan Weir at the Art Gallery of Hamilton, along with Jennifer Watson and Pat Mills. I am grateful for the assistance of Barry Fair, London Regional Art and Historical Museums.

At Niagara-on-the-Lake, James R. Campbell of the Samuel Weir Collection was liberal with his assistance. In Toronto, where the story of Canada's etching revival was centred, I can only begin to name all those who lent support. At the Art Gallery of Ontario, Katharine Lochnan, Michael Parke-Taylor, Brenda Rix, Dennis Reid, Larry Pfaff, Randal Spellar, and Faye Van Horne each responded with grace to my numerous telephone requests and visits to their collections. I would also like to thank Elizabeth Hulse, formerly of the Thomas Fisher Rare Book Collection, University of Toronto, and other members of her family who descended from John Hammond. It is with real sadness that one considers the impeccable contributions to research on the John Ross Robertson Collection at the Metro Toronto Library tragically cut short by the death of John Crothwaite. To his successors, Alan Walker and David Kotin, I offer my gratitude. I must also express my appreciation to Raymond Peringer and the late Hunter Bishop of the Arts and Letters Club for opening its collection and archives for my inspection. As well, I must thank Linda Cobon at the CNE Archives; Lynn Cumine, president of the Women's Art Association of Canada; and Robert G. Hill, editor of the *Biographical Dictionary of Architects in Canada*. Not to be overlooked are Elizabeth Bryce, Edith G. Firth, Stan and Eileen Gardener, Jim Hennok, Don Lake, Stephen McCanse, Robert Stacey, and the late Carl Schaefer and Betty Brett.

I am indebted to Judith Nasby of the Macdonald Stewart Art Gallery, and the late Nora McCullough, Guelph; Dorothy Farr, Agnes Etherington Arts Centre, Queen's University, Kingston; Barbara Tyler, Megan Bice, Sue Gustavison, and particularly Sandy Cooke and Linda Morita at the McMichael Canadian Art Collection, Kleinburg. In Ottawa, I owe a debt to Laura Brandon and Danielle Allard of the Canadian War Museum. At the National Archives of Canada, Lydia Foy, Jim Burant, and Gilbert Gignac of the Documentary Art Collection never hesitated to draw my attention to new discoveries, over a long period of time. Additional thanks go to Anne Goddard and the staff of the National Archives and National Library. Nor should I fail to mention David Milne Jr.

In Montreal, above all, I must express my sincere gratitude to Conrad Graham and Pamela Millar at the McCord Museum of Canadian History. I would also like to thank Micheline Moisan, Mayo Graham, and Marie-Claude Mirandette at the Montreal Museum of Fine Arts; Michel Doyon, Walter Klinkhoff, Helen Neilson, Marjorie Neilson, and Richard Bolton. In Quebec City, I found two valuable colleagues in Denis Martin, Musée du Québec, and David Karel, Université Laval.

In Sackville, N.B., I would like to thank Gemey Kelly and the staff of the Owens Art Gallery, Mount Allison University; in Saint John, Peter Larocque and Andrea Kirkpatrick gave generously of their time and knowledge. In Halifax, Scott Robson, Marie Elwood, Bernard Riordon, Diane O'Neill, and Judy Dietz of the Nova Scotia Museum were most helpful; as were Mern O'Brien of the Dalhousie Art Gallery; Garry D. Shutlak and the staff of the Public Archives of Nova Scotia; and Jocelyn Raymond.

Here at the National Gallery of Canada, I must pay tribute to the many individuals who make such a project possible. From the beginning, the staff of the Library were unfailingly responsive to

my endless demands for service, and I must thank Jacqueline Hunter, Murray Waddington, Maija Vilcins, Sylvia Giroux, Bonnie Bates, Peter Trepanier, Michael Williams, and Cindy Campbell.

During the later stages of my research, I was ably assisted by Lisa-Lise Forget, who spent a summer patiently reading microfilm. Of special help to me was Christine Lalonde, who aided with the important biographical research, first as a graduate student at Carleton University and then as a curatorial assistant in the Department of Prints and Drawings, moving on to assist in the preparation of the exhibition, with humour and serenity.

In Publications, I would like to express my gratitude to Serge Thériault, Chief, for guiding the catalogue through to completion. My thanks as well to photo editor Colleen Evans for her ever-vigilant eye. When the book suddenly changed directions as it neared production, my English editor Lynda Muir helped me pull the rabbit out of the hat. Myriam Afriat capably edited the French text, bringing refinement to the style. I would also like to extend my sincere thanks to my colleague Pierre Landry, who scrutinized the French text for correct use of print terminology. In Photographic Services, Clive Cretney, Charles Hupé, and Meva Hockley succeeded in meeting all the pressing deadlines.

In Exhibitions, I would like to thank the project managers Karen Oxorn and Barbara Ramsay-Jolicoeur, as well as Martha King, who looked after the tour. In Education, I was fortunate to work with Suzanne Lacasse, who always came up with good ideas for presenting the exhibition. In the Restoration and Conservation Laboratory, conservator Geoffrey

Morrow proved once again to be a willing collaborator. In Technical Services, my thanks are owed to Jacques Naud and his staff, among whom Sat Palta deserves particular mention. In Registration, I would like to thank Carole Lapointe for adeptly overseeing the loans and travel arrangements. Without Michael Gribbon to supervise the practical handling of the works in the exhibition for the Department of Prints and Drawings, I would simply have been lost. For the look of the exhibition, I would like to congratulate Tracy Pritchard of Design Services, who showed a sensitivity to the subject.

It goes without saying that an exhibition of this nature simply could not have occurred without the generosity of the lenders. I thank them all, for their hospitality in letting me visit their collections and for their kindness in allowing their works to be included in the show.

Doubtless, I have omitted a number of people who have made a contribution to this project. To them I apologize and offer my sincere gratitude.

Finally, I would like to dedicate this book to the two individuals who have given me the most, my parents, Freeman and Rosita Tovell. My father instilled in me a love of history, making the past the present and the future; my mother showed me that art galleries and exhibitions were the most stimulating places to be.

Rosemarie L. Tovell
Associate Curator of Canadian Prints and Drawings
National Gallery of Canada

Note to the Reader

Abbreviations

AAM	Art Association of Montreal
ACE	Association of Canadian Etchers, Toronto
AGO	Art Gallery of Ontario, Toronto
ALC	Arts and Letters Club, Toronto
AMT	Art Museum of Toronto
CAC	Canadian Art Club, Toronto
CNE	Canadian National Exhibition, Toronto
CPE	Society of Canadian Painter-Etchers, Toronto
CSGA	Canadian Society of Graphic Art
CWMF	Canadian War Memorials Fund
GAC	Graphic Arts Club, Toronto
MMFA	The Montreal Museum of Fine Arts
NA	National Archives of Canada, Ottawa
NGC	National Gallery of Canada, Ottawa
OSA	Ontario Society of Artists, Toronto
PANS	Provincial Archives of Nova Scotia, Halifax
RA	Royal Academy of Arts, London
RCA	Royal Canadian Academy of Arts
RPE	Royal Society of Painter-Etchers and Engravers, London
SGA	Society of Graphic Art, Toronto
TASL	Toronto Art Students' League

Language of Titles

It is the policy of the National Gallery of Canada to translate titles of works into both official languages. However, in recognition of the print movement's international nature during the period covered by this study, an exception has been made for those instances where an artist deliberately chose to title a work in a foreign language. Further, in the case of the fluently bilingual Clarence Gagnon, the title will remain in the language invariably used by the artist for a specific work.

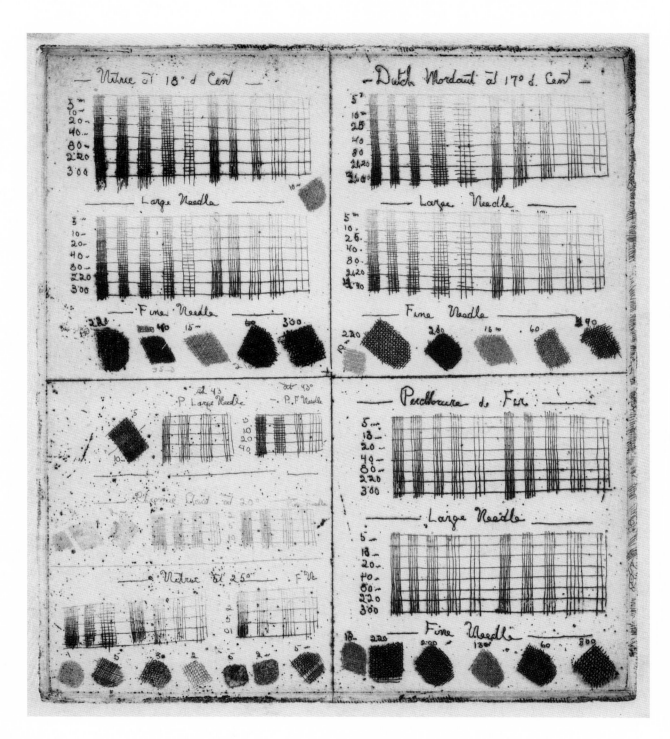

Fig. 1
Clarence Gagnon
Test Plate 1904–05
National Gallery of Canada (37697)

Explanation of Technical Terms

During the period covered in this study, etching and other variants of intaglio printing were the dominant form of artist's prints. The common element in **intaglio** techniques is the creation of the image below the surface of the metal plate, which is usually of copper or zinc. After inking the plate, dampened paper is placed on the plate and run through a press at extreme pressure, thereby picking up the ink in the recessed areas.

The simplest intaglio techniques are executed with specialized instruments, working directly on the metal plate. An **engraving** is made by a burin gouging out grooves to create lines, with the resultant lines looking like penstrokes. If the metal thrown up along the side of the line (called the **burr**) is retained, the technique is described as **drypoint**, and the lines look feathery. A **mezzotint** is made using a roulette to roughen the entire metal surface; the design is then produced by smoothing the roughened surface. Mezzotints have a rich, dark, velvety appearance, in which the design is modelled in tones graduated from dark to light.

More complicated intaglio methods utilize acids or **mordants** to **bite** the image into the metal plates. The types of acid (usually dutch mordant or nitric acid), their strengths, and the room temperatures at which the plate is etched, as well as the size of needle produce subtle differences in the etched lines. Artists often make test plates to serve as a reference while creating their own prints (see fig. 1).

Etching is the most common technique using acid; it is made by coating the metal plate with an acid-resistant, resinous substance called **ground**. With a needlelike instrument or stylus, the artist draws the composition into the hardened ground, carefully exposing the metal plate.

The plate is then immersed in an acid bath. The length of time the plate remains in the acid determines the depth of the etched lines: the deeper the lines, the darker they print.

To vary the quality of the lines, those which are to remain light in appearance are **stopped out** with a varnish to protect them from the acid when the plate is reintroduced into the acid bath. Etched lines have the look of penstrokes, but they have a more spontaneous quality than engraved lines. **Foul biting** occurs when the ground or the varnish is not applied properly, allowing the acid to attack the metal plate at random. Sometimes used intentionally, foul biting shows in the print as tiny specks or irregularly etched areas.

Soft-ground etching is the same process as etching, except that suet or tallow has been added to the ground; this has the effect of preventing the ground from hardening. With a pencil, the artist draws the composition on a thin piece of paper, covering the prepared plate. When the paper is removed, the tacky ground lifts off unevenly where it has stuck to the lines of the drawing. The character of the granular, soft, pencil line is retained in the printing.

The tones created by the **aquatint** technique are similar in appearance to an ink or watercolour wash. The plate is dusted in the appropriate areas with a powdered resin. When heated, the resin melts and adheres to the plate, protecting it from the acid. As with etching, the longer the plate is immersed in the acid bath, the darker the tone. Areas not to be toned are stopped out with varnish.

Spirit-ground aquatint is a variant technique in which the areas to be toned are created by brushing on resin dissolved in a distilled spirit solution such as alcohol. As the spirit evaporates, the resin remains as a finely patterned, cracked

film, which is retained in the metal plate when it is etched in the acid bath. This method of aquatint allows for greater spontaneity in the placement and appearance of tones.

As the artist develops the composition on the plate, it goes through progressive **states**. **Proofs** of these states will be printed, allowing the artist to determine the effect of each addition to or subtraction from the design. When this process is completed, the plate can be printed in a limited **edition** of **impressions** for exhibition and sale.

The printing process itself is a vital aspect of the final look of an intaglio print; and the manner in which the ink is handled is of the utmost importance. After the ink is applied to the plate, the excess is removed from the smooth, unmarked metal surface. If all the ink is removed from the surface of the plate, the design of the print will be in stark contrast to the paper. If a thin film of ink is left on the plate, the resulting **plate tone** can soften the overall effect. Plate tone can also be manipulated in a painterly fashion to convey, for example, the effects of light and shadow in the printed image. After the plate has been wiped, a fine cloth may be used to further tease out the ink from the etched line – a technique known as **retroussage**. In this manner, the painter-etcher can selectively darken or soften the harshness of the etched line. Single lines and densely etched areas with retroussage can be mistaken for drypoint.

Lithography is a completely different printmaking technique, which perfectly translates the aesthetics of drawing. The image is drawn on and chemically fixed to a flat surface, usually a special limestone or lithographic plate, which is printed in a flatbed press. In all printing processes, the image printed will be the mirror image of the design on the printing surface. **Offset lithography** is a commercial printing process that nullifies the image reversal. Lithographs can be drawn on the primary printing surface with a greasy lithographic crayon, or brushed on with liquid tusche. **Lithotints** are lithographs drawn only with liquid tusche – they look like wash drawings.

Transfer lithographs are not drawn on the primary printing surface. The artist draws the composition with a waxy crayon on special paper, which is then pressed face down onto the printing surface. The paper is dissolved with a wet sponge, leaving behind the crayon image, which is fixed to the printing surface as in normal lithography. The drawing in transfer lithography is not as precise or immediate as in straightforward lithography, and often the texture of the paper can be detected in the printed image.

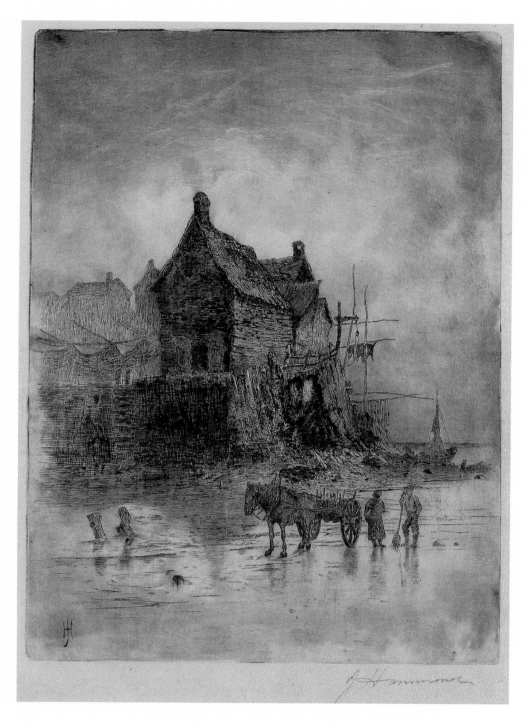

Plate I
John Hammond
Dulse Gatherers on the Coast near Carleton, N.B., state II/II c. 1882–83
(cat. 52)

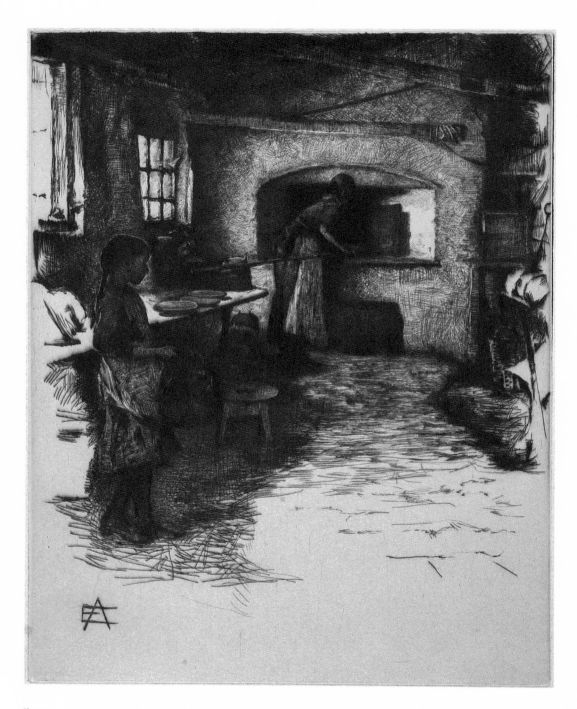

Plate II
Elizabeth Armstrong Forbes
The Bakehouse c. 1886–87
(cat. 33)

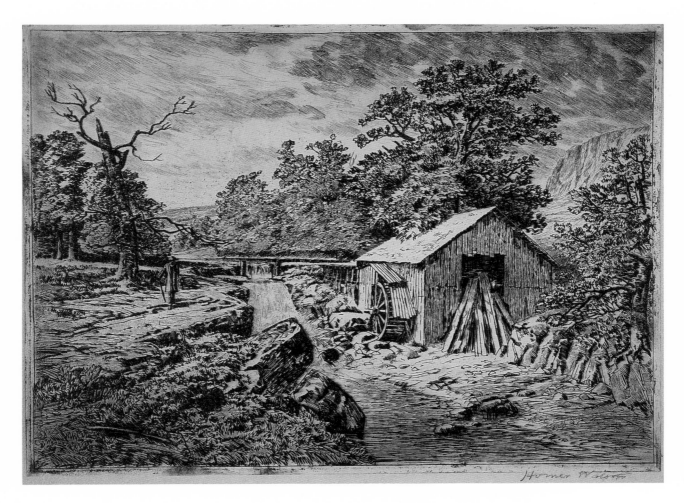

Plate III
Homer Watson
The Pioneer Mill, state II/III 1890
(cat. 121)

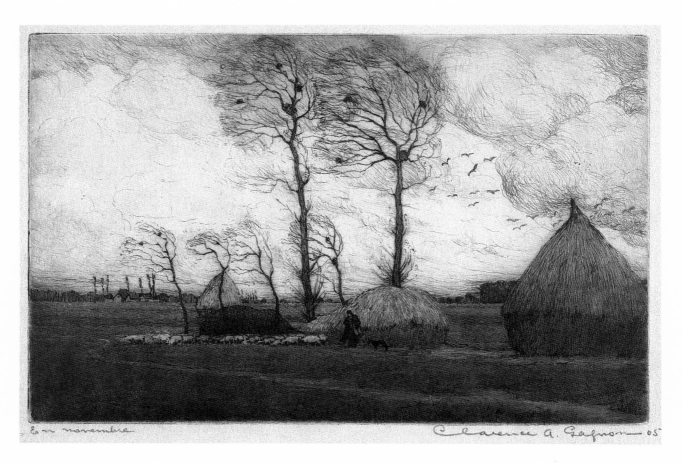

Plate IV
Clarence Gagnon
En novembre 1904–05
(cat. 37)

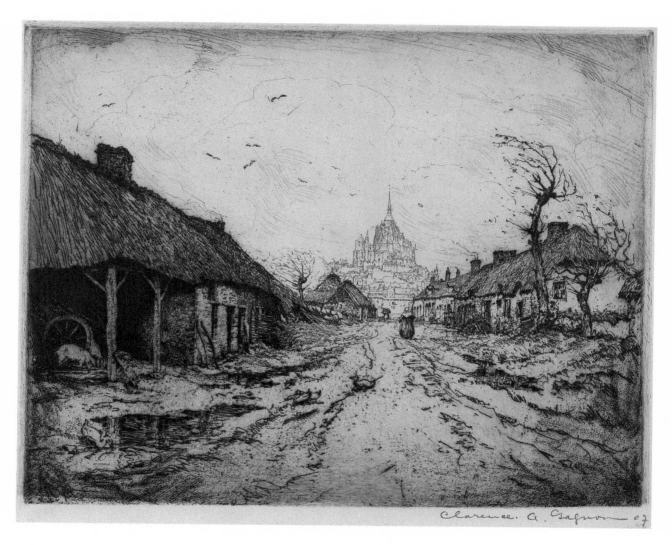

Plate V
Clarence Gagnon
Mont Saint-Michel 1907–08
(cat. 43)

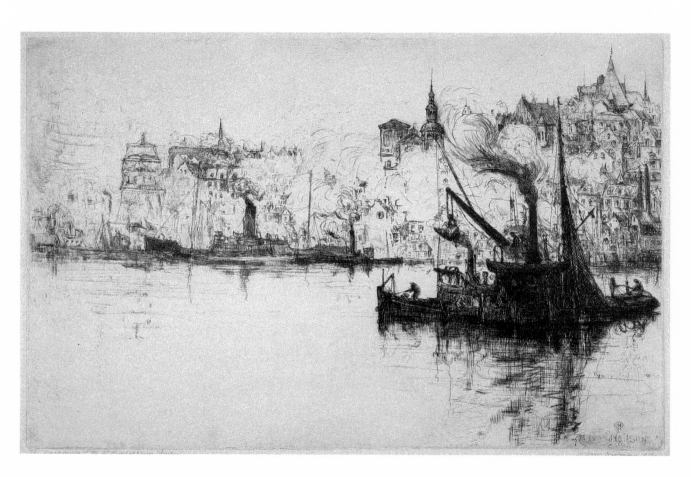

Plate VI
H. Ivan Neilson
The Deepening of the St. Charles River, Quebec 1913
(cat. 86)

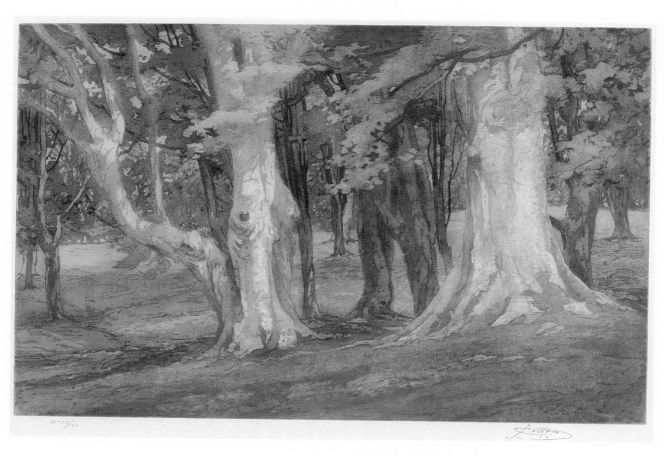

Plate VII
John W. Cotton
Beeches, Epping Forest 1914–15
(cat. 20)

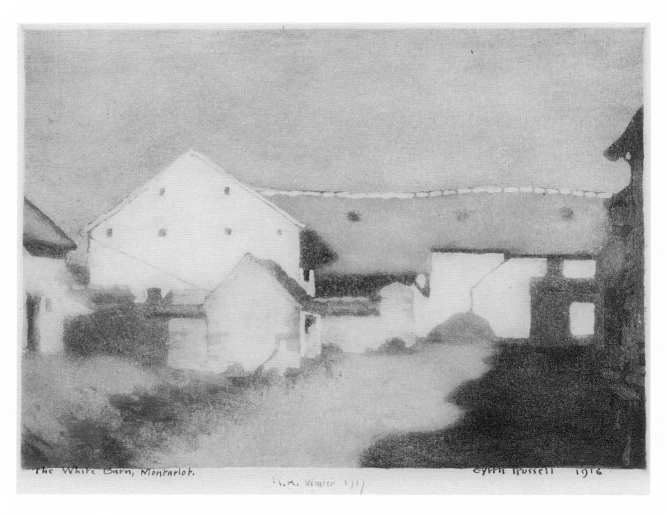

The White Barn, Montarlot. H.M. Winter 1/17 Gyrth Russell 1916

Plate VIII
Gyrth Russell
The White Barn, Montarlot 1916
(cat. 98)

Introduction

ON 21 MARCH 1885, an impressive international exhibition of etchings opened at the galleries of the Ontario Society of Artists in Toronto. Organized by the Association of Canadian Etchers, it was the first exhibition of its kind ever held in Canada. The crowd in attendance were both puzzled and uncertain about what they saw. These were not the large, highly finished engravings after paintings they were accustomed to regard as "art prints." For the most part these were small, informal looking prints, their compositions original subjects created directly on the printing plate. For Canada, as a guest speaker noted, they were "a new class of art."

About halfway through the nineteenth century, artists began to reexamine printmaking as a form of original artistic expression – a creative process separate from the use of print technology in the reproduction of other forms of the visual arts. However, the nineteenth-century print revival was not just a matter of artists reclaiming a medium that had become the province of craftsmen engaged in the printing trade, it also inferred an interest in the artist's print by collectors, dealers, critics, and professional art societies. The production and the reception of the art form were inextricably dependent on each other. Internationally, these two aspects of the revival developed apace. In Canada, the limited number of professional art institutions, critics, and art patrons seriously impeded the printmakers' ability to find acceptance for and profit from their efforts.

During the print revival's most exciting period – from the mid-1800s to World War I – Canada was an underpopulated and newly minted nation, still undergoing a slow colonization of its own vast territory. Cultural institutions were just coming into existence and surviving only in their nascent form: a mere handful of artists of real ability and cognoscenti could be counted on to nurture the visual arts. It could be said that Canada showed little interest in embracing and supporting a national art school. It was difficult enough for painting, which already possessed its certification as "high art." It was worse for printmaking, a "minor" art form that was relatively new to Canada's artistic life – the first datable print by a professional Canadian artist that meets the criteria of artist's print as defined by the print revival is 1877. Before this date, a home-grown reproductive printmaking industry had never been able to take hold on a broad scale; this forced the print to play a lesser role in the unfolding story of a Canadian Fine Art.

Etching and its technical variations (drypoint, aquatint, etc.) was the preferred medium of Canada's first artist-printmakers, largely because etching dominated the international print revival. Indeed, being wildly popular, etching was far ahead of developments in other print media. However, by the time the artist's print really began to hit its stride in Canada, around 1910, on the international scene lithography was rapidly gaining on etching as the medium of choice. For Canadian artists, lithography could have been the alternative to etching, but it ran a distant second. Why? Lithography was too expensive a medium with which to "play," requiring the facilities and personnel of a professional print shop. As well, lithography was possibly too close to the daily work of the most enthusiastic of Canada's printmakers, many of whom came out of the commercial art trade associated with the publishing business. For most of them, etching was not just different, it was a medium with well-established artistic credentials – a new and challenging

medium, yet not totally divorced from their own field of expertise. Etching was also a cheap and social medium; on their own, artists could undertake the technical aspects of printing, learning through trial and error with fellow etchers gathered around the shared portable etching press.

This is the first study of the origins and establishment of the nineteenth-century concept and evolution of the artist's print in Canadian art. It is a story that has its origins in Europe and the United States, with Canada standing on the periphery of an international movement. Yet Canada produced printmakers of international renown, as well as unstoppable pioneers who brought a new art form to their homeland. To understand the complexity of the influences on the movement at home and the activities of Canadian artists abroad, it is necessary to offer a brief outline describing the emergence of the nineteenth-century print revival.

Prologue

The artist's print had existed from the time of the invention of the printing press. Its revival in the nineteenth-century can be seen as part of an aesthetic evolution that took place in opposition to the reproductive visual art products machined in the workshops and factories of the Industrial Revolution. The print revival was also a conscious reclamation by artists of the techniques and creative spirit of the old masters.

During the eighteenth and into the nineteenth century in Europe, engravings after famous paintings and works on a diverse range of popular subjects increasingly won the favour of discerning collectors and of the growing middle class. These engravings were ideal for the embellishment of the home, testifying to one's cultural achievements, degree of affluence, and social standing. The publishing on a large scale of such engravings could harvest such dazzling monetary rewards that a new publishing industry arose to meet the market demands. Artists found that more money could be made through the copyright on their painting (i.e., the fee to be gained from sales of a reproduction) than by the sale of the painting itself. To meet the need for high quality engravings, publishers sought out and encouraged engravers of great talent who could create prints of exceptional

subtlety, richness, and a high degree of finish. These engravers could spend months and in some cases years working on a single plate before turning it over to a publisher for printing. Such a pace could not keep up with the growing demand of the market, nor was it economically feasible. Increasingly, the engravers turned to mechanical devices such as ruling machines that shortened their work and deadened their craft. As well, publishers were developing less expensive printing techniques such as lithography and a variety of photomechanical processes. By the 1880s and 90s, the master engravers were dying off, and enthusiasm for the photogravure seemed unlimited. More and more, the artist-printmaker began to inhabit the place for quality prints demanded by the market.[1]

However, appreciation for the art of the reproductive engraving did not entirely die out. Splendidly finished line engravings had created a sophisticated taste for almost two centuries and the effect was hard to shake. There was still a demand by the more knowledgeable print collectors for reproductive engravings of high quality, as evidenced by the extensive display of such engravings at the Black and White exhibition organized by the Art Association of Montreal in 1881, many of which were borrowed from local collectors. As late as 1912, engravings after other artists' work could be found exhibited next to original prints by Rembrandt and Dürer at the Art Museum of Toronto's *Fifth Loan Exhibition*. And in 1914, Sir Edmund Walker and Eric Brown, curator at the National Gallery of Canada, could seriously discuss acquiring a group of such work.[2]

During the eighteenth and nineteenth centuries, artists such as Paul Sandby, Eugène Delacroix, and Francisco Goya continued to pull extraordinary personal prints that were technically innovative. But by the 1840s and 50s, a growing number of professional artists were beginning to take a renewed interest in the more creative and expressive aspects of seventeenth-century etchings. For their inspiration and education, the artists looked to the work of past masters, who were for the most part Dutch and who excelled in the technique of etching. Rembrandt was their god and his etchings were as revered as holy relics (or as Sir Francis Seymour Haden put it, "the history

of Rembrandt is the history of the whole art of etching"[3]). Not surprisingly, etching became the print medium of choice, and the movement that was fostered by French, British, and American artists is known as the etching revival.

France

It is commonly agreed that the etching revival got its start in 1841 when Charles Jacque, having already attempted a copy of Rembrandt's etching *Head of a Woman*, turned his full attention to the medium. Of the artists associated with the tiny village of Barbizon outside Paris, Jacque was the first to devote himself almost entirely to etching. He consciously sought his inspiration from the Dutch landscape etchers, and through this study rediscovered many forgotten etching techniques. Jacque was able to apply the formula of the old masters to the life of his own time without affectation or conscious archaism. His etchings stimulated such Barbizon associates as Corot, Daubigny, and Millet, who produced an imaginative and impressive body of work through the 1850s and 60s. The Barbizon artists adopted the vignette format, using it for both genre and landscape subjects, and thus created the archetypes for succeeding painter-etchers.

Another landmark of the French etching revival was the brilliant work of the troubled genius Charles Meryon. Meryon's set of twenty-two *Eaux-fortes sur Paris* was produced between 1852 and 1854. His Paris was not the picturesque city of the boulevardier, it was enigmatic, mysterious, and moody, "peopled by ghosts and wet with tears."[4] Meryon set the supreme standard for the urban landscape, which became a fashionable subject for later generations of etchers.

James Abbott McNeill Whistler was the next major player in the print revival, and its most influential. While studying in Paris in the 1850s, Whistler took up the etcher's needle. In 1858, he published his *Douze eaux-fortes d'après nature*, also known as the "French Set." The stunning results immediately established Whistler's reputation, and the fame of these works made them a source of inspiration for the serious etcher for decades to come. The subjects had been drawn from a tour the artist made through the Rhine Valley, later augmented with Parisian subjects. In some cases he drew his subjects directly onto prepared copper plates, while in others the plates were scratched in his Paris studio from drawings and watercolour sketches. The emphasis was on the spontaneous quality of the etching – on freehand draughtsmanship and the inspiration of nature. Whistler's unassuming and picturesque treatment of rural and urban genre subjects became the paradigm for etchers who followed.

The influence of the "French Set" went beyond just the subject matter and drawing style: Whistler had initiated a new visual printing style brought about through technical means. To achieve a variety of line and tonal effects, he used the technique of multiple biting of the plate with acid, which permitted some lines to be etched more deeply (and hence print darker and broader). He also allowed for a Rembrandtesque technique of foul biting, in which acid accidentally attacks the copper where the ground has been weakened – for example at the margins where the plate has been handled. It added to the informal quality of the print, in keeping with the appearance of a sketch. When inking the plates, Whistler again looked to Rembrandt, employing his painterly use of plate tone, in which a residual film of ink is left on the plate and manipulated to create areas of light and dark shadow. Also evident was a method of wiping the plates called *retroussage*, which pulls the ink up from the etched lines and deposits it near the top of the grooves, giving the lines a velvety and expansive appearance.

To enhance these printing techniques, Whistler sought out the kind of antique paper Rembrandt had used. Most nineteenth-century papers were made of wood pulp and rendered a harsh white through bleaching. Searching through the old book shops, Whistler could find warm-toned papers made from rags that brought out the subtle richness of an etching. The fame of the "French Set" gave credence to the superior nature of quality papers, be it antique Dutch papers or the Japanese papers now coming on the market, with their variety of warm tones and thicknesses. Paper became an integral element in a print's creation.

The establishment of an etching revival was also due to the publisher Alfred Cadart. Keenly

interested from the outset, Cadart organized the Société des Aquafortistes, which was active from 1862 to 1867. When this society folded, he founded its successor, the Société des Peintres-graveurs à l'eau-forte (1868–80). Both societies had a frankly commercial purpose, evident in the monthly publication *Eaux-fortes modernes*. Cadart went on to further publishing schemes, which comprised an "endless number of indifferent prints, particularly wearisome succession of uninspired landscapes … but … every now and then … a real gem."[5] His widow continued his work until 1880, by which time they had succeeded in glutting the French etching market. However, the importance of Cadart's work rested with his ability to publish etchings at minimal cost to both the artist and the collector. As well, Cadart was most persuasive in bringing all manner of men and women to experiment with the needle.

Without manuals, the earliest painter-etchers had to rely on professional printers for assistance. Foremost among these was Auguste Delâtre, the printer of Whistler's "French Set" and the one who instructed and directed Whistler in his superb mastery of the technique. Delâtre had taught himself the art of etching by studying the old masters, and his knowledge of Rembrandt's techniques was learned from reprinting some of the master's own plates.[6] He was employed by almost all the pioneers of the etching revival. His small Parisian shop was not just a school but also a place where the artists and their collectors could congregate and examine the latest prints. Delâtre became the "high priest of printing" and was much in demand. In 1864, he was invited to set up a short-lived etching class at the National Art Training School in the South Kensington district of London.

To achieve the maximum dissemination of the new art, accessible technical manuals were required. The first of these, *Traité de la Gravure à l'eau-forte* by the painter-etcher Maxime Lalanne, did not appear until 1866. While it would prove to be highly popular with artists and the curious public, the fact that it was released only in French limited its influence.

Publishers and artist-printers could assist in creating the product, but only a spokesman could validate it. Philippe Burty was chief among the

French critics to champion the revived art form. In 1857, the *Gazette des Beaux-Arts* was founded; from its inception, with Burty as its art critic, the magazine promoted the best etchings being produced. By publishing in every issue high quality reproductions or restrikes of the best plates, Burty and his magazine fostered a true understanding and appreciation of printmaking. After the critic's death in 1890, the *Gazette des Beaux-Arts* continued his mission to promote the work of new talent – Clarence Gagnon's phenomenal early success as an etcher can be attributed to Burty's legacy at the magazine.

Another important French apologist for the painter-etchers was Charles Blanc. In 1861, Blanc identified the strength of etching, holding it to be not suitable for the grand art of elevated classical themes but rather a medium for the picturesque style. He defined etching as follows: "Etching, as we understand it, is pure drawing, that is to say the work of a master who records his ideas as he creates them, and who communicates them directly to us without any intermediary … etching, as we wish to describe it today, is a drawing on copper, executed by a painter."[7] One of Blanc's most significant contributions to the etching revival was his *L'Œuvre complet de Rembrandt décrit et commenté*, published in two volumes in 1859 and 1861. With forty copy etchings after Rembrandt, it was the first book to attempt to reproduce quality illustrations of the master's prints. In 1873, a second edition appeared, adding more copy etchings as well as thirty-five high quality heliogravures offering very precise reproductions of the originals. Blanc's publication served to disseminate to artists and collectors the genius of Rembrandt, the printmaker. The quality of these illustrations was such that they were used to represent Rembrandt in exhibitions, for example in the 1881 Black and White exhibition in Montreal.

The etching revival in France never attained the same levels of popularity – one might almost say mania – it reached in Britain and America. By the 1880s, the market had become saturated with inexpensive artist's etchings, and new media were attracting the attention of the emerging schools of artists. With Impressionism and Post-Impressionism, colour took on a central

importance in art, and artists such as Mary Cassatt and Camille Pissarro turned from black and white to experimenting with the colour print. By 1898 the Société de la Gravure Originale en Couleur was founded. About this time, Delâtre's son Eugène took over his father's shop, becoming the artist-printer to this new group of colour print-makers. Lithography, with its ability to reproduce any style of draughtsmanship, now rivalled etching's popularity in France. A more stylistically flexible medium, lithography was able to adapt to the multitude of ideas prevalent in the Post-Impressionist world. Such innovative artists as Whistler and Fantin-Latour were creating an expressive medium out of this relatively recent and commercially-oriented print process.

Great Britain

The etching revival was imported to Britain by Whistler and his brother-in-law Sir Francis Seymour Haden following the publication of Whistler's "French Set" in 1858. Haden, a surgeon by profession, was at this time a great amateur of etching, both as a collector and sometime practitioner. Haden had witnessed the creation of the "French Set" on Delâtre's press and was immediately enthralled. He took up the art for himself, and by 1859 was producing an impressive number of accomplished etchings that placed him in the first rank of painter-etchers. In 1859 as well, prints from Whistler's "Thames Set" were exhibited at the Royal Academy – the first great prints of the British etching revival.

For the printing of his "Thames Set" Whistler found Frederick Goulding, a young London printer responsive to his needs.[8] Goulding was subsequently taken up by Haden, who promoted the printer to other British painter-etchers. Beyond merely printing for artists, Goulding was active in teaching etching to art students. In 1876, he instructed at the Slade School of Fine Art and the National Art Training School at South Kensington, where he served as the assistant to Alphonse Legros, a founder of the French etching movement. In 1882, Goulding took over Legros' class and found among his pupils Frank Short, whose own estimable talents made him Goulding's successor to the teaching post at South

Kensington, and in time, heir to the mantle of master printer to the British etchers. Together, Goulding and Short established the practice and methodology of formal printmaking instruction in Britain's art schools.

With a public captivated by the reproductive engraving, the British painter-etchers were up against a stiff wall of resistance to the acceptance of their art, but they found an eloquent advocate in Philip Gilbert Hamerton, whose discernment, practical experience, and literary powers made him an ideal spokesman. In 1868, Hamerton published *Etching and Etchers*,[9] an expensive volume, lavishly illustrated with thirty-five prints by leading etchers and a restrike from a Rembrandt plate. An immediate success, the book turned the "attention of the artless to etching,"[10] answering a need for a philosophical, historical, and technical investigation into the medium. Not only did it discuss several schools and the aesthetics of etching, it also provided specific information on building presses, formulae for acids to bite the plates, and much more. It was the most influential publication in the English-speaking world in promoting the art. Hamerton went on to found several art journals devoted to etching, thus spreading the knowledge and appreciation of etching among collectors. At least two of Hamerton's journals made their way to the reading room at the Art Association of Montreal. In 1871, Hamerton wrote a technical manual for artists, *The Etcher's Handbook*, which took up where *Etching and Etchers* left off, and was the first of its sort in the English language. Both books are known to have been consulted by Canadian etchers in the 1880s.

If Hamerton preached the word of the etching revival, Seymour Haden was its pope. No one was more influential in advancing the movement in Britain than Haden. Through sheer energy, force of personality, and missionary zeal, he cast an overpowering shadow over all aspects of the revival on both sides of the Atlantic. He established its doctrine, founded its principal British society, encouraged its practitioners and collectors, both institutional[11] and private; and on top of it all, produced some of its masterpieces. Haden saw his task as twofold: to establish etching as a fine art and to raise the professional status

of its practitioners to a level equal with other visual artists.

Haden's tenets on etching were described in numerous publications and lectures; they became an orthodox doctrine that persisted well into the twentieth century. He insisted that an etcher should work from nature, rapidly, and with a minimum of detail. Above all, he believed that every aspect of printing was an integral part of the etcher's art and should be done by the etcher himself, or with the assistance of a master printer, such as a Delâtre or a Goulding.

To raise their professional standing, Haden pressed the Royal Academy to accept etchers to full Academician status. Failing in this objective, he formed his own "academy" – the Society of Painter-Etchers – in 1880. The choice of names was significant. Haden translated the French term *peintre-graveur* into English to make clear the distinction between his members, as creators of original works of art, and the mere copyists. Membership was inclusive, reflecting Haden's wish that the Society serve as a true promoter of the art; it welcomed British and foreign artists, print connoisseurs and curators, and, from the outset, women.

Haden and Hamerton's success in establishing etching as a viable art form can be easily measured. Etching became the unrivalled darling of Britain's artists and collectors, buoyed by a craze that lasted well into the 1930s. Printmakers in other media latched onto this phenomenon; in 1908, the Senefelder Club was formed in London to promote lithography, with the Canadian James Kerr-Lawson as one of its founding members. In 1909, the Society of Graver Printers in Colour offered artists working in colour etching and woodcut a base from which to advance themselves. The concept of lithography and colour printmaking in the form of artist's prints came to Canada in 1912, when works by members of the Senefelder Club and the Society of Graver Printers in Colour were first seen at Toronto's Canadian National Exhibition.

The United States of America

In 1866, Alfred Cadart came to the United States, transplanting the etching revival to North American soil. Cadart's motive was to develop a new market for his product, and to this end he brought along a large collection of contemporary French etchings to sell. He also carried with him the supplies required to give classes on the process, hoping to encourage a new crop of artists. While Cadart failed in the latter, he did succeed in the former by acting as a stimulus in the development of several major collections in Boston, New York, and Philadelphia.[12] More impetus was given to American collecting two years later, when Whistler had his first exhibition in New York and Hamerton's *Etching and Etchers* was published.[13] Private collectors such as James Claghorn of Philadelphia or Samuel P. Avery of New York would play a vital role, not just by making their collections available to artists for viewing and study but also by actively supporting and encouraging the artistic community.[14]

In the early stages, a scant number of artists were dabbling in original etchings. Needing the support and encouragement of like-minded colleagues, they formed the New York Etching Club in 1877. It was the first etchers' "cooperative," with a membership that included both amateur and professional enthusiasts. James David Smillie was the prime mover behind the association. He had a background in commercial engraving, having learned from his father, James Smillie, America's premier engraver. Through its publications and annual exhibitions, the Club became the North American standard bearer for the etching movement. It spawned similar clubs in Cincinnati (1879), Philadelphia (1880), Boston (1880), and Brooklyn (1881). The Association of Canadian Etchers, founded in Toronto in 1884, was a direct descendant of these American associations.

The chief proponent of the American etching revival was Sylvester Rosa Koehler, who launched himself onto the scene in 1879 with the publication of the *American Art Review*, a journal devoted entirely to etching. The high quality magazine contained original etchings, biographies, and catalogues of the leading American etchers, as well as information and reviews on almost any activity involved with the movement at home and abroad. While the publication only lasted three years, the good will it created within the community made Koehler a confidant of American and Canadian

artists alike. Throughout the 1880s, Koehler would author six publications on American etching,[15] as well as organize major exhibitions in Boston and Philadelphia. His expertise made him a natural choice for curator of prints at the Museum of Fine Arts Boston, where he served from 1885 to 1900, creating the first print department in an American public institution.

Arguably Koehler's most important publication was his translation of Lalanne's *Treatise on Etching*, published in 1880.[16] It was a boon to English-speaking artists everywhere,[17] being a far more detailed, better described, and better organized technical manual than Hamerton's *Handbook*. Koehler's text was of particular usefulness to North American etchers, who suffered from the lack of colourmen or dealers carrying the materials and paraphernalia of etching. He provided alternative sources commonly available in any city (i.e., drugstores, hardware stores), and for particularly specialized items he listed the names and addresses of suppliers in major American cities on the eastern seaboard. Koehler's translation of Lalanne served as the bible for English-speaking painter-etchers until the appearance of Ernest Lumsden's *The Art of Etching* in 1924.

When Koehler set out to publish the *American Art Review*, he located, with J.D. Smillie's assistance, the New York printing establishment Kimmel & Voigt. In the firm's printer, the German-trained Henry F. Voigt, Koehler and Smillie had found America's Delâtre.[18] Koehler not only recommended the firm to artists, in the *Treatise on Etching*, he also engaged it to print the large editions of original prints required for the monthly *American Art Review*. As well, Smillie's New York Etching Club turned over the printing of the plates for their lavish annual exhibition catalogues. Henry Voigt would also be the printer for the Canadians T. Mower Martin and J.M. Barnsley.

The American etchers had no difficulty finding publishers. The market for reproductive prints had always been strong in the United States, as witnessed by the success of firms such as Currier & Ives. By 1880 the artist's etching, with its old master tradition, was becoming a prestigious alternative for the small-time collector eager to make a wise investment. Dealers in engravings were quick to cash in on the growing mania for etchings, and artists were happy to turn their plates over to be published by the firms Christian Klackner, M. Knoedler & Co., Hermann Wunderlich, and Frederick Keppel. Or artists would sell the plates to agencies who wished to raise funds – as Stephen Parrish did when he sold one of his plates to the Art Association of Montreal for their art union.

By 1881, at about the time the Canadian etching revival started, American etchers could hold their own internationally. That year, at Haden's invitation, the London-based Society of Painter-Etchers welcomed American entries to their show; indeed, of the 492 prints exhibited, Americans provided nearly twenty-five percent of the etchings. Haden was so excited by the quality of their work he seriously suggested holding the second annual exhibition of his society in New York, under the auspices of the New York Etching Club.[19] This did not come about; nevertheless, a strong bond was created between the British and American etching revivals, which culminated in Haden's enthusiastic reception during a triumphal lecture tour through the eastern United States in 1882–83.

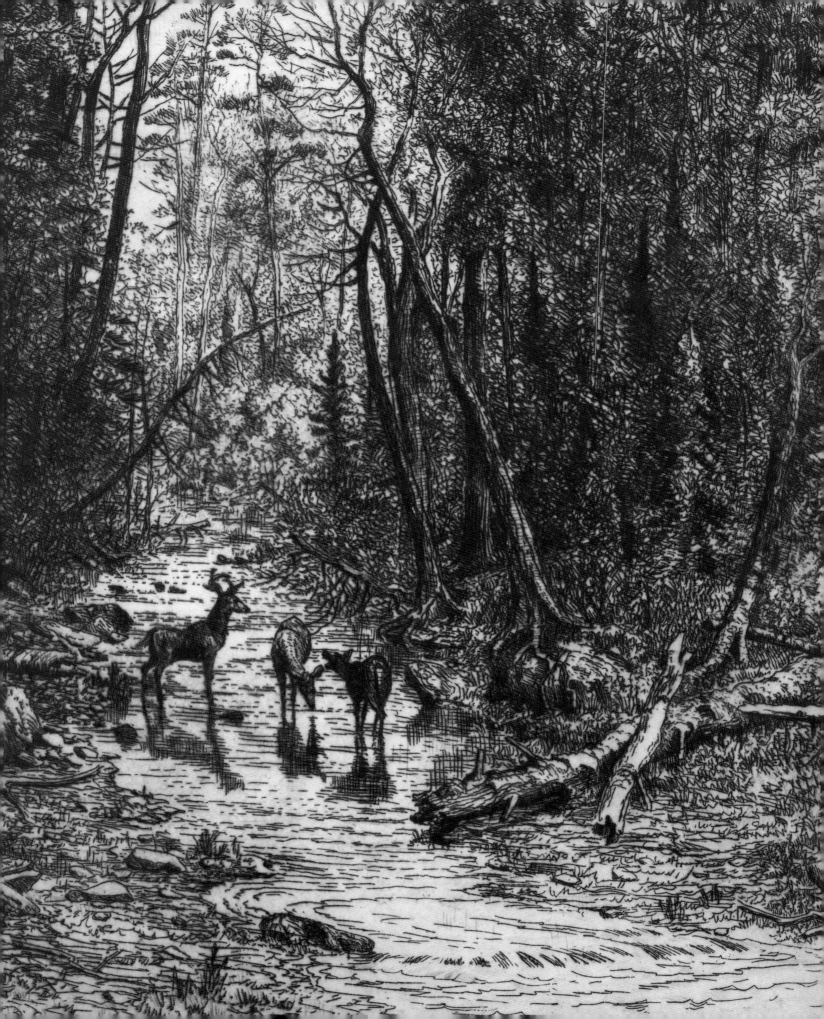

1 Breaking the Ground

The Etching Revival in Canada, 1880–1900

THE FIRST PRINTING presses were introduced into Canada with the arrival of British colonial rule in 1760. A full twenty-one years later, the first prints of pictorial subjects were etched by the talented draughtsman and military surveyor James Peachey. While there remains some debate about where Peachey's large copper plates were printed, they nevertheless opened a new chapter in Canadian art. This first period of Canadian printmaking was brought to light by Mary Allodi in her excellent catalogue *Printmaking in Canada, the Earliest Views and Portraits.*[1] Allodi's work described the early efforts by printers and publishers to create prints of subjects both pleasing to the eye and of topical interest, made for framing and display in the home. The artists, for the most part amateurs, usually submitted their designs to the printer for reproduction. There were instances, however, when printers were unable to find an artist and were obliged to make the designs themselves. Only rarely did the artist involve himself directly with the printing process, as the professional artist James Duncan did in 1843 when he drew his designs directly on the lithographic stone. From the outset, the road for the art print business was a treacherous one, and the combination of gifted printer and gifted artist was a rare occurrence. The Canadian print trade was severely handicapped by an underpopulated home market, already rife with competition from abroad.[2]

The publishing industry's problems would be ameliorated, however, by the mid-1800s, as Canada experienced an expansion of its population through immigration which included printers with professional European training. The era also saw the rise of an urban middle class with a higher level of education and disposable income. The publishing industry grew as the demand increased for newspapers, journals, and commercial items such as brochures, bonds, advertisements, and letterhead. In the 1840s, lithography replaced engraving as a cheaper form of printing, but by the 1870s other photo-mechanical forms of printing, including the Canadian-invented Leggotype, began to vie with hand-drawn lithography. As the number and size of publishing houses in Montreal and Toronto increased, the firms began to rely on in-house artists to produce designs and illustrations. This trend first became noticeable when, in 1869, the Montreal publisher George E. Desbarats and the printer William Leggo joined forces to produce the *Canadian Illustrated News*,[3] a lavishly illustrated weekly magazine based on the British *Illustrated London News*. In the following decade, other newly-founded publishing firms followed suit, developing a large staff of in-house artists; these firms included Rolph, Smith & Co. (Toronto, 1874–1904), The Toronto Engraving Co. (founded 1876, later renamed Brigden's Ltd.), and Bengough Brothers (founded 1875), which under J.W. Bengough would be transformed in 1882 into Grip Printing & Publishing.[4] While these companies employed talented young artists, a glance through their production towards the end of the century shows that the majority of the illustrations were translations of photographs.

The growth of the publishing industry was paralleled by an increase in the number of professionally trained artists, most of whom had received their training in Europe before immigrating to Canada. Coming primarily from Britain and Germany to the relative isolation of this country at mid-century, their perception of the print media would be shaped by the dominant use of the genre in the old country – that is, as a means to

reproduce popular subject matter for profit and self-promotion.

One of the most successful Canadian artists to produce commercially viable art prints was Cornelius Krieghoff, who commissioned a series of chromo-lithographs after his popular canvases of habitant and Indian subjects, between 1848 and 1862. But while it was relatively easy for Krieghoff to have his prints published in Montreal and to find a local market for them, he had most printed abroad. Only two were actually printed in Montreal.[5] In Toronto, Agnes Chamberlin's efforts could also be described as a marketing achievement, but her tribulations in locating printers and publishers for her lithographic illustrations of C.P. Traill's *Canadian Wildflowers* make for poignant reading. The volume was published in four editions from 1869 to 1895, and Mrs Chamberlin, clutching her portfolio of drawings, was forced to seek out different printers and publishers in Montreal and Toronto for each edition.[6] Paul Kane made the fortuitous discovery in Toronto of Hermann Bencke, born and trained in Germany, to produce the magnificent colour lithograph *Death of Omoxesisixany or Big Snake*, c. 1859, after his own painting of the same name. William Raphael found a fellow German, Rudolf Reinhold, to print his chromo-lithograph *The Early Bird Picks up the Worm*, 1868, a genre scene depicting two beggars at Montreal's Bonsecours Market. Raphael would produce a second chromo-lithograph *Habitants Attacked by Wolves* in 1871. The rarity of the Kane and Raphael prints suggests that their publication was not well received by the home market[7] – a fact underscored by the realization of just how few such reproductive prints were actually produced by Canadian artists. The lack of success must be attributed to competition from the high quality (and likely cheaper) engravings and chromo-lithographs mass-produced abroad and marketed through bookshops and picture dealers across the country.

By the 1870s, about the only discernible involvement professional artists had with print-making was the art unions. The first Canadian art union was formed in 1864 by the Art Association of Montreal (AAM) as a means of raising money and encouraging patronage for their exhibitions.

The idea was for the ticket holder to the exhibition to win, through a lottery, specially selected works of art from the show. As a further incentive, each ticket holder would also receive an inexpensive work of art – usually a high quality reproductive print. However, the Art Union of Montreal organizers found making such prints at home next to impossible. The first prints made for a Canadian art union were produced in 1872 by the Society of Canadian Artists. Henry Sandham was in charge of overseeing their selection and creation, and they were printed by William Leggo of Montreal. They were: *Young Canada* by James Weston, *Old Ferryman at Rye Harbour* by Daniel Fowler, *All Alone* by Allan Edson, and *Among the Wharfs, Quebec* by Sandham. As with other Leggotypes that appeared singly or in the *Canadian Illustrated News*, these prints were sometimes described as etchings.[8] The use of the term "etching" in all these instances was a misnomer when referring to the Leggotype process. While Leggotypes were essentially a form of photo-lithography that could reproduce engravings, woodcuts, and photographs, there was a special variant technique in the form of "local scenes, which ... come direct from the artist's hands (these are etched on a composition coated on glass)."[9] In other words, in the Leggotype process the artist could scratch out his drawing on a dark coated glass, the image then being transferred by light to the photo-sensitized printing surface. Some of the art union prints may have been done in this manner, but the existence of a drawing by Daniel Fowler (now in the Montreal Museum of Fine Arts) for his Leggotype suggests that it is more likely the artists simply turned their drawings over to Leggo & Co. of Montreal.

Also in 1872, the Ontario Society of Artists (OSA) was being organized in Toronto and beginning to look for an appropriate print for its art union. A Birket Foster chromo-lithograph ordered in London never arrived. The following year, another Birket Foster chromo-lithograph – *The Boat Race* – was successfully commissioned.[10] When Lucius O'Brien assumed the office of vice-president of the OSA in 1874, he tried to place a more nationalistic cast on its activities by suggesting that instead of searching for prints abroad, it

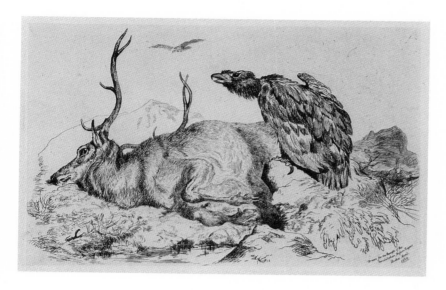

Fig. 2
W.E.P. after Sir Edwin Landseer
Dead Stag 1852
Etching, 16.2 × 25.2 cm (plate)
National Archives of Canada, Ottawa
(C–120846)

would be wiser to promote the work of their own members. From what remains of the Society's records, there never appears to have been any serious interest in calling on the membership and Canadian printers to create their own art union prints. O'Brien proposed that photographs of members' works be offered to the art union subscribers; his suggestion was accepted in 1875, bringing about what could represent the nearly complete alienation of the professional artist from the fine art print publishing trade in Canada.

Artist's Etching in Canada, before 1880

Along with drawing and music, etching had long been considered a useful accomplishment among the British upper classes.[11] As works of art by amateurs, the etchings tended to be made in very small editions for distribution to family and friends. They were modest in size and unassuming in their degree of finish. Subjects tended to be sincere renderings of local landscapes, flora and fauna, and portraits. The first etchings made in Canada were works by these hobbyists, and despite a later change in attitude, the etching revival in nineteenth-century Canada would never entirely lose its amateur character.

It should not come as a surprise, therefore, that the first upper-class Englishwoman with artistic aspirations to come to Canada should also be the first to make etchings. Between 1792 and 1795, Elizabeth Simcoe, the wife of the first Governor of Upper Canada, made two etched portraits of

Indian chiefs, *Pacane* and *Old Sail*. While she was able to etch the plates in York with equipment specially sent to her, the lack of a printing press caused Mrs Simcoe to have the plates printed in Bristol.[12]

In 1840, a scandal erupted over the purloined etchings made by Queen Victoria and Prince Albert of their children and dogs. The publicity disclosed the new royal pastime and sparked an increase in amateur interest. The consequences were evident in Canada: there appeared in the Upper Canada Provincial Exhibitions several winners of special discretionary prizes for etchings, almost all of whom were women: Miss Gill and Mrs Taylor of London in 1854; Miss Caroline Gibbard of London in 1858, for an etching "The Wild Huntsman"; and Mrs C. Harper of Kingston in 1856, for "Pen and Ink Etchings." There was also Miss E.E.E. Gourlay of Hamilton, who won a prize for her "original" etching of animals in the amateur category of the 1866 Upper Canada Provincial Exhibition.[13] None of these prints has come to light, nor has any information on the etchers. However, it is safe to assume that all were from the professional or leisured class, since only they could afford to call upon the local letterpress printer to assist with the actual printing, if not the biting, of the copper plates. The only etcher of the period whose prints we do know is "W.E.P." – whose initials were accompanied by a potted flower, suggesting the last name of Potter. She (or he) made two fine, large-sized etchings after Sir Edwin Landseer, *Dead Stag* (fig. 2) and *Stag and Wolf*, in 1852, for a bazaar to benefit the Female Orphan Asylum in Quebec City. One Upper Canada prize winner for etching who does not fit the amateur mould was William Armstrong, recently turned professional artist, who won a discretionary prize for "etching on linen" at the 1853 fair.

Whereas the amateur etchers probably kept up their hobby in private, they slowly disappeared from public view in the next decade. Professional commercial printers began to take over the displays for the various printing categories at the provincial fairs, while professional artists carefully guarded their own society exhibitions and the fine art section at the Toronto Industrial Exhibition

(the 1879 successor to the Upper Canada Provincial Exhibition). There was little, if any, room left for the amateur etcher to display her work. Yet, when the Association of Canadian Etchers was formed in 1884, half of its members could be described as amateurs. From this we might conclude that it was the amateur etchers who kept the concept of the artist's print alive through the difficult decades at mid-century.

The First Black and White Exhibition, Montreal, 1881

On 22 February 1881, the Art Association of Montreal opened the *First Exhibition of Works of Art in Black and White*, the first of its kind in Canada.[14] According to the Montreal *Gazette*, the show was greeted with some perplexity; but the paper assured its readers this was not an exhibition of black and white dogs nor of blondes and brunettes, but rather "a prosaic exhibition of prints of black ink or pigments on a white background."[15] Black and White exhibitions had begun in Britain and the United States, where they became regular fixtures in larger fine art exhibitions. A nineteenth-century phenomenon, they were in part a response to the proliferation of monochromatic illustrations by accomplished artists that printing houses preferred to use for their publications.[16] Black and White sections in exhibitions became a convenient catch-all for an assortment of monochromatic prints, drawings, watercolours, and oils. Little differentiation was made between media; in fact, it was uncommon to describe the medium at all.

While Montreal's Black and White exhibition contained some drawings, its clear intention was to introduce the art of engraving to the public. Of the 265 works noted in the catalogue, only 33 were listed as either drawings or oils. Apparently taken primarily from local private collections, the contents of the exhibition provide a focused snapshot of the prevailing perception of and attitude towards fine art prints among Canadian cognoscenti.

The Montreal show was arranged chronologically, beginning with eighteen prints by Albrecht Dürer, and featuring works by other old masters such as Lucas van Leyden, Lucas Cranach,

and Rembrandt. Of the nineteenth-century painter-etchers, Charles Jacque and "John" Whistler were represented with one etching each, as were Maxime Lalanne and R.W. Macbeth. There was little consideration given to the relative importance of prints made during an artist's lifetime versus prints that were clearly copies and reproductions of original prints. Of the Rembrandt selection, nine were described as "reproductions published with *L'Œuvre de Rembrandt* of Charles Blanc" and one was described as a "Reproduction from the 2nd state," while there was no indication if the other four prints on view were lifetime impressions or restrikes. That all these "Rembrandts" were given equal weight is evident from the *Gazette* review, for the journalist records having the well-known Flameng copy etching of the "Hundred Guilder" print (from the Blanc book) pointed out to him as the one Rembrandt of special importance in the show.[17] A telling entry in the exhibition catalogue is for a set of "Autotype reproductions of etchings" (a type of photo-reproduction) for J.M.W. Turner's *Liber Studiorum*, including "Aqueduct with Stork." This is the same work, we are informed by the *Gazette* reviewer, that "Ruskin has pronounced the finest of Turner's etchings." The majority of the European printmakers included in the show were, in fact, the master engravers of the eighteenth and nineteenth century, for example Francesco Bartolozzi, William Woollett, and S.W. Reynolds, who engraved the works of some of the finest painters.

This evident failure to discriminate in quality between an original created by an artist, a copy after the artist's work, and a blatant reproduction in another medium was not simply an indication of an uninformed and provincial state of connoisseurship. This lack of critical judgement was exceedingly common in the centres of the etching revival and supported by influential critics such as John Ruskin, who held that engraving was the copyist's art and that faithfulness to the original constituted its merit. The professional societies also upheld this view, preferring to admit engravers into membership in their own category, while refusing to accept painter-etchers either as artists or in a separate category. (As artists, the latter would have to qualify in painting or watercolour or another

already accepted medium.) The policy of admitting engravers was also adopted by the Ontario Society of Artists and the Royal Canadian Academy, but to be fair, at the time they drew up their categories of membership in the 1870s, painter-etchers simply did not exist in Canada. Nonetheless, the Canadian societies were slow to extend membership to artists based solely on their qualifications as printmakers.[18]

As part of the programming for the first Black and White exhibition, the Montreal author and scholar William McLennan gave a lecture on the history of engraving before an attentive audience in the Art Association's rooms on Phillips Square.[19] McLennan focused his lecture on the development of engraving on wood and on metal. These two categories were then subdivided into woodcut, wood engraving, line engraving, mezzotint, etching, and so on. It was a rather pedantic recitation of the techniques, with little commentary on the printmaker's aesthetic creativity. Although McLennan cited Hamerton and Lalanne, he was happier with more conservative and dated writers such as Joseph Maberly, whose book *The Print Collector* was published in 1844. McLennan treated the medium of etching as just another variant of engraving on metal. He acknowledged that etching had "within the last twenty years undergone a remarkable revival and been brought to great perfection in France and England," but was nonetheless reluctant to accord it the superior status promoted by Hamerton. While remaining loyal to Ruskin's pontifications on engraving as the copyist's art, McLennan went on to espouse a more balanced view. In it, etching can simply be seen as the equal of other forms of engraving on metal, but with different characteristics as put forward by Maberly, whom he quotes: "Engraving ... may be considered to personate the art in her full attire of ceremony and state. The etching shews art at her ease, in dishabille, perhaps, but never a slattern; only throwing off much of the restraint and stiffness to which she is on high days, subjected."[20]

McLennan may not have been alone in his partiality to Maberly's views on print connoisseurship, for the printmakers recommended by that author were echoed in the selection for the exhibition. McLennan's lecture also revealed the printed sources which interested Montrealers consulted for information on the current state of the print world; he mentioned "having found such an abundance of material in the works of Dr Wilshire, Jackson and Chatto, Scott, Lalanne, Hammerton [*sic*] and others."[21] The periodicals he cites are *Harper's* and *Scribner's* – both popular American magazines. There is no mention of specialized art periodicals such as the *Gazette des Beaux-Arts* or the *American Art Review*, both in wide distribution throughout France, Britain, and the United States.

Returning to the show itself, we must note a distinctive feature of the AAM's Black and White exhibition – a section set aside for Canadian work, which was singled out with pride by both the *Gazette* and the *Daily Star*.[22] There were twenty-seven works by Canadians, of which only four were described as prints – etchings to be exact. The "etchings" by Daniel Fowler, James Weston, and Henry Sandham were actually the 1872 art union Leggotypes,[23] and the fourth "etching" was a "View from the Mountain, Montreal" by C.J. Way. More than likely, it too was a Leggotype made in the early 1870s. The remaining works by Canadians, including Lucius O'Brien, Robert Harris, William Cruikshank, and T. Mower Martin, were drawings – a large number of which were destined as illustrations for *Picturesque Canada*. Not a single Canadian painter-etcher print was evident.

Taking all aspects of the AAM's first ambitious Black and White exhibition into account, it is clear that by February 1881 the etching revival had not reached Montreal. Yet the show doubtless quickened the pace of its arrival. Montreal collectors did become interested in acquiring prints for their art collections, but they were not helped by Canada's tax laws. In 1882, the government began to introduce customs tariffs on sculpture, which had previously been exempt from import duties. This action prompted the Art Association to petition the Minister of Finance against "the tariff, operating as it does against the interest of art in this Dominion."[24] Their petition gave them an opportunity to request that "high art engravings," drawings, manuscripts, and quality art books also be exempted. When the AAM delegation met with the Minister of Finance in Ottawa, the

Association won only a partial victory, gaining an exemption for books and manuscripts but not for prints, drawings, and sculpture.[25] This decision would seriously impair the creating, collecting, and exhibiting of the artist's print in Canada until well into the twentieth century.

J.W.H. Watts and J.C. Miles

The etching revival arrived in Canada in the form of a modest and shy appearance at the back of the stage of a much larger event – the inaugural exhibition of the Royal Canadian Academy (RCA), which opened in Ottawa on 6 March 1880. Tucked away in the section reserved for "Drawings and Designs" were four "Proofs from Etchings on Copper" by J.W.H. Watts. The etchings of J.C. Miles made an equally unpretentious debut in 1881: described as "Proofs from Etchings," they were buried deep in the watercolour section of the annual Ontario Society of Artists exhibition. Watts and Miles were both professional artists, working in Ottawa and Saint John, New Brunswick, respectively – urban centres that each lacked a community of professional artists. The prints they made are truly pioneering works, demonstrating a remarkable level of ability in locales where only technical manuals and commercial plate printers were available for instruction and example.

John William Hurrell Watts (1850–1917) was an architectural draughtsman and designer in the office of the Chief Dominion Architect at the Department of Public Works. Watts also maintained an active involvement in the fine art community. He was a member of the Art Association of Ottawa, which was founded in 1879, and also taught at their school. With the founding of the Royal Canadian Academy, Watts was elected an associate. These credentials made him the ideal choice to serve as curator of the new National Art Gallery, which was established in conjunction with the RCA to hold the Academy's diploma submissions and government-owned works of art.

By early 1880, Watts had become attracted to etching and had purchased his own press and technical manuals. His earliest efforts in the medium were put on display at the RCA's initial exhibition. Three of the four Watts etchings are known and they tell the story of a beginner struggling

with the technical vagaries of the medium. The first two images show evidence of foul biting (acid finding its way through an imperfect layer of protective ground) and uneven printing, suggesting difficulties regulating an even overall pressure of his printing press. Aesthetically, the lines are all of the same strength and drawn in a manner more suitable for magazine illustration, and he leaves no residual film of plate tone to soften and "colour" the composition. It is possible that the manuals Watts possessed in early 1880 did not describe the painterly use of plate tone – a French printing style that would be fully explained in the English translation of Lalanne's *Treatise on Etching*, soon to

Fig. 3
J.W.H. Watts
Elgin Street, Ottawa 1880
(cat. 123)

be released. With *Elgin Street, Ottawa* (fig. 3), Watts showed a major advancement, not just in understanding of the craft of etching but also in its aesthetic. While needling the composition into the ground to expose the copper, Watts employed a more sophisticated drawing style, with lines that vary in shape and width. And to give further depth and artistry to the image, Watts used two bitings. This meant that after a first immersion in acid, the lines that he wanted to keep light were stopped out with a varnish to prevent any further action of the acid when the plate was immersed the second time. The lines receiving multiple attacks of acid printed more darkly. Watts still avoided using plate tone, but he seemed to have resolved his problems with the pressure of the press.

In 1881, Watts entered more etchings in the July exhibition of the Royal Canadian Academy at Halifax; the number was unspecified and no titles were given. The most ambitious etching found to date, *Montebello on the Ottawa, Residence of L.J. Papineau* (fig. 4), was probably among this group. It is a large, impressive plate, unquestionably demonstrating Watts' preference for architectural draughtsmanship. However, with a great variety of strokes, dots, and cross-hatching all rendered in at least two bitings, the artist has conveyed the texture of the ivy-covered building and the sunny summer garden around it.

During the winter of 1880–81, when Watts was pulling prints such as his view of Montebello, he had found a companion to share his interest in etching. Freshly back from his first year of study in Paris, **William Brymner (1855–1925)** took up his position as headmaster of the Ottawa School of Art, run by the Art Association of Ottawa, in late 1880. Watts was also teaching that year at the school and he persuaded Brymner to etch his only known print, *Old Man Painting at the Louvre* (fig. 5), which is similar to Watts' efforts in size and technical achievement. (The only known impression of this print was pulled by Clarence Gagnon in 1903, when he was experimenting with intaglio printing in Montreal.)[26] The fellowship was short-lived, and Watts would not find another such companion until 1899 when Ernest Fosbery

Fig. 5
William Brymner
Old Man Painting at the Louvre c. 1880–81
(cat. 18)

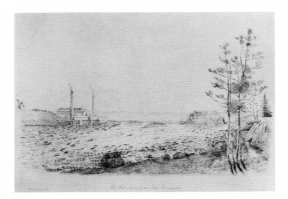

briefly joined him at the printing press. The fact that Watts never taught etching at the Ottawa School of Art meant that any artistic collaboration he might enjoy had to be undertaken privately at his home. This further restriction may account for the near cessation of Watts' activity as an etcher. He never exhibited prints past 1881, and the evidence that he made prints after this date is unclear.

However, Watts' interest in the new art form never abated. As the curator to the National Art Gallery, in 1882 Watts oversaw the provision of exhibition space in the building designated for the Supreme Court. Among his plans, he told the *Ottawa Free Press* on 27 May, was a room set aside purely for the display and enjoyment of prints. This plan was never realized, perhaps due to the combination of an indifferent art community and government stinginess towards the cultural institution. By 1890 the National Art Gallery could only catalogue three items in the print collection: a set of proofs from Lucius O'Brien's *Picturesque Canada*, an unnamed etching presented by Wilson

& Co. of Ottawa, and a series of engravings presented by the Princess Louise, "illustrative of the course of study in the Royal School of Art at South Kensington."[27]

John Christopher Miles (1837–1911) was a rare breed for nineteenth-century New Brunswick – a native-born professional artist. From his birthplace of Saint John, Miles had to go to Boston for studies at the Lowell Institute.[28] Around 1874, he opened a studio in Boston and became a member of the Boston Art Club.[29] By 1879, however, he had returned home and set himself up in a studio. In 1880, he became an Associate Member of the Royal Canadian Academy, and a member of the Ontario Society of Arts until he was dropped in 1894. The 1884 Saint John city directory notes that his son Fred had joined him at the studio out of which they ran their "Academy of Fine Arts and Free Night School."[30] Miles and his son would continue collaborating as teachers at their own art schools into the next century.[31]

The etchings at the 1881 OSA exhibition were probably the same three charmingly naive prints now in the collection of the New Brunswick Museum: *Old Drury Bridge*; *Original Fog Horn, Partridge Island, N.B.*; and *The Falls, Saint John, New Brunswick* (fig. 6). The prints were a collaborative effort, made by the son after the father's designs. They are not etchings but drypoints – a far simpler print technique requiring no specialized knowledge of recipes for grounds or strengths of acids. The lines are simply scratched directly into the copper plate with any sharp-pointed object. Close examination of these drypoints confirms the lack of expertise in Saint John in that period. The pictorial imagery was scratched on the

The Association of Canadian Etchers, Toronto, 1884–85

The appearance of three etchings by T. Mower Martin at the *Art Loan Exhibition* held in the summer of 1884 at the Owens Art Gallery in Saint John, New Brunswick, constituted the informal announcement of a new artists' society. Formal notification was made in a circular sent out to the press and the art community. It read:

> *Association of Canadian Etchers*
>
> The above Association has been formed in the City of Toronto, having as its object the advancement of *original* etching in Canada, by periodical meetings and exhibitions. The intention is to meet together in a friendly and social way, at least once a fortnight, at which time members may advance each other and the art by mutual criticism.
>
> Anyone wishing to take practical interest in free-hand Etching will please communicate with the Secretary. It is proposed to hold a winter Exhibition, due notice of which will be given.
>
> Henry S. Howland, Jr. Sec'y
> Toronto, Canada, July 23, 1884.[32]

plates in the studio and then printed, probably at a local commercial printing shop. For the first two prints, the printer had to run the impressions through the press a second time in order to add the typeset lettering below the image. *The Falls, Saint John, New Brunswick* was better thought out: the image was scratched on a larger plate, leaving space below for the printer to engrave the title and credits. This meant that each impression required only one turn in the press.

These three little prints, which carefully spelled out John Miles' proud title as Associate of the RCA, may have been done as a self-promotion for Miles and his son, in training for the family business. While they may not fit the pure definition of an artist's print, they do reflect a certain confusion or overlapping of the various criteria by which prints were regarded at this time. It can be argued that they are reproductive prints, with the appropriate printed markings of title, engraver, and painter in the margins. But their informal, sketch-like quality and their technique suggest some knowledge of the etching revival.

The Association of Canadian Etchers (ACE) took its lead from two American etching societies. Its intent and *modus operandi* were similar to both the New York Etching Club and the Philadelphia Society of Etchers, which also had been organized as a means of bringing together interested artists to assist each other in learning the complicated etching process. But whereas the American societies included practising painter-etchers who could serve as teachers, the Canadians were not nearly so lucky. Only two of their number are known to have received formal instruction prior to 1884: William J. Thomson, a professional engraver with little experience as an artist, and A.D. Patterson, who had received two etching lessons in Philadelphia. Henry S. Howland, Jr. was an amateur artist who taught himself to etch using Koehler's translation of Lalanne as his guide.[33] His ability to give a lucid demonstration on etching technique at the Association's first exhibition leads to the speculation that he may

also have done some teaching at the meetings. Other publications describing etching techniques that these etchers had in hand were Hamerton's *Etching and Etchers* and *The Etcher's Handbook*, as well as Haden's lectures at the Royal Institute, published in *The Magazine of Art* in 1879.[34]

It is not known at what precise date the membership of the ACE began to coalesce. However, the chain of events that led to the founding of the Association, and something of its character, may be deduced from certain members' biographies. The members, as listed in the catalogue for their first exhibition,[35] seemed an amicable group of amateurs and professionals, well known to each other through ties to the Ontario School of Art and its parent organization, the Ontario Society of Artists. The amateur artists were James Jardine, Thomas Pike, Dr Charles Kirk Clarke,[36] and Henry Howland. Aspiring professionals were Arthur Cox, W. Parker Newton, and William J. Thomson. The professionals were A. Dickson Patterson, the young student George Reid, and T. Mower Martin. The most senior member, with credentials as founding member of both the OSA and the RCA, Martin was the obvious choice for president of the Association, but its heart and driving force was its secretary, Henry S. Howland, Jr.

The scion of one of Toronto's most prominent families, **Henry Stark Howland, Jr. (1855–after 1925)** was a businessman with a passion for the fine arts. He was already an enthusiastic and talented amateur painter when etching captured his heart. By April 1884, Howland was sufficiently knowledgeable to give a well-received paper entitled "The Art of Etching" before the Royal Institute of Toronto. The lecture not only constituted a history of etching but also an explanation of the process.[37] While his fourteen recorded prints, largely of Ontario subjects, indicate he pursued only a brief career as a painter-etcher, Howland was determined to enter the international arena. In May 1885, *Camp Scene, Georgian Bay* (fig. 8) and one other work were shown at the Society of Painter-Etchers in London. He also had etchings accepted for the 1886 and 1887 New York Etching Club exhibitions, and one – *The Grange, Residence of Goldwin Smith, Esq.* (fig. 9) – for their 1888 annual. With only a few prints from

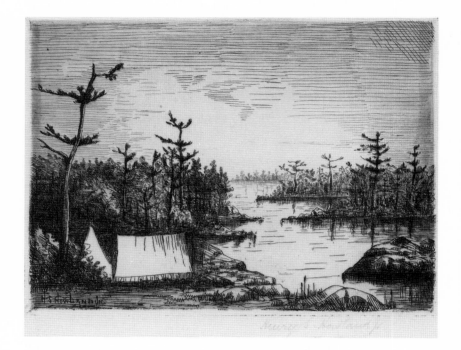

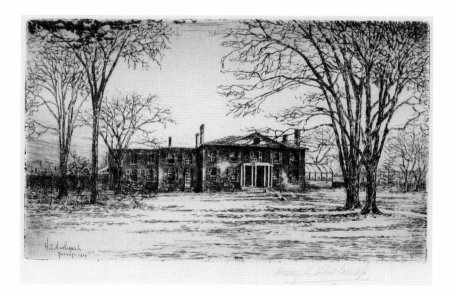

which to judge, it is impossible to determine influences or even the overall quality of Howland's work. Nonetheless, his treatment of the leafless trees and the sombre wintry mood of the scene in *The Grange* reminds one of Adolphe Appian's well-known etching *Village d'Artemare* of 1872.[38] With his manifest knowledge of and enthusiasm for painter-etchings, Howland might aptly be called "Canada's Seymour Haden"; and like Haden, he gathered around him the artists to form the

Fig. 8
Henry S. Howland, Jr.
Camp Scene, Georgian Bay
c. 1884–85
(cat. 56)

Fig. 9
Henry S. Howland, Jr.
The Grange, Residence of Goldwin Smith, Esq. 1887
(cat. 57)

Fig. 10
A. Dickson Patterson (1854–1930)
Stephen Parrish 1881
Etching, 11.2 × 7.5 cm (plate)
National Gallery of Canada, Ottawa
(37995)

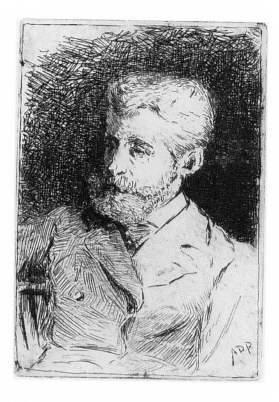

Association of Canadian Etchers, likely making contact with them through James Jardine, whose collection furnished invaluable demonstration pieces for the Royal Institute lecture. In his capacity as ACE secretary, Howland came in contact with the etching revival's movers and shakers.

James Jardine (c. 1850–after 1895) was a clerk with the Bank of Toronto, working in the Peterborough branch from 1869, and being transferred to the main branch in Toronto around 1883.[39] Jardine had formed his collection of engravings as early as 1880, when Robert Harris paid him a visit in Peterborough and could comment on "a splendid collection of books on art, photos, etchings etc. such as I did not expect to see in Canada ... I never met a fellow who has read so much on art as he has."[40] That Jardine's collection did not figure in the ACE exhibition suggests it comprised reproductive engravings and not the requisite "original etchings." The two etchings Jardine entered into the ACE show were probably his only attempts in the medium, and by their titles – "Hound, from a sketch by F. Niederhäusern-Koechlin" and "Comrades, from a sketch by Mme Euphémie Muraton" – were probably copied after works in his own collection.

In 1884, Jardine was hired as secretary to the OSA and placed in charge of its art union. Possessing an "art instinct and a gift of imparting his ideas to others,"[41] he quickly won friends, particularly among the younger members of that art community. The energy and imagination Jardine displayed in his work for the OSA was likely carried over to his work for the ACE, and his talents probably made a fine complement to Howland's organizational skills. However, Jardine showed equal imagination in his handling of the OSA account books, and the revelation of embezzlement in 1888 led to his dismissal – the OSA was nearly bankrupt. Jardine left the city in disgrace, and though he would return briefly, from 1891 to 1895, he remained an exile from the business world and the art community. His departure from the scene must have been a major factor in the eventual failure of the ACE.

Andrew Dickson Patterson, like Howland, came from the cream of Toronto society: his father was the Honourable Mr Justice Christopher Salmon Patterson of the Supreme Court of Canada. Patterson first studied at the National Art Training School, South Kensington, in 1876, and by 1880 had set up a studio in Toronto. His attraction to etching, while initially enthusiastic, was probably brief. On 6 December 1881, he paid for two lessons with Stephen Parrish in that artist's Philadelphia studio, resulting in the small etched portrait of Parrish (fig. 10).[42] Patterson also bought an etching press from Parrish, possibly the Janentzky & Weber tabletop wooden proving press that Parrish had just replaced with a larger and more powerful iron copperplate press,[43] and had it shipped to Toronto.[44] The only etching press known to be in Toronto at this time, it was likely employed by the ACE members during their fortnightly meetings. Patterson did not seem to have further use for the press; his only other known venture into printmaking was the publication in 1888, by Goupil in Paris, of a photogravure of his famous and successful portrait of Canada's first Prime Minister, Sir John A. Macdonald.[45] Although his interest in etching was transitory, Patterson was in a good position to encourage young art students to try their hand at the medium. Along with T. Mower Martin, he was a

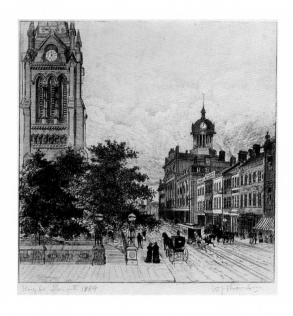

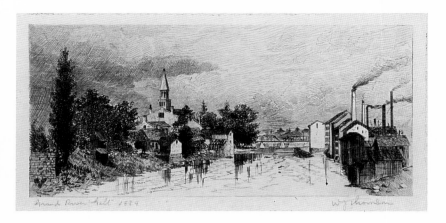

Fig. 12
William J. Thomson
Grand River, Galt 1884
(cat. 112)

Fig. 11
William J. Thomson
King Street, Toronto, 1884 1885
(cat. 113)

Fig. 13
William J. Thomson
Niagara River, Queenston 1886
(cat. 114)

member of the Board of the Ontario School of Art for the 1882–83 school year, and a teacher there the following year, the same time William J. Thomson was a student at the school.[46]

William James Thomson (1858–1927) was a young professional vignette engraver in the growing Toronto printing trade.[47] To improve himself, Thomson enrolled at the Ontario School of Art, taking courses between 1882 and 1886. His technical expertise would have made him a valuable contributor to the ACE etching classes, and his fellow members may have regarded him as their potential Delâtre or Goulding. But Thomson also had something to learn from the others about the painterly aspects of etching. Two of the five etchings he exhibited at the ACE exhibition, *King Street, Toronto, 1884* (fig. 11) and *Grand River, Galt* (fig. 12) have the very finished look of commercial engravings, lacking the expressive, sketch-like quality of a painter-etcher print. They do indicate, however, a young artist striving to understand the artistic possibilities of the medium. Rather than employing a uniform treatment, Thomson has varied the strength and density of the etched lines to create tonal areas that give the

works texture and a satisfying perspective. Within a year or so, and working on his own, he forsook etching for drypoint, finding the method to be more intimate and responsive to his needs. He began to shed the engraver's rigidity and clarity for the soft textural nuances of the painter-etcher print, as his drypoints *Niagara River, Queenston* (fig. 13) and *Railroad Station, Hamilton* (fig. 20) demonstrate. Thomson was the only member of the ACE who would pursue etching throughout his lifetime. And although his attention was constantly divided between his commercial work and his fine art career, to several generations of Canadian printmakers Thomson would represent a unique continuity, gaining a very special place in their hearts.

Fig. 14
T. Mower Martin
Evening, Central Park, New York
c. 1884–85
(cat. 72)

was excited by the medium, particularly its potential for a good income. But to make etchings that would be competitive on the market, he required a higher level of expertise than could be found at the Association's press or in the printing establishments of Toronto. New York was the most promising and closest centre for him to gain the technical proficiency he required, and in the autumn of 1884 he left to work with Henry Voigt of Kimmel & Voigt. *Evening, Central Park, New York* (fig. 14) was one of nine prints completed by Martin in that city. The work suggests some knowledge of Meryon in its treatment of the Dakota Apartments, darkly looming over the edge of the park and silhouetted against the western evening sky. Adding to the eerie quality is the flash of reflected sunlight in the turret windows. Expertly printed, with rich use of plate tone and retroussage, the print shows a quantitative leap in quality over all the other etchings known to have been made to that date by Canadian artists. It also vividly illustrates the handicap posed by a lack of expertise, which the Canadians who remained at home simply could not overcome. Martin's eleven known etchings closely resemble his established style of Victorian or Ruskinian realism. Typical of the self-taught artist, the work fluctuates from crude and awkward to very fine and accomplished. Single unified subjects, such as the woodland interiors seen in *Island Creek* (fig. 15) and *The Untouched Forest* (fig. 16), show Martin's draughtsmanship at its most spontaneous and cohesive, with a sound and sensitive understanding of the intimate qualities etching could offer. But when his compositions comprised many small scattered elements, he tended to get lost in detail and failed to knit the subject together. Martin would prove to be one of Canada's most prolific nineteenth-century painter-etchers, producing at least eighteen subjects dating from 1884 and 1885.[49] He proudly entered them in the annual exhibitions of the New York Etching Club (1885), Ontario Society of Artists (1885), Royal Canadian Academy (1888, 1889), and in the 1885 Spring show of the Art Association of Montreal.

A rising star in Toronto's art community, George Agnew Reid had been a student at the Ontario School of Art before leaving for Phila-

Those first etchings by **Thomas Mower Martin (1838–1934)** on display at the Owens Art Gallery in 1884 raise the question of whether some of the future members of the ACE were getting together for mutual instruction prior to their formal announcement. None of the early Martin etchings has been located, and with no reviews describing these efforts, entitled *Bridge near Ancaster*, *Elms*, and *Muskoka River*, we can only guess at their degree of accomplishment.[48] Martin

Fig. 15
T. Mower Martin
Island Creek c. 1884–85
(cat. 73)

delphia to study at the Pennsylvania Academy. There he probably attended Haden's lectures and demonstrations given on 28 and 30 December 1882, in conjunction with the Philadelphia Society of Etchers' large international exhibition. Caught up in the resulting wave of enthusiasm for etching, Reid tried his hand at demonstration classes connected with the show.[50] His dabblings in the medium were too frail to allow him a berth in the Association's exhibition, and it is not clear what role he played in the ACE. He may have attended a few of their printmaking sessions, as evidenced by the improved skills he demonstrated a few years later in the charming etched invitation to the exhibition of the Palette Club at Lucius O'Brien's studio (fig. 17). Nevertheless, Reid did not take up printmaking seriously until 1919, when he began to show a series of etchings, drypoints, and monotypes at the exhibitions of the Society of Canadian Painter-Etchers.

Fig. 16
T. Mower Martin
The Untouched Forest c. 1884–85
(cat. 74)

The First Annual Exhibition of the Association of Canadian Etchers, Toronto, 1885

The Association of Canadian Etchers boldly launched themselves before the public with an international exhibition of "original etchings." Shortly before the electrifying news of the Duck Lake Massacre, the start of the Second Riel Rebellion, reached Toronto, the *First Annual Exhibition of the Association of Canadian Etchers* opened at the Ontario Society of Artists' galleries at 14 King Street West. On Saturday afternoon

Fig. 17
George A. Reid (1860–1947)
Invitation to Palette Club Exhibition
1893
Etching, 8.6 × 10.8 cm (plate)
OSA Papers, Ontario Archives, Toronto

21 March 1885, the Lieutenant-Governor, John Beverly Robinson, attended by Daniel Wilson, Principal of the University of Toronto, and Professor Goldwin Smith, opened the exhibition that Henry Howland had organized.

As before, the Canadian etchers looked to the United States for their prototype. Theirs was the fourth in a series of progressively ambitious shows held in North America. The first two etching exhibitions had been organized in 1879 and 1881 by the Museum of Fine Arts in Boston, and the third in 1882 by the Philadelphia Society of Etchers[51] – all three were curated by S.R. Koehler. The Canadian show was most closely modelled after Philadelphia's, where Koehler had incorporated not just the etchings of the Society's members but also many works borrowed from artists at home and abroad, augmented with prints from James Claghorn's extensive collection. The Philadelphia event had didactic elements (a press and a case of "etcher's material" were on display) and it was complemented by two public lectures, with demonstrations by Seymour Haden.

The Philadelphia exhibition and the Haden lectures would have been a "must-see event" for Toronto etching devotees such as Howland, and could well have been the genesis of his dreams of a Canadian equivalent. George Agnew Reid's impression of the event and the excitement it generated within the art community no doubt helped to persuade the ACE to take on a similar project. One idea the Canadian etchers borrowed directly from Philadelphia was the inclusion in their show of a didactic display, featuring a press, etching tools, and a series of proofs.[52]

The *First Annual Exhibition of the Association of Canadian Etchers* seems to have been organized rather hurriedly, which would explain why American etchers made up the largest national contingent; there were fifty-three Americans in all. As late as the first week in March 1885, the organizer Henry Howland was still contacting artists directly for submissions.[53] He was also successful in gaining the participation of the entire membership of the established etchers' societies: on 20 February 1885, the Philadelphia Society of Etchers convened a special meeting to discuss the ACE's request for etchings. The Philadelphians resolved to assist their Canadian colleagues, stipulating that the works they sent to Toronto were "to be catalogued as the exhibit of the Philadelphia Society of Etchers."[54] While no documentation exists to prove it, another source may have been the New York Etching Club's annual exhibition held in February.[55] Howland might have approached the Club, or T. Mower Martin could have been the guiding hand, as he was already in New York exhibiting at the February show.

Considering the briefness of the Association's existence, its members were able to display a handsome number of etchings. Howland had eight on view including *Camp Scene, Georgian Bay* (cat. 56); while Martin exhibited nine including *Evening, Central Park, New York* (cat. 72) and *Island Creek* (cat. 73). Patterson showed only his etched portrait of Stephen Parrish (fig. 10), and William J. Thomson displayed *Grand River, Galt* (cat. 112) and *King Street, Toronto, 1884* (cat. 113) along with three others. Arthur Cox, James Jardine, and W.P. Newton, together exhibited another fifteen prints.

The three Canadian exhibitors who were not members of the ACE had acquired their knowledge of etching in the United States, sometimes directly from American etchers. As a practising artist and illustrator in Boston, Henry Sandham had kept up his Canadian connections, and he showed two etchings (including fig. 18).

Horatio Walker, who had just moved to New York City, had taken up etching while living in Rochester, in response to Haden's visit to the Rochester Art Club in early 1883.[56] *A Barnyard* (fig. 19) is a fine example of his work. Walker's only entry in the ACE show, *In Quebec*, may have come to Toronto along with the New York Etching Club entries. In John Hammond's instance, although he remained a resident of Saint John, N.B., his etchings were inspired by his friendship with Stephen Parrish of Philadelphia. (The work of Sandham and Hammond will be discussed at length in the next chapter). Hammond was represented in the ACE show by two etchings: *Coast New Brunswick* (possibly cat. 54) and *Old Houses, Saint John, N.B.*

The European representation in the Toronto show was a disappointment. It numbered only twenty-four artists, and included two Rembrandts from a New York collector, and three Hadens, two of which belonged to Toronto's John Ross Robertson. The weakness of the European participation underlines the fact that artists working in Canada either had little contact with their European counterparts or a limited knowledge of the etching revival on the other side of the Atlantic.

Initially, Howland had hoped to illustrate the exhibition catalogue with original etchings, a common practice of the clubs in New York, Philadelphia, and Boston. (In 1883, the Boston Etching Club went the furthest, producing a catalogue in which both images and text were etched.) However, Howland had difficulty getting his artists to supply their plates in time.[57] Ultimately, he was forced to settle for a list of works, supplemented by quotes from Hamerton's *Etching and Etchers* and Haden's articles in *The Magazine of Art* to help explain the new art.

The show's reception could be characterized as confused: few knew what to make of the prints. The speeches given at the opening revealed the bewilderment of Toronto's most educated citizens at their first confrontation with the new art medium. The Lieutenant-Governor, John Beverly Robinson, expressed certainty that the study of etchings "could not fail to have an elevating effect on the taste" of Canadians, even though the "exhibition might not be as attractive as if the

Fig. 18
Henry Sandham
In Boston Public Gardens 1884
(cat. 100)

walls were hung with oil paintings."[58] The academic Daniel Wilson did a graceful intellectual pirouette: admitting that he was unfamiliar with this "new class of art," he maintained that he was nonetheless certain it "would educate and refine the taste and teach us to discriminate between commonplace and high art."[59] Goldwin Smith

Fig. 19
Horatio Walker (1858–1938)
A Barnyard c. 1884 (1977 restrike)
Etching, 10.2 × 13.4 (plate)
Agnes Etherington Art Centre, Queen's University, Kingston (21–22)
Gift of Arthur Pretty, 1977

was the only one who had actually looked over the exhibition before the ceremonies and who seemed to have some understanding or knowledge of the painter-etcher print. Smith was particularly impressed by Haden's famous *Breaking up of the Agamemnon*, and admonished the Canadian painter-etchers to attempt to capture the same transient effects of light and form instead of "drawing a still and stationary picture."[60]

The most important reviews of the exhibition act as barometers of Canadian progress in comprehending the new art form. In contrast to the cautious response to Montreal's 1881 Black and White exhibition, Toronto reviewers felt confident about expressing strong opinions. *The Educational Weekly* gave the show its only bad review. With condescending verbosity, the unknown reviewer (who possessed some knowledge of the technical aspects of the art) was highly critical of the etchings on display,[61] reserving his fiercest acrimony for what he perceived to be their essential sloppiness. For him, the ultimate criterion for assessment was the purity of the etched line. Retroussage and plate tone were seen as errors in judgement that muddied a finely drawn image, or else could be dismissed as pathetic attempts to mask poor draughtsmanship. How are we to understand this unusual and inexplicable review? Was its author siding with Haden and Hamerton's view of etching as the expression of line, as opposed to the French preference for the painterly print? If so, then why did he single out one of Haden's works – *Calais Pier* – for ridicule? Finally, and most importantly, the reviewer espoused the concept of the painter-etcher print as an original composition, and derided any attempt at using this new art to reproduce another work of art, no matter how artistically done.

Daniel Wilson returned to the exhibition to cover it for *The Week*. His review was kind and thoughtful, if somewhat schizophrenic. He acknowledged that an etching "has a charm for the true lover of Art that no mere transcript of another's picture can possess. It is the quality of originality, this freshness from the hand of the artist, which confers the special value on the modest productions of the etcher."[62] But he lauded those very prints that were "transcripts of another's pictures." Perhaps Wilson's youthful experience in Britain as a line engraver was in conflict with his striving to understand the artist's print. The only information he had upon which to formulate his opinions on etchings as artist's prints were the bits of Hamerton and Haden quoted in the catalogue, and Howland's lecture at the opening. Wilson diligently memorized these sources and used them as a guide in examining and commenting on the individual prints.

The Association of Canadian Etchers' first annual exhibition was both a success and a failure. It was successful in that it seemed to spur a limited interest in the new art, and by all accounts the attendance was very good. The few sales to private collectors must have been encouraging, though not sufficient to cover the expenses of the exhibition. The principal reason for its failure was undoubtedly the Canadian customs duty, against which the Art Association of Montreal had petitioned the federal government in 1883. The duty was imposed without exception on every print brought into the country, whether it was for public exhibition, for sale, or had been printed abroad by a Canadian artist for publication at home. The duty nearly bankrupted the ACE and effectively prevented further consideration of large exhibitions. Borrowing from private collectors would have alleviated the problem, but there were at this time in Toronto too few to depend on – John Ross Robertson was the only Canadian private lender to the 1885 exhibition. Clearly, exhibitions and associations could not continue without the tangible support of wealthy collectors or established exhibition bodies. The final irony was that while the artists were in Toronto, the interested collectors and public institutions were in Montreal.

The Second Black and White Exhibition, Montreal, 1888

Before a preview audience of three hundred, the Art Association of Montreal opened its second Black and White exhibition on 21 May 1888, at its galleries on Phillips Square.[63] It bore no resemblance to the 1881 show. In the introduction to the catalogue, the AAM acknowledged the more avant-garde trends in the appreciation of the

artist's print and declared that it confined itself to "one branch of the engraver's art, but that probably the highest – Etching."

A major advance had taken place, not only over the first Black and White exhibition in 1881 but also over the 1885 ACE exhibition. The Toronto show had been an artist's exhibition, where the originality and creativity of the medium was paramount. The second Black and White exhibition, with its emphasis on the rarity and speciality of print impressions within an edition, was clearly a collector's exhibition. The introduction to the catalogue spelled out not just the technical procedure of etching, but also went on to describe aspects of the artist's print, such as remarques, artist's proofs, early state impressions, that were becoming increasingly desirable criteria for collectors looking for that rare impression for their portfolio. Print connoisseurship was stressed. For example, the visitor was asked to note the importance of the choice of paper on which the etching was printed, and its effect: it could serve as a "guide to the condition of the Etching, as any care shewn in the selection of the material should indicate a desirable condition of the plate."

Almost from the outset of the etching revival, both in Britain and the United States, the leading artists found that money could be made from the production of large editions of particularly well-received prints. Seymour Haden, for example, made about £2,500 by producing two large editions of his most famous print, *Breaking up of the Agamemnon*. These large editions, numbering into the hundreds and more, were achieved by steel facing the soft copper plates. But to make these prints more appealing to the connoisseur, the artist and the publisher/printer collaborated to introduce variations within the editions. These could include a making limited number of impressions with remarques – small drawings needled around the margins of the subject; as well, a limited number of trial proofs or artist's proof impressions could be produced, lending a certain cachet. The artist's signature added to the impression was a coveted guarantee of originality. The most common differentiation was made in the choice of paper, from soft etching paper to stiff, glossy japanese vellum, to material such as satin: each

would elevate the desirability, and hence the price, of the impression.

The catalogue for the second Black and White exhibition testifies to the level of familiarity among the private collectors of Montreal, not just with the etching revival but also with the finer points of connoisseurship. Nearly all of the 307 etchings listed in the catalogue were carefully described as either signed artist's proofs, remarque proofs, first or second state impressions, etc. The selection – overwhelmingly painter-etcher prints – was also impressive. Among the French painter-etchers were Corot, Daubigny, Delacroix, Jacque, Lalanne, Legros, Meryon, and Millet. There was a good representation of American etchers, such as Otto Bacher, Stephen Parrish,[64] Charles Platt, and Henry Farrer. The British entries were led by Haden with twenty-six, and Whistler with seven etchings, including prints from the "French Set" and the "Thames Set."

Thirteen Canadian collectors contributed to the show. All were mainstays of Montreal's cultural elite, among them David Ross McCord and members of the Greenshields and Morrice families. The dealership of William Scott & Sons was also listed as a lender, and in fact may have been the original source for many of the prints in private hands. The firm had been active dealers of painter-etcher prints from as early as 1882.[65] The one non-Montreal contributor was the New York dealer Frederick Keppel, who lent forty works by earlier generations of etchers, including nine by Rembrandt and two by Adrian van Ostade. This signalled the start of Keppel's participation in many print exhibitions held in Canada up to World War I.

The quality and breadth of the selection and the sophisticated level of connoisseurship mark a major step forward in the establishment of the artist's print in the Canadian cultural milieu. Much of the credit for this must undoubtedly be given to dealers such as Frederick Keppel, who maintained a very active program of cultivating collectors and disseminating information on his stock. Also, many of the Montreal collectors travelled widely and could easily purchase prints at private galleries in Paris, London, and New York. But some credit must go to the Art Association of Montreal. In addition to their Black and White

exhibitions, in 1882 they created a reading room on the Association's premises and stocked it with such important periodicals as Hamerton's *The Portfolio* and *The Etcher*, as well as *The Graphic*, a serial, *English Etchings*, and more broadly-based magazines like the *Gazette des Beaux-Arts*, *The Art Journal*, and *The Magazine of Art*, all of which paid close attention to the etching revival.[66] By 1886 it was receiving the catalogues of the New York Etching Club, illustrated with original prints. From the contents of the Association's library listed in the 1890 and 1891 annual reports, it is obvious that Montreal's collectors had access to an informed selection of publications on printmaking by the leading writers and critics of the day. Tellingly, the library lacked any practical printmaking manual, despite the presence of its own art school, housed on the premises.

That the Association had no interest in encouraging or stimulating a home-grown print revival could also be seen in the contents of the second Black and White exhibition. The Canadian artist is nowhere in sight. The lone Canadian participant in the show was Henry Sandham, represented by his etching *Old Canadian Homestead*, which had previously made an appearance at the 1885 ACE exhibition. By the end of the first decade of the etching revival in this country, the Canadian collector could be said to be far ahead of the artist in enthusiasm for the artist's print.

The exhibition received limited attention from the public and the press. Only the *Gazette* sent a reporter, whose coverage was restricted to the opening festivities. In its 1888 annual report, the Council of the AAM noted:

> [The Second Black and White Exhibition] reflected much credit on the Association; letters of a congratulatory description having been received from various high authorities on this sort of work in other countries. The admirable Catalogue prepared for this Exhibition calls for a special word of commendation. It is to be regretted that the attendance, both on the part of members and the public, was not more numerous, though it is on the other hand a matter of much satisfaction that those who are acquainted with

the niceties of the work done with the Etching needle came again and again, showing how highly they appreciated the fine quality of the works exhibited and the opportunity afforded them of study.

The Association of Canadian Etchers, 1890

In March 1890, a short announcement appeared in *The Week*:

> There is to be an attempt to revive the Association of Canadian Etchers ... the old members are as enthusiastic as ever, but the heavy duty payable on etchings coming into Canada, even when by Canadian artists, hampers the business of production, and our artists find it more satisfactory to carry their plates to New York and dispose of them to publishers there, than to attempt to publish them in Canada. The newly revived association will, if possible, have the printing done in Toronto, and so save expense and duty.[67]

Clearly the goal of having high quality printing done in Toronto was not yet possible, and these brave words by an unknown voice were the last heard from the ACE.

The factors causing the ultimate failure of the first society of Canadian printmakers are complex and varied. A major weakness was the Association's inability to attract the most influential and accomplished Canadian artists, most of whom were residing in Toronto. Between March 1885 and March 1890, the ACE lost several of its members and did not manage to recruit more. During this five-year period, only two, Martin and Howland, continued to make any real attempt at entering their work in exhibitions at home and abroad. Most of the etchings they were exhibiting had been made in 1884–85; it would seem from this that the fortnightly meetings, which would have encouraged the pulling of new prints, were no longer taking place. As for the most committed members, their numbers were also waning. Howland would become preoccupied with his sales and promotional business, which would lead him in 1895 to New York to set up an advertising agency. In 1887, Martin made his first trip to

Fig. 20
William J. Thomson
Railroad Station, Hamilton 1896
(cat. 115)

the Rockies on the Canadian Pacific Railway, and instantly fell under the spell of their majestic beauty. Many more trips ensued, and Rocky Mountain subject matter would dominate Martin's easel. Although Thomson kept the flame alive, the fire dwindled to faint embers.

Of course, the ACE cannot be held responsible for the obstacles that prevented printmaking from becoming an economically attractive option for Canadian artists. Nowhere in this country was there a printer/publisher willing to take on the large editions of steel-faced etchings that were the bread and butter of the etching revival elsewhere. This was the essential means of producing inexpensive prints that could be competitive on the home and foreign markets. (Canada's meager population meant that the home market was not viable alone.) The Canadian painter-etcher was thus forced to resort to foreign print publishers, thereby incurring the lethal customs duty. Also conspicuously absent in Canada during the 1880s, when the etching revival was at its peak in North America, was any real support from the established artists' societies and institutions for the development of public print collections and exhibitions – support that might have benefited the artist's print. Nor did the private collectors and dealers of Montreal and Toronto take on the task of advancing the art form by means of purchases, sale exhibitions, or publishing ventures.

The nineteenth-century etching revival in Canada was, in effect, a branch of the American revival, and the health of the Canadian etchers' movement was dependent on its American counterpart. By the late 1880s and early 90s, the American etching revival was also languishing, albeit for completely different reasons: it was choking on its own success. Painter-etchings had become a craze. The easy money to be made from sales to a large buying public was coveted by print publishers, who offered artists high prices for their etched plates. These publishers began to co-opt the etching revival, and more and more artists joined in the production of large editions of prints with the apparatus of painter-etchings. In such mass-produced editions, the collector's criteria of artist's proofs, state impressions, remarques, and signatures were rendered meaningless. Standard-bearers such as the New York Etching Club tried to banish these prints from their exhibitions, but soon they too were seduced into the practice. The Canadian market was also being saturated by the prints, made available through bookshops and art dealers, particularly such leading dealers as Matthews Bros. & Co. in Toronto and W. Scott & Sons in Montreal.[68] The overproduction and commercialization of etchings

Fig. 21
The artists' studio at Grip Printing & Publishing (J.E.H. MacDonald in front), circa 1900
McMichael Canadian Collection
Archives, Kleinburg, Ont.

discredited the art form, both for its public and its practitioners. A definitive sign of decline was the folding of the venerable New York Etching Club, which held its last exhibition in 1893.

For the whole of the 1890s, the etching revival in Canada went into near hibernation. A slight stirring could be ascribed to W.J. Thomson, apparently the only artist still making prints after 1890. His *Railroad Station, Hamilton* (fig. 20) is one of these rare prints. There is no record of any prints in public exhibitions during the final decade of the nineteenth century.

Art Education and Printmaking, 1875–1900

If the artist's print were ever to succeed in this country as a home-grown movement, then it would have to be in the hands of a younger generation. The Canadian painter–etchers of the 1880s were self-taught, learning about the concept, technique, and aesthetic through printed sources, with only a limited exposure to original works of art. No formal instruction was available in Canada to these first-generation painter–etchers. However, even as they were attempting to introduce the artist's print, provincial governments were beginning to establish art schools with standardized curricula.

In the late 1870s and early 1880s, both the Ontario and Québec governments set up commissions to investigate the art schools in Boston, Philadelphia, and New York. Particular consideration was given to the art training system developed in Britain and administered out of the South Kensington Museum (now the Victoria and Albert Museum) in London. By the end of the next decade, the provinces had adopted and were putting into place the British system, which incorporated both a fine art application and an industrial and design function, originally intended to improve the quality of goods produced by the Industrial Revolution. The training of art teachers was emphasized. Province-wide competitions were implemented to guarantee uniform standards throughout the system. Many new schools were created, and several existing ones were reorganized to comply with the new curricula. From the outset, however, instruction in fine art and commercial art never completely fused.

The first professionally-run art school, the Ontario School of Art, was founded in 1876 by the Ontario Society of Artists, as part of their charter. From its start, the school included an engraver on its board of management. But while engravers and lithographers were enrolled, practically no printmaking courses were offered: a single wood engraving class was given in the 1883–84 school year.[69] In general, while it conformed with most of the Department of Education's curriculum, the Ontario School of Art stressed courses that catered to the development of draughtsmanship and other fine art talents, downplaying the more commercial applications. This emphasis was particularly attractive to commercial artists working in the Toronto publishing trade who wished to expand their skills as illustrators and designers. By 1899 workers from companies such as Grip Printing & Publishing (see fig. 21), Toronto Engraving Co., and Toronto Lithographing Co., who were enrolled at the Toronto school, were winning a large number of provincial prizes.[70] The Hamilton School of Art was one of several newer art schools to adopt the teaching of the commercial aspects of art, as they came under the jurisdiction of the Department of Education in the 1880s. A survey of the Department's reports shows that the

printmaking taught at Hamilton included wood engraving, lithography, and photogravure – all with industrial applications. The Hamilton Art School did offer a course in etching during the 1889–90 school year, but only two pupils enrolled.[71]

In Québec the situation was not much different. The Art Association of Montreal founded its art school in 1880, and the courses offered were drawing from the antique and live model. By 1889 a landscape watercolour class was introduced; oil painting did not become part of the curriculum until 1900.[72] Also in Montreal, the Abbé Joseph Chabert established and ran his own *Institution Nationale: École spéciale des beaux-arts, sciences, arts et métiers et industries* from 1871 to 1877. There the famed French printmaker Rodolphe Bresdin instructed the "Session de Gravure" for at least one year, 1874. But Bresdin's brief tenure in Montreal (1873–77) left no discernible trace on the local art community.[73] It remained for the provincial government, under the Council of Arts and Manufactures, to set up an art school system. In 1875, several schools offering mechanical drawing, free-hand drawing, architectural drawing, etc., had been established throughout the province, and in short order they were employing the South Kensington system. Only the Montreal school was large enough to offer printmaking courses. The lack of interest in wood engraving displayed by the Montreal students was in keeping with the diminishing use of the technique in the publishing trade. However, the enrolment for the lithography course introduced by Henri Julien in 1882 was quite substantial. The course continued under J.A.P. Lebelle and J.A. Harris through to 1900, attracting artists of the calibre of A.Y. Jackson and his brother Henry A.C. Jackson. Its intent, however, was to train commercial lithographers – which was A.Y. Jackson's first career.[74]

In the Maritimes, the situation for the training of painter-etchers was not any brighter. In New Brunswick, John Hammond became the first principal of the Owens Art School, which opened for classes in October 1885 at Saint John. Despite his own experience in the medium, etching was not taught, probably due to the expense of purchasing good equipment and material. When the Owens Art Institute and its school

moved to Mount Allison College at Sackville in 1893, no provisions were made for an etching class. Hammond allowed his curriculum to follow established practices of the time – primarily drawing from the antique and live model.[75]

In Nova Scotia, the Victoria School of Art and Design was founded in 1887, modelled on the South Kensington system. Among the courses assigned to the principal W.E. England was "Illustrating and Etching," but it is not clear if an etching course was taught during the school's first year. At its first annual meeting, the secretary of the board called for "a suitable building, and an additional teacher of practical work such as modelling and etching."[76] The following year, the Victoria School of Art and Design did offer an etching class, but on the premises of the Halifax Ladies College.[77] At the 1889 annual meeting, it was noted with disappointment that "in Etching for which careful provision had been made there was but one pupil."[78] The course would not be offered again until well into the twentieth century. Nevertheless, this class holds the distinction of being the first etching class offered by an art school in Canada.

In Toronto, disputes between the OSA and the Department of Education, coupled with financial restraints, caused a four-year closure of the Ontario School of Art, beginning in 1886. While the government put its support behind

its own Toronto School of Art, this school did not offer the formal art instruction sought by the illustrators and graphic designers working in the city's lithography and engraving establishments.[79] The Toronto Art Students' League (TASL) was formed in September 1886, in response to this need. The TASL was very much a self-help cooperative, composed of the most ambitious and talented young illustrators in Toronto's printing/publishing trade. Its founding members included W.W. Alexander, A.H. Howard, William Bengough, Robert Holmes, C.M. Manly, and William J. Thomson, who were soon joined by C.W. Jefferys, F.H. Brigden, Owen Staples, and David F. Thomson (William Thomson's brother). Membership was opened to women in the 1889–90 school year.[80] The TASL's initial aims were the holding of art classes in their own rooms and the organizing of field trips throughout Ontario and Québec. Drawing was of prime importance, and life classes were offered in the evenings, with instruction given by the more experienced members.[81] Their activities began to expand: from 1889 they held regular exhibitions of the year's work, and at C.W. Jefferys' instigation, from 1893 to 1904 they produced a set of calendars that boast some of the finest art nouveau decorative design in Canadian art, for which they are best remembered today. Based on specific Canadian themes, the calendars reflected and amplified the strong nationalism among the membership.

During these early years, the members of the Toronto Art Students' League did not forget their occupational interests in printmaking. At a special meeting held at their quarters on 13 February 1888, TASL members and their guests were invited to view a sizable display of etchings and engravings, as well as "compositions" by members.[82] (The etchings were likely by William J. Thomson.) A second exhibition of similar work was held in December 1889, and a contemporary account records: "a lithographic drawing on the stone, wood blocks engraved and zinc engravings, which showed the application of art to industrial work. The League is thus taking the public into its confidence and not attempting to be anything else than it is – an association of students and workers."[83] William J. Thomson, now the vice-president, attempted to elevate the attitude of the League's membership toward printmaking with an etching class that started in January 1890, on Saturday afternoons. Thomson, being the best qualified member, must have been the teacher. Despite the report that the etching class had made "a very creditable beginning," it did not continue beyond the second school term.[84]

Reviews of TASL activities and exhibitions after 1890 never again describe any activity involving printmaking. However, it was the members of the Toronto Art Students' League and its successors, the Mahlstick Club and the Graphic Arts Club, who would revive and secure the artist's print in the next century on Canadian soil.

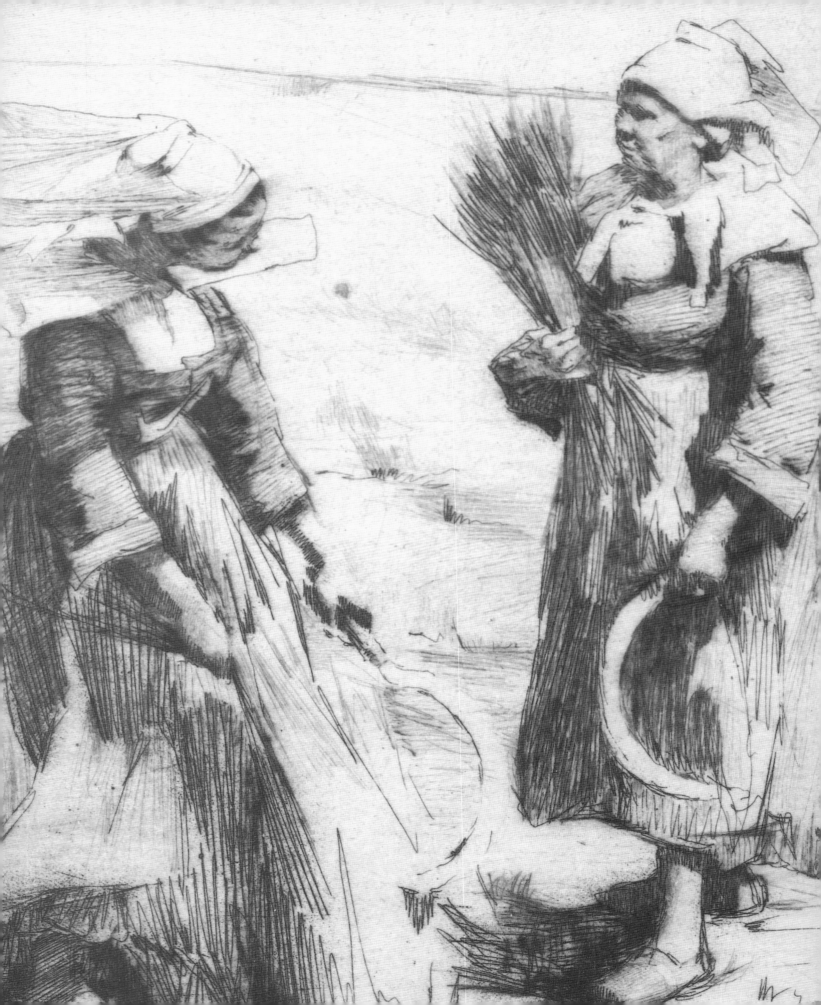

2 In the Mainstream

Canadians and the International Print Movement, 1877–1920

IT WAS COMMON practice for artists to take up printmaking in collaboration. Painter-etchers shared equipment and expertise, and showed their work together in self-organized exhibitions, enjoying a communal enthusiasm for the new art. So it was that the Canadian artists who worked outside the country in the decades around the turn of the century found themselves in the midst of some of the most important circles of painter-etchers; and they took part in the etching revival's evolving customs and applications. Some would eventually return to Canada; others would become true expatriates, periodically sending their prints to Canadian exhibitions. Thus they encouraged, through practice and example, a regeneration at home of the etching revival in the early years of the twentieth century.

Participation in the American Etching Revival, before 1900

Although his studies and career were primarily pursued in the United States, the first Canadian-born artist to participate in the etching revival was inspired to do so by one of the French founders of the movement, Jean-François Millet. In 1873, **Wyatt Eaton (1849–1896)**, a promising young art student in Paris, formed a relationship with the French painter that continued until Millet's death in 1875.[1] Although Millet did not teach Eaton the technique, the two had conversations on etching, which seem to have begun when Eaton brought Millet a copy of Charles Blanc's newly published edition of Rembrandt's etchings.[2] The young Canadian was not highly enamoured of his mentor's etchings, finding they lacked an acceptable level of technical ability; but he held Millet's paintings and drawings in high esteem.[3]

Despite his contact with Millet, there is no indication that Eaton paid very close attention to easily available prints by other Barbizon artists while in France. His knowledge of French etching was likely developed in the United States, where he had studied from 1867 to 1872 at the National Academy of Design in New York. The American etching revival maintained strong ties with its French counterpart,[4] and ever since the 1866 visit of Alfred Cadart, collecting French etching was fairly usual among American art patrons. Eaton, who knew the print collector Samuel P. Avery,[5] would have had little difficulty in finding the opportunity to study the work of the leading contemporary French practitioners once he had decided to take up the medium.

Wyatt Eaton's earliest known etchings are dated 1877. In January of that year, Eaton returned to New York to take up a teaching position at the Women's School of Art at the Cooper Union,[6] concurrent with R. Swain Gifford, who was considered the best American painter-etcher after Whistler.[7] That May, Gifford took part in the small etching demonstration in James David Smillie's studio that marked the founding of the New York Etching Club. The participants and first club members included Frederick Dielman, Samuel Coleman, and Walter Shirlaw, who would become Eaton's friends. They all soon joined the Society of American Artists, which the Canadian helped found in June 1877. Wyatt Eaton might well have learned the technique from any of these enthusiastic young painter-etchers; however, there is no evidence that he ever joined the New York Etching Club or participated in their regular sessions of instruction and critique. (In fact, Eaton apparently never exhibited his etchings.) Another possible stimulus to etching was the special

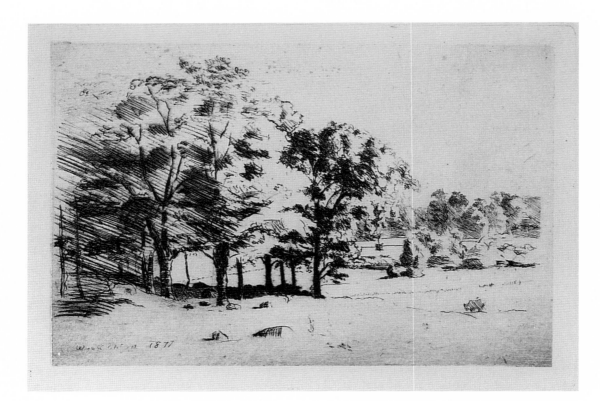

Fig. 23
Wyatt Eaton
*Trees in the Forest of
Fontainebleau* 1877
(cat. 23)

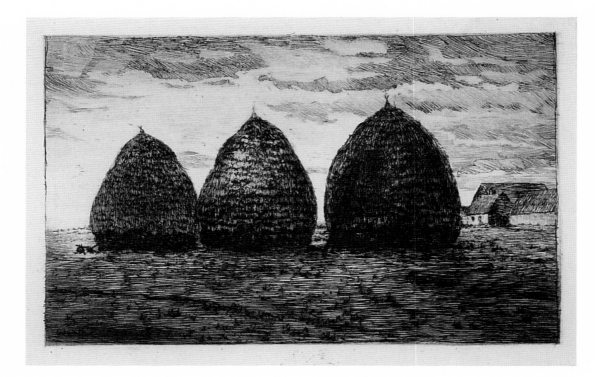

Fig. 24
Wyatt Eaton
Haystacks at Barbizon 1877
(cat. 24)

Fig. 25
Wyatt Eaton
Laure 1877
(cat. 25)

Fig. 26
Wyatt Eaton
Self-portrait 1879
(cat. 26)

commercial course that included printmaking, being offered by the Women's Art School – Eaton could have availed himself of its facilities.[8]

At least seven etchings were made by Eaton between 1877 and 1881. If the technical aspects of the medium were learned from his American friends, his landscape etchings show an indebtedness to the Barbizon School. The brisk and rough horizontal shading, loose drawing, and the almost casual composition of *Trees in the Forest of Fontainebleau* (fig. 23) owe much to Corot's etchings of similar subjects. The drawing of *Haystacks at Barbizon* (fig. 24) is similar to Corot's darker, night subjects, but the more finished, unvignetted composition and the treatment of the sky reflect Daubigny's style. However, it is with the portrait etchings that Eaton comes into his own, as his informal, carefully illuminated *Laure* (fig. 25) and *Self-portrait* (fig. 26) readily demonstrate. Single, delicately etched lines trace their way to areas of concentrated parallel lines. Plate tone is used in a painterly manner to complement and accentuate the drawing. A favourite technique is to strengthen the dark, densely etched portions of the subject by juxtaposing them with an unmarked, cleanly wiped area of the plate. Wyatt

Eaton's handful of beautifully executed prints are happy confirmations of French sources within the American etching revival.

When **Henry Sandham (1842–1910)** moved from Montreal to Boston in late 1880 to set up a branch of William Notman's photographic studio empire, he arrived at a small but active and highly informed art community. Boston was the base from which S.R. Koehler disseminated the etching revival, and under his auspices Boston's Museum of Fine Arts had organized North America's first international exhibition of etching in January 1879; a second large show of American etching followed in April 1881.[9] The Massachusetts Charitable Mechanic Association also devoted a section of their 14th and 15th exhibitions to approximately one hundred etchings and engravings. Sandham would likely have attended these events to which he contributed canvases and watercolours. In addition, from 1880 to 1885, the Boston Art Club received regular submissions to its Black and White sections from Koehler's *American Art Review* and from members of the New York Etching Club.[10] Sandham served on the Boston Art Club's exhibition committee in 1884 and 1885.

As well as being able to examine first-hand the best of contemporary etching, Sandham was acquainted with nearly all of the city's practising painter-etchers: this would have given him access to their presses and expertise. The Boston Etching Club had announced its formation in 1879, with artists, designers, and architects being invited to join.[11] Little is known of this organization, which only managed to produce one exhibition, in 1883, with a fully etched catalogue.[12] By 1884, when he pulled his first known etching, all of the members listed in this catalogue belonged – along with Sandham – to either the Boston Art Club or the Paint and Clay Club of Boston.

Two etchings by Henry Sandham were included in the Association of Canadian Etchers' 1885 exhibition in Toronto: the large *In Boston Public Gardens* (cat. 100) and the modest-sized *La Salle's Homestead*.[13] Only the first print is known and it attests to the artist's unfamiliarity with the possibilities of the medium. He has treated the image not as a fresh and expressive line drawing, but as a heavily worked composition rendered in a style more suitable for commercial illustration. This is hardly surprising as at the time Sandham was having great success as an illustrator for Louis Prang's lithography publishing company in Boston, as well as for *The Century Magazine* and *Harper's*.

Since the time of Gutenberg, publications of high quality with sumptuously printed illustrations have been the bibliophile's passion and have attracted skilled artists. In the mid-nineteenth century, publishers recognized the very special cachet original etchings could give their books: this helped to validate painter-etcher prints and broaden their acceptance. Sandham was not entirely new to the concept, having tried his hand at such a venture in Canada as early as 1870, by creating wood engravings for John Fraser's *A Tale of the Sea and Other Poems*. By 1888 he had become a more capable etcher and was moving in more worldly publishing circles when five of his etchings appeared in the limited edition volume *The Restigouche and its Salmon Fishing* by Dean Sage. This lavish book was illustrated with original etchings by some of America's finest practitioners, among whom were Stephen Parrish, Anna Lea Merritt, and C.H. Platt. Henry Sandham was most

Fig. 27
Henry Sandham
Osprey 1888
(cat. 101)

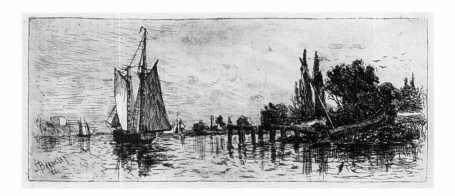

Fig. 28
J.M. Barnsley
Study from Nature 1881
(cat. 8)

effective when he kept to the informal vignette – long proven to be a successful format for etching. *Osprey* (fig. 27) was his last image in the book; the balance between the darkly etched bird and the lightly bitten drawing of the forested landscape makes it one of the most elegant nineteenth-century Canadian painter-etcher prints.

James MacDonald Barnsley (1861–1929) began his studies at the St. Louis School of Fine Arts in Missouri in 1879, and was soon having his drawings published in local magazines.[14] One of these, *Art and Music*, used his first etching *Study from Nature* (fig. 28) – a view of sailboats on the Mississippi – in its December 1881 issue. The title was standard usage in those days, intended to reassure viewers that the artist had conceived the design and executed it "on the spot" – directly onto the copper plate. This little etching was a sturdy first try, exhibiting sure draughtsmanship and competent, if somewhat uncertain, manipulation of the

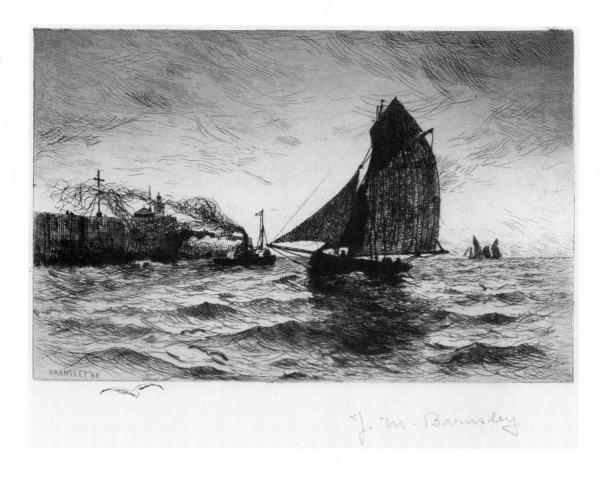

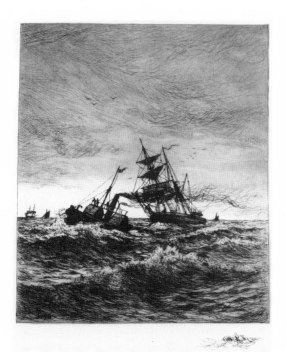

plate tone to effect highlights. St. Louis was not a centre for etching, and neither the artist nor the local engraver J.M. Kershaw[15] could gain a sophisticated knowledge of painterly applications there. Furthermore, even if Barnsley were aware of the aesthetics of the art, as a student he may not have had the courage to attempt to direct an engraver who could claim over thirty years' experience.

After further studies in Paris, Barnsley returned to Canada, settling in Montreal by early 1888 but dividing his time between that city and New York. The AAM's Black and White exhibition of May 1888 would have shown the artist that while Montreal might be a forbidding place to make prints, it did possess a wealthy group of interested and knowledgeable print collectors. That October, Barnsley presented two etchings at his exhibition at W. Scott & Sons: *On the English Channel* and *Entrance to Dieppe Harbour* (fig. 29), after his 1886 Salon painting.[16] A third, *A Head Wind* (fig. 30), was added for the February 1889

exhibition at the New York Etching Club, and shown as *With a Fair Wind* at the 1889 AAM Spring annual.

Kimmel & Voigt of New York, the foremost artists' printers in North America, had undertaken the printing of *A Head Wind* and likely of the two other etchings. All three are similar in size and share a level of technical expertise and manner of inking the plate. The sureness and freshness of the drawing in these prints strongly favours the supposition that the artist drew directly on the plate himself. The harmonious treatment of etched line in conjunction with the painterly use of plate tone makes clear that Barnsley and his printer enjoyed a sympathetic working relationship. The prints are faithful to Barnsley's personal style and cannot be directly compared with the work of other American or French etchers specializing in marine subjects. These few etchings may have been the only prints Barnsley made before acute mental illness cut short his promising career in January 1892.

Some Canadians did more than look enviously upon the lucrative American market for etching. Four years before Barnsley, T. Mower Martin had availed himself of the expertise at Kimmel & Voigt. While Martin, along with other ACE members, had access to a small etching press in Toronto, he was evidently looking for more in terms of the size of plates, the quality of printing, and marketing. No doubt he wanted to capitalize on the current fad for inexpensive original art. Of the eight plates he placed with publishers, only two are known to have been sold: Christian Klackner of New York paid a total of $225 for *On Current River, Thunder Bay, Lake Superior* and *In the Woodland*, which he published in 1885.[17]

Martin is the only Canadian painter-etcher known to have succeeded in marketing his prints in this manner; although others – for example, Arthur Cox and J.M. Barnsley – might have had such large-editioned publications of their etchings in mind when they sought out Kimmel & Voigt.[18] This might also be what Henry Sandham envisaged for his *In Boston Public Gardens*.[19] During the 1880s, the sale of plates to publishers such as Klackner was a common and lucrative practice among top American and European artists. By the 1890s, however, particularly in the United States

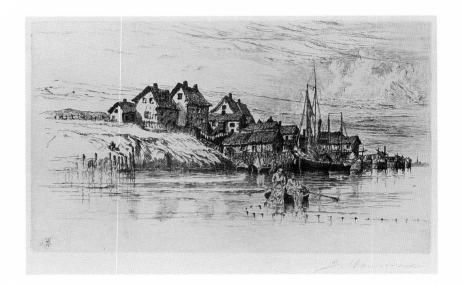

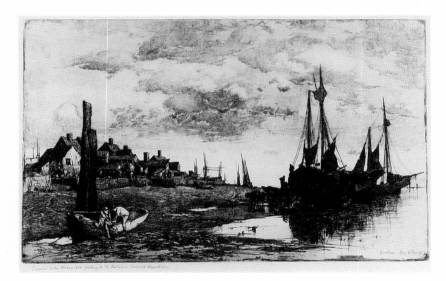

where overproduction and abuse were rampant, these prints would become stigmatized as crassly commercial.

The Society of American Etchers was formed in 1888 with the aim of raising the standards of etching's production. That same year, the dealer and publisher Frederick Keppel issued the pamphlet *What Etchings Are* in an attempt to define the criteria of connoisseurship, such as states, proofs, and quality of printing.[20] In 1890, Keppel and the Society of American Etchers joined forces to rescue the medium from the practices of the mass marketers.[21] In his efforts to build up the prestige of artist's prints, Keppel had become a leading exponent of limited edition prints. His

Fig. 31
John Hammond
Fundy Coast 1883
(cat. 54)

Fig. 32
Stephen Parrish (1846–1909)
Low Tide, Bay of Fundy 1882
Etching, 30 × 47.9 cm (plate)
Owens Art Gallery, Sackville, N.B.
(1895.209)
Presented by F. Keppel & Co.,
New York

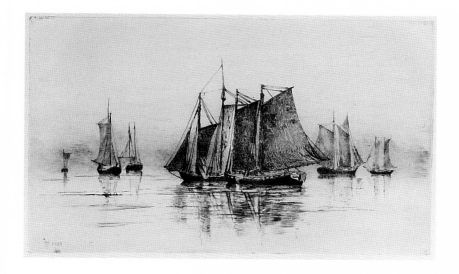

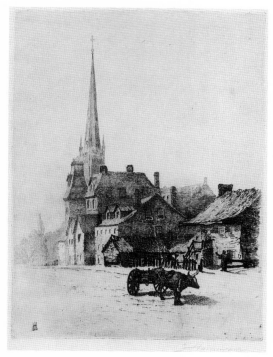

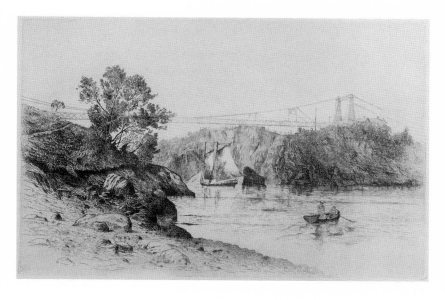

Fig. 33
John Hammond
Waiting for the Tide, Bay of Fundy
1883
(cat. 53)

Fig. 34
John Hammond
Suspension Bridge, Saint John, N.B.
c. 1884
(cat. 55)

Fig. 35
John Hammond
Old and New Saint John 1882
(cat. 50)

actions were not entirely altruistic: he set out to keep the market attractive to the discerning collector while boosting the value of his carefully selected stock.

John Hammond (1843–1939) was running a branch of the photographic firm of W. & J. Notman in New Brunswick when he came into contact with the circle of American painter-etchers. He encountered Stephen Parrish and his young disciple Charles H. Platt in Saint John while the two Americans were on a sketching trip through the Maritime Provinces in August and September 1881.[22] It appears that Hammond went to see Parrish in Philadelphia the following April and was given five etchings by the

American.[23] Hammond probably received his first lessons in etching during this visit, which explains the earliest date on his prints – 1882.[24] The influence of Parrish is unquestionable in Hammond's work: the tendency towards densely drawn compositions and heavy inking of the plate, which emphasizes draughtsmanship, and strong silhouetting or darkening of certain portions. A comparison between Hammond's *Fundy Coast* (fig. 31) and Parrish's *Low Tide, Bay of Fundy* (fig. 32) illustrates the extent of Hammond's indebtedness.[25] Among his identifiably Canadian subjects, mostly marines, are: *Waiting for the Tide, Bay of Fundy* (fig. 33), perhaps his most serene image; *Old and New Saint John* (fig. 35), an apparently unique urban view; and *Suspension Bridge, Saint John* (fig. 34), the finest of the group. A delicate marriage of marine subject and landscape, *Suspension Bridge* has a richness in detail and tone unequalled in his prints to date. The consistent evenness in the printing forces one to consider that this was one of the two plates Hammond turned over to

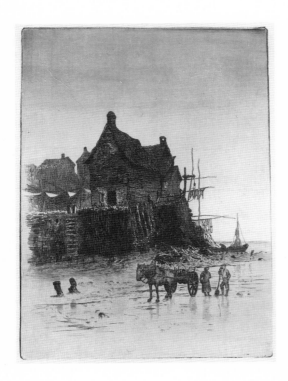

Fig. 36
John Hammond
Dulse Gatherers on the Coast near Carleton, N.B., state I/II c. 1882–83
(cat. 51)

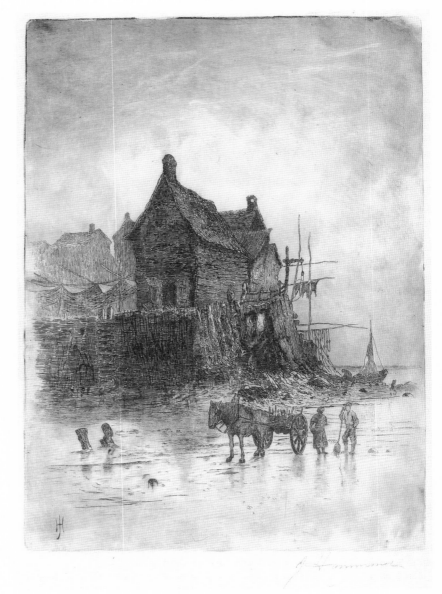

Fig. 37
John Hammond
Dulse Gatherers on the Coast near Carleton, N.B., state II/II
c. 1882–83
(cat. 52)

Parrish for printing (the impression exhibited here came from Parrish's collection).[26]

The rarity of subjects found in more than one impression makes it difficult to determine the extent of Hammond's technical adventurousness. However, two impressions of *Dulse Gatherers on the Coast near Carleton, N.B.* (fig. 36 and 37) show that he may have experimented quite freely. The first impression has a generous but even use of plate tone, which knits the tightly drawn portions of the image to the large empty areas of sky and beach. Another impression leaves a great deal of unevenly wiped, residual ink on the plate, emulating the effect of a thick coastal fog.

In 1884–85, Hammond travelled to Europe to acquire works of art for the Owens Art Institute and to take his first formal art studies. There he met Whistler and the noted Belgian painter-etcher Storm van's-Gravensande, but neither of these encounters led to any printmaking.[27] However, Hammond did return to Canada with a large portfolio of sketches of European cities,

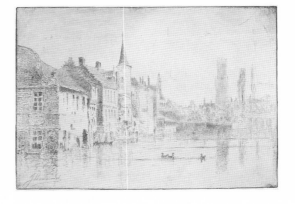

Fig. 38
John Hammond
Bruges c. 1886
Etching, 17.7 × 24.4 cm (plate)
Private collection

which he used as the basis for further etchings. Possibly he began to work on these plates in late 1886 when Parrish was again touring the Maritimes.[28] He produced five European etchings in all, one Italian and four Belgian subjects. Hammond's European plates (see fig. 38) have become softer in appearance, seeking out more moderate contrasts of tone and substituting a general impression for the sharp clarity of form. This muted sensitivity is in keeping with a movement in all of Hammond's work towards a more Whistlerian and Dutch impressionism. It is doubtful that he dabbled in the medium after this period. Etching for Hammond was very private work, as indicated by the paucity of signed impressions and the many proofs of incomplete or abandoned subjects, not to mention the limited exhibition history.[29] Isolated from other artists with whom he could share his interest in printmaking, he turned his attention to painting. Nevertheless, John Hammond can be credited with at least twenty-four plates, a large number for a Canadian painter-etcher of that era, and he produced some of the etching revival's most accomplished prints of Canadian subjects.[30]

Participation in the British Etching Revival, before 1900

Now largely forgotten in her native country, **Elizabeth Armstrong Forbes (1859–1912)** was a highly gifted painter-etcher.[31] She worked within the group of artists surrounding the volatile and egocentric Whistler, whose two most favoured acolytes of this period were Walter Sickert and the young Australian Mortimer Menpes. By the time she first met Menpes at Pont-Aven in 1882, he was already a skilled painter-etcher, Whistler's principal printer (having helped with the "Venice Set" of 1880–81, Whistler's masterwork), and a member of Haden's Society of Painter-Etchers. Menpes let Elizabeth Armstrong profit from his rare, intimate knowledge of Whistler's etching techniques, which he imparted through practical demonstration; and he allowed her to study his personal collection of Whistler's prints. Armstrong's first plate, made that year at Pont-Aven, was a simple practice piece in drypoint; it comprised several portraits, including the figure in Whistler's *Speke Hall*.[32]

Fig. 39
Elizabeth Armstrong Forbes, in the 1880s
Taken from H.J. Morgan, ed., *Types of Canadian Women* (Toronto, 1903)

Settling in London in the summer of 1883, Armstrong found an artistic outlet in her continued collaboration with Menpes. At the press in his studio over the next two years, she produced an exquisite body of drypoints of Breton subjects, as well as portrait prints that included the delightful image of Menpes' daughter Dorothy (fig. 40) – her best known work. Certainly she knew Whistler, and possibly she had the opportunity to watch him at work in Menpes' studio at this time.[33] Elizabeth Armstrong rapidly gained international recognition, exhibiting with London's Society of Painter-Etchers and at important venues in Paris, Philadelphia, and New York.[34] Her work was admired by Whistler's coterie, one of whom, Otto Bacher, collected her prints.[35]

Around November 1885, she moved to Newlyn, a fishing village in Cornwall. A small colony of artists was beginning to form in this picturesque spot, and among them was her future husband, the young painter Stanhope Forbes. In that first year at Newlyn, she made five drypoints of Cornish subjects, *The Bakehouse* (fig. 41) for one, evidently proving the plates in London with Menpes. After that time, however, she made only

Fig. 40
Elizabeth Armstrong Forbes
Dorothy, No. 2 c. 1883–84
(cat. 31)

Fig. 41
Elizabeth Armstrong Forbes
The Bakehouse c. 1886–87
(cat. 33)

one more print, *The Sisters*, produced after her marriage to Forbes in 1889. What caused Elizabeth Armstrong to abandon a medium in which she clearly excelled? The artist offered this explanation:

> [Printmaking] was a branch of art of which I was intensely fond, and one of the few modes of expression which I could pursue more easily in London than elsewhere. Afterwards, when I had settled in Cornwall, the difficulty of having my plates printed, more especially of having the trial proofs pulled while actually at work, proved too discouraging, and gradually, to my regret, I found myself compelled to lay aside my etching tools....[36]

Although she didn't allude to it, another factor must surely have been finding herself an instrument of war in the ongoing feud between Whistler and his brother-in-law Haden that began in 1867 when Whistler pushed Haden through the window of a Parisian café. As a member of Whistler's circle and Haden's Society, Elizabeth had been walking on dangerous ground. The consequences erupted in 1886 when, in an amazing display of double standards, Haden inexplicably attacked her for using someone else to print one of her plates.[37] This was likely an indirect criticism of Whistler via his man Menpes. Mortimer Menpes' long absence from London (1887–88), when he travelled to Japan, probably sealed her decision to give up printmaking.

A progression may be seen in Armstrong Forbes' drypoints, starting in 1882–83 with the single figure studies isolated from their environment, such as *Dorothy, No. 2* (fig. 40). The next group usually places the figure in a context, as in the rare action subject *The Reapers* (fig. 42) and the sensitive study *The Old Lady and Her Stick* (fig. 43). The last prints of the Cornish period are all set in dark interiors. *The Bakehouse* (fig. 41) from this period reveals a confident mastery of the medium. These Newlyn drypoints are intricately and densely drawn, with rich contrasts, dark and light values, and sensitive use of line and burr. Not wishing to lose the rich lines created by the easily flattened burr, she printed only a few impressions from each plate. Writing of influences on the artist, Robert Getscher points to Menpes, whose "blocky peasant types" of the 1880s are echoed in Armstrong's early prints; through him she learned of Whistler and "how to achieve a delicacy of line, extremely elegant vignetting, handsome printing, and quiet, intimist subjects."[38] Getscher also notes the close similarity of *The Bakehouse* to Whistler's *The Kitchen* (K.24) from the "French Set," which Menpes helped Whistler print in its final state in 1885.

While the recent focus on feminist art and the Newlyn School have rekindled appreciation for Elizabeth Armstrong Forbes' paintings and drawings, her reputation as a printmaker was never really lost. Twentieth-century publications on British printmaking have regularly discussed and illustrated her work. Getscher's important 1977 exhibition *The Stamp of Whistler* brought Elizabeth Armstrong to the notice of a broader North American audience. Without doubt, she can be considered the finest nineteenth-century painter-etcher Canada produced.

Her achievement as a woman artist was not unusual in the context of the etching revival. Talented women, who normally encountered numerous obstacles on their artistic paths, could find an equal footing with their male peers within the movement. The cooperative nature of print-making proved an asset to Victorian and Edwardian women, with their ingrained modesty and forced dependence on men for protection. Artistic collaboration with a man, such as Elizabeth enjoyed with Mortimer Menpes, eased a woman's integration into the art world.

A look at history reveals that involvement with printmaking was not a new thing for women. From the sixteenth century on, many functioned as professional engravers connected with the workshops of their male relatives. Indeed, engraving was one of the first trades to be open to women, and was considered an essential and highly respectable occupation.[39] We have also noted that well-to-do women had long gravitated to etching as a hobby. From this, one might observe that when painter-etchings came into vogue in the mid-nineteenth century, women were not so much attracted to the medium as already working with it.

"Lady-etchers" – as they were called by the art writers of the day – received more recognition than women artists engaged in painting, sculpture, and watercolour. For example, when the Royal Society of Painter-Etchers was founded in 1880, women were immediately accepted into membership, while they were kept out of established organizations such as the Royal Academy.[40] That etching associations (including most of the American societies[41]) readily opened their doors to

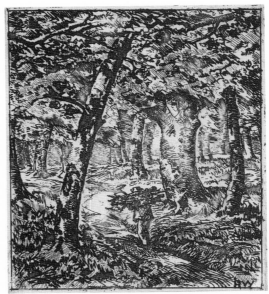

women was largely because younger art societies tend to be less stringent about qualifications, particularly in newer, more marginal areas of activity. Or, to put it bluntly, the painter-etcher movement was not yet the preserve of a group with vested interests. The fact that societies were looking to enlist as many members as possible did not mean that they had to compromise on artistic ability. From the outset, women could be found in the

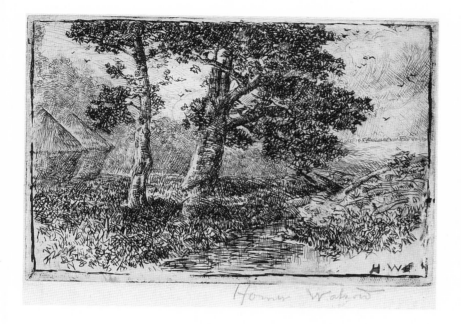

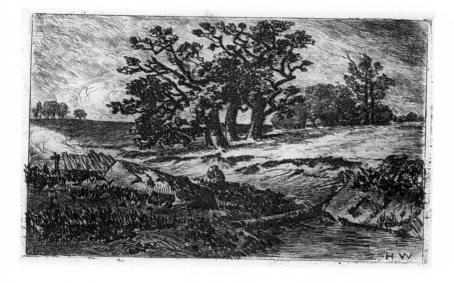

had given two of these to his mother-in-law, Queen Victoria. Watson soon made the acquaintance of George Clausen, a French-trained genre painter and proponent of the naturalist school whom he considered the most interesting landscape artist he had seen to date.[43] While this Canadian's encounter with Whistler, which might have consisted of no more than an introduction and a handshake at London's Hogarth Club,[44] has been used by Canadian art historians to justify the claim that Whistler was Watson's etching instructor, in reality, Homer Watson's first and only prints were made with Clausen's encouragement and direction.

The first indication that Watson contemplated taking up etching came in a letter to Lorne in October 1889 seeking access to *The Pioneer Mill*, the painting that had made his reputation and which was now at Windsor Castle, because "some friends ... have suggested that an etching of the 'Pioneer Mill' would be a success in Canada."[45] Who might these "friends" have been? Possibly James Spooner, Watson's Toronto dealer, who had informed him about the printmaking activities of the Canadians Martin and Cox in New York, as well as the ACE exhibition.[46] Spooner was also sending him etchings.[47] J.W.H. Watts, amateur painter-etcher and curator of the National Art Collection in Ottawa, brought Watson up-to-date on the AAM's second Black and White exhibition.[48] Another close friend, A. Dickson Patterson, visited Watson in the summer of 1888, en route to Paris to have his painting of Sir John A. Macdonald printed as a limited edition photogravure.[49] It was Clausen who persuaded Watson to take this concept one step further and make an original work of art based on his own canvas – similar to the etching Barnsley had done after his Salon painting.

Between late October and late December 1889, under Clausen's watchful eye, Watson perfected his technique on five small subjects based on drawings from his Canadian sketchbooks. These included *Faggot Gatherer* (fig. 45) and *Hay Ricks* (fig. 46), and led up to the very finished *Landscape with Oak Trees* (fig. 47).[50] In January 1890, James Kerr-Lawson commented favourably on these first efforts: "They are rugged, gritty and delightful all of them – you seem to have already become

front ranks of painter-etchers. Their number and their talent led S.R. Koehler to organize the exhibition *The Work of the Women Etchers of America*, at the Museum of Fine Arts Boston in 1887; he was able to select 388 prints by twenty-two artists. The following year in New York, the Union League Club sponsored another all-women exhibition, with 513 prints by fifty-five artists.[42]

In 1887, **Homer Ransford Watson (1855–1936)** sailed for England, hoping to advance his career. He could already boast of early success in Canada with the sale of three canvases to the Marquis of Lorne, the Governor General. Lorne

intimately acquainted with the new medium — seized it with a firm grip, and I am sure that you will only have to treat your large plate of the 'Pioneer' in as large and reckless a manner as the smaller ones to make it a howling success."[51]

In preparation for his print *The Pioneer Mill*, Watson had visited Windsor Castle in October 1889 to render a drawing after the painting, for reference. Months later, in his studio, he began the etching by attacking the plate with the same vigour and ruggedness as with the smaller subjects. The evolution of this subject in three states reveals much of the artist's conception of the print and his technique. The first state (fig. 48) shows Watson laying out all the basic compositional elements, probably as they would have appeared in the copy drawing. However, he took care to reverse the image on the plate, so that when printed it would "read" from left to right, like the painting. He made a courageous deep biting of the plate in the acid bath, unusual for a first state, creating strong dark lines and solid areas of black; the result is a stark, harshly printed line drawing. In the second state (fig. 49), he introduced shading to the mill, the rocks on the bank of the stream, and the heavy storm clouds overhead, while the precipice in the background is more clearly defined. With this second biting Watson created a more subtle print, but for late nineteenth-century tastes the drawing would have been too uniform in its treatment of texture and light, lacking a subtle degree of finish. In the third state (fig. 50), we see a further attempt to modulate the harsh tonality of the first state by introducing lines to shade the stark white rectangle of the mill roof; plate tone complements these few changes. Of the seven known impressions of the third state, each separate printing shows a marked variety in inking, evidence that Watson was searching for the right balance of etched line and plate tone for the final print run. In other words, the artist was working towards those creamy-toned, delicately etched, and immaculately printed plates sought after by connoisseurs. But Watson could not divorce his etching style from his own, rather rough and ready drawing style, inculcated by his beginnings as a self-taught artist. The relative crudeness, which we admire today as energetic self-expression, would have been

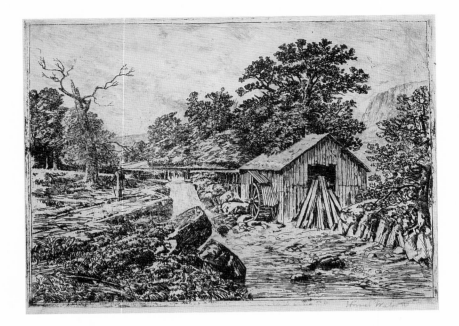

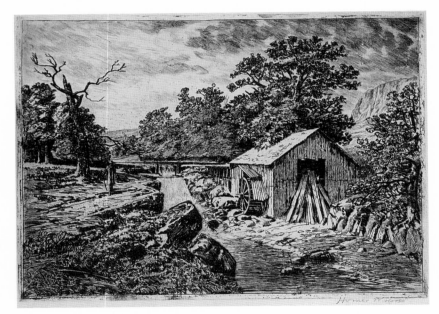

anathema to the sophisticated print publishers of Europe and North America in Watson's time.

The manner and style of the completed print was very similar to Clausen's, who was not much interested in the cuisine of etching, with its ethereal line and chastely printed plate.[52] The influence of Clausen's rough approach to etching is patently clear when comparing his *Going Home* (fig. 52) with Watson's prints. However, as Watson's etchings are also remarkably faithful to his own drawing style, the relationship between the two etchers

Fig. 48
Homer Watson
The Pioneer Mill, state I/III 1890
(cat. 120)

Fig. 49
Homer Watson
The Pioneer Mill, state II/III 1890
(cat. 121)

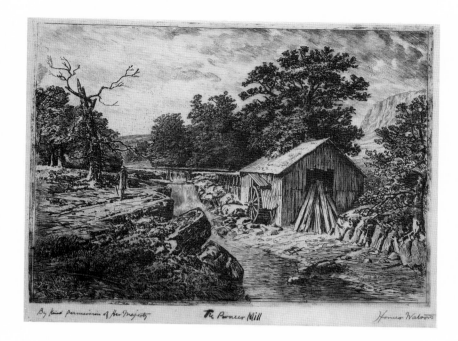

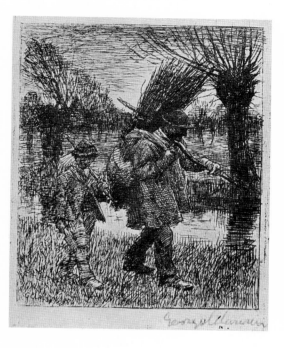

Fig. 50
Homer Watson
The Pioneer Mill, state III/III 1890
(cat. 122)

Fig. 51
Flyer for *The Pioneer Mill*,
annotated by Homer Watson
with his first impressions of
George Clausen
From H. Watson's Sketchbook F
National Gallery of Canada (7878)

Fig. 52
George Clausen (1852–1944)
Going Home, state I/III 1884
Etching, 9.5 × 7.6 cm (plate)
Taken from *Print Collector's Quarterly* 8:2 (July 1921), p. 206

did not publish *The Pioneer Mill*. He had sheets printed up announcing its publication (fig. 51), but they became so much scrap paper. All the proofs, probably no more than a dozen, were sent to his sister Phoebe Watson in Doon around the end of March 1890. Most were given away to family and friends such as J.W.H. Watts, James Mavor, and Lucius O'Brien (cat. 122 is from O'Brien's collection).[53] The end result was not just a reproduction but a painter-etcher print, produced in a very limited edition, with the unique hand of the artist evident in all its states and impressions. *The Pioneer Mill* is the most ambitious nineteenth-century Canadian print, a milestone in the transition of the print from reproduction to original work of art.

Participation in the Second American Etching Revival, after 1900

During the first decade of the twentieth century, the American etching revival was moribund. There were no functioning print societies to encourage a new generation of etchers, either

should probably be seen not so much as that of instructor and student, but rather as that of two kindred artists sharing an extraordinarily sympathetic aesthetic.

Homer Watson's original motive for taking up etching was to create a quality reproduction of his most famous painting, in order to spread his name and make some money. Ultimately, Watson

through printing sessions or exhibition venues. Almost all of the artists who had been involved with the movement's emergence were now dead.[54] The remaining few had turned to painting as a more commanding artistic enterprise.

The most active American etcher of the era was Joseph Pennell, who had been living in Europe since 1883, and by 1901 had replaced Menpes as Whistler's chief disciple and apologist. Pennell promoted the idea of collaborations between artists and writers for the creation of alluring travel literature, which had a ready market among North American and British readers. Frequently, his illustrations were original artist's prints, accompanying articles written by his wife, Elizabeth Robins. It was a project to illustrate an article on Tuscany for *The Century Magazine* that first brought Pennell to Europe in 1883. The assignment appealed to him for more than monetary reasons: "An illustrator receives more publicity from a magazine which publishes illustrations than any other artist, for though large numbers of people may see in one

Fig. 53
Charles Henry White, in about 1890
Photo courtesy of Pat Mills, Hamilton, Ont.

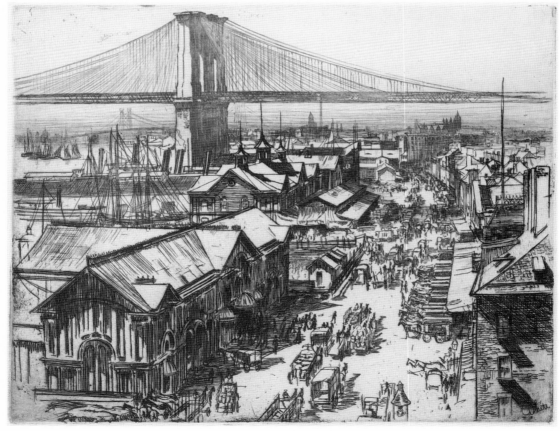

Fig. 54
C.H. White
New York Fulton Market Set: Fulton Market 1904–05
(cat. 126)

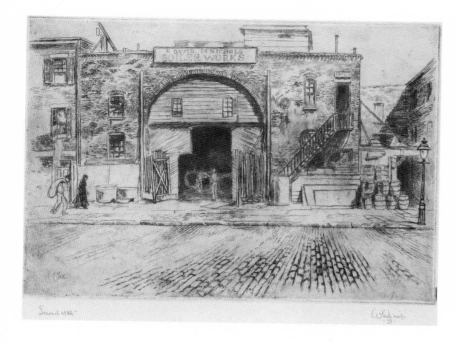

Fig. 55
C.H. White
New York East Side Set: The Boiler Works 1902
(cat. 125)

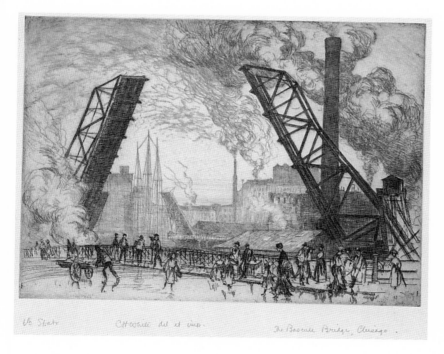

Fig. 56
C.H. White
Chicago Set: The Bascule Bridge 1908
(cat. 128)

city an art exhibition, an illustrated magazine is an art gallery for the world...."[55]

These magazines and books illustrated with etchings helped to produce a taste among a broad base of conservative print collectors for picturesque views of medieval and Renaissance Europe.[56] The depiction of quaint, run-down buildings and streets, all glazed with a romantic patina, became a staple format of the painter-etcher print. A great many artists, mostly American or British, were unable to resist this blissful congruence between subject, medium, and market. Nor were the Canadians immune, as we shall soon see, and the reputations of painter-etchers such as Frank and Caroline Armington and Clarence Gagnon were built, in whole or in part, on this material.[57]

After studies at the Art Students' League in New York and with Jean-Léon Gérôme in Paris, **Charles Henry White (1878–1918)** fell into Joseph Pennell's orbit in 1901, in Venice. Under the American's guidance, he began to etch plates of Venetian views. Sensing that the European by-ways were already well trodden and that an artist might be tempted to resort to making a "pot-boiler of an old château ... when the rent comes due,"[58] White chose a different path. He made for New York, where he could work relatively free from convention, and began a career as a creator of American urban views. Initially, his only real competition was "*the* etcher par excellence of New York City,"[59] Charles F.W. Mielatz, who had been active in American printmaking's hey-day in the 1880s. White gave Mielatz a run for his money: between 1902 and 1905, he produced four sets of etchings of New York scenes (see fig. 54 and 55). Two prints from this series were selected by James David Smillie for the 1904 Universal Exposition at St. Louis and won White a bronze medal.[60]

Taking his cue from Pennell, White looked to the magazine trade for his income. In February 1905, *Harper's Monthly* published the first of numerous articles he would both illustrate and write.[61] Over the next three years, he made etchings of New York, Philadelphia, New Orleans, Richmond, Boston, Charleston, Salem, Pittsburgh, Washington, Baltimore, and Chicago (see fig. 56). By 1909 he was in Europe again, doing articles on

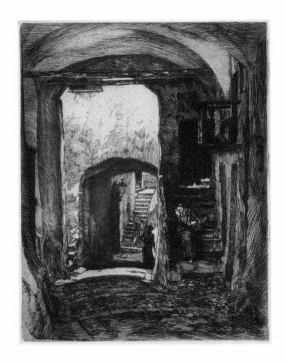

Fig. 57
C.H. White
San Remo Set: Medieval San Remo 1913
(cat. 129)

Paris, Bruges, and possibly Lisieux. White held a virtual monopoly on travel articles illustrated with etchings for *Harper's Monthly*, and his work set the standard for this important popular magazine.[62]

In a period of general indifference towards printmaking, C.H. White was one of the few to uphold the technical and aesthetic traditions of the etching revival and to pass them on. From 1907 to 1909, he taught etching at his alma mater, the Art Students' League of New York (taking over the class that George Senseney had started in 1906).[63] He also played an important role in forming popular taste, that is, in breaking Europe's domination of the picturesque and creating a North American etcher's vocabulary that stressed progress in the guise of urban and industrial subjects. Working directly on the plates, out on the city streets, White was ever conscious of the human condition, as exemplified in *The Condemned Tenement* (fig. 58). Witty, informative, lyrical, and straightforward, he did not share Meryon's disturbed vision of dark shadows and alleys – at least not until his haunting and sober "San Remo Set" (see fig. 57). White earned important advocates: his work was particularly admired by Frank Weitenkampf, the

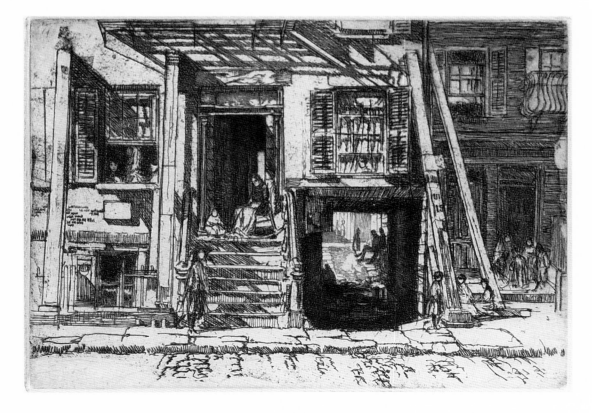

Fig. 58
C.H. White
The Condemned Tenement 1906
(cat. 127)

David Brown Milne (1882–1953) studied at the Art Students' League of New York from 1903 to 1905, too early by a year to take advantage of its first etching class. He worked hard to find a toehold as an illustrator in the enormous and ruthless New York publishing world, and in 1908 managed to sell five drawings of city scenes to *Cosmopolitan Magazine* (which evidently were never published).[67] The next year found him working up another set of pen-and-ink drawings of urban views that he intended to sell to a magazine — this time there were no takers. By October 1909 Milne was comparing his first efforts at etching with those of Joseph Pennell on display at F. Keppel & Co. The two artists shared a subject at the time: New York skyscrapers. But while Pennell celebrated American civilization, its vitality and technical achievements epitomized by the soaring structures, Milne surveyed New York as a travelogue illustrator would, recording new buildings, for example the Plaza Hotel, in addition to such historical landmarks as the Sleepy Hollow Dutch Reformed Church.[68] Did the failure to interest magazine publishers in his drawings induce the

influential print curator at the New York Public Library, who observed: "White has again emphasized the old truth that there is beauty to be found in everyday surroundings and in our own land, and has set before us the picturesque qualities of street and alley, of waterfront and factory district of ... American cities."[64] Joseph Pennell, never a generous commentator about other artists, praised White's etchings, especially his New York bridge subjects.[65] And Carl Zigrosser, one of America's leading print specialists, organized a large memorial exhibition of White's prints in 1920.[66]

Fig. 62
David Milne
Fifth Avenue from the Steps of the
New York Public Library c. 1911
(cat. 82)

Fig. 63
David Milne
Madison Square: Spring 1911
(cat. 79)

enterprising David Milne to try his hand at the copper plate and needle, with the goal of selling his etchings as illustrations?[69]

By 1911 Milne had set aside his dream of becoming a commercial illustrator and was concentrating on his career as an artist. His return to the etching press was marked by a shift to a more personalized subject matter, and he created a number of etchings that far exceeded his earlier work in sophistication of imagery, style, and technique. Pennell remained an influence, but one can also see Milne's close observation of Whistler in *Ellis Island* (fig. 60) and *Figure in the Sun* (fig. 61); while Théodore Roussel seems to have inspired the lovely *Madison Square: Spring* (fig. 63). The artist was always eager to be up on the latest developments, and these images show the results of his frequent visits to print galleries. Living around the corner from the newly completed New York Public Library on 5th Avenue and 42nd, Milne had easy access to the collection of prints donated by S.P. Avery. When it came to technique, Frederick Keppel recommended Koehler's compendium to Milne. Keppel also sent him to the printer Peter J. Platt, whose shop on Barclay Street was a mecca for prominent American etchers of the period, such as John Sloan.[70]

By the time Milne became involved with etching, the climate was starting to warm up again for the medium. White's course at the Art Students' League was one indication of heightened interest, another was the class begun by J.D. Smillie at the National Academy of Design in New York. However, the strongest impetus for a second revival came from Chicago. In March 1910, the Chicago Society of Etchers received its charter and could list twenty members. The Society saw itself primarily as an exhibiting body, and set out to be as "broad in ideals as possible and to be national in scope."[71] Its first exhibition, held in January 1911 at the Art Institute of Chicago, featured members' prints, but extended its reach to include the work of Donald Shaw MacLaughlan. Considered to be the premier etcher after Whistler's death in 1903, this Canadian-born painter-etcher was an American citizen who made

his home in Europe. By October 1911, the Chicago Society had grown to fifty-five active members, with 203 associate members.[72] Corresponding to this rapid increase in size, the Society's second exhibition in 1912 expanded: Canadians David Milne, Frank and Caroline Armington, John Cotton, and Dorothy Stevens were all represented.

Chicago's moving force in the cause of the painterly etching was Bertha Jacques. One of those rare self-starters, Jacques was infused with the pioneer American spirit. She was thirty when she came across her first prints at the World Columbian Exposition in 1893, and paid daily visits to the rooms where works by Whistler, Haden, Anders Zorn, Félix Buhot, D.Y. Cameron, and Frank Short were on view. She went on to examine the Rembrandts and Meryons in the collection of the Art Institute of Chicago. But looking was not enough. After careful reading of Hamerton and Lalanne, and with her dentist husband's help to make etching tools, Jacques was ready to pull her own plates. In 1900, she could boast the only etching press "west of New York." She used it to assist other etchers and was always on the lookout for new potential.[73] Assuming the modest position of secretary-treasurer when the Chicago Society of Etchers was formed, Jacques became the club's heart and soul. Generous

Fig. 64
John Cotton at the Toronto Art Students' League, circa 1892–93
Ontario Archives, Toronto

with her time, kind and supportive with her critiques, she encouraged numerous American and Canadian etchers, including David Milne and William J. Wood. More Canadians would exhibit in the years to come.

John Wesley Cotton (1868–1931) had a front-row seat for this "second American etching revival." Trained as a commercial lithographer, TASL member Cotton had moved to Chicago from Toronto around 1893 to take up a position with a printing firm. As the new century began, a decision to change career directions led him to start studies at the Art Institute of Chicago's school and to join local art societies. This plunged the Canadian into the cluster of artists who would take up etching, and he may have been one of Bertha Jacques protégés. A charter member of the Chicago Society of Etchers in 1910, he had four works in its first show. Cotton kept alive his ties with Toronto's printmaking community and thus acted as the personal link to the Chicago Society, which became an important international venue for many Canadians and something of a lodestar in their activities. We will pick up Cotton's career again in London and Toronto, later in this chapter.

Canadians in Paris, or the Art of Self-promotion

The European etching revival never suffered the sort of decline experienced by its American counterpart; rather it continued to expand and diversify, incorporating other print media. The system that promoted printmaking remained well in place in Europe, regardless of new traditions and changing practices. Painter-etchers with talent and ambition had only to use the system astutely in order to advance in their profession.

The arrival of three Canadians in Paris – Clarence Gagnon in 1904 and Frank and Caroline Armington in 1905 – sets the stage for a fascinating comparative study of how three young Canadian artists went about making their names (and their livelihoods) as part of the vital community of American artists residing in the French capital.[74] One of the first things **Clarence Gagnon (1881–1942)** did in Paris was join the American Art Association, a social club for art students and artists,[75] whose members included George C. Aid,

Herman A. Webster, and D.S. MacLaughlan.[76] Herman Webster also studied with Gagnon under Jean-Paul Laurens at the Académie Julian, and their genesis as painter-etchers may have been a shared experience. Both began to etch in late 1904, apparently under the tutelage of Donald Shaw MacLaughlan.[77]

Gagnon and Webster shared stylistic sources of inspiration (Whistler, Rembrandt, Appian, Meryon, and Lepère); in all probability they were examining the same prints in the Bibliothèque Nationale. They spent time together in 1906 at Pont-de-l'Arche.[78] There is no denying the similarity between the etchings the two artists made from 1904 to 1907 — one need only compare Webster's *Les Blanchisseuses* (fig. 65) with Gagnon's *Rue des Cordeliers, Dinan* (fig. 66). Gagnon's early etchings owe a technical debt to MacLaughlan, showing the same preference for the pure, bitten line (and avoiding the use of other techniques such as aquatint), the same careful choice of inks and paper, and the practice of drawing the subject directly on the plate without preliminary sketches.

Fig. 65
Herman Webster (1878–1970)
Les Blanchisseuses, Pont-de-l'Arche c. 1906
Etching
Taken from *Studio* 51:214 (Jan. 1911), p. 289

Fig. 66
Clarence Gagnon
Rue des Cordeliers, Dinan 1907–08
(cat. 41)

Fig. 67
Clarence Gagnon
Grand Canal, Venice 1905–06
(cat. 38)

Fig. 68
Clarence Gagnon
Canal San Pietro, Venice 1905–06
(cat. 40)

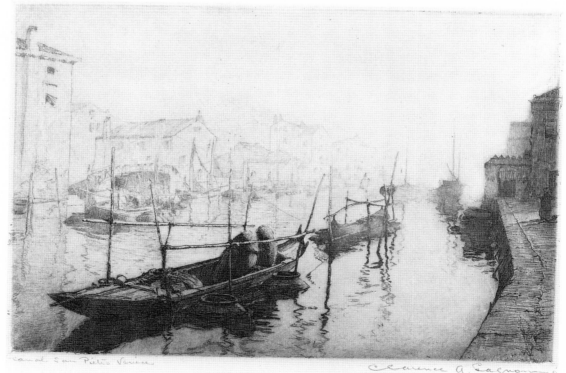

Fig. 69
Clarence Gagnon
En novembre 1904–05
(cat. 37)

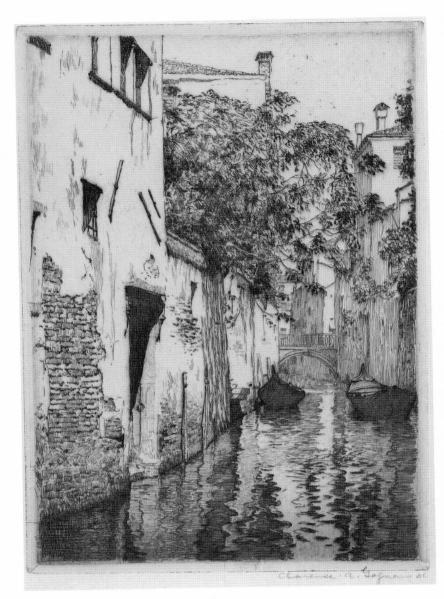

Fig. 70
Clarence Gagnon
Canal San Agostino, Venice
1905–06
(cat. 39)

Thus, Gagnon often worked from nature, or created composite images borrowing elements from postcards or photographs. For example, the dark water and its reflections in *Canal San Agostino, Venice* (fig. 70) was taken from one his own snapshots.[79] He also copied his teacher's practice of varnishing out large areas of the plate to achieve modulations in the intensity of bitten line – an effect most evident in the lightly etched central portion of *Canal San Pietro, Venice* (fig. 68).

Gagnon's work as an etcher was marked by an early maturity and a phenomenally rapid growth. In May 1905, he exhibited two startlingly accomplished prints – *En novembre* and *Luxembourg Gardens* – at the Salon de la Société des Artistes Français. The expressively drawn, richly inked *En novembre* (fig. 69) captures the cold and windy weather about which the artist complained in his letters from Pont-de-l'Arche in 1904. Begun soon after, in 1905, Gagnon's Venetian prints evince a stylistic transition from cleanly drawn renderings of fully sunlit views to tonally nuanced subjects, showing a growing interest in capturing the transitory light and shadows peculiar to that city's topography. With this change, clearly evident in *Grand Canal, Venice* (fig. 67), *Canal San Agostino, Venice* (fig. 70), and *Canal San Pietro, Venice* (fig. 68), comes a more nervous, brittle draughtsmanship, which will carry on to his next few prints. The common reversal of image among his Venetian subjects and the unfinished print of *Venice from the Lagoon* (fig. 71) confirm that Gagnon began most

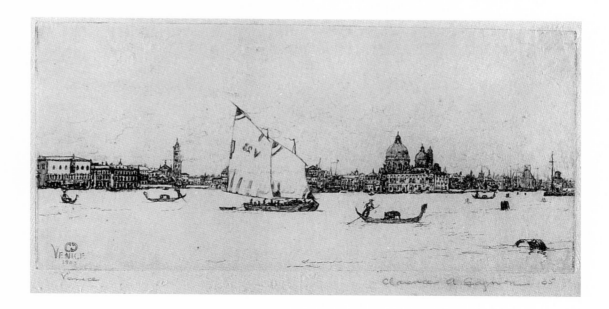

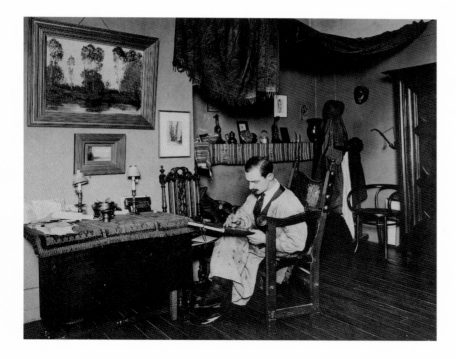

of these plates by roughing in the basic composition on the spot. Back in his Paris studio, he carefully built up the details, introducing a varied depth of etched lines through stopping out and multiple bitings; he then augmented and complemented the design by careful manipulation of plate tone.

Rushed for time, Gagnon was forced to exhibit the first Venetian prints in January 1906, before he felt they were ready, but quickly finished them to his satisfaction within a few months. Comparison of the impressions dated 1905 with those dated 1906 reveals that his "finishing" process entailed strengthening some of the lightly etched lines to bring the image into sharper focus, often losing the transitory light effects for which he was originally searching. A photograph of the artist in his studio (fig. 72) shows him working directly on his plates with a graver.

In 1907, a transformation occurred in Gagnon's etching that can be attributed to a rare and privileged experience with Rembrandt's etchings. Between December 1906 and January 1907, Gagnon assisted MacLaughlan in pulling a set of restrikes from the old master's own plates.[80] His windmill subjects – *L'orage* (fig. 73) for example – are clearly inspired by Rembrandt, but other works such as *Rue des Cordeliers* (fig. 66) and *Mont Saint-Michel* (fig. 74) show a new sensitivity to the expressive qualities of densely drawn etched line, a rich painterly method of inking, and a moodiness

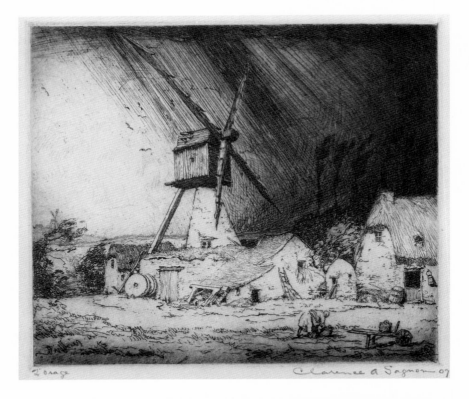

Fig. 73
Clarence Gagnon
L'orage 1907—08
(cat. 42)

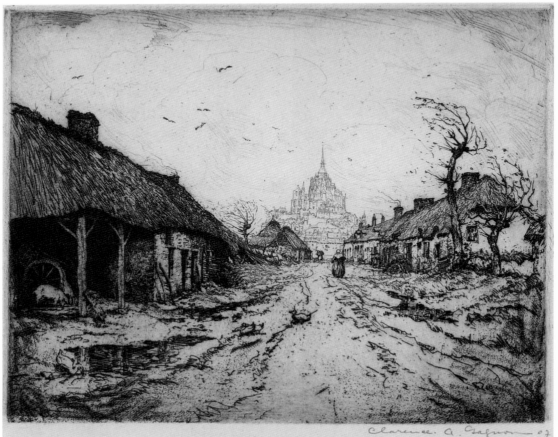

Fig. 74
Clarence Gagnon
Mont Saint-Michel 1907—08
(cat. 43)

or emotional quality now truly felt and not just observed. The many etchings of 1907 mark the zenith of Gagnon's committment to the medium. Nothing further was done until two prints were produced in 1910, and while they were very fine, they did not advance his work. There followed a seven-year hiatus, until 1917, when personal circumstances made Gagnon desperate for more income.[81] Trying two Canadian subjects, the artist realized that he had lost his touch with the etcher's stylus.[82]

The Armingtons first enrolled at the Académie de la Grande Chaumière, then moved on to the acclaimed Académie Julian. At these art schools catering to Anglo-American students printmaking was not taught, and so **Frank Armington (1876–1941)** turned to a fellow student Maurice Achener, who had begun to etch while studying art in Munich. Achener may have given Frank his first lessons in etching, but since he was the lesser artist his influence was limited.[83] The two seem to have possessed a mutual regard for MacLaughlan's style, particularly for his expansive yet centrally focused compositions. Armington's individuality was expressed through vigorously drawn lines, and

he brought a distinct moodiness to his depictions, being more interested in the impression of a subject than in its topographical accuracy. He had evidently been examining Whistler and Meryon, and absorbing their formulae and a degree of their intensity.[84] From the very start, Armington displayed a sure draughtsmanship, a sensitivity to textures, and a happy understanding of how to convey the effects of light and shadow with line drawing. He achieved these results through subtle manipulation of the technical aspects of the medium. Soon his etchings became rather monumental and romantic, as is evident in his German works of 1909. These were the images that captured the attention of the print world and brought him recognition, particularly in Britain.[85] Armington's debt to Whistler is evident in *Portal im Rathaushof, Rothenburg* (fig. 77); but the composition of *Albrecht Dürers Haus, Nürnberg* (fig. 78) appears to have been viewed through the distorting eye of Post-Impressionism.

Caroline Armington (1875–1939) took up the etching needle with her husband's encouragement. She made her first prints in August 1908 and gained a rapid mastery of the technique.

Fig. 75
Frank Armington, circa 1930
National Gallery of Canada Library

Fig. 76
Caroline Armington, circa 1930
National Gallery of Canada Library

Fig. 77
Frank Armington
Portal im Rathaushof, Rothenburg 1909
(cat. 7)

Her style also showed an affinity for compositions with a central focus, but her interest was in the literal depiction of the subject. This concern for topographical detail gave her prints an enormous appeal to her clientele. There should be no question as to Caroline Armington's genuine talent as a printmaker. She was at her best when her subjects were informal, with loose, free draughtsmanship giving her images the look of having been sketched rapidly and on the spot. This is the strength of *Ponte dei Sospiri, Venice* (fig. 80), a heroic etching for the artist. As long as she retained a spontaneous manner of drawing, as she did with the evocative *L'arc de triomphe, Saint-Jean-du-Doigt* (fig. 79), her prints achieved success. By 1917–18, however, she began to shift towards the highly finished scenes preferred by the "tourist trade." Her drawing style gradually stiffened as all the vivacity was drained away. This kind of work sold well and so there was little incentive to develop further or even "modernize" her style.

Once the craft of etching has been learned, the next step for ambitious artists is to promote

Fig. 78
Frank Armington
Albrecht Dürers Haus, Nürnberg
1909
(cat. 6)

Fig. 79
Caroline Armington
*L'arc de triomphe,
Saint-Jean-du-Doigt* 1915
(cat. 4)

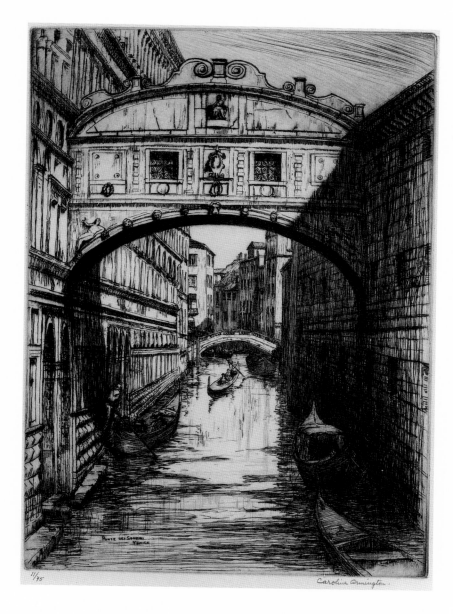

Fig. 80
Caroline Armington
Ponte dei Sospiri, Venice 1912
(cat. 3)

their prints and thereby build their reputations. In France, every artist longed to be accepted at the annual Spring or Autumn Salon. The Canadians understood that to achieve this kind of recognition abroad was sure to augment their prestige at home. Unfortunately, for the aspiring printmaker in Paris the possibility of being overlooked in these overcrowded exhibitions was even greater than for the painter. Clarence Gagnon's debut as an etcher went completely unnoticed at the May 1905 Salon de la Société des Artistes Français. Frank Armington was also ignored when he first showed his etchings at the 1907 Salon. In truth, prints were not exactly given pride of place at these venues: "At the Salon des Artistes Français the rooms allocated to etchers are nothing more than a corridor; at the Salon de la Société Nationale it's even worse, they are relegated to the ground floor behind the decorative arts, and nobody ever bothers to go there."[86]

To give his etchings greater visibility, Gagnon participated in a joint exhibition with Aid and Webster in the rooms of the American Art Association in January 1906. The results were nothing short of spectacular for the Canadian. Within a few days of the show's opening, he was approached by the *Gazette des Beaux-Arts* to publish a restrike of his *Vue de Rouen* to accompany Roger Marx's laudatory review in the March issue.[87] Gagnon thus benefited from the magazine's longstanding tradition of promoting etching. Certainly the exhibition had attracted positive notice in the Parisian press and had brought Gagnon to the attention of local collectors, but he was well aware that the publication of a restrike in this prestigious, internationally distributed magazine would vastly improve his standing. And he fully intended to capitalize on the situation: even before the issue was released, he was asking his Montreal dealer to raise the prices of his prints already in stock.[88] The *Revue de l'Art Ancien et Moderne* continued the momentum by singling out Gagnon's *Canal San Agostino, Venice* (cat. 39) for photographic illustration in their critique of the 1906 Spring Salon de la Société des Artistes Français, where his Venetian etchings received an honourable mention.[89] Further restrikes would be published in the *Gazette des*

Beaux-Arts in 1908 and 1913, to accompany reviews of each year's Salon.[90]

Publicity of this nature lent impetus to Gagnon's career, and by 1907 he had sold works to the Victoria and Albert Museum in London.[91] He was also in demand with dealers. To avoid locking himself into exclusive contracts, he would send batches of prints on consignment, and on these terms, secured dealers in Berlin, Munich, Dresden, London (John Lane, E.J. van Wisselingh, and Colnaghi), and Paris (Jacques Bramson, Henry Graves & Co., L'Art Décoratif).[92] Some of his etchings may have been sold through van Wisselingh's main dealership in Amsterdam as well. By 1909 he had added F. Keppel & Co. of New York to the list.[93] Dealers of such a high calibre could call the attention not just of collectors and curators to an artist, but also of critics. The London dealer John Lane was a publisher too, and he brought Gagnon's etchings to the notice of the collector and critic Thomas Simpson.[94] Thus Gagnon gained the distinction of being the only North American etcher to find his way into Simpson's *Modern Etchings and Their Collectors* (1919), an important investor's guide aimed at the fevered British market. Such publications and the assiduous care of his dealers would result in Gagnon pulling more impressions from his copper plates twenty years after they were first etched, and long after his career as a painter-etcher was, to all intents and purposes, over.

The Armingtons, meanwhile, were endeavouring on several different fronts to bring their works before the public. In 1908, Frank returned to the Salon de la Société des Artistes Français with sets of Parisian and Dutch etchings that garnered an honourable mention. Caroline displayed her earliest prints at this Salon. An exhibition of Frank's prints at the American Art Association followed. Response was slight and so in 1910, with Frank having completed a strong set of etchings on a trip to Nuremberg, Rothenburg, and Munich, they broadened their campaign. He exhibited at the Royal Society of Painter-Etchers and Engravers (RPE) in London, and they both were accepted at the Annual Autumn Exhibition of Modern Art at the Walker Art Gallery in Liverpool.[95] This was also the year that the

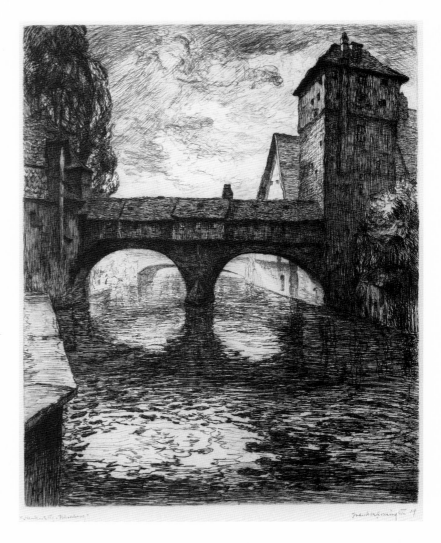

Fig. 81
Frank Armington
Henkersteg, Nürnberg 1909
(cat. 5)

Armingtons sent their etchings across the Atlantic in an effort to make their work known in Canada, with entries in the AAM spring show and at the CNE in Toronto. Gagnon's new Montreal dealer Johnson & Copping gave them an exhibition in November, sending it on to the Nova Scotia Museum of Fine Arts in December.[96]

While Frank and Caroline Armington showed their work at many of the same venues as Clarence Gagnon, their attitude toward printmakers' societies differed. Gagnon never joined these groups. The Armingtons, however, saw membership as offering distinct advantages and as a natural adjunct to their exhibiting activity. They sought entry in the growing number of French societies, and when similar associations began to spring to life in the United States, they were quick to submit their prints. Thus their etchings were seen at

the Chicago Society of Etchers beginning in 1912, and the New York Society of Etchers in 1914.[97] From then on, Frank and Caroline rarely missed an opportunity to show their work, albeit with a marked preference for Parisian and American exhibition venues.

Compared to their quick recognition of Gagnon, the art press was slow to acknowledge Frank Armington. The first notice of any consequence came in the January 1909 issue of the *Revue de l'Art Ancien et Moderne*, which focused on his Bruges etchings.[98] Following his election to the RPE, Armington was spotlighted in an article in the November 1910 issue of *Studio*;[99] and in 1912, the *Gazette des Beaux-Arts* accompanied a feature article on him with a restrike of *Königstrasse, Nürnberg* from 1910.[100] From a careful reading of the *Studio* article, one can deduce that its catalyst was the acquisition of Armington's work by the British Museum, the Victoria and Albert, and the Library of Congress in Washington.

The way the *Studio* article came about confirms a time-honoured perception in the art world: the correlation between the status of the institute that holds an artist's work and the status of the artist. For this reason, artists are anxious to see their works enter major collections early in their careers. Clarence Gagnon quickly managed to have his etchings purchased by public collections in Britain and Holland.[101] The Armingtons were not as lucky and so donated their prints, beginning in 1909 with gifts to the British Museum and the Victoria and Albert in London; thereafter to the Musée du Petit Palais and the Musée du Luxembourg in Paris, as well as to the New York Public Library. Consequently, after less then ten years at the etching press, the Armingtons could truthfully claim to be represented in all these collections. To be fair, outright purchases also transpired, among which were the original acquisitions by the Library of Congress and the ones made by the National Gallery of Canada in 1910 and 1911. However, the Armingtons adopted the practice of sweetening purchase deals with donations to ensure that public collections kept up-to-date with their artistic development, and so established and maintained their credentials throughout their productive years.

While the three Canadians would honestly present their efforts in printmaking as serious and high-minded endeavours, as conservative artists they were unable to disassociate the medium of etching from its firmly entrenched style and subject – picturesque views of old Europe (which, incidentally, sold well). Although living in the hub of the art world, they seemed oblivious to other trends – the waning of Post-Impressionism, the rise of Symbolism and Fauvism, indeed of the entire upheaval now called Modern Art – and clung to the tried and true conventions of the painter-etcher print. For the Armingtons, the reason was commercial: they were rapidly developing a market for their prints among the American community of residents and tourists centred around the American Church in Paris. For Gagnon, the reason was an unyielding ambition. For all three, there was little incentive to venture into the stormy seas of controversy; it was preferable to make their artistic reputation in calmer waters, where critics, collectors, and exhibition juries would be sympathetically predisposed to their work. And where better to measure up to the foremost in the field and start one's quest for the picturesque than in the city claimed by Whistler for all aspiring etchers – Venice. Gagnon's Venetian set not only launched his career, but it induced him to plan a program of trips in search of scenic subjects: to Heidelberg, Nuremberg, Belgium and Holland, even Spain and Tunisia. When the latter journey had to be postponed, Gagnon remarked: "I would like to have gone to some new places so that my work would present a greater variety. The more variety in your work, the more surprises in store for the people, and the more interesting your career is for those who watch it."[102] Of course, there was no shortage of charming locations in France to fall back on. These same sites were rendered on copper by dozens of artists of all nationalities, as a quick glimpse at any catalogue of etchings from this period shows. Other Canadians on this busy itinerary were the Armingtons, C.H. White, Dorothy Stevens, John Cotton, S.H. Maw, Herbert Raine, James Kerr-Lawson, and J.W. Morrice, to name just a few.

The failure to break the stranglehold of European pictorial conventions put our three artists in a quandary as to how to depict Canadian

subjects. Gagnon's case best illustrates the dilemma: steeped as he was in the European mode, he could not find the correct etcher's vocabulary for the Canadian picturesque and dared not risk alienating his market. After a visit to Canada in 1908–09, he wrote: "I would like to have done some of Quebec when I was there but the cities at home have so little character of their own, especially from an etcher's point of view, they would fail to arouse any interest in the art centres over here. It is only the national scenery of Canada, especially our Canadian winter, which interests them on this side...."[103] The Armingtons did rise to the challenge of depicting their homeland in etching in 1911, crossing the country on a commission from the Canadian Pacific Railway. These prints cannot be considered among their best work, and in the future they would stick with the old familiar European views, and the exotic settings of North Africa and the Middle East.[104]

One last aspect of the careers of the three expatriates that merits comment is the question of posthumous fame in their native land. Why is it that Clarence Gagnon enjoys continuing recognition in Canada as an outstanding painter-etcher while the Armingtons have fallen into near oblivion? The answer lies in the fact that Gagnon never lost sight of his home ground. During his years in France (1904–36), he returned to Canada several times for prolonged stays; and when abroad, he assiduously paid attention to exhibition and sales opportunities at home. He understood the importance of having a presence in Canadian collections, and took care to cultivate influential friends and use them as his eyes, ears, and agents in the home art community. For their part, the Armingtons went to great lengths to foster their standing principally in the United States and among Americans in France, and failed to do so in the country of their birth. Their sole effort to exhibit and sell in Canada was in 1910, and they never donated a single print to a Canadian institution. During their lifetime, only the National Gallery of Canada and the Art Gallery of Ontario possessed a sampling of their work. Certainly, their bitterness over customs duties was a factor in their staying away from Canadian exhibitions and dealers; but in the last analysis, the Armingtons were not interested in

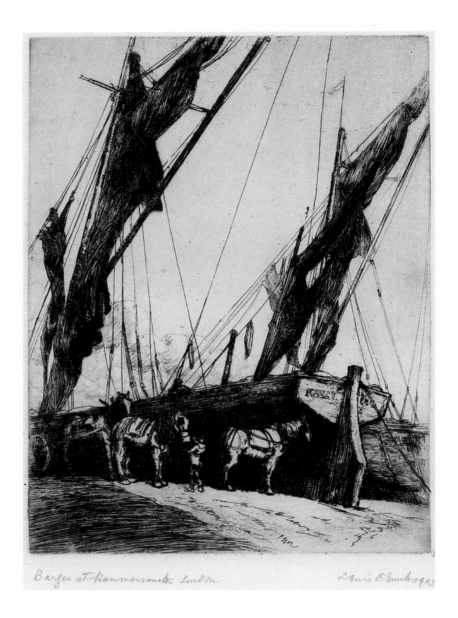

Barges at Hammersmith London Lewis E Smith

being trailblazers for Canada's etching revival. In Caroline's words: "It is very nice for Canada to have pioneers but they do not sell well enough to make a living."[105] The price they paid for not promoting themselves at home was to remain forgotten for almost fifty years after their deaths.

The Influence of Foreign Instruction on the Second Canadian Etching Revival

From the 1880s on, it was not unusual for Canadians to further their art studies in France and Britain, where opportunities abounded for would-be painter-etchers. It is worthwhile to follow a few aspirants through their education

Fig. 82
Lewis E. Smith
Barges at Hammersmith, London
1913
(cat. 102)

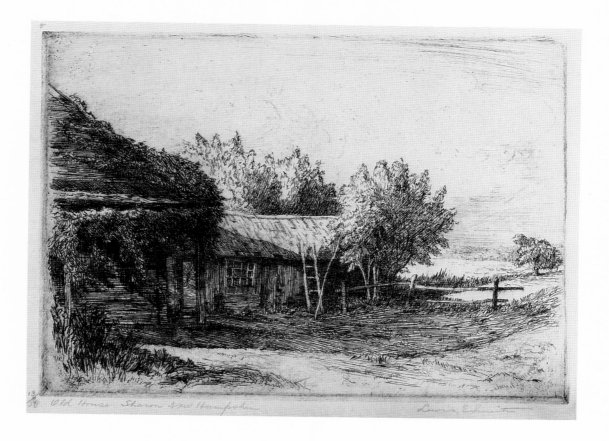

overseas, since they would become the teachers of the various print techniques at home, and thus set the stamp of their specific training on the second stage of the painter-etcher movement in Canada. As we have observed, in France printmaking was taught strictly through private instruction. It was not offered at the private academies or ateliers that modelled themselves on the methodology of the École des Beaux-Arts, placing the emphasis on drawing, painting, and sculpture. No other artistic milieu, however, offered young artists such exciting and varied approaches to printmaking. Perhaps due to their rather conservative art background, most of the Canadians who were drawn to printmaking in Paris selected etching as their medium.

Lewis Edward Smith (1871–1926) learned to etch from Frank Armington in 1910, while on a summerlong trip to Britain and France.[106] Having just been appointed principal of the Victoria School of Art and Design in Halifax, Smith wanted to study European teaching methods; and he evidently intended to revive the long dormant etching class and make it part of his school's curriculum. Surviving prints of this date indicate that Armington's instructions were rudimentary: he took Smith through the various intaglio techniques – from simple line etching and drypoint to soft-ground etching and aquatint – in perhaps as little as one or two printing sessions. Smith received further instruction while he worked as a graphic designer with the Carlton Studio in London from 1912 to 1914. He attended Ernest Jackson's lithography course at the London County Council Central School of Art, and studied etching under Luke Taylor, a Frank Short graduate. Smith's enhanced technical skill is ably demonstrated by *Barges at Hammersmith, London* (fig. 82). It would seem his membership in the short-lived Boston Society of Etchers gave him access to a press on which he produced four etchings, including his most ambitious print *Old House, Sharon, New Hampshire* (fig. 83).[107]

In 1909, **Dorothy Stevens (1888–1966)** left London after four years at the Slade School of Fine Art, to further her studies at the Académie de la Grande Chaumière and the Académie Colarossi

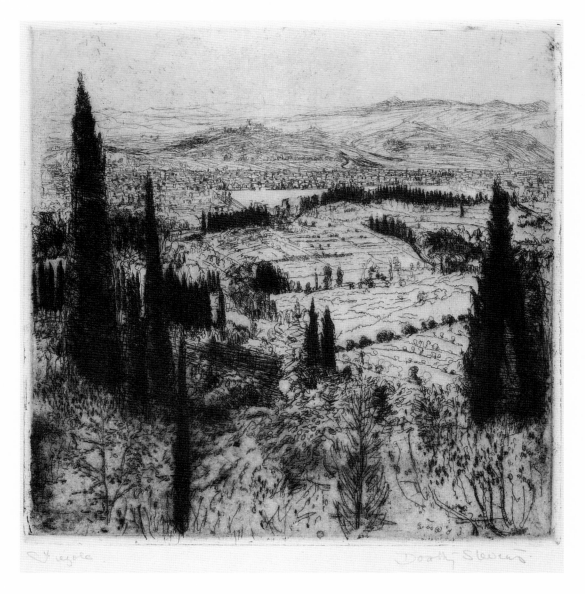

Fig. 84
Dorothy Stevens
Fiesole c. 1910
(cat. 106)

in Paris. There, etching captured her interest. We do not know who her teacher was, but we might speculate that she, too, found an instructor in her compatriot Frank Armington, whose apartment studio was next door to both art schools.[108] Stevens launched herself into the medium, showing such a quick grasp that her etchings were accepted at the Spring exhibitions of the Société des Artistes Français in 1910 and 1911. She made two visits to Florence in 1910–11:[109] Florentine views and figurative studies were among her first print subjects. The artist preferred to have her drawing on the copper plate convey all the effects she wanted; thus, she restricted herself to linear etching techniques and avoided almost entirely

painterly methods of printing, such as aquatint, that would further embellish the image. Consequently, the actual etching of the plate could be audacious, as for example, the densely etched lines that retroussage translated into dark evergreens in the print *Fiesole* (fig. 84). Upon her return to Toronto, she would immerse herself in the artistic community and – as practitioner and mentor – help rekindle the etching revival in her native land.

Printmaking was an integral part of the art school curriculum in Britain. The poor showing of British industrial design at the Great Exhibition in London had led to the creation in 1857 of the National Art Training School (associated with the South Kensington Museum) and various regional

art schools, to provide instruction with the accent on the applied arts. In 1864, an etching class under R.J. Lane was established at South Kensington, with some of the other state schools following suit. By 1900 classes in the various forms of printmaking were relatively commonplace in the larger institutions.[110] Sometimes outside students were given access to these classes, and in this manner S.H. Maw and Herbert Raine may have received training with the etcher's needle while studying architecture in London. Or a professional artist might sign up as a part-time student for the etching class only, which was the case for Cyril H. Barraud. Similarly, J.W. Beatty may have taken a couple of lessons at an unspecified school while living in London in 1906–08.[111]

In 1911, John Cotton left Chicago for London, hoping to study under Frank Short at the School of Engraving of the Royal College of Art (as the National Art Training School was known after 1896). Short was the most recent of a brilliant line of master printers to teach the etching class. Undoubtedly Britain's finest engraver, he was

expert at every intaglio technique. His was the premiere engraving school – and the paradigm. When its graduates went on to be instructors throughout Britain, they disseminated Short's methodology and thereby stamped British intaglio printmaking with its own recognizable style.

John Cotton was accepted into the School of Engraving but had to be content with one of the extra classes supervised by a protégé of Short.[112] The style of instruction Cotton received is significant, for he would bring it back to Toronto and teach it to others. Short's aim was to make his students master craftsmen:[113] they worked in every engraving technique, beginning with line etching and moving on to such variants as drypoint, softground etching, aquatint, and finally mezzotint. Here, Cotton learned the technique that enabled him to delineate his subjects as if drawn with a brush. Along the way, the students would learn about preparing the plates, the types of waxy ground to coat the plates, the strengths and types of acid baths. In whatever medium, each plate would be taken through a number of states (or

Fig. 85
John W. Cotton
Low Tide, St. Ives Harbour 1912
(cat. 19)

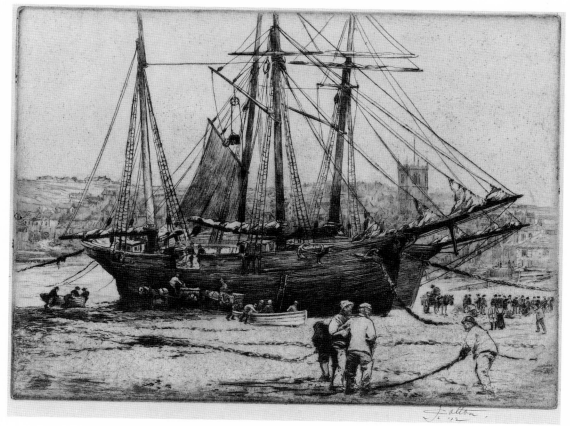

Fig. 86
H. Ivan Neilson, around 1887
Photo courtesy of the Neilson Family

stages) to completion, affording an opportunity to learn how to correct and add to the image. A crucial aspect of the instruction was understanding the different properties of paper types and printing inks, and how they interact. Assorted methods of inking and wiping the plates were tried, and the results examined after printing. Cotton was a conscientious student and within a year had thoroughly comprehended the intricacies of Short's methods. He may also have monitored some classes at W. Lee Hankey's new School of Colour Printing. Cotton's first colour print, *On Hampstead Heath*, was on view at the Royal Academy's 1912 summer exhibition, while he was visiting the artists' colony of St. Ives in Cornwall (see fig. 85).

Ernest Lumsden was another teacher of note whose ideas and techniques would enrich the Canadian etching movement. When Lumsden first considered taking up etching he was living in Reading, with no opportunities for instruction nearby, so he acquired a copy of Koehler's translation of Lalanne and taught himself. He found he had an aptitude for the medium, and it did not take long for the world to recognize his technical genius. His first prints were pulled in 1905, and by 1908, with his work already acclaimed, Lumsden assumed his duties as instructor of the etching class at the newly founded Edinburgh College of Art.

Henry Ivan Neilson (1865–1931), of a prominent Quebec City lineage, was a practising professional artist living in Scotland and one of Lumsden's first students. Neilson's exposure to major Scottish painter-etchers such as D.Y. Cameron and Muirhead Bone conceivably encouraged him to tackle the medium. In his eagerness, he purchased an etcher's box in 1908 equipped with all the paraphernalia he would need (see frontispiece).[114] The solid body of work he began after returning to his native Quebec City would bring him recognition as one of Canada's finest etchers. Neilson would also carry Lumsden's teachings to the École des Beaux-Arts in Quebec. The etching course he started there in 1921 was the first continuous printmaking class offered by a major Canadian art school. Lumsden's influence probably also reached Canada by agents other than Neilson. The architect James Crockart, a former student of Lumsden, could have transmitted his teachings to the members of the Arts Club in Montreal. When Lumsden published his own manual in 1925 – *The Art of Etching* – it replaced Koehler as the most accessible and instructive handbook for a new generation of etchers.

Canadian Involvement in the International Lithography Revival

Up until now, our prime focus has been on Canadian artists' involvement as etchers in the international printmaking scene. But what of lithography? Between 1895 and 1898, a series of large exhibitions were held in France, Germany, Britain, and the United States to mark the centennial of lithography's invention by Aloys Senefelder.[115] By celebrating the printing technique as an artistic medium these events would stimulate artists to push lithography to greater levels of creativity.

The medium had come a long way in the hundred years since its invention. Originally conceived as a means of printing musical scores, lithography was quickly adopted by the pictorial

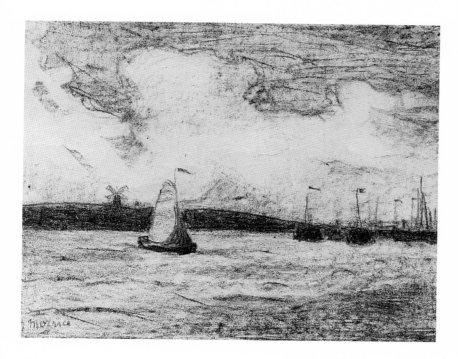

Fig. 87
James Wilson Morrice
Near Dordrecht 1898
(cat. 83)

printing trade. Its simple principle of reproducing drawings chemically fixed to a smooth-surfaced limestone meant that a lithographer was able to create the image on the stone faster than an engraver could, lowering the cost of publishing; lithographs could also be printed in apparently limitless numbers. From the start, lithography attracted artists of the stature of Benjamin West, Delacroix, Géricault, and Goya. By 1850, however, technical advances had made the printing process more complex, thus effectively excluding artists. The lithographic process became the domain of highly skilled technicians, who carefully guarded their fiefdom.

The situation began to improve for artists with the development of better transfer papers, which allowed them to draw their images for the stone without having to set foot in the print shop. This specially prepared papers let artists create their images in the studio or from nature, and if a mistake occurs, the sheet can be simply tossed away. The method has one drawback: the necessary roughness of transfer paper subtly robs the drawing of its sharpness of line and shading. The final result lacks the precision and immediacy one would find in an image drawn directly on the stone.

In the 1870s and 1880s, transfer lithographs became a fairly common artist's medium in

France. In Britain, Whistler adopted it, producing around 150 prints between 1887 and 1896. The 1887 exhibition in London of his Impressionist lithographs known as "Nocturnes," signals the moment lithography came into its own as an art form in England.[116] Whistler's promotion of the medium was complemented in France by the efforts of André Marty, whose *L'Estampe originale* (1893–95) contained sixty original artist's lithographs in each inexpensive issue, printed in an edition of a hundred. Marty sought out artists such as Bonnard, Puvis de Chavannes, and Toulouse-Lautrec to provide him with original lithographs for the publication, which has been described as the single most influential force in the lithography revival.[117] Despite the financial success of the venture, Marty discontinued it to pursue other publishing interests. The dealer Ambroise Vollard took up where André Marty left off, producing in 1896–97 limited edition albums of lithographs by a variety of artists. Following Vollard's preference most of the lithographs were in colour, and the results were mediocre. The edition planned for 1898 was abandoned, but Vollard did continue to publish individual portfolios by accomplished artists.

At this time and in this milieu, **James Wilson Morrice (1865–1924)** made his only known print, the transfer lithograph *Near Dordrecht* (fig. 87) of 1898. The affable and talented Canadian was becoming known in Paris, and as he was a Post-Impressionist, his work would have found favour with Vollard. Whether the dealer enticed Morrice to make this print for his aborted 1898 album is open to conjecture. If this were the case, it would help explain the isolated nature of the lithograph in Morrice's œuvre, as well as the fact that the only impression is on an inferior quality of paper, suggesting it is merely a proof.[118] Alternatively, it may have been done in emulation of Whistler, as this is the period when Whistler's art exerted the greatest influence on Morrice.

The first decade of the twentieth century was marred by controversy over the artistic validity of transfer lithography, and the medium was in need of the kind of support etching was able to elicit from critics and collectors. To put an end to this debate, artists would have to be seen to be more

directly involved with the printing process. But when artists did venture into the lithographer's shop they found the fees exorbitant; and it was not economically feasible for them to set up their own print studios, as etchers did. Not only were the press, stones, and other requisites prohibitively expensive, but an artist could not expect sales to recoup his costs. As far as lithography was concerned, the public expected to pay the same low prices for art prints as for other mass-produced images.

Among collectors, lithographs did not enjoy the inflated market values and cachet that etchings did. Nor did they have the same collector- and dealer-imposed controls (limited editions, artists' signatures, etc.) that could inspire public confidence in lithography as a genuine art form. The medium was in need of some formal body that could fix the rules and elevate it to the same realm of respectability as etching. The Senefelder Club, founded in 1908, was the answer. The Club evolved out of a short-lived periodical, *The Neolith*, four issues of which were released in 1907–08 by F. Ernest Jackson, the lithography teacher at London's Central School of Art. It featured illustrations by diverse artists including Gerald Spencer Pryse, Walter Sickert, George Clausen, Frank Brangwyn, and James Kerr-Lawson. When *The Neolith* folded, some of the contributing artists called a meeting in Kerr-Lawson's studio to explore the possibility of forming a lithographers' society.[119] Also in attendance were A.S. Hartrick, Jackson, and the irascible but energetic Joseph Pennell, who became the Club's first president and principal spokesman. The first order of business was to set up their own studio. It proved an economic disaster, and to keep things going they appointed F. Vincent Brooks, an already established lithographer, as their official printer. With regular and affordable access to a printer and press, the group was able to do away with transfer paper and experiment directly on the stone, exploring the medium's intrinsic properties and aesthetics.

To achieve the goal of raising the standards of lithography, influential print curators were made members of the Senefelder Club. Editions were limited to a maximum of fifty, after which the stone was to be defaced, preventing any

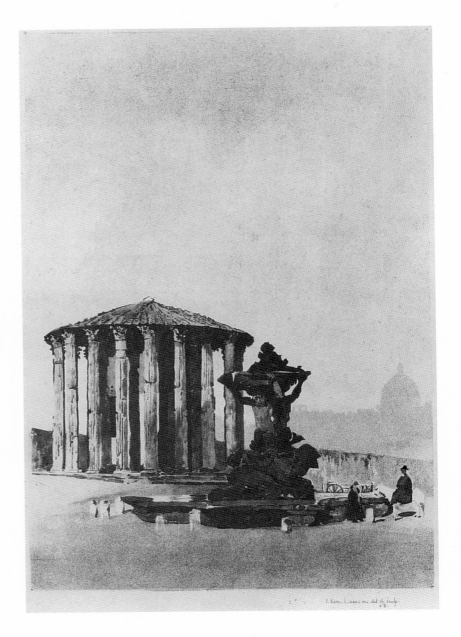

further impressions being pulled. The members signed each impression as proof of originality. The Club organized annual exhibitions that travelled within the U.K. and to Europe, the United States, India, Australia, and New Zealand. In 1912, prints by the members of the Senefelder Club were shown for the first time in Canada at the Canadian National Exhibition in Toronto; and in April 1920, at the Winnipeg Art Gallery.[120]

The lithographs comprising the "Italian Set" of **James Kerr-Lawson (1862–1939)** (see fig. 88 and 89) were created in 1908, making them among the first printed under the aegis of the

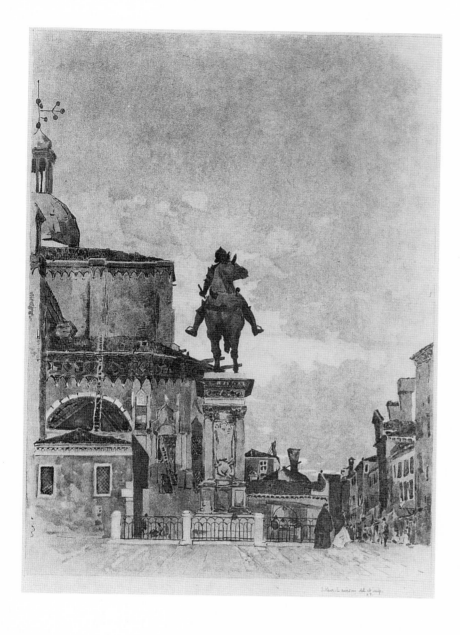

reviewing Senefelder Club shows, *Studio* magazine singled out Kerr-Lawson's abilities as a lithographer, also pointing out his originality in the use of liquid tusche.[122] All of his lithographs can be dated from 1908 to 1914, and while they were not many in number, they did exert an influence on the new lithography movement. From 1912 on, Kerr-Lawson's lithographs were well received at important Canadian print shows. They were the first true artist's lithographs seen in Canada and became the measure for subsequent Canadian lithography.

Fig. 89
James Kerr-Lawson
Il Colleone, Piazza Santi Giovanni e Paolo, Venice 1908
(cat. 62)

Senefelder Club. The delicate images – actually lithotints – drawn directly on the stone with brush and liquid tusche, showed how sensitively the medium could convey the transparency and immediacy of wash drawings. Greatly admired by print connoisseurs, the "Italian Set" gained Kerr-Lawson unprecedented attention. Malcolm Salaman appreciated the artist's mastery "of all the nuances of lithography," and Sir Frederick Wedmore observed that "Mr Whistler is probably the only artist of our time who has used the lithographic stone for wash drawings as significant and successful as those of Mr Kerr-Lawson."[121] While

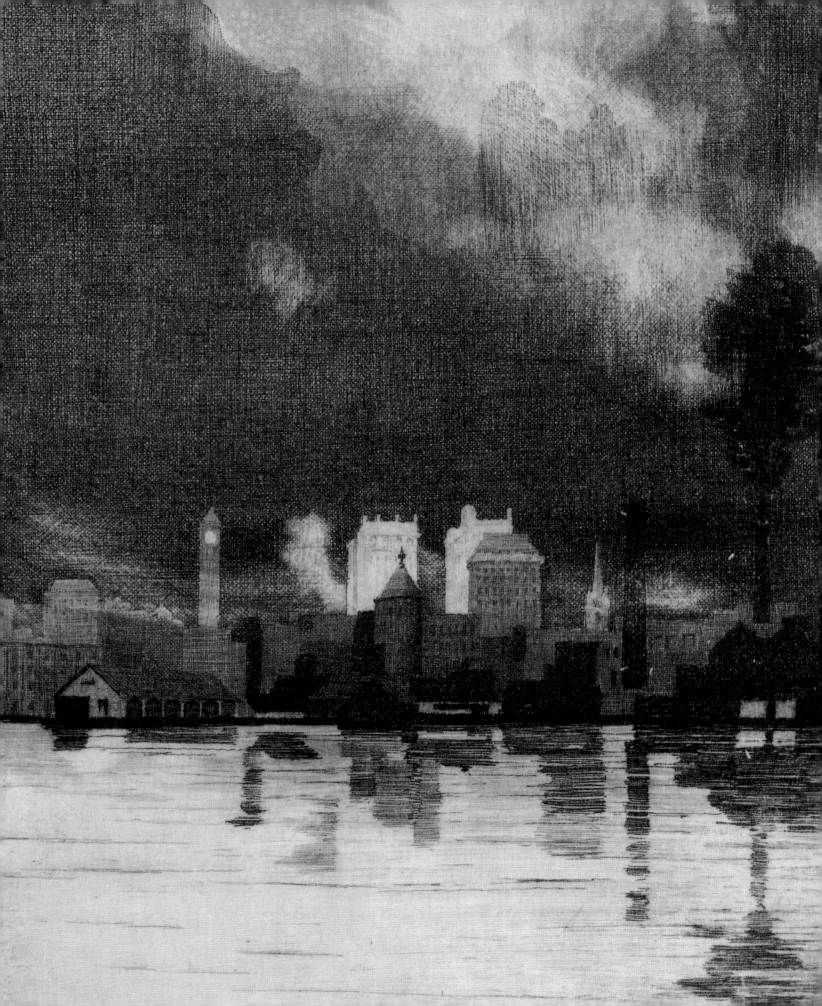

3 Erecting the Frame

The Artist's Print in Toronto, 1900–1917

AT THE DAWN of the twentieth century, the artist's print was enjoying robust health in Europe. In North America, however, printmaking was in the doldrums, with Canada continuing to take its cue from the United States. As the American print movement rallied, towards the close of the first decade, a new generation of Canadian artists embraced printmaking. Etching remained the medium of choice, and it was in the course of this second etching revival that the artist's print finally came into its own in Canadian art. Still lacking the kind of support from collectors, publishers, art institutions and societies that could be found elsewhere, Canadian artists learned to be more self-reliant and adaptive in a country which, even in its most settled areas, was culturally still at the pioneer stage.

Toronto proved, once again, to be the major centre for the renewal. This time, too, the artists who turned to printmaking were not the leading painters of the day, but tended to come from the ranks of illustrators who worked in the thriving commercial printing trade. This new generation of printmakers no longer counted amateurs among their ranks. The previous painter-etchers based in Canada had attempted to plant themselves in a most ambitious manner instantly and on unprepared ground. Their successors did the opposite, approaching printmaking with care and patient dedication. Since economic constraints such as the prohibitive customs duties had not changed, their progress had to be much more deliberate. They organized their own shows and found wealthier exhibiting bodies to take on the cost of importing prints for their exhibitions. Then they stayed by their presses, learning to etch and pulling their own small editions of prints.

In that era, Toronto would not have seemed to be a hospitable place for a print revival. The established art societies were in stasis, as if awaiting an injection of new life and spirit. Civic commitment to the arts was nonexistent. Resuming a decade-long debate, in January 1899 *Saturday Night* bewailed the city's cultural apathy and called for the establishment of a "public manifestation for our aesthetic life embodied in a permanent tangible form."[1] What was needed was a place for the artists and the public to learn about art through a reference library and exhibitions. The primary object of such an institution would be to collect local and international art. The magazine went on to warn of the imminent loss of two print collections, "which are doomed under existing circumstances to be scattered and annihilated as far as public service is concerned for the want of some responsible body to step in and secure them for the future."[2] In an attempt to rally civic pride, the writer concluded her plea with a challenge: "Montreal has an art gallery: why not Toronto?" Yet, while the article identified Toronto's cultural shortcomings, it did not take into account the existence of a relatively large and highly energetic community of artists who were willing to do something for themselves.

The Successors of the Toronto Art Students' League

By 1898 the Toronto Art Students' League had begun to fall upon difficult times. At its annual exhibition at the H.J. Matthews Gallery, a reviewer noted that "this League is in somewhat reduced condition as regards membership, owing to the free tuition offered by the OSA and the removal of several of its chief members over the [border]."[3] The next year, the TASL was forced to give up

its rooms at 75 Adelaide Street East and move to smaller quarters at 17 Jordan Street. From 1900 on, city directories no longer listed a street address for the TASL, and its scant membership could barely get up enough work for the last annual exhibition in 1901.[4] Its sole raison d'être seemed to be creating illustrations for the calendars. From 1902, the League's location became a mere postal address – the office of W.W. Alexander, then vice-president of Alexander & Cable Lithographing.

The spirit of the TASL did not die, however. It lived on in the restless younger artists who formed their own independent offshoot in 1898, the short-lived Little Billee Sketch Club, whose members included T.G. Greene, J.E.H. MacDonald, E.L. Laur, and Fred S. Haines.[5] In November 1899, these artists banded with other recent COSAD graduates to found the Mahlstick Club.[6] T.G. Greene, a talented young illustrator, was elected president, and its first annual members only exhibition was held in May 1900.[7] An invitation to this event was addressed "From ye younge boyes to ye olde boyes," suggesting a warm welcome to the remaining adherents of the dwindling TASL. The invitation was apparently accepted: over the next years, works by David F. Thompson

and C.W. Jefferys appeared in the Mahlstick Club's annual exhibitions, while the membership of W.W. Alexander and Walter R. Duff can be confirmed by a photograph (fig. 90). J.W. Beatty was also said to be member.[8] In a sort of reciprocity, Mahlstick Club members provided the only illustrations for the final TASL calendar of 1904.

The Mahlstick Club took up residence in the TASL's vacated premises at 75 Adelaide East,[9] where the Club's three annual exhibitions were held. A TASL tradition they preserved was that of a club within a club, whereby members made at least one drawing daily, which they dutifully inscribed with the initials N.D.S.L. (*Nulla dies sine linea*, or no day without a line.) But whereas the TASL had set about to be a teaching body for both men and women, the Mahlstick Club was

Fig. 90
The Mahlstick Club, between 1899 and 1902
Colgate Papers, Ontario Archives, Toronto
Key: 1. Fergus Kyle, 2. E.L. Laur, 3. Fred Haines, 4. Norman Price, 5. W.W. Alexander, 6. Walter R. Duff, 7. D.I Brown, 8. T.W. MacLean, 9. A.A. Martin, 10. Neil McKechnie, 11. Victor Darling, 12. Edgar McGuire, 13. Bert Sloan, 14. Louis Meyer, 15. G. Dawson, 16. Arthur Goode, 17. T.G. Greene, 18. C.M. Manly, 19. A.H. Robson

Fig. 91
John Innes (1863–1941)
Roped 1900
Etching, 25.1 × 35 cm (plate)
National Archives of Canada, Ottawa,
Recor Collection (C–142671)

for men only, and saw itself as a place where practising artists could pool their resources to pay for studio space and models. They would meet several evenings a week, often for purely social reasons. No restrictions were placed on the medium or subject matter of work for display at their exhibitions. The Club's character was manifest in the freshness and vitality of these shows. No doubt, their "haphazard and free-and-easy" tone was a welcome relief from the "solemn and austere functions" put on by the more established artists' societies.[10]

Fig. 92
An early meeting of the Graphic Arts Club, circa 1903/04
Standing, left to right: J.W. Beatty, Walter R. Duff, T.W. MacLean
Seated, left to right: Neil McKechnie, W.W. Alexander, F.H. Brigden, C.W. Jefferys
Colgate Papers, Ontario Archives, Toronto

No reviews of Mahlstick Club exhibitions mention etching or any other form of printmaking as a medium practised by members, despite the involvement of many in the printing industry. Nonetheless, the existence of a portfolio of etchings made by John Innes in 1900 (see fig. 91) implies that printmaking was not an alien concept in that milieu. Innes, a commercial illustrator who had once worked as a cowboy at High River near Calgary, moved in the same professional circles as Mahlstick Club members and could well have belonged himself.[11] His witty use of remarques (Innes' little marginal illustrations were guns, spurs, and branding irons, playing on cowboy subject matter) suggests a knowledge of the more sophisticated use of the device among contemporary French and British painter-etchers. But the rather severe printing and a minimal use of painterly tone implies that Innes had called on the services of a professional plate printer in Toronto. In other words, in Innes' case, there is no evidence of creative collaboration around the press with other artists.

The Graphic Arts Club

In September 1902, T.G. Greene left Toronto for London, England, to establish his own advertising firm, the Carlton Studio. He took along fellow Mahlstick Club members A.A. Martin and Norman Price; the next year, J.E.H. MacDonald joined them.[12] As a result, the Mahlstick Club lost not only its most talented members but also, it would appear, its most active organizers. Not surprisingly, after the Club held a final exhibition in May 1903, it quietly faded away. In its place was born the Graphic Arts Club (GAC), a formal blending of the TASL and the Mahlstick Club.[13]

The first meeting of the GAC in November 1903 saw C.W. Jefferys elected president;[14] J.D. Kelly, vice-president, while W.W. Alexander became secretary-treasurer.[15] The list of officers, all former TASL members, suggests that the new club valued experience and stability, signalling a more serious purpose than had been found at the Mahlstick Club. The contributors to the GAC's initial exhibition, held in its rooms in May 1904, comprised members of both earlier societies along with some new names – Owen Staples for one.[16]

Although no women participated in the first shows, their presence, possibly as early as 1907, does indicate that the door was open to them.[17]

In 1904–05, the Graphic Arts Club rented rooms at 37 Melinda Street. In late 1905, J.D. Kelly became its president, Alexander its vice-president, and T.G. Greene, treasurer. The city directory for 1906 lists the GAC at 36½ King Street East, above a restaurant, in the building that housed J.W. Beatty's studio. The Club began to extend membership to important newspapermen and writers, such as Newton MacTavish, editor of the *Canadian Magazine*, and Augustus Bridle, who would become editor of the *Canadian Courier*.[18] These members gave the GAC more than just access to publications, they were an influential voice within the cultural community. The Club now described itself as "A society of artists and literary men interested in the graphic arts largely as a medium for the characteristic illustration of Canadian life and the Canadian country."[19] This synergy of artists and writers also spawned the Arts and Letters Club in 1908, the year that the GAC moved into two rooms at 70 Victoria Street.[20] Now under the presidency of Alexander, the GAC's activities were settled: "The Club meets every Saturday night for composition sketches and discussions of art matters. An annual exhibition of paintings and sketches in colour, black and white, etc."[21] In 1909, Robert Holmes

Fig. 94
Owen Staples
Self-portrait 1906
(cat. 104)

took over the presidency. Former TASL president, recent member of the OSA, and associate of the RCA, Holmes' credentials could only lend weight to the influence of the GAC.

The Graphic Arts Club and the Reintroduction of Etching

Because the GAC's artist members were primarily illustrators, the majority of their work was confined to drawing and watercolour. Whatever oil painting they did was exhibited at the more traditional art societies. Around 1906, however, a few

Fig. 95
T.G. Greene
The Card Players, state I/II
c. 1908–10
(cat. 44)

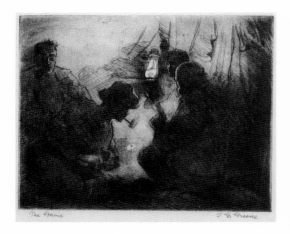

Fig. 93
T.G. Greene
The Card Players, state II/II c. 1908–10
(cat. 45)

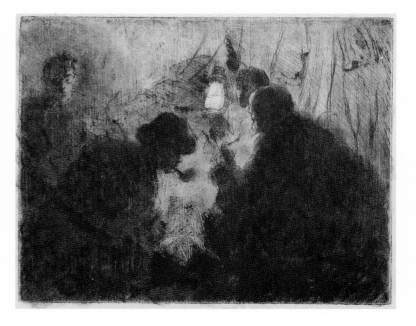

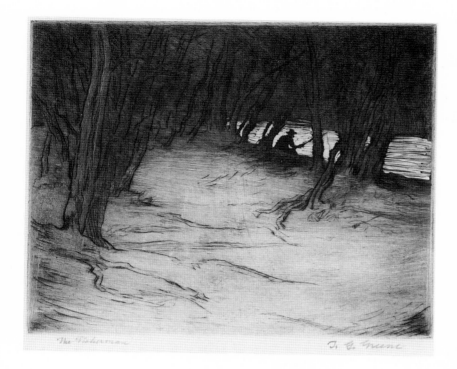

Fig. 96
T.G. Greene
The Fisherman c. 1911
(cat. 46)

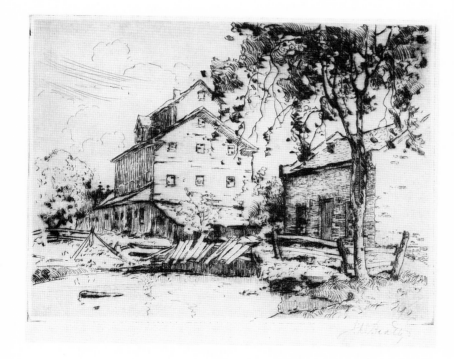

Fig. 97
J.W. Beatty
The Mill, Meadowvale 1908–09
(cat. 16)

of them began to take up printmaking. That year, **Owen Staples (1867–1949)**, principal artist on the staff of the *Toronto Telegram*, etched a charming self-portrait (fig. 94) which he used as his Christmas card and sent to his employer, the antiquarian and print collector John Ross Robertson. The presence of foul biting shows that he was inexperienced with the use of acids.[22] Lack of confidence in this area is also demonstrated in the prints made by T.G. Greene and J.W. Beatty in 1908. The fact that both artists began printmaking at the same time and worked exclusively in drypoint raises the possibility that they worked together. **Thomas Garland Greene (1875–1955)** quickly understood the subtle nuances plate tone could give, and in *The Card Players* (fig. 93 and 95) began to experiment. Subsequent drypoints such as *The Fisherman* (fig. 96) show Greene's printing ability at its best; his aesthetic approach to printmaking was consistent with his real love – watercolour. **John William Beatty (1869–1941)** made about a dozen drypoints of European and local subjects from 1908 to 1909. *The Mill, Meadowvale* (fig. 97) and *St. Patrick's Market* (fig. 98) are two of the most accomplished, executed in a post-Whistlerian manner, similar in style to Joseph Pennell. Beatty's use of drypoint suggests the influence of Greene and above all William J. Thomson. Perhaps Thomson, ACE alumnus and apparent new member of the GAC, kindled this interest in printmaking and even dictated the medium, to which he had become

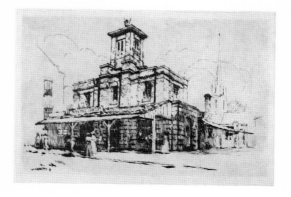

Fig. 98
J.W. Beatty
St. Patrick's Market 1909
(cat. 17)

partial.[23] **Edgar Lee Laur (1867–1943)**[24] may also have been a student of Thomson's. His *Evening* (fig. 99) of 1908 is a mezzotint, a technique not requiring the use of acids, which Thomson is known to have taught. The photographic quality of *Evening* calls to mind Laur's work at the Merchant Portrait Company; the print has the appearance of a charcoal drawing based on a photograph. However, the precision of the imagery is stylistically similar to the American Realism of Thomas Eakins, as brought to Canada by George Reid, Laur's teacher. *The River* (fig. 100) of 1913–14 is more impressionistic in style. From his earliest attempts, Laur demonstrated a high degree of technical proficiency with intaglio printmaking, outdistancing his GAC confreres. He was the best practitioner of mezzotint up to about 1920, after which time he branched into etching, aquatint, and drypoint, always retaining a preference for moonlight landscapes and rivers as his subjects.

The earliest of these prints reveal that the artists were trying to create their etchings "blind" – that is, without benefit of a public collection of painter-etcher prints to examine first-hand. Other means to study the aesthetics of printmaking were quickly found. Sir Edmund Walker, president of the Canadian Bank of Commerce and a discerning print collector, was beginning to develop the Canadian content of his collection by purchasing the work of Gagnon and Thomson,[25] and he was known to be generous in allowing artists access to his prints.[26] Moreover, the GAC had a subscription to the British art periodical *Studio*, a source of information on current trends in printmaking, with articles on the foremost etchers.[27] *Studio* also carried articles on techniques: Frank Newbolt's "The Art of Printing Etchings"[28] went into a standard explanation of materials and methods, with illustrations showing different effects of painterly printing, that is, the use of plate tone and retroussage. Greene's prints, particularly the various states of *The Card Players* (cat. 44 and 45), hint at his experimenting along the lines of Newbolt's article.

In response to this interest in printmaking, the Graphic Arts Club may have purchased an etching press as early as 1910,[29] which would account for the increase in etching activity by Greene, Beatty, Thomson, Laur, and Staples, who

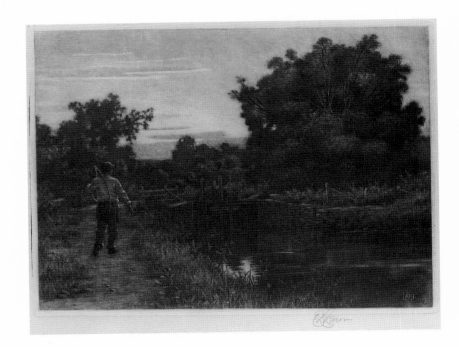

Fig. 99
E.L. Laur
Evening 1908
(cat. 63)

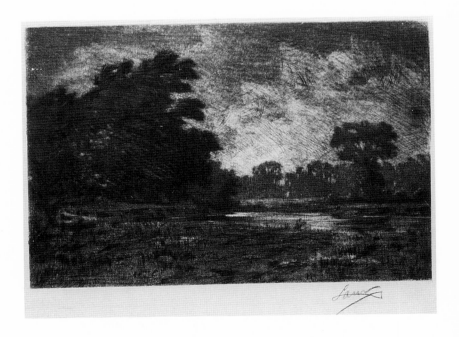

Fig. 100
E.L. Laur
The River c. 1913–14
(cat. 64)

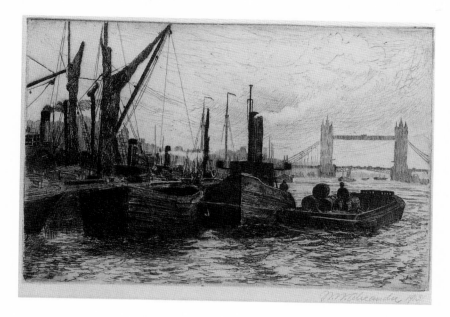

Fig. 101
W.W. Alexander
Thames Traffic 1913
(cat. 1)

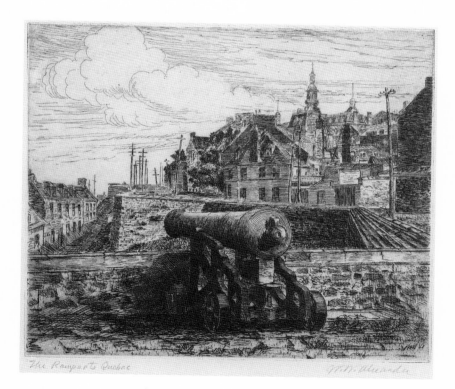

Fig. 102
W.W. Alexander
The Ramparts, Quebec c. 1914
(cat. 2)

were joined by Duff and Alexander. The first etchings made by **William Walker Alexander (1869–1948)** in 1911 were Québec subjects; an elementary understanding of the painterly use of plate tone is evident, but knowledge of the cuisine of etching is lacking. Alexander was a skilled lithographer, with his own printing business; however, he needed experience with the subtleties of artistic etching.

The arrival of the European-trained painter-etchers Dorothy Stevens in late 1911 and John Cotton in 1912 brought the Toronto community of artists first-rate printmakers and instructors. The impact of their presence can be perceived in Alexander's subsequent etchings. *Thames Traffic* (fig. 101) of 1913 shows a measurable increase in his grasp of technique, and it soon became something of a talisman for the artist: he reproduced the image for a Christmas card and as an illustration for an Alexander & Cable advertising brochure.[30] The solid, clear, detailed composition suggests a source other than a drawing, possibly a photograph. *Thames Traffic* was one of the most proficient etchings done at the time in Toronto. *The Ramparts, Quebec* (fig. 102) is another strong print, whose composition was perhaps gleaned from drawings made on TASL sketching trips.[31] Unhappily, few of Alexander's etchings attained the level of *Thames Traffic*, and the medium remained little more than a hobby for him. Even experienced artists fell under the influence of Stevens and Cotton: the vigour and boldness of Thomson's *Fisherman's Harvest, Vancouver* (fig. 104) owes much to Cotton's prints, as demonstrated by *Fish Market, Bruges* (fig. 103). The newcomers energized the little group at the GAC, encouraging others such as J.E.H. MacDonald to take up the etcher's needle. By mid-1912, Toronto could count upon a solid band of artists committed to making and promoting the artist's print.

John Cotton's work grew in maturity during these Toronto years. *The Lime Kiln* (fig. 105) confirms his solid grasp of standard etching: subject, draughtsmanship, and printing style have been successfully married. *Beeches, Epping Forest* (fig. 106) is perhaps his masterpiece, testifying to the artist's ease in handling the technically complicated process whereby two or three separate plates are used to

Fig. 103
John Cotton
Fish Market, Bruges 1915
Etching, 13.8 × 20.4 cm (plate)
National Gallery of Canada (1130)

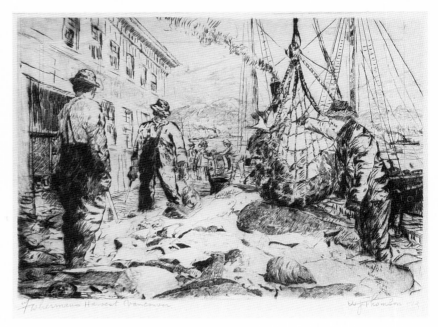

Fig. 104
William J. Thomson
Fisherman's Harvest, Vancouver
1913
(cat. 116)

create richly coloured aquatints. The subtle print-ing and multiple biting of *Beeches* have created a work of art that replicates the watercolour's soft brushwork and layers of transparent wash. Cotton had clearly learned some of the wizardry Short had invented, including the employment of photo-sensitized ground to receive the image of a chalk wash drawing.[32] The "out of focus" effect of some of the drawing may have been achieved using this technique.

Frederick Stanley Haines (1879–1960) was apparently John Cotton's faithful disciple. Shortly after returning from his studies at Antwerp's Académie Royale des Beaux-Arts in 1914, Haines began printmaking and travelled the same route as Cotton in mastering one technique at a time – from etching to soft-ground etching, to aquatint, and finally to colour aquatint. By 1919, with *The Old Beech* (fig. 109), Haines had become highly skilled at aquatint and was ready to add the final nuances of colour. In *Indian Summer* (fig. 107) and *Dawn* (fig. 108), Haines created two stylisti-cally varied colour aquatints: one emulating Impressionist brushwork, the other evolving out of *art nouveau's* sinuous line. Both prints were influenced by the Group of Seven, with whom he was now associated through his cousin Frank Carmichael. Yet, his real source of inspiration was Japanese prints, and he had been allowed to study Sir Edmund Walker's private collection.

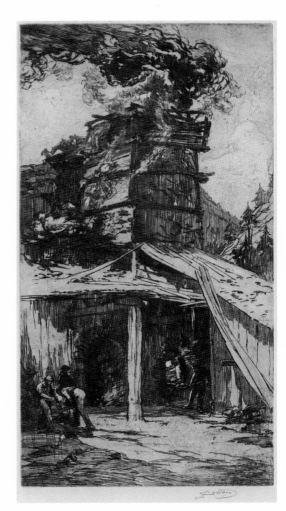

Fig. 105
John W. Cotton
The Lime Kiln 1915
(cat. 21)

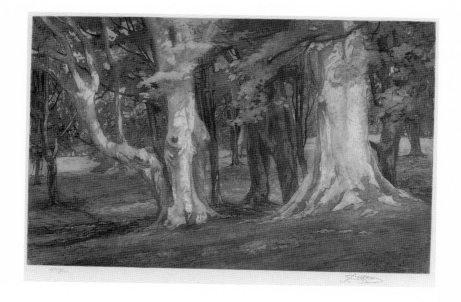

Fig. 106
John W. Cotton
Beeches, Epping Forest 1915
(cat. 20)

Fig. 108
Fred S. Haines
Dawn c. 1920
(cat. 48)

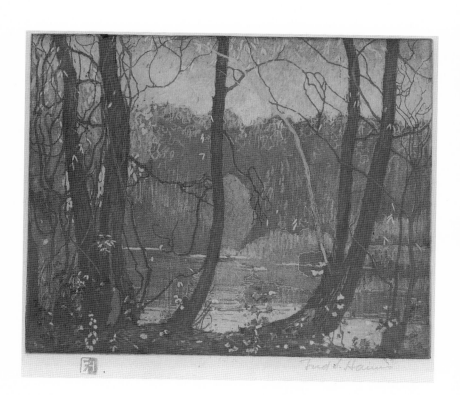

Fig. 107
Fred S. Haines
Indian Summer c. 1920
(cat. 49)

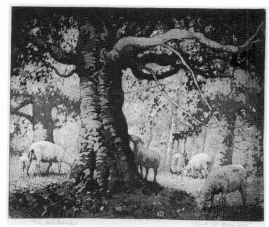

Fig. 109
Fred S. Haines
The Old Beech c. 1919
(cat. 47)

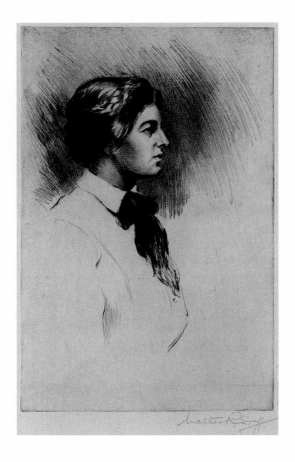

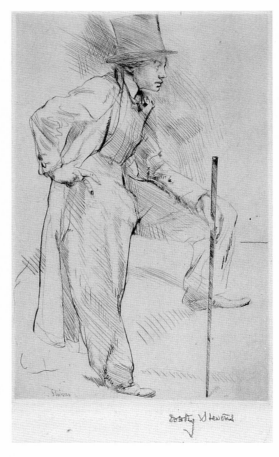

In emulation of the Japanese printmakers, Haines adopted the use of a stamp.

While **Walter Raymond Duff (1879–1967)**, a commercial artist and protégé of Dorothy Stevens, created etched landscapes and architectural subjects, his importance as a printmaker rests with his portraits. Etched portraiture was not a particularly rewarding branch of the art to follow. It required a very high level of draughtsmanship and perception. The face can only be rendered in line, which, unlike painting or drawing, cannot be easily corrected if errors are made. Nor would there be a market for such prints beyond the sitter's friends and family. However, Duff and Dorothy Stevens must be credited with effectively establishing the genre in Canadian art. Duff's practice was to meticulously develop his subjects through careful attention to the topography of the face. For formal portraits, he preferred to proceed from drawings or photographs: *Miss Florence Wyle* (fig. 110) could have either as its source.[33]

In figurative and portrait studies such as *The Gamine* (fig. 111), Dorothy Stevens was able to display her Slade drawing techniques, effortlessly capturing the pose and character of her subject with a few expertly drawn lines scratched directly on the prepared plate. She also enjoyed recording the neighborhood around her downtown Toronto studio, for example in *King and Yonge Streets* (cat. 109). A high point in Stevens' career as a painter-etcher came at the 1915 Panama-Pacific International Exposition in San Francisco: the nineteen etchings she exhibited there (including cat. 106–108) won her the silver medal.[34]

The Graphic Arts Club and the Canadian National Exhibition

The presentation and promotion of prints was a critical item on the Graphic Arts Club agenda. Given the past bleak history of print exhibitions in Canada, one may be surprised to find the sudden burst of venues in 1912. However, on close

inspection it becomes evident that the GAC must take much of the credit, having carefully laid the groundwork for exposing the public to this still relatively new art form in Canada. Unquestionably, the calibre of Stevens and Cotton's work, coupled with the appearance of etchings by Gagnon and the Armingtons in Toronto, lent validity to their efforts.

Four exhibitions organized by the GAC are documented: the first in May 1904, one held in March 1905,[35] another in December 1907,[36] and one known only from an undated poster (see fig. 112). A fifth show was sponsored by its sister organization, the Arts and Letters Club, in March 1910.[37] There is no indication prints were on display in any of these instances. The GAC concentrated its exhibiting activities on the Canadian National Exhibition (CNE), the annual fair held in late summer in Toronto. An art show had long been an integral part of this event. A committee oversaw the art component, and a new Fine Arts

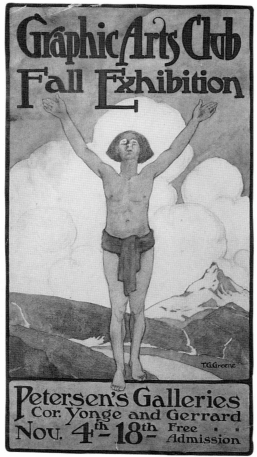

gallery was opened on the CNE grounds in 1903. The old gallery became the domain for a variety of "minor" or applied arts exhibits, including commercial printing. In March 1907, a subcommittee was struck to study the revision of this section, with instructions to consult with the GAC.[38] No record remains of their recommendations, but we may presume that the GAC proposed an upgrade. Gone would be the displays of factory work and specimens of commercial printing technology; in their place would be applied art in keeping with design work coming out of the arts and crafts movement and graphic art as practised by professional illustrators. The GAC was given its own gallery space within the Applied Arts Building in 1908.[39]

At the 22 February 1909 meeting of the Art Committee, the GAC was put in charge of the graphic art section for that year, with funds to pay for their expenses; C.W. Jefferys and A.H. Robson were appointed the organizers. The display, in the refurbished old gallery, was greeted with enthusiasm.[40] It included the works of Club members, that of several prominent contemporary American illustrators, and a British illustrator. Although no prints were shown, the scope of the presentation – with its international element – heralded a new direction for applied arts at the CNE and a new status for the graphic arts.

The CNE Art Committee decided to include a British component in its next exhibit.[41] Committee member A.H. Robson, also a GAC member, was named the convenor for the displays in the Applied Arts Building, and apparently he asked W.W. Alexander to travel to Europe to select the work. The "British" work chosen included etchings by Joseph Pennell, Caroline Armington, Frank Armington (cat. 5 and 7), and Clarence Gagnon; evidently Alexander made a special trip to Paris to look up the Armingtons.[42] In the Canadian section were prints by T.G. Greene (cat. 44), W.J. Thomson, and Owen Staples, whose *Steel Construction* (fig. 113), a striking print, derived from his work at the *Toronto Telegram*.[43]

The work the Graphic Arts Club did for the CNE in 1910 overreached their previous effort: they provided a sizeable graphic art section of 131 objects and assisted in gathering a large

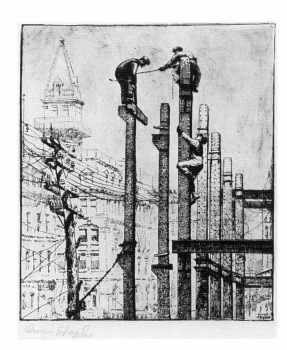

Fig. 113
Owen Staples
Steel Construction 1910
(cat. 105)

Canadian and British applied art and architectural section of over 300 items. A catalogue was published, likely at CNE expense. This 1910 display in the CNE's Applied Arts building was the firmest validation to date in Toronto for the graphic arts as a serious art form.

For the 1911 exhibition, $300 was allocated to the GAC to organize a display similar in scope to the previous year's. Also in 1911, the GAC made a bid for permanent representation on the Art Committee, nominating Alexander and Robson, with another member serving as secretary; but it is not clear if they succeeded.[44] However, the GAC appointed Alexander and Robson, along with the dynamic newcomer Arthur Lismer, to its own committee of management to oversee their CNE effort.[45] For the first time, the CNE management decided to include prints among its annual purchases. Granted, it was only one etching, *Entrance to Henry VII Chapel* by Joseph Pennell, but it signalled the start of a long history of CNE patronage for prints.[46] No catalogue of the display was published in 1911, and the graphic art section was only referred to in a small note at the beginning of the CNE's fine arts catalogue. Fortunately, the Arts and Letters Club published a review in their magazine *The Lamps*, as did the *Canadian Courier*; they described the display as the largest ever, featuring

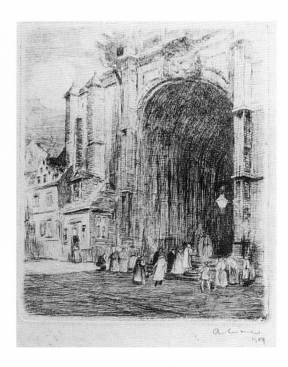

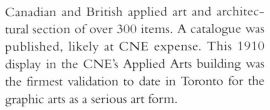

Fig. 115
Arthur Lismer
The Cathedral Door (Entrance to St-Jacques Cathedral, Antwerp)
1909
Etching, 17.3 × 13.9 cm (plate)
McMichael Canadian Collection, Kleinburg, Ont. (1981.196A)
Gift of Marjorie Lismer Bridges

Fig. 114
Arthur Lismer, in about 1911–12
McMichael Canadian Collection Archives, Kleinburg, Ont.
Gift of Marjorie Lismer Bridges

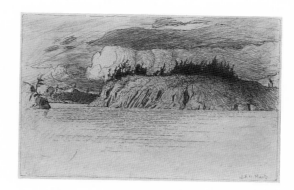

was also being given greater control over the content of the displays, which they would retain exclusively until the formation of the Society of Canadian Painter-Etchers in 1918. In the summer of 1912, the GAC mounted its most ambitious exhibition ever; and a graphic arts catalogue was published along with the painting and watercolour catalogue. It lists almost 500 items, with an astonishing representation from some of Britain's most avant-garde print societies – the Senefelder Club, the Society of Graver Printers in Colour, and W. Lee Hankey's School of Colour Printing at Hammersmith. A section devoted to "Etching, British and Foreign" included prints by both Armingtons and John Cotton. Still in England, Cotton had just completed his studies at the School of Engraving. Given his interest in colour prints, one must consider that he played a role in inviting British participation in this medium. Among the Canadian etchers were Alexander, Duff, Charles W. Simpson of Montreal, Stevens, Thomson, W.J. Wood, and Arthur Lismer, whose *The Cathedral Door* (fig. 115) was possibly included. Lismer's only known etching, it is best described as a tentative effort.[52]

James Edward Hervey MacDonald (1873–1932), a GAC member since 1907,[53] was just back from a trip with Lawren Harris to Dr James MacCallum's cottage on Georgian Bay. Unable to complete the first etchings he was developing based on his summer sketches in time for the CNE, MacDonald submitted three transfer drawings which he described as "studies for etchings" (see fig. 116). The finished prints, *Thunder Cloud, Georgian Bay* (fig. 117) and *A Georgian Bay Island* (fig. 118), followed after the show. Between 1912 and 1913, he created at least nine etchings, with *Autumn Weather, La Tuque, Laurentians* (fig. 119), derived from an October 1913 sketching trip, being one of the last and most impressive. With all his etchings, the artist eschewed the standard aesthetics of the medium and adopted the more vigorous line and mood of his current paintings, which we now identify with the Group of Seven's "revolutionary" style. The rugged energy of these prints is attractive to late twentieth-century eyes, but in their day, the style may have been off-putting to etching aficionados.[54]

work in black and white by American, British, and Canadian illustrators, with loans coming from such publications as *Harper's*, *Punch*, and *The Graphic*.[47] Once again, the prints of Pennell, Gagnon, and the Armingtons were included – possibly works kept over from the 1910 exhibition.[48] W.J. Thomson's drypoints were also on view, catching the attention of another aspiring etcher William J. Wood.[49] One may infer that more prints by other GAC members were also shown.

In March 1912, the CNE agreed to give the GAC permanent representation on the Art Committee and in April set up a Graphic Arts subcommittee with A.H. Robson as its chair; W.W. Alexander, as its secretary, received a $150 honorarium.[50] Once the GAC had proved its ability in 1913, CNE management bestowed an annual grant on it to defray all expenses related to organizing the graphic art exhibits.[51] The Club

The success of the 1912 graphic art show at the CNE cannot be measured by press reviews, which seem to have been nonexistent. The CNE became a major patron of the exhibition, purchasing thirteen prints by British and Canadian artists; the National Gallery of Canada was another important purchaser, acquiring seventeen prints; while a further dozen went to private collectors.[55] For the first time in a GAC-sponsored exhibition, artist's prints were not merely given pride of place but were the dominant element, comprising almost two-thirds of the display. The show was a milestone in the reception of the artist's print, and bolstered the GAC's enthusiasm for expansion beyond Toronto, as the participation of the Montrealer Charles Simpson suggests. (Within a few months, the Club would reorganize itself as the Society of Graphic Art and seek a national mandate.) The primacy of prints in the 1912 display may have been due in part to the increasing number of painter-etchers in the GAC, but a growing acceptance of prints among other art organizations also directed the need to increase the calibre of its print display.

The struggle for recognition of the artist's print within professional art institutions was ongoing in this era. Some societies were beginning to be more accepting, particularly the AAM and the RCA, but prints were slow to be seen at exhibitions in Toronto.[56] The Canadian Art Club (CAC), formed in 1907 by seceding members of the OSA,[57] broke the ice by showing etchings for the first time. In a March 1909 show, the Club introduced Toronto to Clarence Gagnon with nine works (including cat. 41–43). As a private organization, the CAC could afford to be selective, keeping its membership to professional artists recognized at home and abroad for work of distinction. The inclusion of Gagnon's etchings as his only work and not segregated from paintings and watercolours amounted to the first honest treatment of prints as works of art by a professional fine arts body in Toronto. Although artist's prints did not become a fixed element of their shows, Gagnon would hang etchings in the 1911 and 1912 CAC annuals, while twelve etchings by H. Ivan Neilson and seventeen lithotints and lithographs by James Kerr-Lawson would appear in their 1914 annual. Only one other venue

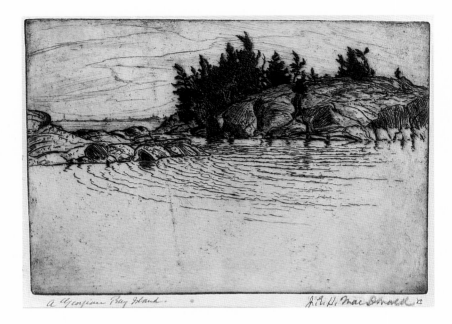

Fig. 118
J.E.H. MacDonald
A Georgian Bay Island c. 1912
(cat. 70)

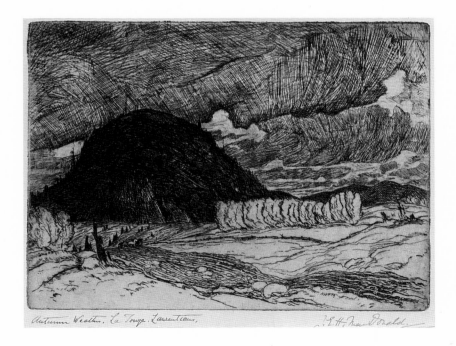

Fig. 119
J.E.H. MacDonald
Autumn Weather, La Tuque, Laurentians c. 1913
(cat. 71)

sponsored by a professional society placed prints on view before 1912: the 1911 RCA annual exhibition held in Toronto displayed a handful of prints by Gagnon, Stevens, and Simpson. For anything more, the city had to depend on the Graphic Arts Club's shows at the CNE.

The Fifth Loan Exhibition at the Art Museum of Toronto

In light of Toronto's recent history, the range of material and erudition found in the Art Museum of Toronto's *Fifth Loan Exhibition* of prints and drawings of April 1912 is quite breathtaking. Materializing virtually out of nowhere, this Black and White-style exhibition was in fact a selection of close to 1000 prints and 100 drawings that offered the Toronto public the broadest sweep of contemporary and historic work by national and international artists. The accompanying catalogue, compiled by Professor James Mavor of the University of Toronto, gave the visitor a thoughtful course on the history of prints and the fine points of connoisseurship.[58] It set out three basic categories: "original" artist's prints, "interpretative" prints (made by copying other artists' works), and "reproductions" of prints, for example the heliogravures after Rembrandt's prints. Various techniques such as lithography, wood engraving, etching, and other forms of intaglio printing (mezzotint, etc.) were discussed. The nearly 700 original prints made this the largest category by far.

The actual hanging of the show seemed to follow Mavor's catalogue divisions. Crowded into three rooms lent out by the Toronto Public Reference Library, the first and third galleries were given over to original prints, while the central space appears to have been devoted to prints after other artists and reproductions. Dürer, Rembrandt, and other old masters were in evidence, but the emphasis was upon the originators of the etching revival (Meryon, Jacque, Whistler, Haden), and leading contemporaries (Frank Brangwyn, D.Y. Cameron, D.S. MacLaughlan, Anders Zorn, John Sloan, and Frank Short). Placed among the international artists were some of Canada's first- and second-generation artist-printmakers: Henry S. Howland, Jr. (cat. 57), William J. Thomson (with twenty-three prints including cat. 115), Homer Watson (cat. 118),

Clarence Gagnon (with twenty-two prints including cat. 38–43), Dorothy Stevens (with eighteen etchings including cat. 107), and J.W. Beatty. James Kerr-Lawson was represented by his "Italian Set" lithotints (cat. 61 and 62).[59]

How had such a stunning print exhibition come about? The answer is complex and must begin with the incorporation in 1900 of that long-awaited public institution, the Art Museum of Toronto (now the Art Gallery of Ontario). Actually, the incorporation only meant that a council had been formed to create an art gallery. Led by Sir Edmund Walker, it included Professor Mavor, along with George Reid and Edmund Morris who represented the artists. Without a home, the Art Museum used the OSA's gallery for its first exhibition in 1906. The handsome skylit rooms in the newly built Reference Library were its next temporary space. Permanence would only come in 1913, at the Grange, a historic house and former residence of Goldwin Smith. Until it found fixed quarters, the Museum had no need for professional staff, and it was left to members of the council to organize shows.

It may have been Sir Edmund Walker who proposed a print and drawing exhibition, but he seems to have offered only occasional advice and appears to have been somewhat disinterested (planning to attend a Mendelssohn choir concert rather than the opening of the show).[60] Professor Mavor and Edmund Morris were the chief organizers for the *Fifth Loan Exhibition*,[61] and both were well suited for the task. The Scottish-born and educated James Mavor had established himself as one of Canada's most intelligent art writers. Edmund Morris, the secretary and driving force of the Canadian Art Club, was known for his energy and organizational skills. During a trip back to Scotland in December 1911, Mavor contacted dealers and artists in Britain, searching out loans. Morris was in charge of following up these contacts, as well as procuring loans from dealers and artists in the United States and Canada.

Perhaps the *Fifth Loan Exhibition's* greatest surprise is the number of local private collections that were drawn upon to create it. Sir Edmund Walker is an expected name on the list, but the presence of at least thirty other collections with

Fig. 120
Dorothy Stevens, J.E.H. MacDonald, and C.W. Jefferys, on the OSA
Hanging Committee, 1916
OSA Papers, Ontario Archives, Toronto

very fine historic and contemporary prints of all schools is astonishing. Compared to the lone private collection evident at the first ACE annual of 1885 and the two mentioned in the 1899 *Saturday Night* article, one has to acknowledge that in just over a decade, print collecting had come a long way. Where did these collectors buy their prints? In Toronto, only Roberts' Art Galleries was selling what may have been artist's prints, but not with great regularity; while advertisements by Matthews Brothers & Co. confirm that they kept a stock of unspecified etchings and engravings.[62] Other local sources were the CAC and CNE exhibitions, but the only Canadian to have any real success in attracting local buyers at these venues was Clarence Gagnon. In fact, just two other Canadian artists were represented in the show by works from private collections – James Kerr-Lawson (lent by Walker) and Homer Watson (lent by James Mavor and Archibald Browne). Unquestionably, these thirty some collectors were intent on acquiring

international prints of distinction and were likely purchasing their art abroad from established print dealers. Small wonder, then, was Frederick Keppel's quick move to make available a large selection of his best stock for sale and loan at the Canadian show.

The *Fifth Loan Exhibition* received a fair amount of press coverage, considering that its opening preceded by a few days the sinking of the *Titanic*, which eclipsed all other news items. At least five of Toronto's leading papers reviewed the exhibition, in some cases following up with more detailed and thoughtful critiques. The seriousness of the coverage is a sign that the show was not just well received but was something of a sensation. While the usual positive remarks were made about the old and modern masters, Canadian etchers received surprisingly sympathetic attention, as these comments from the *Star Weekly* affirm:

> ... when placed with the works of such men as Rembrandt, Whistler, Seymour Haden, and moderns like Joseph Pennell and D.Y. Cameron, it seemed as though the Canadians would be overwhelmed. What has been accomplished in this is indicated by the fact that they have stood the test. Of course it would be folly to say that our etchers ranked as high as the men with world-wide reputations, but, in no other branch of art do our artists appear to such advantage when seen beside the men of the Old Land.

Writing of individual Canadians, the commentator went on:

> Mr. [William J.] Thomson has a special gift for taking familiar scenes and bringing out their beauty and poetry ... Clarence Gagnon is so well known ... that one immediately turns with interest to his etchings.... He etches with a refinement of line and sense of romance that makes everything done by him notable. There is a distinct contrast between his work and Miss Dorothy Stevens, of Toronto, who may be described as the boldest of the

Canadian etchers. She has a cleverness and daring that give a distinctiveness to all her pictures. [She] revels in figure work and even when her outlines seem a little crude they indicate originality. When she turns to landscape there is a bigness and scope to her ideas that suggest the modern English etchers.[63]

Adding favourable remarks on the work of J.W. Beatty and Homer Watson, the reviewer summed up: "The work of the five artists stands as a vindication of Canadian etching." Rather poignantly, the show was seen by several reviewers as a vindication for the Association of Canadian Etchers and its *First Annual Exhibition* of 1885.[64] At long last, Canadian artists were receiving recognition at home for their printmaking accomplishments. And the print show presented by the GAC at the 1912 CNE soon after the AMT's *Fifth Loan Exhibition* solidified institutional support for the artist's print.

The National Gallery of Canada's Print Collection

A comparison between the intensive press coverage of the *Fifth Loan Exhibition* and the total absence of reviews of the impressive graphic art section at the CNE a few months later speaks volumes about the role of public institutions in the validation of art. The Art Museum of Toronto's promotion of the artist's print through shows and catalogues was of undeniable importance to the medium. Only the National Gallery of Canada (NGC), however, set about to build a public print collection; thereby giving artists monetary rewards for their work, offering the highest recognition of their talents, and preserving their contributions to the art of printmaking for future generations.

There was no apparent policy decision made by the NGC to develop a print and drawing collection. As early as 1882, two years after the founding of the institution, curator J.W.H. Watts had hoped to create such a collection, but his dream was not realized until twenty-seven years later. In 1909, Sir Edmund Walker was on the Gallery's Advisory Arts Council and recommended the first print purchases – twenty-one etchings by Clarence

Gagnon.[65] It was the Armingtons' turn in 1910, as three prints by Frank and one by Caroline were purchased. A young Englishman, Eric Brown, was named curator in 1911; he and Walker saw eye to eye on developing this part of the collection.[66] Together they selected more prints by the Armingtons from the 1911 CNE display and acquired the first works by international artists. The drawing collection was initiated with the purchase of Italian old master drawings and some by Barbizon artists. By the end of 1912 the NGC owned 191 prints, primarily by Europeans from the seventeenth century on. The Canadian painter-etchers were not ignored: forty-six etchings by Dorothy Stevens, John Cotton, H. Ivan Neilson, and William J. Thomson were acquired.

From 1912 forward, prints and drawings would constitute a significant portion of the NGC's acquisitions. Art shows in Canada were the main source for these early purchases, and many of the European prints acquired in 1912 were purchased from the *Fifth Loan Exhibition* and the CNE. Thereafter, London and New York dealers became the preferred source for European prints. The collection that rapidly coalesced under Walker and Brown's aegis represented the leading Canadian and international printmakers of the day and an array of old masters. By 1920 the National Gallery could boast the only significant public collection of artist's prints in Canada, with holdings of approximately 200 Canadian and 800 international works.

A few months after the April 1912 opening of the NGC's first truly functional art gallery premises in the east wing of the Victoria Memorial Museum building, Brown was supervising work on the first permanent public display of prints in the country. At the outset, it was to be no more than a few screens featuring recent acquisitions from the two Toronto shows placed in a gallery.[67] Finding the plans inadequate, Brown contemplated using display cases for the etchings and lithographs; and a set of thirteen mahogany cases, similar to the ones Walker used for his personal print collection, was found and installed.[68] Initially, the NGC was content to show its print collection only in its own galleries. With the burning of the Parliament Buildings in early 1916, the Gallery

was forced to vacate its premises to make room for parliament. Homelessness led to innovation: the first travelling print exhibition – British lithography – was organized for the Art Museum of Toronto in February 1917, moving on in November to the Nova Scotia Museum of Fine Arts.[69] When the Gallery reopened at the Victoria Memorial building in September 1921, a direct appeal to the Prime Minister by Walker resulted in the establishment of a separate print and drawing department. Its first curator was Walker's protégé, the Torontonian Henry P. Rossiter[70] – the first professional print curator in the country. Only then was the NGC able to mount on a regular basis in-house and travelling exhibitions devoted to prints.

Through this decade, a division of labour between the National Gallery and the Art Museum of Toronto was orchestrated by the intensely nationalistic and public-spirited Walker, who served as chairman of both institutions. The NGC was to concentrate on developing a print collection with a strong Canadian content, while the AMT was to promote Canadian printmaking by organizing a series of exhibitions between 1914 and 1917. The harmonious relationship contributed greatly to the legitimization of the Canadian artist's print as a serious and creative art form.

The Exhibitions of Canadian Etchers at the Art Museum of Toronto

The idea of holding exhibitions solely of works by Canadian etchers originated with the Society of Graphic Art (SGA), as the Graphic Arts Club was now known. Its sister organization, the Arts and Letters Club, held a show from 4 to 14 February 1914 titled *Some Canadian Etchers*, organized by J.E.H. MacDonald, the ALC's exhibition secretary.[71] It was garnered from the work of SGA members and complemented by a lecture on etching.[72]

On 22 February, the *Toronto Sunday World* announced an exhibition of about 100 etchings by Toronto artists to open at the Art Museum of Toronto in March.[73] The AMT could have considered transferring the Arts and Letters Club show wholepiece to the Grange; instead, curator Edward R. Greig worked with the SGA and its

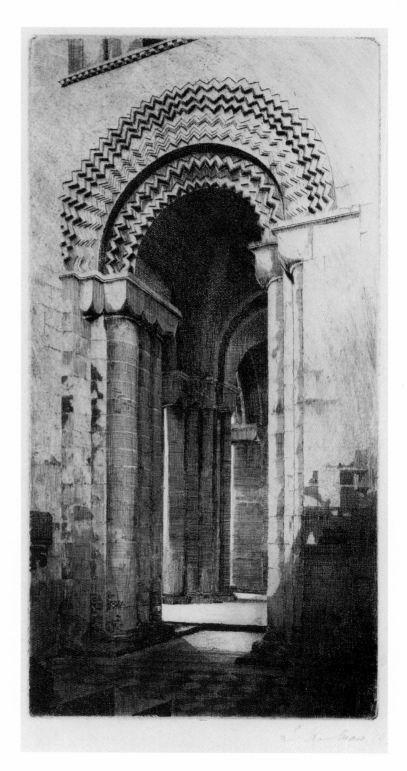

Fig. 121
S.H. Maw
Ely Cathedral, England (Interior, No. 1) 1913
(cat. 75)

Fig. 122
S.H. Maw
Toronto Bay c. 1914
(cat. 76)

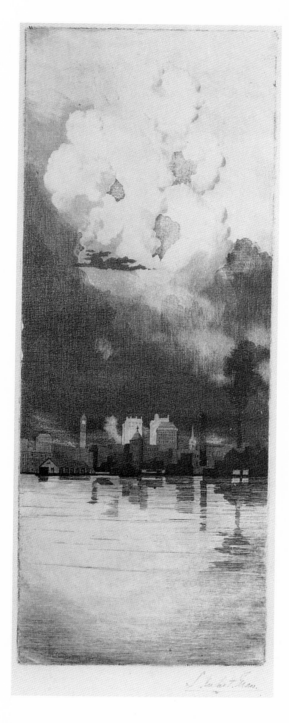

Laur, A.E. Waite, S.H. Maw, and possibly W.J. Wood.[75] Henry S. Howland, Jr.'s work provided a link with the past.

A new presence was the architect **Samuel Herbert Maw (1881–1953)**, a specialist in the design of architectural detail, who arrived in Toronto in May 1912 to work for Darling and Pearson, joining the GAC in 1913.[76] The first evidence of Maw as an etcher was two Venetian subjects and *Ely Cathedral, England* (fig. 121), which appeared at the April 1913 OSA annual. While Maw preferred to base his prints on the drawings he made in Europe, one of his earliest submissions to the AMT show was *Toronto Bay* (fig. 122). Maw's strength as an etcher lies more in the precision of his drawing than in the technical process, and it is his curious method of drawing in close parallel lines that gives the images their richness and photographic quality. *The Lagoon, Venice* (fig. 124), a slightly later print, is a modern version of Whistler's mist-shrouded city, with smoke-belching steamers rather than gondolas gliding before it. One is tempted here to consider the influence of H. Ivan Neilson's harbour subjects.[77] Another newcomer in the GAC's sphere, the Quebec City etcher was enjoying a prolonged visit to Toronto at the time.[78] Several reviewers found Neilson's energetic etchings the most interesting in the show, not simply for their obvious high quality, but because of their novelty for the Toronto audience.

The exhibition was warmly received by the local press, and the NGC purchased twenty-two works by eight of the exhibitors, among them Maw's *Toronto Bay*, Thomson's *Fisherman's Harvest* (cat. 116), and Stevens' *Sortie de l'église* (cat. 108). But it was the Saturday afternoon demonstrations of printing techniques that practically stole the show. Using the SGA's press, installed in the gallery for the occasion, S.H. Maw, W.W. Alexander, and perhaps Dorothy Stevens demonstrated etching,[79] while John Cotton made an aquatint and W.J. Thomson gave instruction on mezzotint.[80]

Overseeing the print exhibition was Edward Greig. He had been appointed the AMT's first secretary and curator in early 1912, just in time to assist Mavor and Morris with the final details and hanging of the enormous and complex *Fifth Loan*

president T.G. Greene[74] to present a display tailored to the AMT's needs. The show, with the long-winded title *A Collection of Etchings by Toronto Etchers with Original Plates showing Methods and Processes*, was on view in the Grange library from 6 to 30 April 1914. It comprised nearly 75 etchings by Thomson, Cotton, Greene, Stevens, Staples, Alexander, MacDonald, Duff,

Fig. 123
T.G. Greene
Invitation to Exhibition of Canadian Etchers 1915
Etching, 12.3 × 15.5 cm (plate)
Massey College, University of Toronto

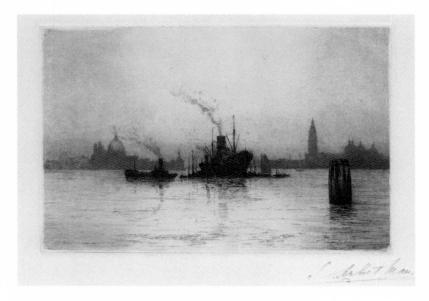

Fig. 124
S.H. Maw
The Lagoon, Venice c. 1917
(cat. 77)

Exhibition. No doubt the experience taught Greig some valuable lessons about exhibition preparation, especially the need to keep a degree of control over content and purpose. In 1915, Greig undertook his own etching show, national in scope, with the didactic aspect toned down in favour of a solid display of the finest production. The *Second Exhibition of Canadian Etchers* ran from 17 April to 15 May at the Grange, and presented 121 prints.[81] Given enough lead time, T.G. Greene was able to make an etched invitation to the exhibition (fig. 123).

Greig had solicited prints directly from artists across the country. The Toronto contingent included W.W. Alexander, J.W. Cotton, W.R. Duff, T.G. Greene, Fred Haines, F.W. Jopling, E.L. Laur, J.E.H. MacDonald, S.H. Maw, Owen Staples, Dorothy Stevens, W.J. Thomson, and five others. Neilson sent his prints from Quebec City, Ernest Fosbery from Ottawa, and Cyril Barraud from Winnipeg. Gagnon was contacted in Paris, and etchings by the Armingtons and MacLaughlin were borrowed from the NGC.[82] Edmond Dyonnet, RCA secretary, furnished names and addresses of Montreal etchers for Greig to contact.[83] This brought about the inclusion of Herbert Raine, Charles Simpson, and Ethel Seath. The SGA stood in the wings ready to assist, once again lending their press for the print demonstrations[84] which were given on four Saturday afternoons by Thomson, Maw, Stevens, and Cotton.[85] Texts

describing techniques aided the visitor's understanding of the various intaglio media.[86]

There were 700 visitors to the exhibition, the greatest number coming on the popular demonstration days.[87] Press notices were favourable but generally more terse than before. One reviewer labelled the show as "more exquisite this year" owing to the addition of well-known out-of-town artists, and praised the Armingtons, Gagnon, and Cyril Barraud in particular.[88] The National Gallery showed its support by purchasing ten prints, among them Barraud's *The Road to the Valley* (cat. 11). But of greatest interest was the request by the CNE's manager that a major portion of the show be sent on for inclusion in their graphic art section.[89] Permission was obtained from all the artists concerned, and the 1915 CNE graphic art section became a near duplicate of the *Second Exhibition of Canadian Etchers*.

The unquestioned success of the show induced the AMT to make it an annual event.[90] The *Third Exhibition of Canadian Etchers* (1–22 April 1916) offered a greater variety of media, with 125 etchings, lithographs, and wood engravings.[91] Greig made an effort to be comprehensive, and new exhibitors were Walter J. Phillips and George Fawcett of Winnipeg, and Gyrth Russell of Halifax (living in England at the time).[92] The Armingtons sent a selection of etchings from Paris, and from London James Kerr-Lawson entered some of his lithographs. Old hands

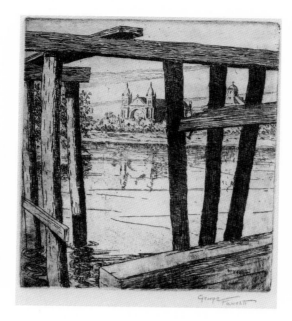

wearing off for the Toronto audience, attendance dropped to 561 and just one newspaper, the *Globe*, carried a brief, three-paragraph report, although Estelle M. Kerr's thorough critical review did appear in the *Canadian Courier*.[94] Despite a drastically reduced wartime budget, Sir Edmund Walker selected sixteen etchings for the NGC's collection. The purchases included George Fawcett's *St. Boniface* (fig. 125), W.J. Phillips' *The Red River at Winnipeg* (fig. 126), and F.W. Jopling's *In a Toronto Shipbuilding Yard* (fig. 127).

The *Fourth Exhibition of Canadian Etchers* was held at the Grange from 5 to 28 April 1917; slightly over 100 prints were on view.[95] The principal exhibitors remained unchanged, with Lewis Smith the only new etcher of significance; he entered *Barges at Hammersmith* (cat. 102), along with three others. Greig had attempted to add freshness by broadening the number of artists invited to exhibit, but either the lack of new work or absences due to the Great War hampered his efforts. Writing to Eric Brown, Greig noted that whereas there might not be any "marked progress … there are some very good things;" and Walker concurred that the show "was not as good as last year."[96] Nonetheless, attendance was up to 638, peaking on Saturdays when any scheduled demonstrations would have been held. Reviews

included Alexander, Cotton, Gagnon, Greene, Haines, Jopling, Neilson, Raine, Simpson, Staples, Stevens, and Thomson. Etching demonstrations were presented on the first and last Saturdays by H. Ivan Neilson and Owen Staples; on other Saturdays John Cotton demonstrated aquatint techniques, and W.W. Alexander and Dudley Ward joined forces to introduce lithography.[93] The novelty of these exhibitions was obviously

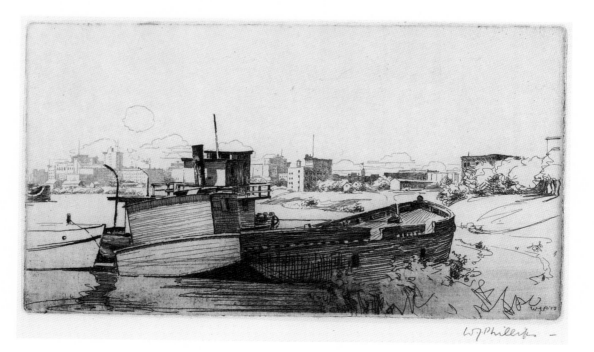

Fig. 127
F.W. Jopling
In a Toronto Shipbuilding Yard
1915
(cat. 59)

Fig. 128
Dorothy Stevens
Sortie de l'église 1913
(cat. 108)

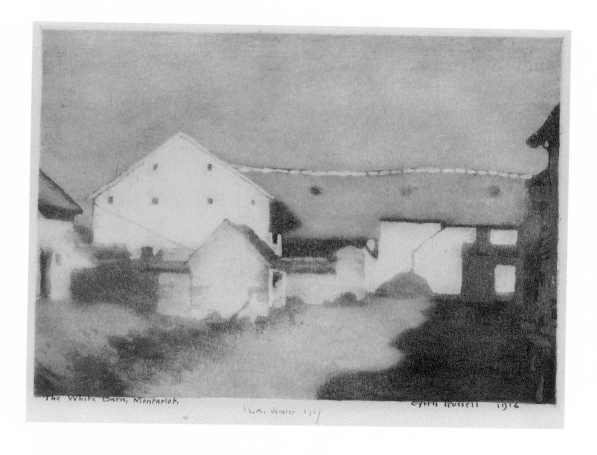

Fig. 129
Gyrth Russell
The White Barn, Montarlot 1916
(cat. 98)

Fig. 130
Walter R. Duff
Newton MacTavish 1910
Etching, 34 × 21.5 cm (plate)
National Gallery of Canada (36852)
Gift of Dr and Mrs James Malpass,
1992, in honour of her grandfather,
Newton MacTavish

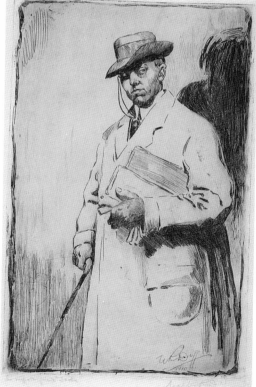

appeared in Canadian and American papers,[97] and the NGC purchased thirteen prints from the exhibition, including Gyrth Russell's colour aquatint *The White Barn, Montarlot* (fig. 129). Arthur Lismer, now in Halifax, wanted the show to be held there under the auspices of the Nova Scotia Museum of Fine Arts. Permission was granted by the artists, and the exhibition (minus the NGC purchases) was sent to Halifax.

Newton MacTavish and the *Canadian Magazine*

In 1906, Newton MacTavish became editor of the *Canadian Magazine*, enriching the monthly publication with his interest in the fine arts. An early member of both the Graphic Arts Club and the Arts and Letters Club, MacTavish developed a taste for etching and an appreciation of Canada's fledgling printmakers. As their numbers grew and their output improved, MacTavish used his magazine – which had until then only looked to painters and sculptors – as a vehicle to disseminate their work. Beginning in February 1912, he published three

richly illustrated articles on Joseph Pennell by Britton B. Cooke.[98] In August 1913, he commissioned Gyrth Russell, barely out of art school in Halifax, to illustrate an article on that city with drawings and prints.[99] It was the magazine's practice to feature an exemplary work of Canadian art, unrelated to any item in the issue; and in 1914 etchings began to be illustrated in this manner. Indeed, from April 1914 to January 1916, barely an issue went by without a print by Walter R. Duff, H. Ivan Neilson, Clarence Gagnon, Gyrth Russell, or Dorothy Stevens. The chief beneficiary of MacTavish's patronage to printmakers, Stevens received a commission for six etchings to be used as single illustrations, and was asked to illustrate an article by Estelle Kerr on Belgium for the December 1914 issue – for which *Sortie de l'église* (fig. 128) was created.[100] It is possible Stevens' and Kerr's travel expenses were covered by the *Canadian Magazine*.

This intense gaze at contemporary Canadian etching culminated in a perceptive article by MacTavish in *Studio* in January 1915.[101] Never before had a serious article discussing a Canadian school of etchers appeared in an international art magazine. MacTavish observed that while Canada could boast of "a good many dabblers [in etching] … there are only a few good ones." He did not link the Canadian painter-etcher movement with any particular school or artist. His thesis was simple: he identified the nation's leading painter-etchers and discussed their work purely in terms of the standard precepts of the medium's aesthetic. His selection was perhaps too limited, excluding such able practitioners as the Armingtons, John Cotton, C.H. White, and Elizabeth Armstrong Forbes. Among those he considered the finest were artists already appearing on the pages of his own magazine: Clarence Gagnon, H. Ivan Neilson, Dorothy Stevens, and Gyrth Russell.[102] MacTavish wrote of etching with intelligence and his choice of images – Gagnon's *Canal San Agostino* (cat. 39) and Neilson's *The Deepening of the St. Charles River* (fig. 132) being prime examples – shows a good eye

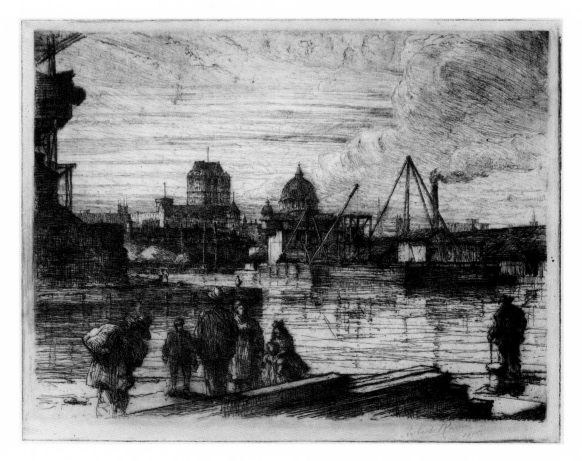

Fig. 131
Herbert Raine
Evening, the Canal, Montreal 1915
(cat. 92)

for the medium. He was the best Canadian commentator on prints for the period, and it is a pity that his writing on the subject was limited to just this one article.[103] In a sense, the text was a little premature — if MacTavish had waited for Greig's AMT shows of 1915, 1916, and 1917, he would have seen the real flowering of Canadian etching and aided it with his insightful commentary.

When the time seemed right for a follow-up article, MacTavish chose Estelle Kerr to write it for the December 1916 issue of the *Canadian Magazine*.[104] Kerr took a different tack from MacTavish, putting forward an argument for an overt Canadianism in the home-grown painter-etcher movement. Clearly she was responding to the call within her own Toronto artistic circle for the creation of a national school of art, the same nationalist groundswell that was giving birth to the Group of Seven. Kerr's ideas were circumscribed by the works she had seen at the AMT

and her friendship with the Toronto etchers. (One of the original members of the GAC, she had shared a studio with Dorothy Stevens). A further drawback to her analysis was a limited knowledge of contemporary international etchers. Consequently, although Kerr could discern that the subjects selected by Canadian artists tended to avoid the quaintly picturesque as practised in Europe, she attributed this solely to the influence of Frank Brangwyn, the prominent British etcher and lithographer. She correctly noted the stylistic impact of Brangwyn's muscular depictions of urban scenes on Herbert Raine's *Evening, the Canal, Montreal* (fig. 131). But she made no reference to Joseph Pennell and C.H. White, well-known artists who were creating a mode for less sentimental depictions of North American urban scenes. Pennell and White's penchant for recording the energy and promise of the new world, concurrent with a less romantically encumbered

Fig. 132
H. Ivan Neilson
The Deepening of the St. Charles River, Quebec 1913
(cat. 86)

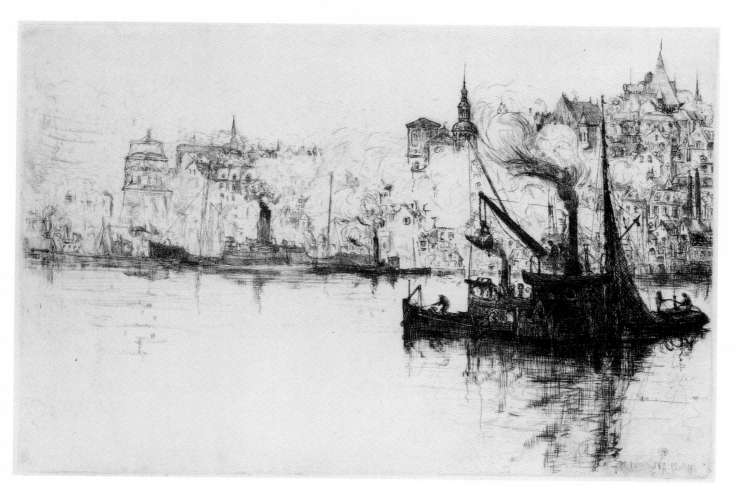

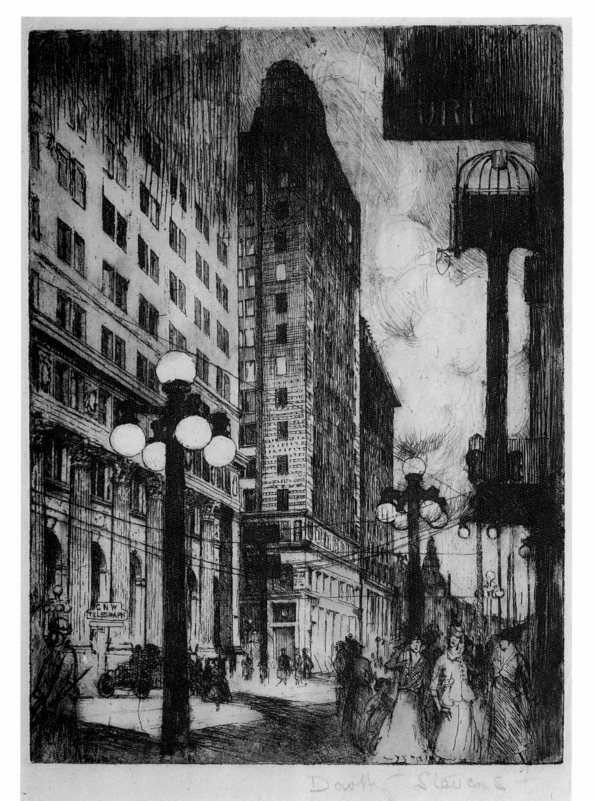

Fig. 133
Dorothy Stevens
King and Yonge Streets c. 1915
(cat. 109)

notion of history, was reflected in the etchings of such Canadians as Neilson, Staples, Stevens, and Thomson. Signs of the modern urban and industrial environment are often present in their Canadian images, and Kerr chose this kind of subject for her illustrations, including Stevens' *King and Yonge Streets* (fig. 133).

Canadian subject matter was at the heart of Kerr's argument, and she cited Neilson's decision to depict only Canadian subjects in his prints.[105] As Toronto painters ventured to the northern woodlands of Algonquin Park and Georgian Bay to create a uniquely Canadian style of painting, so the painter-etchers went out into the city streets and environs. Kerr singled out a few specific treatments of various regions of Canada: Neilson for Quebec City; Stevens, Maw, and Jopling for Toronto; Thomson and Cotton for the Ontario countryside; Barraud, Fawcett, and Phillips for views of Winnipeg and its rivers. What she saw in these works was an affirmation of an economically and culturally vigorous Canada, which was destined to prevail over its wartime enemies. Kerr avoided mentioning other strains evident in the work of the Canadians, for to do so would have undermined her thesis. Thus, she failed to acknowledge that many present-day Canadian artists were content to work within the stylistic and subject conventions of the British and American etching revivals, depicting European subjects. They were all steeped in these conventions, which had won etching its credentials as a creative art among cognoscente in this country.

It is difficult to judge the actual effect of MacTavish's promotion of Canadian etching on the pages of the *Canadian Magazine*. The momentum for exhibiting Canadian prints was already underway, and the magazine's support helped validate the promoters' efforts. The encouragement of private and public collecting is another matter. The National Gallery of Canada and, in a more limited way, the management of the Canadian National Exhibition would be the only significant public collectors for decades to come. And with the exception of Sir Edmund Walker, no serious private collector of Canadian prints would emerge until the mid-century.

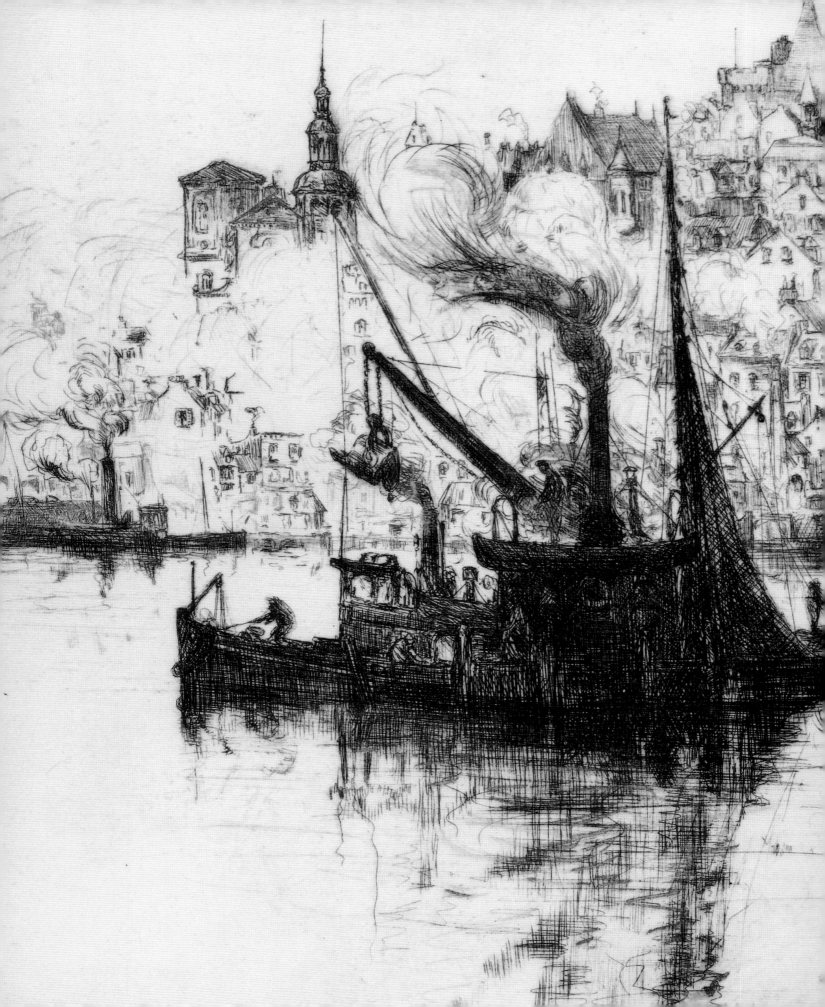

4 Completing the Structure

The Print Movement Becomes National, 1910–1920

THE FOURTH ANNUAL Exhibition of Canadian Etchers in 1917 confirmed that printmaking was well established in Toronto. Interesting to note was the appearance from across the country of some of the best prints in the AMT's exhibitions. Some of these were submitted by artists working alone in other communities, but who were nonetheless well within the orbit of the Toronto etchers. Also in recent years, pockets of printmaking had begun to form in other centres, the most active ones being in Halifax, Montreal, and Winnipeg.

Quebec City and Ontario

The communal nature of the painter-etcher movement dictated against totally isolated activity. Publications and correspondence could stimulate printmaking to some extent, but they were rarely an effective substitute for the immediate and sympathetic interaction of one artist with another, or with an encouraging connoisseur.

Returning to the vicinity of Quebec City in late 1909, H. Ivan Neilson replicated the sense of artistic community he had enjoyed with several Scottish societies by founding the Society of Quebec Artists in January 1911.[1] However, he did not have an artist to work beside him at the etching press he had brought from Scotland. Unquestionably, a stimulus for his etching came from Toronto. The warm reception his prints received both at the Canadian Art Club and the AMT etchers' shows was undoubtedly encouraging, as was his acceptance within Toronto's circle of painter-etchers. Over the winter of 1913–14 Neilson lived in Toronto, returning again in 1919; and even when back in Quebec, he maintained ties with his Toronto colleagues during this period.

By the end of 1920 Neilson had produced fifty-three prints of the seventy-three in his total œuvre, all but two of these scenes of Quebec City and the life of the St. Lawrence River and its tributaries. At first, Neilson was attracted to such picturesque subjects as *Sous-le-Cap, Quebec* (fig. 135). Later, he seldom opted for the perspectival view up narrow streets, so beloved by participants in the etching revival, and only a handful of his prints focus on city landmarks. His overwhelming preference was for the teeming activity of the harbour, with its confusion of rigging, smokestacks, and crafts of all sizes. *The Deepening of the St. Charles River, Quebec* (fig. 132) is Neilson's finest expression of this theme. Harbour subjects are common enough in the work of other etchers, but Neilson

Fig. 134
H. Ivan Neilson, circa 1920
National Gallery of Canada Library

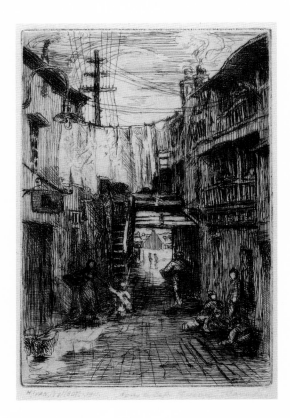

Fig. 135
H. Ivan Neilson
Sous-le-Cap, Quebec 1911
(cat. 84)

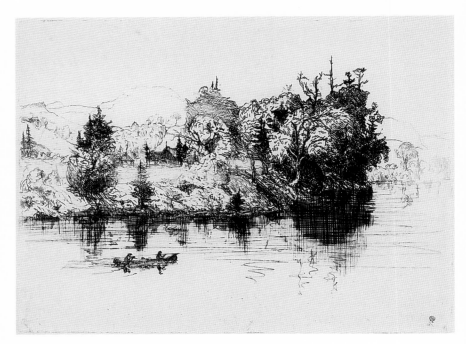

Fig. 136
H. Ivan Neilson
*Clark's Point, Valcartier, or Jacques
Cartier River near Valcartier* 1912
(cat. 85)

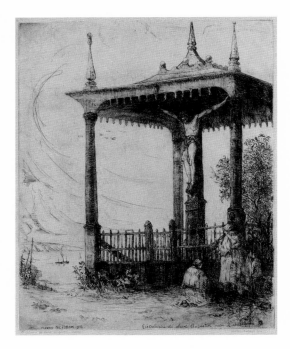

Fig. 137
H. Ivan Neilson
*Le Calvaire de Saint-Augustin,
near Quebec* 1916
(cat. 87)

– the sailor and former marine engineer – brings a quite different personality to bear on their representation. Firstly, it is clear that his vantage point is usually that of a boat in the thick of things; and secondly, he does not cast a veil of aestheticism over the more industrial aspects of the scene, as do most of his contemporaries. He describes ships with accuracy but without undue detail, taking pleasure in powerful hulls, cranes, dredging equipment, and all the paraphernalia that makes the harbour a living organism. He does not shrink from thick etching needles and strong mordants, or acids, and sometimes deliberately does not pare down the profusion of elements in order to preserve the sense of industrial clamour and movement. This gives the impression of robustness or "virility" that reviewers commented upon.

Elsewhere, in the course of his summer explorations of Québec by canoe or sailboat, a more lyrical note is sounded, as seen in *Clark's Point, Valcartier*

(fig. 136), but Neilson's approach is always down-to-earth, shedding altogether any fey influence left over from his Scottish period. Even in his depiction of the ancient *Calvaire de Saint-Augustin* (fig. 137), he does not play upon the inherent quaintness of the scene, but seems in full sympathy with the simple piety of the country worshippers, and renders the Calvaire itself with a fitting rusticity.

More than any other Québec etcher of this period, Neilson displayed a love of etching cuisine: in his mixing of tools, his application of acid washes, aquatints, and fast mordants, his exploitation of acid accidents, and his development of images through successive changes of state. These changes never consisted of eliminations, since the artist prided himself on not altering his marks once made, but simply of additions of detail or shading. He sometimes used preparatory sketches and tracings, but usually without transferring an exact composition to the plate. There is a rapidity and spontaneity in Neilson's approach which shows in the outcome, occasionally to the detriment of the design, but generally to the benefit of the vitality of the piece.

Ernest Fosbery (1874–1960) began his studies in his hometown, at the Ottawa School of Art. In 1899, J.W.H. Watts took the young student under his wing and introduced him to etching (Watts would remain a friend and inspiration, and

bequeath Fosbery his press and etching equipment).[2] This experience was cut short by Fosbery's absence from 1900 to 1911, when he worked in Boston and Buffalo. On his return to Ottawa, he resumed etching, and in May 1914, created eight or nine plates of local landscapes in rapid succession.[3]

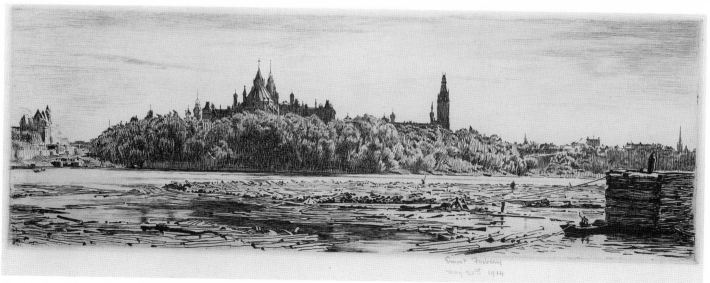

The display of prints mounted by Eric Brown at the National Gallery allowed the artist to examine first-hand a collection of etchings, and must account for Fosbery's unusually quick and sensitive grasp of contemporary printmaking aesthetics — he soon outshone his mentor, Watts. Fosbery showed the etchings to Brown, who purchased six for the NGC, while Sir Edmund Walker bought three for his own collection.[4] *Spire of St. Andrew's Church, Ottawa* (fig.140) is the kind of small, intimate etching, dear to the hearts of the nineteenth-century British school. In a vignette format, the essence of the subject is captured with a few light strokes of the needle. *Ottawa* (fig. 139) is grander in scale, coming closer to more modern tastes yet retaining the delicacy of drawing. Both prints avouch for a sure understanding of the use of varied strengths of line, which translates into a happy play of light and texture. Fosbery's exquisitely rendered mezzotint *The Café* (fig. 138) of 1918 has a bleak, wintry, nighttime scene as a subject.

William John Wood (1877–1954) presents an amazing story of the rare self-starter who, despite physical isolation and economic hardship, managed to devote his whole life to an art that seldom received any appreciation. Wood was a labourer, working in the small towns of Ontario's cottage country. Aspiring to be an artist, he had taken some instruction in Toronto and Boston before being hired by the *Temiskaming Herald*. This job provided him with the rudiments of etching, and he ventured into the medium using a laundry wringer for a press. Upon moving to Orillia, Wood went to work at the carriage factory owned by the painter Frank Carmichael's father. The friendship that developed with Carmichael brought Wood into contact with Arthur Lismer, and led to an entrée into GAC exhibitions. Among the first of Wood's prints to be shown in Toronto was *The Artist Painting in the Country* (fig. 141), said to be of Carmichael. At this early stage, Wood shows an increasing technical ability, and he varies the weight and tone of his lines. The drawing style is uniquely his own, energetic and frantic, barely under control – it succeeds on sheer vitality. Wood gained the support of the artists who would form the Group of Seven, including J.E.H. MacDonald, whose own efforts at etching are similar in feeling

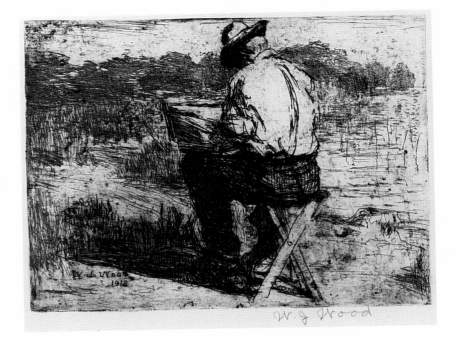

to *The Artist Painting in the Country*, and date to the same time. Encouraged by this support and recognition, Wood proceeded to design and build his own etching press.

Service with the Canadian Army in England did not diminish Wood's need to create prints. His proximity to London allowed him to attend various art functions, including the RA's winter exhibition of graphic art and Frank Short's accompanying slide lecture. These events renewed his interest

Fig. 141
W.J. Wood
The Artist Painting in the Country
1912
(cat. 130)

Fig. 142
W.J. Wood
At Whitsuntide 1917
(cat. 131)

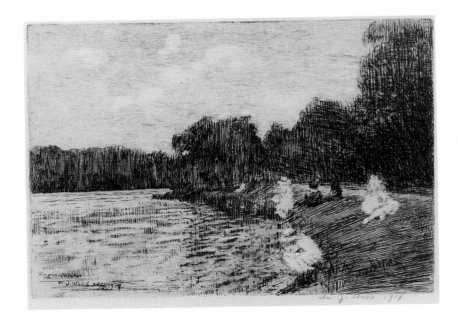

Fig. 143
W.J. Wood
Still-life 1919
(cat. 132)

in etching, and he was soon at work on several plates, the most arresting being the enigmatic *At Whitsuntide* (fig. 142). Here, Wood employed a curiously aggressive style of etching, mixing the concepts of several intaglio techniques. For example, he drew the water in parallel vertical strokes, a method commonly used in line engraving, but then burnished out many of these etched lines, as in the mezzotint process. When the work was printed, Wood had created the transient effect of light dancing across the rippling surface of the river; its ghostly quality was further emphasized by the figures, which were defined not by outline but by the densely etched spaces around them and the absence of any plate tone within their forms. A double influence can be detected in this image: the notion of creating forms without outline was derived directly from Anders Zorn, while the idea of observing reality through the effects of light and texture was evidently learned from Walter Sickert.

In Midland, Ontario, after the war, Wood began to create startlingly daring prints, such as *Still-life* (fig. 143). Casting all hesitation aside, he used line etching merely to rough in the subject; light, texture, and the strong emotional impact of

the print were effected by the use of plate tone in combination with foul biting and lavis (acid painted directly onto the exposed copper plate). It was the kind of printmaking that would not be seen in Canada for another thirty to forty years, and must have given rise to cruel censure at the time. Perhaps in response to such criticism, Lismer wrote Wood in 1922: "Professionalism is humbug. An artist should see a medium to express an ideal, a philosophy, a reflection of life, rather than to pursue the medium for the sake of its technical attraction.... They had a very fine quality of reality – I mean by that, one forgot the etching in enjoyment of the fullness of life in it."[5] Such rare expressions of support petered out during the later years, as Wood's prints became increasingly influenced by his passion for Zorn's etchings. By the 1930s, Wood's sole ally and correspondent on matters pertaining to his prints was the ever generous Bertha Jacques of the Chicago Society of Etchers.

Halifax

When Henry Mortikai Rosenberg arrived in Halifax during the summer of 1897 to take up his appointment as principal of the Victoria School of Art and Design, prospects for etching in Nova Scotia seemed to brighten. Rosenberg was one of the "Duveneck Boys" – pupils of American artist Frank Duveneck in Munich – who had spent the summer of 1880 with their teacher in Venice. There they met Whistler, and a close collaboration developed that saw Whistler, Duveneck, and another pupil Otto Bacher each creating their own groundbreaking sets of Venetian etchings.[6] Rosenberg, too, produced a handful of etchings that he showed eight years later at the New York Etching Club. His attachment to the medium was desultory, however, with some works being made during his student travels in Europe (see fig. 144), and a few plates dated no later than 1890 made after his return to the United States. These were printed at Kimmel & Voigt, and the plates and copyright were sold to at least two New York dealers. Isolated in Nova Scotia, without a press or nearby facilities, Rosenberg never seems to have returned to etching until called out of retirement to teach the course at the Halifax art school in 1922.[7] No evidence found to date suggests he

ever made etchings of Nova Scotia subjects, and the minutes of the annual meetings of the Victoria School of Art and Design do not mention an etching class during Rosenberg's tenure (1897–1910).[8]

In February 1910, a local artist and former student took over as principal. Having taught at the Halifax Ladies College, Lewis Smith was surely familiar with the Victoria School and its problems of low attendance and conservative curriculum, which retained South Kensington's applied arts emphasis. Smith wanted to change directions, making it a school for training young artists. As we have seen, a study leave in Europe prepared him to give instruction in the basics of etching technique. This may have been when the art school acquired its etching press.[9] To stimulate local interest, Smith arranged to have fifty-seven of the Armington's etchings brought from Montreal to Halifax, where they went on view in December 1910.[10] Only a recent graduate **Gyrth Russell (1892–1970)** was enticed to Smith's press. Over the winter months of 1911 the two worked together, Smith creating etchings based on his European work; while Russell concentrated on Halifax subjects, confidently placing his creations on view for the first time at the Nova Scotia Provincial Exhibition in 1911.[11] Russell quickly outstripped his teacher in ability. Early on, he showed a preference for more painterly processes, and by 1912 was producing very delicate colour aquatints. By creatively employing pure aquatint, Russell found a printing technique that translated the wintry light cast across the snow-covered city. In *Bedford Row* (fig. 147), his use of a light brown and a dark brown ink replicates the merging of colours experienced in snowstorms, while the speckled texture of the aquatint denotes the falling snow. Russell takes his printmaking several steps further with *Winter Scene, Halifax* (fig. 146), printed in three shades of brown. He has mixed his colours directly on the plate, carefully shaping and delineating the buildings, and highlighting the rooftops and street illuminated by the sunset. A second printing in blue further softens the lines in the manner of winter light. His painterly approach was in keeping with the colour prints of the French Impressionists, and he would shortly immerse himself in their art while studying in

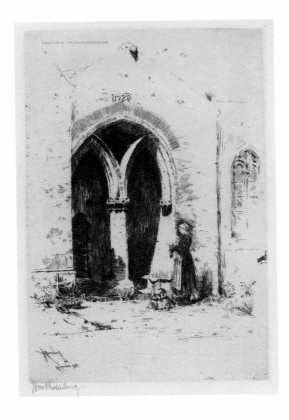

Fig. 144
H.M. Rosenberg (1858–1947)
Rosporden 1885
Etching, 27.2 × 17.7 cm (plate)
National Gallery of Canada (37707)

Fig. 145
Gyrth Russell, around 1912
Taken from *Canadian Magazine* 52:2
(Nov. 1918), p. 603

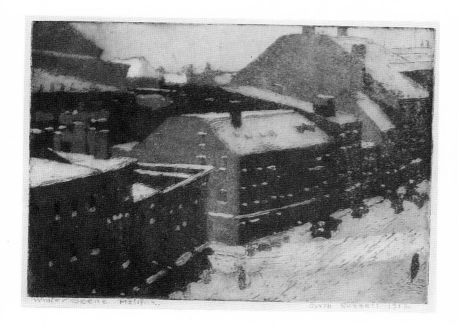

Fig. 146
Gyrth Russell
Winter Scene, Halifax 1912
(cat. 97)

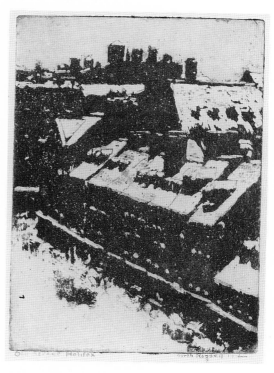

Fig. 147
Gyrth Russell
Bedford Row (The Old Street, Halifax) 1912
(cat. 96)

Paris in late 1913. The effect of his brief sojourn in France (he was forced to leave for England when war broke out) can be felt in the exquisite colour aquatint *The White Barn, Montarlot* (cat. 98). The painterly concerns Russell had been so carefully exploring in his early prints had now come to full fruition, along with a heightened use of colour.

It was difficult to establish a cohesive group of etchers in Halifax. There was real talent in the city, but it tended to come and go as the tide. From 1912 to 1914, Smith continued his studies in England; a sojourn in Boston followed from 1916 to 1918.[12] In 1913, Russell left to study abroad, settling permanently in Britain by 1916 and gradually losing contact with his birthplace. **Arthur Lismer (1885–1969)** took over as principal of the Victoria School of Art and Design in 1916, and in typical fashion set out to energize the somnolent art community. The arrival in early 1918 of fellow Torontonian and SGA member S.H. Maw must have heartened Lismer; similar subjects such as transport ships suggest that Maw was examining Lismer's images of naval activity. A comparison of Lismer's lithograph *The Transport* Aquitania (fig. 148) with Maw's etching *The* Olympic *in Halifax Harbour* (fig. 149) evinces similarities in composition and perspective; but Lismer focuses on the effort of docking the massive ship alongside the pier, while Maw is more interested in capturing the majesty of the camouflaged ship as it is towed through the harbour, evidently seeing it as a floating medieval cathedral. An architect by profession, Maw came to help rebuild Halifax after the December 1917 explosion, a job that left him little time to etch.[13] Maw, Lismer, and Smith were the only ones making prints at the end of the decade in Halifax.

Printmakers in Halifax were never sufficient in number to form their own society, and the only venues for presenting their works were the Nova Scotia Museum of Fine Arts and the Nova Scotia Provincial Exhibition. In this period, the organization of the fine art component at the annual summer fair was the responsibility of the Halifax Local Council of Women. The exhibit usually consisted of paintings and watercolours drawn largely from private collections in the province. The hand of Lewis Smith can be detected in the 1911 display, which included works by his close friend J.E.H. MacDonald and MacDonald's

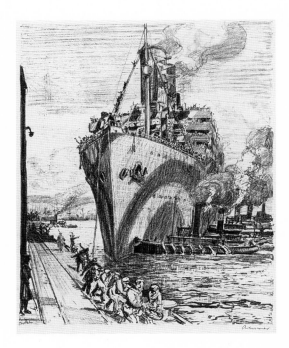

Fig. 148
Arthur Lismer
The Transport Aquitania 1918/19
Lithograph, 41 × 33 cm (image)
Royal Ontario Museum, Toronto (979–X1–24.I)

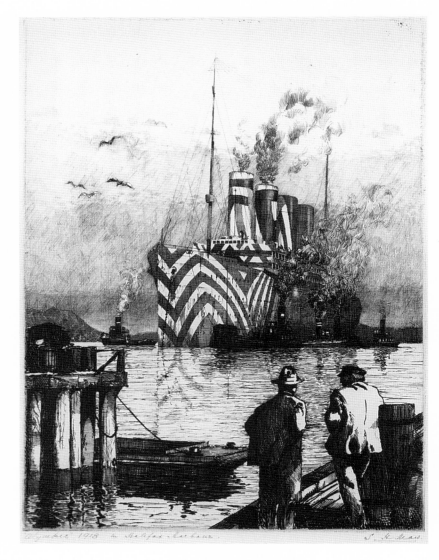

Fig. 149
S.H. Maw
The Olympic *in Halifax Harbour*
1918
(cat. 78)

colleague A.H. Robson. There was an international dimension to the large number of etchings shown: Rosenberg offered works by "Duveneck Boys" Otto Bacher, G.E. Hopkins, and T.M. Wendl from his own collection, while Smith contributed works by the Welsh etcher George Howell Baker from his. An American collector loaned an array of prints by Donald Shaw MacLaughlan, and Clarence Gagnon sent seven etchings to the show. Local artists included Smith, Russell, and Rosenberg – who put five of his Venetian etchings on view.[14]

At the 1912 Provincial Exhibition only Russell entered etchings. In 1913, however, the Local Council of Women called upon Frederick Keppel for a selection of international painter-etchers – Félix Bracquemond, Félix Buhot, Haden, Lalanne, Legros, Millet, Pennell, Herman Webster, and Whistler.[15] Canadian etchers represented were John Cotton, Gyrth Russell, C.W. Simpson, and H. Ivan Neilson (with *Sous-le-Cap, Quebec*, cat. 84).[16] World War I brought about a scaling down of the display: in 1915, local collectors furnished all the etchings by international artists, and Canadians

C.W. Simpson, Dorothy Stevens, John Cotton, Lewis Smith and his sister Edith completed the print exhibit.[17]

Halifax's other major venue, the Nova Scotia Museum of Fine Arts, had been founded in April 1908.[18] The 1910 showing of the Armingtons' etchings appears to be the first exhibition the Museum sponsored, but it had to be installed in a vacant store.[19] The lack of a permanent home did not deter Lewis Smith, secretary of the Museum's council, from building a collection; and to this end he purchased Frank Armington's *Henkersteg, Nürnberg* (cat. 5) out of the show. He also wrote to Elizabeth Armstrong Forbes asking for a loan of her work and that of other members of the

Newlyn School.[20] With Smith's departure in 1912, all museum activities seemed to come to a halt and memberships fell off.

On his arrival in Halifax, Lismer had found only the remnants of an art gallery: pictures were hanging dusty and neglected in rooms above the art school. Quickly, he resurrected the Museum's charter, started a membership drive, and cleaned up the display rooms.[21] A loan exhibition of paintings from the NGC opened there in late February 1917 and was well received. Lismer immediately set about procuring, with Greig's collaboration, sixty prints from the *Fourth Exhibition of Canadian Etchers*.[22] Planning to include an etching demonstration on the art school's press, Lismer remarked nervously that it had been a long time since he had etched a plate or printed one.[23] The show, which ran from 19 May 1917,[24] was deemed a success by Lismer, and the Museum's council purchased four prints, one each by Greene, Stevens, Raine, and Smith.[25]

A third exhibition organized by Lismer opened on 30 November 1917, consisting of lithographs by Senefelder Club members, Whistler, and Fantin-Latour, all borrowed from the NGC. It was coupled with a loan show of small paintings and sketches from the OSA. Opening night guests were treated to a demonstration work prepared by

Lismer – *The Transport, Halifax* (fig. 150) – displayed along with its stone, which he had managed with some difficulty to have made in Halifax at Royal Print & Litho. At Christmas, he would send the same lithograph to Eric Brown, who would swiftly grasp its import as the first true Canadian artist's lithograph in the Senefelder Club tradition and purchase an impression for the National Gallery. Meanwhile, the lithography exhibition had come to an abrupt close on 6 December, when the cataclysmic explosion in the harbour shook the works off the wall: Lismer rescued the undamaged glass from the frames to repair the shattered windows.

In the midst of his own important wartime commission for lithographs, Arthur Lismer took time to mount a selection of war lithographs from the British government. Opened on 21 February 1919 by Nova Scotia's Lieutenant-Governor, the show drew a scant 150 visitors. By this time Lismer's ardour for proselytizing had been seriously diminished by local indifference.[26] He also complained of receiving no assistance in mounting the show, and concluded in frustration: "It's the last exhibition I shall put on here, I'm afraid. There is absolutely no interest."[27] True to his word, he left Halifax in August 1919 to return to Toronto.

Montreal

From 1900 to 1910, Montreal could still be called the preserve of the print collector not the printmaker. The city's cultural bastion remained the Art Association of Montreal. Its art school, as run by William Brymner, restricted the curriculum to anatomy, elementary drawing, painting, and watercolour. The AAM's other primary activity continued to be the annual spring exhibitions, which never bothered to include a special section devoted to prints. In fact, between 1906 (when Clarence Gagnon submitted two recent works) and 1920, the AAM's spring shows only contained a light scattering of prints. H. Ivan Neilson's *Deepening of the St. Charles River* (cat. 86) was shown there in 1913.

In 1907, the AAM launched its third Black and White exhibition, which ran from 24 January to 9 February, attracting a total attendance of 844.[28] This standard and not terribly exciting international display of 400 prints showed little progress

Fig. 150
Arthur Lismer
The Transport, Halifax, N.S. 1917
(cat. 65)

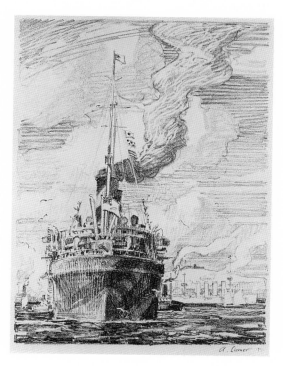

or initiative beyond the Black and White exhibition of 1888. As before, the AAM relied on local collectors, with dealers F. Keppel & Co., H. Wunderlich & Co., Durand-Ruel & Sons, W. Scott & Sons, and Henry Morgan & Co. rounding out the display.[29] The selection ranged from old masters to contemporary European and American painter-etchers. The only Canadian was Clarence Gagnon with thirteen recent etchings, six of which were from the stock of his Montreal dealer, Morgan.[30] Perhaps of greatest interest to the public was the set of twenty-eight etchings by Queen Victoria and Prince Albert pirated by the royal couple's printer in 1840. The exhibition attracted no critical attention in the press.

The contribution of local dealers to the third Black and White exhibition made evident the growth of the print market in Montreal. The city's art dealers continued to cater to the tastes of its print collectors. W. Scott & Sons, which had been in the print business since its inception, publishing Krieghoff's chromo-lithographs and carrying Stephen Parrish's etchings, now broadened its stock to include Pennell, Whistler, Short and many other British etchers. James Morgan, who ran a gallery in his department store, started carrying Clarence Gagnon's etchings in 1905 and found a ready market for them. Taking over from his father in early 1906, F. Cleveland Morgan showed even higher ambitions for the dealership. Acting as the agent for E.J. van Wisselingh & Co. of Amsterdam and London, he launched a month-long sales exhibition of modern international etchings in 1909.[31] Another Montreal dealer Johnson & Copping had begun advertising as "print sellers" as early as 1905.[32] They became Gagnon's agent in Canada in 1909, sending his prints to various venues across the country. From 1913 on, James Copping operated Copping's Art Store, out of which he continued to support Canadian printmakers. He was the agent for local etchers Herbert Raine and Charles Simpson.[33] Montreal was unique in Canada for its support of a local fine art print trade.

The third Black and White exhibition exposed a definite weakness of the AAM – not a single work came from its own collection. Indeed, it had no viable print collection upon which to draw. Not until the spring of 1918 did the

Association's council create such a section under the jurisdiction of the library, inaugurating it with a loan show of prints from local collectors.[34] Among gifts to the collection were twenty-three prints, only two of which were Canadian: Cleveland Morgan donated etchings by Gagnon and Herbert Raine. For much of 1919 the new print room was taken over for painting exhibitions.[35] That was the year the architect William S. Maxwell consented to look after the print section. With his long history of supporting printmaking locally, Maxwell was a good choice, but his appointment underscored that the running of the print room was an amateur operation. In 1920, Maxwell tried to put together a print exhibition program, but was only able to mount a show of etchings by Walter R. Duff;[36] a display of Canadian etchings from the NGC was postponed indefinitely. Actively seeking contributions towards a purchase fund, as well as soliciting gifts, Maxwell set the tone by donating the drypoints he helped Gagnon make in 1903, along with prints by Raine and Brymner. However, Japanese prints dominated the 1919 and 1920 purchase lists. Canada's oldest fine art institution finally had a print room of sorts, but it did not have a well-defined acquisitions policy or program.

The focus began to shift from the collector to the painter-etcher in the second decade. Early intimations of printmaking activity in Montreal include the etchings of Ethel Seath that appeared at the 1907 RCA annual and the 1908 Spring show of the AAM. Where Seath learned to etch is unknown; we can surmise that it was during her schooling at the Council of Arts and Manufactures, or while on the art staff of the *Montreal Star*.[37] The dearth of artists' societies in the city at the time meant that there was no group to share her printmaking interests, but she was adopted by Toronto's etchers.[38] The local painter-etchers who came after Seath all belonged to the Arts Club.

Founded in May 1912 at the studio of Maurice Cullen, the Arts Club was born out of the Pen and Pencil Club, an informal body working out of Edmond Dyonnet's studio.[39] William S. Maxwell served as its first president and oversaw the refurbishing of the club house which opened in March 1913. The Arts Club gave the Pen and

Pencil Club shelter under its roof, thus increasing the number and variety of artists on the premises. Incorporated in February 1913, the Arts Club defined its role as a place for "Artists, Architects and Men of similar tastes to meet socially, hold exhibitions and generally stimulate an interest in Art matters." In addition to Cullen and Dyonnet, charter members included Herbert Raine, Charles W. Simpson, and Cleveland Morgan, who were joined by Robert Harris, L.M. Kilpin, Clarence Gagnon, and James Crockart.[40] Save for Dyonnet and Morgan, all these Arts Club members became painter-etchers or tried their hand at the process. Gagnon did not pull any prints with members, but he did exhibit his etchings at the Club shows.[41]

The first of the Arts Club members to take up etching was apparently Charles W. Simpson. His earliest efforts were on view at the 1911 RCA show.[42] Simpson's teacher could have been the Scottish architect James Crockart, a student of Ernest Lumsden, who lived briefly in Montreal in 1911.[43] However, as Simpson's etchings were technically awkward and heavy, it is more likely that he was self-taught and not very knowledgeable about the medium's aesthetics. He never developed a sensitive touch, but he did pass on his interest in etching to other artists, such as Robert Harris who only dabbled in it, producing a few trial proofs of portrait heads and a rather weak etching of

Nelson's Column in Montreal. In 1914, Herbert Raine took instruction from Simpson.[44] Crockart returned to Montreal at this time, and one sees the quality of etching among the Arts Club membership picking up. The art teacher L.M. Kilpin, recently immigrated from London with South Kensington training, also began etching, and his prints bear traces of Raine's stylistic influence.

Herbert Raine (1875–1951) was working as an architect in Montreal when business dried up at the outbreak of the Great War; he bought a press and set himself up as an etcher. Raine's first prints, done in 1914, made use of highly finished drawings and watercolours done a dozen years earlier while in Europe, and are among the most painterly prints that he ever executed. They are large, dramatic, and technically ambitious, combining etching with aquatint and drypoint, and occasionally soft-ground etching. Stylistically, they are thoroughly British, though still somewhat inept. There is also a marked tendency to manipulate surface ink (a device for which Simpson had a lasting weakness).[45] From the outset, Raine showed a better grasp of the possibilities inherent in the medium than his teacher Simpson ever did, and his stylistic indebtedness to Frank Brangwyn tells of a man quite familiar with current etching aesthetics. The Brangwyn-like *Evening, the Canal, Montreal* (cat. 92), perhaps his first Canadian subject, was exhibited at the RCA in 1915 and was purchased from the show by the NGC.

By 1915 Raine found within his own surroundings, particularly in Old Montreal, an abundance of the sort of "picturesque bits," to use the parlance of the day, for which he and other artists had scoured Europe. His preference for old styles of architecture caused him concern at the impending demolition of some of the most ancient streets and spurred him into recording them. The area depicted in *Old Houses in a Courtyard, St. Vincent Street, Montreal* (fig. 152)[46] was etched repeatedly: it was doomed to vanish in 1920 to make way for the new courthouse. From 1914/15 to late 1920, Raine produced at least thirty-two prints of this quarter,[47] which were shown in December 1920 at the gallery of W. Scott & Sons.[48] So successful was the exhibition that it was decided to photo-mechanically reproduce the best of the prints in book form,

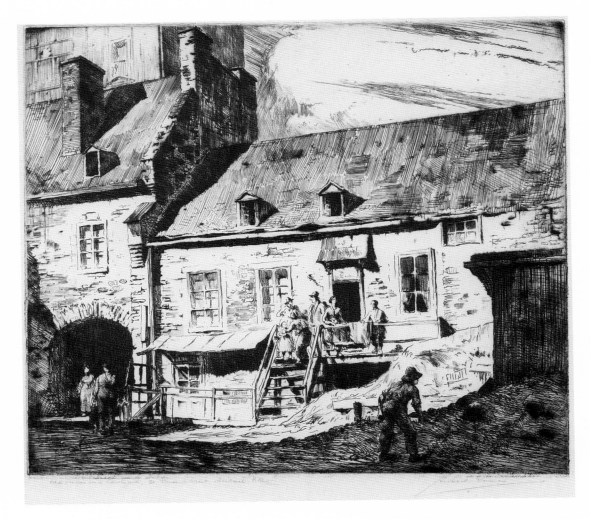

Fig. 152
Herbert Raine
Old Houses in a Courtyard,
St. Vincent Street, Montreal, P.Q.
c. 1918
(cat. 95)

as *Old Montreal, Reproductions of Seventeen Etchings by Herbert Raine*; it was published in an edition of 500 in May 1921.[49] While it has been assumed that the artist embarked upon his etchings of Old Montreal in emulation of Meryon's "Eaux-fortes sur Paris,"[50] these prints are a natural continuation of Raine's long habit of drawing architectural details and quaint corners, and he should be credited, moreover, with being one of the first, along with Neilson, to recognize a potential market for prints of local rather than European scenes. Raine is known today largely through the dissemination of this book, as well as a smaller publication done with Birks in about 1927, which reuses six subjects and introduces four new ones.[51]

Between 1914 and 1920, Raine gradually freed himself from the busy, literal style with which he began, and simplified his technical approach. By 1917–18 many works were displaying a judicious use of blank space and a lighter touch in the etching, now mixed deftly in equal parts with drypoint. As the confidence of his work on the plate increased (always done from drawings rather than directly from nature, since the reversal inherent in printing would have been unacceptable to the architectural historian in him), a preference emerged for the immediacy and spareness of drypoint alone. This technique requires great sureness of draughtsmanship, and Raine's long years of drawing practice paid off in the 1920s and 30s with many outstanding plates in this medium.

Montreal was by no means Raine's only source of material. There is evidence of an extensive trip through the Charlevoix region and across the river to Kamouraska in the summer of 1916. Dated drawings,[52] as well as prints, show him returning

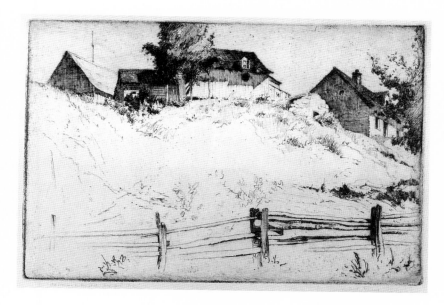

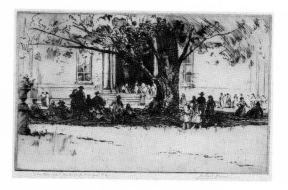

Fig. 154
Herbert Raine
The Pilgrims, Sainte-Anne-de-Beaupré, P.Q. 1917–18
(cat. 94)

Fig. 153
Herbert Raine
*Old Houses on the Hill,
Beaupré, P.Q.* c. 1917
(cat. 93)

repeatedly to the Beaupré and St-Joachim areas, lovingly recording the rustic farms and village streets. Two works from this period are *Old Houses on the Hill, Beaupré* (fig. 153) and *The Pilgrims, Sainte-Anne-de-Beaupré* (fig. 154). His is the most thorough documentation of this phase in Québec life of any printmaker. Herbert Raine swiftly became Montreal's pre-eminent painter-etcher, and was especially acknowledged in Estelle Kerr's article of 1916.

Winnipeg

As the new century began, Winnipeg was Canada's third largest metropolis. Energetic immigration and homesteading policies had combined with a healthy international market for wheat to propel the city's evolution from fur trading post into the rail and commercial centre of the Canadian West. However, situated at the eastern edge of the Prairies, Winnipeg remained relatively isolated, and its outlook tended to be regional. The city was experiencing, nonetheless, a level of prosperity that could support a professional art community, albeit a small and vulnerable one.

In 1903, several professional artists banded together to form the Manitoba Society of Artists, modelled after the OSA, with Frank Armington serving as the first vice-president; in 1911, they would reorganize themselves as the Manitoba Society of Artists and Craftsmen.[53] At their foundation, they called for the establishment of a

municipal gallery, an art school, and a provincial institute that would afford access to art instruction and develop the nucleus of a collection. During the first few years, the Society managed to organize members' shows and brought in work from the Art Students' League of New York and the Art Institute of Chicago. However, they were not able to mount large exhibitions on a regular basis.

Also in 1903, the Women's Art Association, headquartered in Toronto, opened a branch in Winnipeg with the intention of sponsoring art classes, lectures, and hosting exhibitions. The local branch separated from the Toronto group in 1909 and formed the Western Art Association, to promote the study of art and to create and maintain an art collection. The group's prime mover was Mary Clay Ewart, an American artist trained at the Pennsylvania Academy of Fine Art. The two associations were mutually supportive and worked hard to advance the fine arts in Manitoba.

At the time these organizations were formed there was only one possible venue for an art exhibition in the city – the Winnipeg Industrial Exhibition. This annual summer fair had begun in 1891 and would continue through to 1915, and an art section was an important facet of it. In 1906, the prosperous local contractor James McDiarmid joined its art committee, marking the beginning of an exemplary career of art patronage. McDiarmid oversaw improvements to the gallery space and an upgrading of the quality of the art section.[54] Under

his leadership, the Winnipeg Industrial Exhibition began to sponsor shows featuring local artists, as well as elaborate loan exhibitions, for example the one by RCA and OSA members, and other prominent Canadian and international artists in 1908.[55] This show included a set of etchings by Clarence Gagnon which were likely the first artist's prints ever seen at a public exhibition in Winnipeg.

Throughout 1911 and 1912, the concerted efforts of the Western Art Association, the Manitoba Society of Artists and Craftsmen, and James McDiarmid were aimed at establishing an art gallery. As a member of the Winnipeg Industrial Bureau, McDiarmid procured space in their new building for a gallery and funds toward its operation. The Winnipeg Museum of Fine Arts opened in December 1912 with an exhibition of recent works by RCA members that included etchings by W.W. Alexander, J.W. Beatty, J.W. Cotton, Clarence Gagnon, T.G. Greene, Arthur Lismer, Charles Simpson, Dorothy Stevens, and W.J. Thomson. It was Winnipeggers' first opportunity to see the work of Canada's leading painter-etchers. The museum afforded the city a year-round venue for important loan shows. An exhibition of contemporary Dutch art from the dealership of E.J. van Wisselingh arrived there in April 1913; sponsored by the Western Art Association, it offered an assortment of etchings. In January 1914, the Winnipeg Museum of Fine Arts hosted an RCA exhibition, followed in March by the Royal British Colonial Society show, which boasted an impressive display of etchings by Brangwyn, Short, Pennell, and R.W. Macbeth. The Museum also organized its own events, putting on Western Canadian Artists' annuals and the *Art Union Exhibition* for the Winnipeg Patriotic Fund.[56]

A glimpse into the state of private print collecting in Winnipeg may be gained from the last two shows mentioned. The June 1913 *Western Canadian Artists' Exhibition* assigned a special place to etchings borrowed from local collectors James McDiarmid and George Wilson. It is said that Wilson's collection of etchings contained "samples of almost all the well-known specialists in this line."[57] In reality, he possessed a few prints by such modern masters as Seymour Haden, Appian, and

Fig. 155
Cyril H. Barraud, Winnipeg, August 1915
Photo courtesy of John P. Crabbe, Winnipeg

W. Lee Hankey. McDiarmid's collection was just beginning, and he would not add an appreciable body of work by international printmakers until the 1930s.[58] But he did not hesitate to recognize the talent of the newly arrived Cyril Barraud in 1913 (indeed, one of Barraud's first Winnipeg subjects was the yard of McDiarmid's downtown workshop, cat. 10).[59] At the Art Union show of December 1914, the patriotic citizen could purchase etchings by Legros and Lalanne or reproductive engravings after the sentimental Victorian paintings of John Everett Millais, all drawn from the collections of anonymous donors.

Up to this time, art education in Winnipeg had been a matter of private schools or private studio instruction. The situation was somewhat alleviated with the creation of technical schools such as St. John's in 1912, but the demand for a formal art school persisted.[60] In 1913, with the strong support of the artists' associations, McDiarmid's committee at the Industrial Bureau decided to open an art school in their building and began searching for staff. Alex J. Musgrove, a Scot with teaching experience at the Glasgow School of Art, was hired as principal of the new Winnipeg School

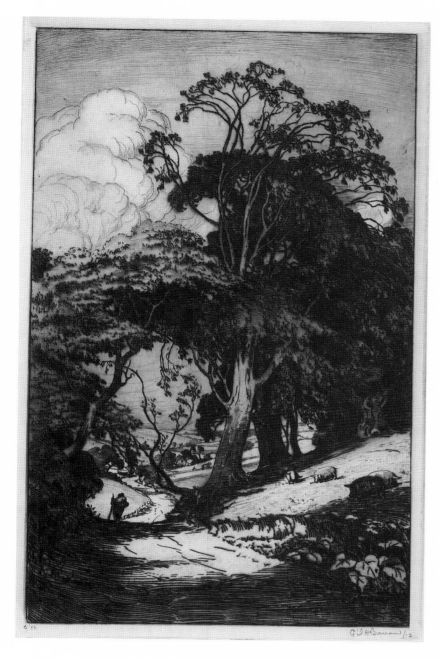

Fig. 156
Cyril H. Barraud
The Road to the Valley 1913
(cat. 11)

natural leader in Winnipeg's small artistic community. In February 1914, he was elected president of the Manitoba Society of Artists and Craftsmen, and in March 1915, he and Mary Ewart founded the Winnipeg Art Club – a loose association of professional and amateur artists who would gather on Saturday evenings for informal life classes.[63] The Club counted the city's most talented artists among its members: F.H. Brigden, Ewart, Barraud, Walter J. Phillips, Valentine Fanshaw, L.L. FitzGerald, and George Fawcett. The collector George Wilson also belonged. The Winnipeg Art Club held its inaugural exhibition in May 1915 at Richardson Bros. Galleries.

Three members – Barraud, Fawcett, and Phillips – who had all arrived in Winnipeg from England between 1912 and 13,[64] found the Club a conducive milieu for a mutual interest in printmaking. **George Fawcett (1877–1944)** was a freelance commercial artist and **Walter Joseph Phillips (1884–1963)** was the art instructor at St. John's Technical School. Cyril Barraud was the most experienced painter-etcher of the three, with a solid exhibition history that included a British Royal Academy annual in 1912 and good notices in *Studio* magazine.[65] He had promptly set up his press and begun producing etchings of local scenes and ones derived from his British watercolours. An example of the latter is *The Road to the Valley* (fig. 156), done in 1913. The piece marked a turning point in his etched production, showing a mature and craftsmanlike treatment with a very painterly use of plate tone. The earlier awkwardness, which manifested itself in a tendency to handle subjects as mere line drawings, had passed. Stylistically, Barraud had looked to the realist work of such contemporary British etchers as Charles Holroyd, Alfred East, and William Strang, with their emphasis on strong outline and massing of forms. An advocate for etching, he lectured on the art to the Western Art Association on 16 January 1915.[66]

George Fawcett's first efforts in the medium suggest that he was self-taught. Made before leaving England, his early pieces appeared in the major Winnipeg art shows of 1913–14, and seemed to blend his work as an illustrator with English and continental holiday sketches. They did not demonstrate the technical sophistication that was the

of Art. The Englishman **Cyril Henry Barraud (1877–1965)**, who was lured to the city to work as an architectural draughtsman, became a part-time teacher.[61] Even though both Musgrove and Barraud had a background in etching, no printmaking courses were offered at the school when it opened in September 1913.[62]

Barraud's previous experience on the executive of the Gilbert-Garret Sketch Club, which organized the large annual exhibitions of student work from all of London's art schools, made him a

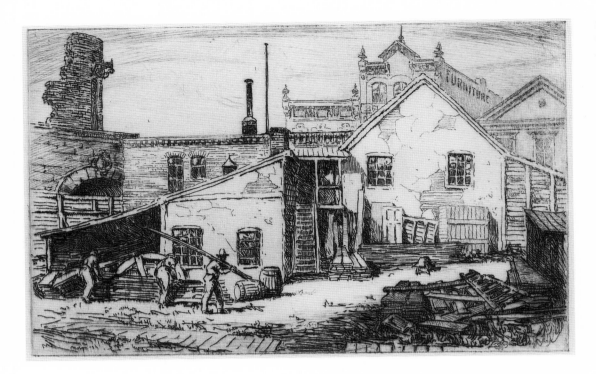

hallmark of British art school instruction. At the Art Club's Saturday evenings, Fawcett was evidently invited to resume work on Barraud's press, and his first etching of a Winnipeg subject was put on view at the Club's 1915 show at the private gallery belonging to Arthur and Howard Richardson. Barraud never persuaded Fawcett to be more adventurous in the medium, or more careful in his use of materials: Fawcett seemed unconcerned that the heavy watercolour paper he utilized often cracked in the press. However, Barraud's influence is felt in Fawcett's choice of subjects: Barraud's *J. McDiarmid's Yard* (fig. 157) and Fawcett's *The Blacksmith's Yard* (fig. 158) are both unprecedented images for this period in Canadian printmaking. As Fawcett gained confidence, he tried his hand at aquatint, employing it in a uniform, flat-toned, rudimentary manner, reluctant to explore its subtle tonalities. His *St. Boniface* (cat. 28) was evidently inspired by Whistler's prints of the Battersea and Putney bridges, which he would have seen in books and periodicals.

Given the commonality of background, experience, and stylistic concerns, in the city's tightly-knit art community friendship between Phillips and Barraud was almost a foregone conclusion. They may well have been sketching partners during

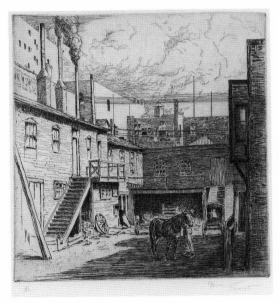

their first winter in Winnipeg. Certainly, they teamed up in the summer of 1914 at Lake of the Woods. A joint exhibition at Richardson Bros. followed, with both artists presenting watercolours of shared subjects, while Barraud also showed several etchings. To Phillips, the end of the 1915 school year must have seemed the opportune moment to learn etching from Barraud,[67] but their sessions were curtailed by 27 August 1915

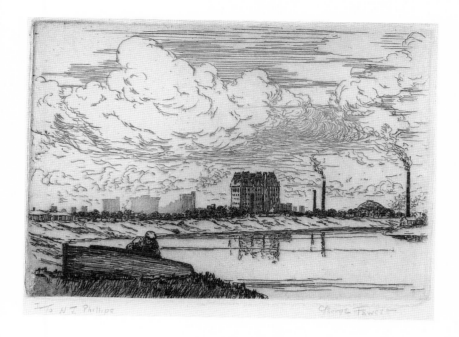

Phillips began to produce a solid body of etching. The broad spread of Winnipeg, characterized by two rivers and a low, flat horizon line, captivated Barraud. Through his depictions of the modern city, he ably countered the aesthetic dictum of the European picturesque, and demonstrated that the prairies could offer their own specific appeal and rewards to the etcher. Not only did Barraud appreciate the city's particular urban geography, he also acquired a love of the wide and uninhabited landscapes of Manitoba's countryside, its many lakes and rivers. Fawcett and Phillips, too, recognized and adopted these elements in their art. All three developed a remarkably similar subject vocabulary, and one need only compare Fawcett's *The Fort Garry* (fig. 159) with Barraud's *Fort Garry and the Red River* (fig. 160), or Barraud's *Keewatin Channel* (fig. 161) with Phillips' *The Lake* (fig. 163) to gauge their close working relationship. A common interest in describing functional yet decaying commercial elements of the city's river frontage is manifest in Fawcett's *St. Boniface* (cat. 28) and Phillips' *The Red River at Winnipeg* (cat. 88).

In terms of technique, Barraud brought to Winnipeg the pristine mastery of etching as taught by Frank Short and his former students, now instructors at the best British art schools. This near flawless craftsmanship was never fully realized by Fawcett, who experimented with combining

when Barraud enlisted in the Canadian Army. There had been time enough, however, for Phillips to become sufficiently enamoured of etching to purchase Barraud's press and equipment, pursuing the craft in association with Fawcett.[68] Phillips made his debut as a printmaker in 1916 at the *Third Exhibition of Canadian Etchers* in Toronto.

Barraud, Fawcett, and Phillips can be said to have formed their own school of etchers. Under Barraud's guidance and example, Fawcett and

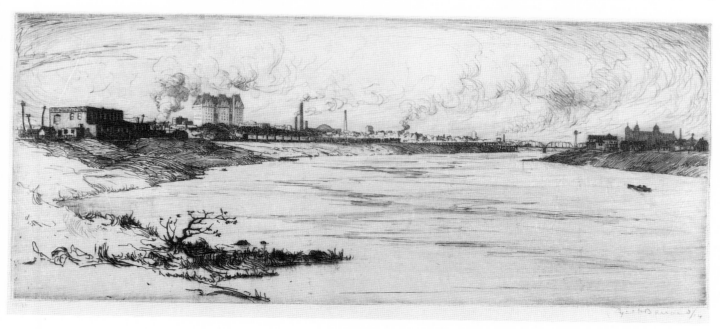

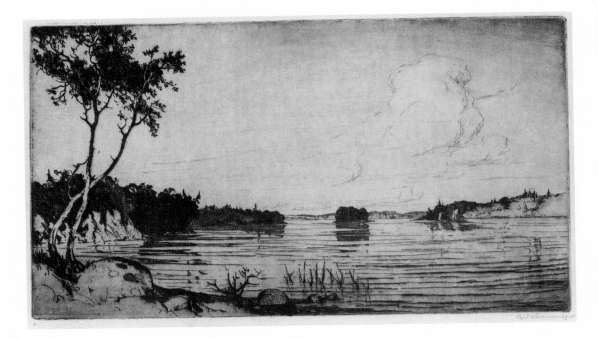

Fig. 161
Cyril H. Barraud
The Keewatin Channel 1915
(cat. 13)

techniques such as aquatint and mezzotint but lacked the inclination to master them.[69] Phillips, however, possessed the perfectionist's disposition which would only allow for the most thoughtful and considered execution of a print. When Barraud was away at war, Phillips found little in Fawcett's technique to emulate; but on his own he made swift progress, and his skill at the craft of etching was among the best of Canadian trained artists to date. *The Backwater* (fig. 162) of 1917 is a remarkable achievement considering the limited opportunity Phillips had in Winnipeg to examine first-rate prints. Phillips' strength as a draughtsman came into play in etched portraits such as *Mrs W.P. Sweatman* (fig. 164), a powerful character study.[70] In landscape etching, he showed a growing interest in Japanese stylistic elements. These prints became richer in tone and more complex in their attempt to render visual effects, which pushed his etchings towards a closer stylistic proximity with his watercolours.

In 1919, Fawcett left Winnipeg. Walter Phillips continued printmaking, although in 1918 he had forsaken etching for colour woodcuts. He would excel at this medium, acquiring an international reputation and exerting a major influence on artists across the country for years to come. The woodcuts led Phillips to new printing colleagues

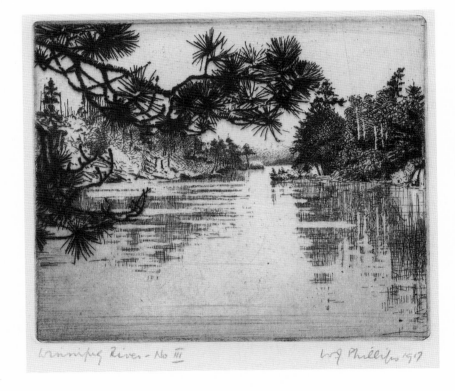

Fig. 162
Walter J. Phillips
The Backwater 1917
(cat. 90)

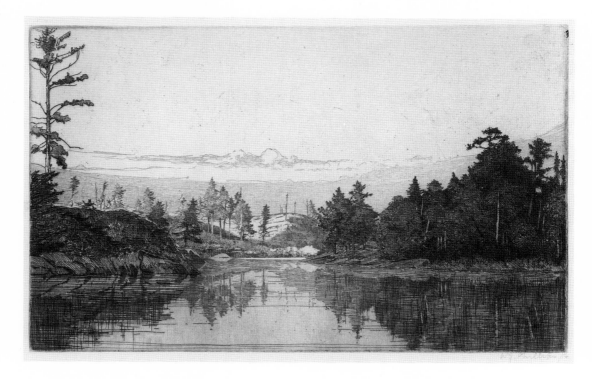

Fig. 163
Walter J. Phillips
The Lake 1916
(cat. 89)

Fig. 164
Walter J. Phillips
Mrs W.P. Sweatman 1917
(cat. 91)

among the artists associated with Brigden's, a commercial wood engraving company that had opened a branch in Winnipeg in 1914. This new alignment of artists solidified Winnipeg's place as a leading centre for printmaking in Canada. In 1919, the Winnipeg Art Gallery began to host several print-related exhibitions, including the Society of Canadian Painter-Etchers' first show that November.[71] In the first four months of 1920 alone, they showcased 100 lithographs by Joseph Pennell, 250 English woodcuts from George Wilson's collection, and 80 lithographs circulated by the Senefelder Club. Phillips became an art critic on the *Winnipeg Tribune*, giving himself a pulpit from which to proselytize the art of printmaking. More importantly, he continued to teach, in Winnipeg, Calgary, and Banff, imparting to several generations of Western Canadian printmakers his love and respect for the craft.

During the period covered in our study, printmaking west of Winnipeg was negligible. In the other Prairie provinces, the large urban centres necessary to sustain a core of professional artists had yet to evolve sufficiently. In the more established province of British Columbia, there had been some activity by visiting artists: Ernest Lumsden,

for example, began a set of etchings of Victoria in 1910. However, the only resident artist who can be documented to have made prints was James W. Keagey, a Vancouver architect with some training under Joseph Pennell; he placed a few etchings on view at the 1917 British Columbia Society of Artists annual exhibition.[72] By 1920 British Columbia's isolation from current art developments was only just beginning to be broken.

The Society of Canadian Painter-Etchers

At the September 1912 business meeting of the Graphic Arts Club, Arthur Lismer, supported by the Club's vice-presiden T.G. Greene, expressed concern over members' diminishing enthusiasm and commitment.[73] The two were appointed to head a committee to look into revitalizing the GAC. The new program, which would add composition classes and at least one lecture a month, was approved in October.[74] The GAC's name would be changed to the Society of Graphic Art (SGA), with the membership – illustrators, designers, printmakers, painters – to be as open as possible. They declared their intention to accept members nationwide and to hold exhibitions in various Canadian cities.[75] Their first annual exhibition, organized by Lismer, was to be in London, Ontario, but opened instead on 7 November 1913 at the AMT's rooms in the Toronto Reference Library.[76] Subsequent to this successful show, the SGA obtained the rights to hold the RCA life class, which had Academicians serving as instructors and was open to members of all art societies.[77] The life class raised the SGA's profile, and its accompanying grant lent economic stability. Although etching was still encouraged at the SGA, which also supported the AMT's etchers' shows, the focus of the organization had altered, and printmakers now felt that their needs were not being treated adequately.

Emboldened by increasing success, the SGA's painter-etchers considered creating their own society. At a meeting in early June 1915, the formation of an etching society was discussed, with W.W. Alexander putting forward the motion that a branch of the SGA be created to foster and promote the art.[78] No doubt, the print exhibitions orchestrated by Greig in 1914–15 affirmed the viability of such displays in Canada. But as long as

Fig. 165
William J. Thomson, in about 1920
National Gallery of Canada Library

the AMT was willing to continue the series, there was little incentive for the existing painter-etchers to take on the work of mounting their own shows. Besides, the two printmakers who were the most active organizers – Alexander and Greene – were already occupied with the running of the Arts and Letters Club and the SGA, respectively.

By April 1917, even as Greig was opening the *Fourth Exhibition of Canadian Etchers*, he was already tiring of the job. Concurrently, Eric Brown paid a visit to an exhibition of the Painter-Gravers of America in New York, whose representative extended an invitation to all Canadian etchers to join. Brown wished to pass on the invitation through Greig, who responded: "I shall be very glad to send a circular of the Painter-Gravers of America to each of the Canadian etchers. Personally, I would very much rather see the Canadian etchers form their own society, as I fear an international society could not be very successful."[79] Greig reiterated his misgivings to H. Ivan Neilson;[80] and to Lewis Smith he wrote: "I also hope that the Canadian etchers will soon form a society as I think they should, and I think the time has come for them to do it."[81] Believing his suggestions had fallen on deaf ears, Greig set about organizing a fifth exhibition of Canadian etching.[82]

Thus, on 22 January 1918, just days after sending out to artists for submissions, Greig must have been surprised and elated to receive the following news from Fred Haines: "You have no doubt heard of our forming an etching society. Our intention was not to conflict in any way with the good work you are doing, but rather by stimulating the fellows to greater endeavour, indirectly help you. The officers are to draw up a constitution, and I wondered if you had the address of Bertha Jacques, who I think is secretary of the Chicago Society of Etchers ... I would be grateful for any suggestions you might have to make this society a success."[83] The officers were William J. Thomson, president, W.W. Alexander, vice-president, and Fred S. Haines, secretary.[84] Thomson, now working in Philadelphia, was more of a figurehead, in honour of his long history – Haines took on the actual running of the new Society of Canadian Painter-Etchers (CPE). Greig's response was generous: he set aside the April exhibition slot for the CPE and turned over his updated address list of Canadian printmakers. By February, Haines was writing to etchers across the country offering membership.[85]

April passed without the nascent society managing to mount its first exhibition. By summer, the CPE had teamed up with the SGA to arrange the graphic arts section at the 1918 CNE, furnishing 89 etchings, drypoints, mezzotints, wood engravings, and lithographs by twenty-one artists. They were now in a position to realize one of the SGA's enduring dreams – a show that would tour the country. The CPE's portion of the CNE display would open in Halifax on 1 October.[86] Eric Brown informed them about further contacts and venues in Saint John, Sherbrooke, Montreal, Hamilton, Fort William, Winnipeg, Regina, Moose Jaw, Saskatoon, Edmonton, Prince Albert, and Vancouver. The precise exhibition schedule cannot be determined.[87] No catalogue was produced; fortunately, the presentation at the Winnipeg Art Gallery in November 1919 was reviewed in detail by W.J. Phillips.[88] The show that the Canadian Painter-Etchers would title their first annual exhibition opened at the Art Museum of Toronto on 26 April 1919, continuing to 19 May; fifty-four more CPE annuals would occur. As the second decade of this century came to a close, Canada finally had a functioning artists' society devoted exclusively to printmaking.[89]

The Canadian War Memorials Fund

In November 1916, newspaper magnate Max Aitken, later Lord Beaverbrook, established the Canadian War Memorials Fund (CWMF), headquartered in London, to document and publicize Canadian military activities during World War I.[90] A major function of the organization would be the commissioning of artists to paint pictorial records. Beaverbrook brought his considerable influence and monied connections to the Fund, making it into an effective propaganda machine. In March 1917, Britain set up a similar organization, the British Pictorial Propaganda Committee. The Senefelder Club immediately persuaded it to commission sets of lithographs, thereby setting a precedent for the Canadian body to follow.[91]

Initially, Beaverbrook was able to run the Fund as a private patronage scheme out of London, selecting only British artists. But word of the Fund and of this perceived snubbing of Canadian artists overseas reached their colleagues back home, causing some dismay. Sir Edmund Walker, as chair of the federal Advisory Arts Council, conferred with Eric Brown before responding. Beaverbrook proved receptive to their arguments in favour of a greater involvement of Canadian artists, and in August 1917 he arranged for the appointment of Cyril Barraud, Gyrth Russell, James Kerr-Lawson, and A.Y. Jackson.[92] Caroline Armington was taken on at her own request in January 1918.[93] (Barraud, Russell, and Armington were commissioned to make full editions of prints.) Not completely assuaged by the appointment of a few token Canadians to the Fund, artists in Canada put pressure on Walker and Brown. The latter must have viewed the CWMF's £15,000 with envy; the war years saw the NGC budget shrink from $100,000 in 1914 to $8,000 in 1918, allowing little prospect of meeting Canadian artists' demands.

In December 1917, Eric Brown received Arthur Lismer's timely Christmas present – the demonstration lithograph *The Transport, Halifax* (cat. 65). In a follow-up letter, Lismer expressed

his desire to do his bit for Canada's war effort from Halifax, which "more than any other city in the Dominion ... is of vital interest as a war city."[94] Brown was open to this first bid to document happenings on the home front, but lacking funds and a clear mandate Walker hesitated. In the spring of 1918, however, Canadian artists got wind of British artist Harold Gilman being dispatched to record naval activity in Halifax and were outraged. To salvage the situation, Beaverbrook's offer to turn over the CWMF to Walker and pass on a fund of $15,000 was accepted.

Arthur Lismer was the first to be commissioned by the Fund to provide paintings and lithographs of Halifax harbour in wartime.[95] He would make a total of sixteen lithographic subjects for the CWMF, but not without difficulty. Experience was not the issue, for Lismer had worked with lithography before immigrating; the main problem was "antagonism" to the project on the part of the local printing firm, Royal Print & Litho.[96] W.W. Alexander came to the rescue, sending Lismer zinc litho plates. As was his practice, Lismer made field sketches around the harbour and aboard naval vessels, which he worked up into finished drawings in his studio, then redrew onto the litho plates. In mid-November, Lismer took about six completed plates to Toronto for proofing at Alexander & Cable.[97] The results were discouraging, for he found the metal plates unresponsive to his style of drawing. On his return to Halifax, a new and more understanding manager had taken over at Royal Print & Litho. The guarantee from the CWMF of full payment for printing costs sealed the bargain, and Lismer set to work, enthusiastically drawing on the lithographic limestone. The work in the print shop proved rewarding this time, despite the printers' sullen refusal to meet Lismer's challenges to exceed their normal practice. *The Little Drifter and the Big Freighter* (fig. 166), *H.M.C.S.* Grisle *on Convoy Duty* (fig. 167), and *Harbour Defence, Winter* (fig. 168), done in the Senefelder Club spirit, show that the artist revelled in the process of drawing directly on the stone, boldly exploiting the aesthetics of the grease pencil, liquid tusche, and scraping (or grattoir), to capture in a new mode the wonderful agility and passion of his drawings.

Fig. 166
Arthur Lismer
The Little Drifter and the Big Freighter 1918–19
(cat. 66)

Fig. 167
Arthur Lismer
H.M.C.S. Grisle *on Convoy Duty* 1918–19
(cat. 67)

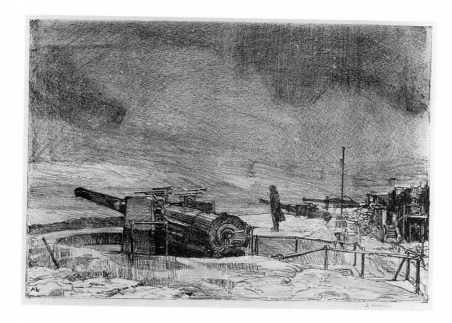

Fig. 168
Arthur Lismer
Harbour Defence, Winter 1919
(cat. 68)

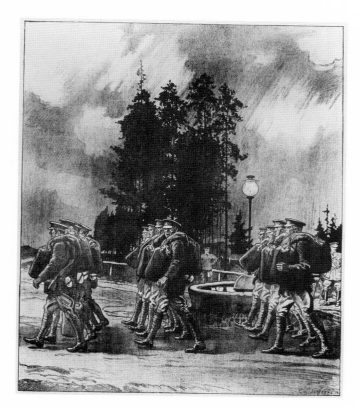

Fig. 169
C.W. Jefferys
Departure of the Siberian Battery from Petawawa Camp 1919
(cat. 58)

In July, Ernest Fosbery offered to make etchings of training camps, but this commission was given instead to **Charles William Jefferys (1869–1951)**, who completed a set of transfer lithographs of various facilities in Ontario. Jefferys' prints were made at Alexander & Cable, and in spite of his long friendship with Alexander and his own apprenticeship at Toronto Lithographing Company, he too experienced real frustrations in printing at a commercial establishment.[98] The artist first worked up his drawings on lithographic transfer paper, but after that was wholly dependent on the printers, and had to patiently wait for the large offset presses to come free of the demands of regular business. Delays between pulling proofs, subsequent revisions, and finally printing the editions could stretch the process out to weeks and months. Nonetheless, Jefferys was able to complete four lithographs for the CWMF, of which *Departure of the Siberian Battery from Petawawa Camp* (fig. 169) is the most realized, depicting newly trained soldiers marching robotlike under a stormy sky, towards an uncertain fate.

As more artists learned of the work of the CWMF, Walker and Brown had trouble sticking to their carefully drawn-up list of candidates. Frances Loring told Dorothy Stevens of her commission to record women working in Toronto munitions factories. Stevens fired off a letter to Brown requesting a commission for etchings of the same subjects and the Toronto shipbuilding yards; despite some annoyance, Brown complied. **Frederick Waistell Jopling (1859–1945)**, a commercial artist recently returned from the United States, did not wait for an invitation, and after a bit of lobbying he received one of the last commissions to record munitions manufacturing work and shipbuilding in Toronto harbour.

The prints made for the Canadian War Memorials represent a high-water mark in Canadian printmaking. As a group they show that Canadian printmakers could stand shoulder to shoulder with their colleagues from abroad. The best of Lismer's lithographs, for example *The Little Drifter and the Big Freighter* (fig. 166), depict the Canadian navy's heroic struggle against the sea as a metaphor for war. Barraud's magnificent etching *The Great Square, Arras* (fig. 170) conveys the

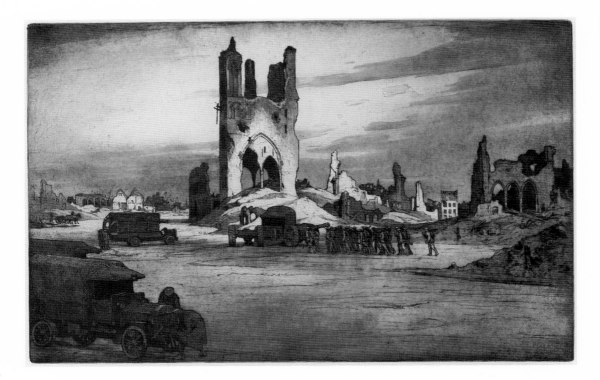

Fig. 170
Cyril H. Barraud
The Great Square, Arras 1917–18
(cat. 14)

stark brutality of the German bombardments, while his *Evening on the Ypres-Poperinghe Road* (fig. 171) is a haunting scene probably taken from the sketchbooks he filled while serving on the front. Jopling's mezzotint *Forging the 9-inch Shell* (fig. 172) is one of the collection's most memorable images, with the ferocious white heat of the blast furnace threatening to engulf the workers attending it. Dorothy Stevens wholly captures the grit and clamour of munitions plants in her *British Forgings* (fig. 173). In terms of complex composition and visual texture, her etching *Building the Freighter* (fig. 175) outdoes Robert Gagen's painting of the same subject (which, ironically, Brown and Walker had been afraid she would merely duplicate). The texture and colour of shell-shattered earth is caught in drypoint by Gyrth Russell in *Mine Crater, Vimy Ridge* (fig. 174). Russell's war etchings display an intensity and toughness that contrasts with his usually sweet-tempered subjects. And C.W. Jefferys, for whom lithography or any form of printmaking generally held little appeal, produced his best work in the medium.

In January 1919, the Canadian War Records Office, which managed the CWMF in London, put on view the works of art completed to date in

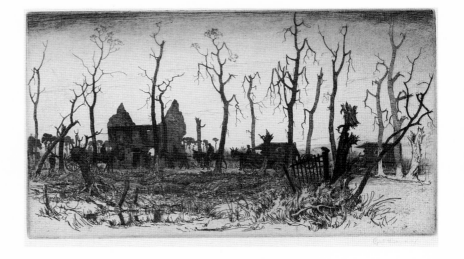

Fig. 171
Cyril H. Barraud
Evening on the Ypres-Poperinghe Road 1917–18
(cat. 15)

Fig. 172
F.W. Jopling
Forging the 9-inch Shell 1918–19
(cat. 60)

Endnotes

Introduction

1. Anthony Dyson, *Pictures to Print, the Nineteenth-Century Engraving Trade* (London: Farrand Press, 1984), p. 75.

2. Sir Edmund Walker to Eric Brown, Toronto, 27 May 1914, "Sir Edmund Walker Misc. Correspondence 1914," file 01.01, NGC Archives.

3. Seymour Haden quoted by S.R. Koehler in "The Works of American Etchers," *American Art Review* I:1 (Nov. 1879), p. 5.

4. Campbell Dodgson, *The Etchings of Charles Meryon* (London: The Studio, 1921), p. 10.

5. Martin Hardie, *Frederick Goulding, Master Printer of Copper Plates* (Stirling, Scotland: Eneas MacKay, 1910), p. 145.

6. Katharine A. Lochnan, *The Etchings of James McNeill Whistler* (New Haven and Toronto: Yale University Press / Art Gallery of Ontario, 1984), p. 55.

7. Charles Blanc, "De la gravure à l'eau-forte et des eaux-fortes de Jacque," *Gazette des Beaux-Arts*, vol. 9 (1861), p. 194.

8. Hardie *op. cit.*, p. 24.

9. P.G. Hamerton, *Etching and Etchers* (London: Macmillan, 1868). Three editions were published in London in 1868, 1876, and 1880. The outstanding popularity of the publication in North America is attested to by its printing history in Boston, where the second edition was published in 1876 and reprinted in 1878. The third edition was published there in 1881, followed by nine more printings between 1883 and 1916.

10. Joseph Pennell, *Etchers and Etching*, 4th ed. (New York: The Macmillan Company, 1931), p. ix.

11. From 1860 on, Haden assisted the South Kensington Museum (now the Victoria & Albert Museum) in forming a collection of prints by such contemporary artists as Meryon, Whistler, Bracquemond, and Legros. This became one of the first public collections that could be examined by both aficionados and practitioners of printmaking. Hardie *op. cit.*, p. 153.

12. Henry Russell Wray, *A Review of Etching in the United States* (Philadelphia: Penfield, 1893), p. 54. For a detailed account of the influence of Cadart's introduction of contemporary French etching on American artists and collectors, see Rona Schneider, "The American Etching Revival: Its French Sources and Early Years," *The American Art Journal* (Autumn 1982), pp. 40–65.

13. Gladys Engel Lang and Kurt Lang, *Etched in Memory: The Building and Survival of Artistic Reputation* (Chapel Hill and London: University of North Carolina Press, 1990), p. 55.

14. Banker, civic leader, president of the Pennsylvania Academy of Fine Art, and supporter of the Philadelphia Society of Etchers, Claghorn made his collection of 50,000 prints available to artists for private study. His collection is now in the Baltimore Art Gallery.

 Avery was a dealer and collector, and one of Cadart's first buyers. He exhibited his collections regularly at his own galleries and lent them to important public exhibitions in New York. He left his collection of 17,000 prints to the New York Public Library. James Watrous, *A Century of American Printmaking: 1880–1980* (Madison: University of Wisconsin Press, 1984), p. 18.

15. For a listing with critical description, see Thomas P. Bruhn, *American Etching: The 1880s* (Storrs, Conn.: The William Benton Museum of Art, University of Connecticut, 1985), pp. 15–23.

16. S.R. Koehler, *A Treatise on Etching by Maxime Lalanne* (London: Sampson Low, Marston, Searle & Rivington, 1880), p. 69.

17. An announcement of its publication, accompanied by a favourable critique, appeared in "The Etcher's Notes," *The Etcher*, London (Aug. 1880), n.p.

18. Maureen C. O'Brien and Patricia C.F. Mandell, *The American Painter-Etcher Movement* (Southampton, N.Y.: The Parrish Art Museum, 1984); and *Nineteenth Century American Etchings in the Collection of the Parrish Art Museum* (Southampton, N.Y.: The Parrish Art Museum, 1987). Voigt's printer's proofs are in this Southampton collection.

19. S.R. Koehler, "Lectures," *American Art Review* II:2 (1881), p. 174.

1 Breaking the Ground

1. Mary Allodi, *Printmaking in Canada, the Earliest Views and Portraits* (Toronto: Royal Ontario Museum), 1980.

2. Mary Macaulay Allodi and Rosemarie L. Tovell, *An Engraver's Pilgrimage: James Smillie in Quebec, 1821–1830* (Toronto: Royal Ontario Museum, 1989), p. 10.

3. Angela E. Davis, *The Grand Western Screenshop: Printing, People and History* (Regina: Norman MacKenzie Art Gallery, 1992), p. 10. For one of the most complete accounts to date on the illustrated publishing trade, see the same author's "Business, Art and Labour: Brigden's and the Growth of the Canadian Graphic Arts Industry 1870–1950," Ph.D. thesis, University of Manitoba, Winnipeg, 1986.

4. Elizabeth Hulse, *A Dictionary of Toronto Printers, Publishers, Booksellers and the Allied Arts, 1798–1900* (Toronto: Anson-Cartwright Editions, 1982).

5. J. Russell Harper and Peter Winkworth, *Scenes in Canada: C. Krieghoff, Lithograph Drawings after His Paintings of Canadian Scenery, 1848–62* (Montreal: McCord Museum of Canadian History, 1972). Also titled: "Exhibition of Prints in Honour of C. Krieghoff, 1815–1872," cat. nos. 15 and 16. Recently, impressions of these prints were discovered with their original labels; the titles were *Calling Moose "Huron" Indian* and *In Doubt of Track "Iroquois" Indian*. They were printed by Burland, L'Africain & Co., Montreal, and published by William Scott.

6. Agnes Chamberlin, "Introductory Note to the Fourth Edition," in Catherine Parr Traill, *Canadian Wildflowers*, 4th ed. (Toronto: W. Briggs, 1895).

7. There are four known impressions of the Paul Kane litho-
graph. The only known impression of the Raphael chromo-
lithograph *The Early Bird Picks up the Worm* is in the NGC
collection and came with what appears to be an estate list,
ascribing the lithograph to Reinhold. For further informa-
tion on the Raphael prints, see Dennis Reid, *Our Own
Country Canada* (Ottawa: National Gallery of Canada, 1979),
pp. 181–82.

8. Other Leggotypes described as "etchings" include Alan
Edson's "The Great Bluff on the Thompson River, B.C."
(*Canadian Illustrated News* 5:8, 24 Feb. 1872, p. 116) and
Sandham's "The Quarries near Montreal by Moonlight"
(*Canadian Illustrated News* 2:18, 29 Oct. 1870, p. 288). In
1871, Sandham exhibited "Old Mill at Côte St. Louis" at
the Society of Canadian Artists' exhibition; the work was
described as a "Leggotype after an etching" in the *Montreal
Gazette*, 6 Mar. 1871.

9. J.B. Woodbury, "Photo-Block Printing in America,"
Photographic News, London (7 Mar. 1873), p. 119; other
articles describing the Leggotype process are: "Talk in the
Studio," *Photographic News*, London, 28 Feb. 1873, p. 107;
and "The Leggotype," *Philadelphia Photographer*, vol. 3
(1866), p. 144.

10. "Nature, Science and Art," *The Nation* 1:8 (21 May 1874),
p. 96.

11. James Laver, *A History of British and American Etching* (New
York: Dodd, Mead & Co., 1929), pp. 45–46.

12. Edith G. Firth, "Mrs Simcoe's Etchings," unpublished
research notes based on the correspondence between
Elizabeth Simcoe and Mary Anne Burgess in the Simcoe
Papers at the National Archives, Ottawa, and the Ontario
Archives, Toronto, Feb. 1994. I am grateful to Ms Firth for
making her notes available to me.

 In January 1792, at Mrs Simcoe's request, Mary Anne
Burgess ordered etching material and an instruction manual,
which were shipped across the Atlantic to York. Completing
what she could in Upper Canada, Mrs Simcoe sent the two
etched plates back to her friend in England. Mrs Burgess
found a printer in Bristol to print the plates in editions of
fifty; these were sent to Mrs Simcoe in August 1795.

13. The identification of the artist is not clear. From 1860 to
1868, a Mrs Gourlay of Barton Lodge, Hamilton, and a Miss
Gourlay of Hamilton (both sharing the first initial "E")
appear as winners at the Provincial Exhibitions (UCPE) in
various amateur categories such as animal subjects and pen-
and-ink drawings. The two never win prizes the same year.
It is not clear if these are one and the same person; it would
seem, however, that Mrs Gourlay is related to Colonel
Gourlay of Barton Lodge, commander of the 23rd Welsh
Fusiliers. UCPE, 1860–62, 1864–66, 1868; also Henry James
Morgan, *Canadian Men and Women of the Time* (Toronto:
William Briggs, 1912), entry for John Edgar Reginald
Gourlay; and Hamilton City Directory for 1888–89.

14. The type of display was not new. The first Black and White
sections in Canadian exhibitions were organized in 1877 and
1878 for the Ontario Society of Artists. Both contained
drawings and some architectural designs.

15. "The Black and White Exhibition," *Montreal Gazette*,
23 Feb. 1881.

16. Francine Tyler, *American Etching of the Nineteenth Century*
(New York: Dover Publications Inc., 1984), p. xi. In 1886,
the Ontario Society of Artists held a Black and White exhi-
bition that contained original drawings and their printed ver-
sions from *St. Nicholas* and *Century* magazines. See L.C.,
"The Black and White Exhibition," *The Week* 3:25 (20 May
1886), pp. 403–04.

17. The reproductions are heliogravures (photo-mechanical
reproductions) from Charles Blanc's 1873 edition *L'Œuvre
de Rembrandt*. See George Biorklund, *Rembrandt's Etchings,
True and False* (Stockholm, London, and New York: GB,

1965), pp. 196–97.

18. The first painter-etcher to become a full member of the
Royal Canadian Academy was Herbert Raine, in 1926.

19. William McLennan, "An Outline of the History of
Engraving, read before the Art Association of Montreal Feb^y
25th, 1881," Art Association of Montreal, 1881.

20. *Ibid.*, p. 17; quote taken from [Joseph Maberly], *The Print
Collector, An introduction to the knowledge necessary for forming a
collection of ancient prints, containing suggestions as to the mode of
commencing collector, the selection of specimens, the price and care of
prints etc.* (London: Saunders and Otley, 1844), p. 20.

21. I have not been able to discover which publications he is cit-
ing for the first-mentioned authors. The Lalanne is his *Traité
de la Gravure à l'eau-forte*, not Koehler's English translation
published just six months before the lecture. The reference
to Hamerton is probably his *Etching and Etchers*.

22. "Etchings and Sketchings," *Montreal Daily Star*, 24 Feb. 1881.

23. "All Alone" by Alan Edson was also in the exhibition,
described as a pen-and-ink. It is not clear if this was actually
the drawing for the print or the fourth Art Union of
Montreal Leggotype print, miscatalogued.

24. "Proceedings at the Annual Meeting, 13 January 1883," *Art
Association of Montreal, Report of the Council for the year ending
November 30, 1882*, p. 21.

25. *Art Association of Montreal, Report of the Council for the year
ending December 1883*, pp. 3–4.

26. The print was pulled in the presence of W.S. Maxwell, who
donated it to the Montreal Museum of Fine Arts. Maxwell
noted on the print that Brymner had lent the plate to
Gagnon in order for him to experiment with the printing
process. See also Chapter 2, note 76.

27. [J.W.H. Watts], *National Art Gallery of Canada* (Ottawa:
Department of Public Works, c. 1890); Government of
Canada Sessional Papers (No. 9), 1884, Appendix 32,
p. 370; and Sessional Papers (No. 10), 1885, p. cxvii.

28. Biographical information is taken from *MacAlpine's Directory
for Saint John*, 1879–1911; J. Russell Harper, *Early Painters
and Engravers in Canada* (Toronto: University of Toronto
Press, 1970), p. 223; Ontario Society of Artists Papers,
Mu2251 (OSA Membership), Ontario Archives; W.P. Dole,
"Some Fine Art," *Acadiensis* III:1 (Jan. 1903), pp. 41–50;
Janice H. Chadbourne et al., *The Boston Art Club: Exhibition
Record 1873–1909* (Madison, Conn.: Sound View Press, 1991).

29. *Ibid.* (Chadbourne 1991), p. 18. According to the records of
by-laws and constitution, Miles's Boston Art Club member-
ship is first recorded in 1878 and continued from 1891 to
1904. He exhibited with this body in 1874, 1877, from
1897 to 1900, and in 1905.

30. The school is not listed in the city directories. It is mentioned
in the *Official Guide of the Canadian Section, Colonial and
Indian Exhibition*, London, 1886, Part IV, p. 345. J.C. Miles
is listed as principal and was "assisted" by H.C. Miles [*sic*].

31. In 1900 and 1905, J.C. Miles gave his address at the
Boston Art Club exhibition as 69 Main Street, Malden,
Massachusetts. The 1903 Saint John City Directory, how-
ever, begins to list him in the city. In 1901, the directory
shows the Miles Art School being run by Fred Miles.

32. Henry Russell Wray, *A Review of Etching in the United States*
(Philadelphia: Penfield, 1893), pp. 85–86; an abbreviated
version of the circular was published in "Literary Gossip,"
The Week 1:35 (31 July 1884), p. 353.

33. Henry S. Howland, Jr. to S.R. Koehler, Toronto, 12 Jan. 1886.
S.R. Koehler Papers, Archives of American Art, roll D186.

34. "Thomas Mower Martin 1885 Notebook," private collec-
tion, Calgary (Martin noted the recipe for bosse ground as
described by Hamerton in both books); and "Mr Seymour
Haden on Etching," *The Magazine of Art*, vol. 2 (1879),
pp. 188–91, 221–24, 262–64. (The Haden article was

quoted in the catalogue to the Association's 1885 exhibition).

35. *Catalogue of the First Annual Exhibition of the Association of Canadian Etchers held at the Galleries of the Ontario Society of Artists Toronto*, 21 Mar.–4 Apr. 1885.

36. Dr Charles Kirk Clarke's role is a mystery. He was a pioneer in Canadian psychiatry and at the time of the exhibition, a physician at the Provincial Lunatic Asylum in Toronto. Clarke did have a sincere interest in the arts. In 1881, he became an honorary member of the RCA, and was perhaps the "physician" listed in 1882 as a student at the Ontario School of Art. Cyril Greenland, *Charles Kirk Clarke* (Toronto: The Clarke Institute of Psychiatry, 1966); *Second Annual Exhibition of the Royal Canadian Academy*, Halifax, 1881; and *Report of the Department of Education*, Ontario Legislative Assembly Sessional Papers (No. 5), A1883, Part IV: "Technical Education."

37. "Literary Gossip," *The Week* 1:22 (1 May 1884), p. 350.

38. Hamerton held Appian's treatment of leafless trees in particular esteem. He wrote of "denuded trees of late autumn, that in nature remind me more frequently of Appian than any other landscape painter." *Etching and Etchers* (Boston, 1876), p. 203.

39. *County of Peterborough Directory* (Toronto: Hunter, Rose & Co., 1869); *Second Annual Exhibition of the Royal Canadian Academy*, Halifax, 1881; *Toronto City Directory* (Toronto: R.L. Polk & Co., 1883).

40. Moncrieff Williamson, *Robert Harris, 1849–1919: An Unconventional Biography* (Toronto and Montreal: McClelland and Stewart, 1970), p. 64.

41. Robert F. Gagen, "Notebooks: Ontario Society of Artists, 1890–1910," OSA Papers, Mu2252, Ontario Archives, p. 2.

42. "Stephen Parrish Record of Painting and Etchings 1877–1915," private collection, U.S.A. The present location is unknown. A copy was supplied by Rona Schneider, Brooklyn, N.Y., in 1984.

43. Maureen O'Brien and Patricia C.F. Mandell, *The American Painter-Etcher Movement* (Southampton, N.Y.: The Parrish Art Museum, 1984), p. 9. According to Parrish, the less powerful tabletop press was fine for proving a print, but it did not give as sharp or even an impression as a regular plate press. This problem is evident in the few known examples of impressions pulled by ACE members in Toronto.

44. "Stephen Parrish Record of Paintings and Etchings 1877–1915," private collection, U.S.A., p. 332 (entries for 6 and 30 Dec. 1881); and "Stephen Parrish Account Book 1880–89," p. 63 (entry for 6 Dec. 1881), Parrish Family Papers, Free Library of Philadelphia, Archives of American Art, roll 4409.

45. "Painting Sir John A. Macdonald's Portrait," *Saturday Night* 42:32 (25 June 1927), p. 2. The Sigmund Samuel Collection at the ROM has what could be a proof impression before letters of the photogravure on chine collé. It is signed and titled below the plate.

46. *Report of the Department of Education*, Ontario Legislative Assembly Sessional Papers (No. 4), A1884, Part IV: "Technical Education," p. 180; and *Report of the Department of Education*, Ontario Legislative Assembly Sessional Papers (No. 5), A1884, p. 242.

47. [W.W. Alexander ?], *William J. Thomson, Canada, Engraver 1857[sic]–1927* (Toronto: Society of Canadian Painter-Etchers, 1930), p. 5; and Toronto city directories 1881–1913. Said to have begun as an apprentice engraver in 1872, Thomson is first listed in the profession in the directory of 1881. He worked briefly for such publishing firms as Rolph, Smith & Company (1886) and the *Globe* (1890–91), but for the most part he worked on his own, freelancing at first, and from 1905 to c. 1913 running his own Thomson Engraving Company.

48. "Venerable Artist Kindled Spark of Art in Toronto," *Toronto Daily Star*, 20 July 1927. Martin claimed to have printed his first etchings with a laundry wringer; however, it is most probable they were made on the ACE's press.

49. Martin's remarkable inconsistency in titling in contemporary exhibitions, auction sales, and his notebook, combined with similarity of subject matter in his works, complicates the determination of numbers and dates.

50. Christine Boyanoski, *Sympathetic Realism, George A. Reid and the Academic Tradition* (Toronto: Art Gallery of Ontario, 1986). Three of these etchings exist in the collection of the AGO: one is a portrait of a nun and the other plate, in two impressions, is of dual subjects (the turbaned head of a man, and a house). Both impressions of the second print are dated "Philadelphia 1883."

51. *Etchings Exhibited at the Museum of Fine Arts* (Boston: Alfred Mudge & Son, Jan. 1879); *Exhibition of American Etching* (Boston: Alfred Mudge & Son, 1881), Museum of Fine Arts Boston, 11 Apr.–9 May 1881; and *First Annual Exhibition of the Philadelphia Society of Etchers* (Philadelphia: Pennsylvania Academy of Fine Art, 1882), 27 Dec. 1882–3 Feb. 1883.

52. This display does not appear in the catalogue but is described in "Association of Canadian Etchers: Opening of the First Annual Exhibition," *Toronto Globe*, 24 Mar. 1885.

53. "Diaries of James D. Smillie 1865–1910" (entry for 6 and 7 Mar. 1885), Archives of American Art, roll 2851. Smillie received a letter from Howland asking for etching proofs including steel-faced etchings. Smillie sent eight framed etchings; his ninth print in the show comes from an unknown source.

54. "Minutes of the Philadelphia Society of Etchers," 20 Feb. 1885, Philadelphia Society of Etchers Records, Buck County Historical Society, Doylestown, Pa., Archives of American Art, roll 4408.

55. It must be more than a coincidence that as many as 72 to 92 prints in the New York show were also in the ACE show, and that both exhibitions had completely identical representations of 18 to 21 American and European etchers. This would also account for the overlap in the presence of some of the Philadelphia etchers.

56. David Karel, *Horatio Walker* (Quebec City: Musée du Québec, 1986; English edition, 1987), cat. nos. 106 to 108, pp. 282–85; and Susan Collier, "The History of the Rochester Art Club," manuscript prepared for the Margaret Woodbury Strong Museum, Rochester, N.Y., 1974. Walker's etchings are only known through a set of restrikes printed in 1977 by Christopher Broadhurst for the Agnes Etherington Art Centre, Kingston, Ont., in an edition of two.

In early 1883, Walker exhibited his first etching *Mare and Colt* at the Club's annual exhibition; it is only known to us as the zinc plate described as *Farm Buildings* (Karel 108). The next year, Walker showed *A Barnyard* at the New York Etching Club, which was probably the same print displayed as *A Pastoral* at the Rochester Art Club 1884 exhibition and likely now known as *A Pig Sty* (Karel 107). Two more etchings were pulled in time for exhibitions in 1885: the posthumous portrait of a local painter, *Grove Sheldon Gilbert* (Karel 106), and *In Quebec*, shown at the New York Etching Club and the ACE.

David Karel contends that Walker returned to etching in 1908, citing the Montross Gallery catalogue for an exhibition of paintings held in March 1909, which lists 27 drypoints of Dutch and Belgian subjects. The copy of the catalogue consulted by Karel in the New York Public Library is glued into scrapbooks, partially obscuring the exhibition reference: the title of the exhibition has been added by hand. At Mr Karel's prompting, a second copy was found in the library of the Pennsylvania Academy of Fine Art; it shows that Walker's painting exhibition ran concur-

rently with a William Maris exhibition. The prints listed are by Maris.

57. Henry S. Howland, Jr. to S.R. Koehler, Toronto, 28 Mar. 1885, S.R. Koehler Papers, Archives of American Art, roll D186.

58. "Association of Canadian Etchers," *Toronto Globe*, 24 Mar. 1885.

59. *Ibid*.

60. *Ibid*.

61. "C.," "The Exhibition of Etchings," *Educational Weekly* 1:15 (Jan.–June 1885), p. 234. "C." also took exception to the exhibition's review in *The Week*. See also D[aniel] W[ilson], "The Association of Canadian Etchers," *The Week* 2:18 (2 Apr. 1885), pp. 278–79.

62. *Ibid*. (*The Week*), p. 278.

63. "Private View, The Exhibition of Etchings at the Art Gallery," *Montreal Gazette*, 22 May 1888. This was the only press coverage the exhibition (which ran until 2 June) received.

64. Stephen Parrish was a particular favourite among Montreal collectors. In March 1882, he sold all eight prints entered in the RCA exhibition held at the Art Association's rooms. There evidently was a strong demand for more, and within a month Parrish sent an additional twenty-six to the AAM's secretary. On 26 May 1883, Parrish submitted eight etched plates for selection as an art union print (from these, "The Upper Hudson" was chosen). The AAM made the print available to its members as late as 1887, but orders had to be placed directly with Kimmel & Voigt in New York who held the plate for the Association. "Stephen Parrish Account Book 1880–89," pp. 71–72, 76, 79, 103–04, and 284, Parrish Family Papers, Free Library of Philadelphia, Archives of American Art, roll 4409; and *Art Association of Montreal, Report of Council 1883*, p. 8, and *Report of Council 1887*, p. 12.

65. "Stephen Parrish Account Book 1880–89," pp. 87, 89, 91, 101, 111, 113, 115, 129, 132, 133, 144, 152, 155, and 165, Parrish Family Papers, Free Library of Philadelphia, Archives of American Art, roll 4409. W. Scott & Sons were one of Parrish's most important dealers, carrying a complete and continuously updated stock of his etchings; they appear regularly in his account book from Dec. 1882 to Nov. 1887.

66. *Art Association of Montreal, Report of Council 1881–1885*.

67. "Art Notes," *The Week* 7:17 (28 Mar. 1890), p. 268.

68. Their ads offering these prints appeared regularly in newspapers and in catalogues for the art society exhibitions in both cities.

69. *Report of the Department of Education*, Ontario Legislative Assembly Sessional Papers (No. 5), A1883, Part IV: "Technical Education," p. 249.

70. *Ibid*., A1899, p. 180.

71. *Ibid*., A1891, p. 307.

72. *Art Association of Montreal, Report of Council 1880–1900*.

73. Bernard Mulaire, entry for Joseph Chabert in *Dictionary of Canadian Biography*, vol. X (Toronto, Buffalo, and London: University of Toronto Press, 1990), p. 650; the school is listed in the Montreal Directory for 1874–75 and 1875–76. For information on Bresdin in Canada, see Michael Parke-Taylor, "A Canadian Allegory by Rudolphe Bresdin: 'L'Apothéose de Cartier'," *RACAR* IX:1–2 (1982), pp. 64–68.

74. See *Council of Arts and Manufactures of the Province of Quebec. Annual Report*, Province of Quebec Sessional Papers, 1874–99. Henry A.C. Jackson won the lithography prize in 1897 and 1898; A.Y. Jackson also won a lithography prize in 1898.

75. Virgil G. Hammock, *Art at Mount Allison – A History* (Sackville, N.B.: Owens Art Gallery, 1977).

76. Victoria School of Art and Design, *First Annual Report 1887–88* (Halifax: Nova Scotia Printing Company, 1888), p. 10.

77. Victoria School of Art and Design, *Prospectus for the Year 1888–89*.

78. "Victoria School of Art and Design Minute Book," Papers of the Victoria School of Art and Design, MG17, vol. 6, Public Archives of Nova Scotia, Halifax.

79. William Colgate, "The Toronto Art Students' League," *Ontario Historical Society* 45:1 (1953), p. 6.; see also Robert Holmes, "Toronto Art Students' League," *Canadian Magazine*, vol. 4 (1895), pp. 171–88.

80. "Art and Artists," *Saturday Night* 2:33 (13 July 1889), p. 7; and "Art and Artists," *Saturday Night* 2:44 (28 Sept. 1889), p. 7.

81. For a description the TASL's earliest activities, see "Art and Artists," *Saturday Night* 2:14 (2 Mar. 1889), p. 7.

82. "Art and Artists," *Saturday Night* 1:12 (18 Feb. 1888), p. 10.

83. "Art and Artists," *Saturday Night* 3:2 (7 Dec. 1889), p. 7.

84. "Art and Artists," *Saturday Night* 3:7 (25 Jan. 1890), p. 7. In 1892, Thomson retired from the TASL executive.

2 In the Mainstream

1. Wyatt Eaton, "Recollections of Jean-François Millet," *Century Magazine* 38:1 (May 1889), pp. 90–104; and Charlotte Eaton, "Millet's Peasant Life as a Boy: Its Influence on His Art, Told from Notes of the Late Wyatt Eaton, His Friend and Pupil," *The Craftsman* 13:4 (July 1908), pp. 351–62.

2. Giles Edgerton, "Millet as an Etcher: Some Reminiscences of Wyatt Eaton at Barbizon," *The Craftsman* 13:1 (Oct. 1907), p. 56. Much of the material in this article consists of direct quotes from manuscript notes by Eaton, probably written in conjunction with his 1889 article (*ibid*.) and provided by his widow, Charlotte Eaton.

 Eaton wrote: "He [Millet] was, of course, familiar with many of the more important plates, but the smaller reproductions were mostly new to him. These he examined with an absorbing interest and at times seemed quite overcome with admiration. He remarked that 'In looking at the works of a great master, one is always disposed to feel that here is the greatest'."

3. Edgerton (*ibid*.), pp. 55 and 56. Eaton, however, would never consider delivering an unsympathetic critique of his mentor and he softened his comments: "In etching, Millet would draw upon copper as if it were paper, and attempt to carry out this effect of the first drawing in biting and printing. This would naturally as a result have a more intimate and autographic value." The autographic, direct quality that caused Eaton pause was the very aspect of Millet's prints that had helped to free etching from the densely worked-up prints of the reproductive engravers, a battle largely won by 1889. Eaton formulated his observations on etching from the point of view of the second generation of more technically experienced painter-etchers.

4. Rona Schneider, "The American Etching Revival: Its French Sources and Early Years," *American Art Journal* (Autumn 1982), pp. 40–65.

5. Madeleine Fidell Beaufort, Herbert L. Kleinfield, and Jeanne K. Welcher, eds., *The Diaries, 1871–1882, of Samuel P. Avery, Art Dealer* (New York: Arno Press, 1979), pp. 236 and 366. Eaton is mentioned in the diaries on 30 June 1874 and 4 July 1875, while Avery was in Paris.

6. Wyatt Eaton to J. Alden Weir, 5 June 1877, J. Alden Weir Papers, Archives of American Art, roll 70; Will H. Low, *A Chronicle of Friendships 1873–1900* (London: Hodder & Stoughton, 1908), p. 232; and G.W. Sheldon, *American*

Painters (New York: D. Appleton, 1879), p. 172. Eaton taught at the Cooper Union until 1882.

7. Francine Tyler, *American Etchings of the Nineteenth Century* (New York: Dover Publications Inc.), p. xviii; and Elton W. Hall, "R. Swain Gifford and the New York Etching Club," in *Prints and Printmakers of New York State 1825–1940*, ed. David Tatham (Syracuse, N.Y.: Syracuse University Press, 1986), pp. 183–212.

8. Dr S.P. May, "Report on Art Schools Recently Visited in the United States," Ontario Legislative Assembly Sessional Papers (No. 5), A1883, pp. 251–52. The class was devoted to training women for independent employment and was conducted on business principles. It took orders "for illustrating, design, wood engraving, etc.," and by 1881 was being funded by Prang & Co. Art Publishers. See also Phyllis I. Peet, "The Emergence of American Women Printmakers in the late Nineteenth Century," Ph.D. diss., UCLA, 1987, pp. 65–75.

9. *Etchings Exhibited at the Museum of Fine Arts* (Boston: Alfred Mudge & Son, Jan. 1879); and *Exhibition of American Etching* (Boston: Alfred Mudge & Son, 1881), Museum of Fine Arts Boston, 11 Apr.–9 May 1881.

10. Janice H. Chadbourne et al., eds., *The Boston Art Club: Exhibition Record 1873–1909* (Madison, Conn.: Sound View Press, 1991). This source gives a complete listing of Sandham's entries from 1881 to 1901, and details his activities on various exhibition committees. He was most involved with the 1884 and 1885 shows.

11. *American Art Review* I:1 (Nov. 1879), p. 271.

12. The only surviving catalogue is in the Print Department of the Museum of Fine Arts Boston (Koehler, book 1000). Koehler records that the exhibition took place in April 1883, and names only four exhibitors: W.F. Halsall, E.H. Garrett, C.F. Pierce, and F.T. Merrill.

13. In the ACE catalogue, no. 234 *In Boston Public Gardens* is priced at $12.50 and no. 233 *La Salle's Homestead* is priced at $7.50. Price is a good reflection of the relative size of prints.

14. See chronology in J. Barry Lord, *J.M. Barnsley (1861–1929), A Retrospective* (Vancouver: Vancouver Art Gallery, 1964), n.p.

15. The printer's name and title appear in the magazine's table of contents. Kershaw was noted as an engraver working in St. Louis as early as 1850. James F. Carr, ed., *Mantle Fielding's Dictionary of American Painters, Sculptors and Engravers* (New York: James F. Carr, 1965).

16. "A Canadian Artist, Mr. J.M. Barnsley. Success in Europe. Some of His Works – Art Notes." Unidentified newsclipping, J.M. Barnsley file, Montreal Museum of Fine Arts Library [c. 20 Oct. 1888].

17. "Thomas Mower Martin 1885 Notebook," private collection, Calgary. These prints bearing the Klackner copyright are in the Dunnigan Collection, Parrish Art Museum, Southampton, N.Y.

18. James Spooner to Homer Watson, Toronto, 31 Jan. 1885, Homer Watson Papers, NGC Archives. Cox had just returned from New York with a batch of his own etchings, and Spooner was scathing in his critique of the work. A sketching partner of T.M. Martin, Cox probably made his prints at Kimmel & Voigt alongside Martin.

19. The only impressions that have been found are from the collection of one of the artist's descendants. It is possible they are proofs before the copyright, title, etc., were added to the plate. The relatively large size and generous margins are similar to these copyrighted etchings. Herman Wunderlich & Co. of New York was Sandham's dealer in the 1880s and also a major publisher of such etchings. *Kennedy Quarterly* 12:4 (Dec. 1973), p. 252.

20. Frederick Keppel, *What Etchings Are: A Manual of Elementary Information for Beginners* (New York: Frederick Keppel & Co., 1888).

21. James Watrous, *A Century of American Printmaking, 1880–1980* (Madison: University of Wisconsin Press, 1984), p. 18.

22. There is no clear documentation for this meeting. However, in a letter to Koehler from Yarmouth, N.S., Parrish wrote of "friends we have after journeying in new centres, amongst strangers." Parrish to Koehler, 11 Sept. 1881, S.R. Koehler Papers, Archives of American Art, roll D186. A Parrish drawing of the shore at Carleton, N.B. (then a village outside Saint John), in the Killam Library, Dalhousie University, Halifax, and Hammond's print *Fundy Coast* (cat. 54) have an identical vantage point, suggesting the artists were sketching side by side.

23. "Stephen Parrish Record of Paintings and Etchings 1877–1915," p. 380, private collection, U.S.A.; and "Stephen Parrish Account Book 1880–89," p. 73, Parrish Family Papers, Free Library of Philadelphia, Archives of American Art, roll 4409. The entry is dated 13 Apr. 1882. The prints given to Hammond include two Canadian subjects, which would have had a special significance for him: "Carleton, N.B. – On the Bay of Fundy" and "On the Saint John, Portland, N.B."

24. *Ibid.* There is no indication in Parrish's record book or account book of his giving Hammond formal instruction. According to Rona Schneider, who is currently working on a catalogue raisonné of Parrish's prints, he kept meticulous records of his income relating to his work as an artist and teacher. If Parrish were to have given Hammond free etching lessons out of friendship, however, they may not have been recorded.

25. Another interesting comparison can be made between Platt's "Portland on the St. John" of 1882 and Hammond's *Fundy Coast* (cat. 54).

26. "Stephen Parrish Account Book 1880–89," p. 95, Parrish Family Papers, Free Library of Philadelphia, Archives of American Art, roll 4409. The entry dated 7 March 1883 indicates that Parrish printed two plates for a fee, one in an edition of 15 and another in an edition of 25. The generally weak and inconsistent printing displayed by most of the prints pulled by Hammond in Saint John suggests he did not have an adequate press at his disposal.

27. It was in Dordrecht, in Sept.–Oct. 1885, that Hammond came upon both Whistler and Storm van's-Gravensande. It has been speculated that the Canadian took the opportunity to etch with them, but both artists were on sketching trips and Hammond's encounter with them seems to have been of no more than an afternoon's duration, recording a scenic spot.

28. "Stephen Parrish Account Book 1880–89," pp. 204 and 271, Parrish Family Papers, Free Library of Philadelphia, Archives of American Art, roll 4409. At this time, Parrish made a painting of a winter subject titled "Windsor, Nova Scotia," and in November 1886, he etched two plates: "A Wintry Day" and "Boatyards – on the Saint John."

29. Hammond only put his etchings on display a few times, once at the first ACE annual of 1885 in Toronto, and on at least three occasions in Saint John, according to articles in the *Saint John Daily Telegraph*: "The Owens Art Gallery," 15 Apr. 1885; "The Owens Art School," 15 Apr. 1887; and "Queen's Jubilee Art Exhibition," 23 June 1887.

30. Some of Hammond's uncancelled plates found their way into private hands in the Sackville, N.B., area. Around 1967, probably in conjunction with the Owens Art Gallery's Hammond retrospective, a set of restrikes was pulled and distributed – printed in various coloured inks on a cream-coloured heavy wove paper. Another set of restrikes was pulled by David Steves for the Owens Art Gallery around 1983, from plates acquired at that time – printed in an edition of three, in bright silvery-black ink on very white Johannot wove paper. (Information provided by Peter Larocque, New Brunswick Museum.)

31. Little has been known about Armstrong Forbes' formative years. Around 1866, Elizabeth moved to Ottawa when her father took up a position with the federal government. Showing an early talent, she took lessons from the Abbé Joseph Chabert; and when his school closed in 1870, Elizabeth's parents decided to let her study abroad. In 1872 or 1873, she attended the National Art Training School in London; however, the sudden death of her father forced her return to Canada after only a few months. By 1875 she was living with her mother in Yorkville, and in 1876 exhibited a watercolour at the OSA annual. She studied (1878–81) at the newly formed Art Students' League of New York under William Merritt Chase, thriving in the school's communal atmosphere. Chase's suggestion to further her studies in Munich led to an unhappy year of isolated private instruction. Seeking an artistic community, in 1882 she moved to the Anglo-American art colony of Pont-Aven in Brittany.

32. Arthur K. Sabin, "The Dry-points of Elizabeth Adela Forbes, formerly E.A. Armstrong (1859–1912)," *Print Collector's Quarterly* 9:1 (Feb. 1922), pp. 75–100; and Robert H. Getscher, *The Stamp of Whistler* (Oberlin, Ohio: Allen Memorial Art Museum, Oberlin College, 1977), p. 196. Sabin illustrates the only impression of E. Armstrong's first print, which belonged to Menpes. Getscher notes that Menpes owned a copy of *Speke Hall* (K.96). The other figures portrayed on the plate were the artist's mother and Fortuny, a well-known etcher, possibly copied after another print.

33. Although she was undeniably acquainted with Whistler, she did not mention knowing him when interviewed for any of the contemporary articles or books about her, but then she never mentioned Menpes either. In 1886, her fiancé, Stanhope Forbes, "earnestly hoped she had seen the last of Whistler for some time, however amusing he may be." Cited in Caroline Fox and Francis Greenacre, *Painting in Newlyn, 1880–1930* (London: Barbican Art Gallery, 1985), p. 78. In a letter dated 23 Nov. 1886, Forbes writes: "I can hardly bear to think that very likely you are going to meet him [Whistler] tomorrow." Cited in Betsy Cogger Rezelman, "The Newlyn Artists and Their Place in late-Victorian Art," Ph.D. diss., School of Arts, Indiana University, 1984, p. 290, note 166.

34. During her active years as a printmaker, Armstrong Forbes' drypoints appeared at the First Annual Exhibition of the Philadelphia Society of Etchers (1882), the Paris salons of the Société des Artistes Français (1883 and 1885), the London Society of Painter-Etchers (1883–87, member in 1885), and at the New York Etching Club annual of 1891.

35. Fox and Greenacre *op. cit.*, p. 77. The authors cite an 1886 letter from Stanhope Forbes to his mother, noting the admiration Whistler's circle had for his fiancée.
 Art Property of the late Otto H. Bacher, Anderson Art Galleries, New York, 2 Mar. 1910, lot 2–4. Titled "Grace before Meat," "Girl Knitting by the Window," and "Girl Peeling Apples," they are probably *Saying Grace* (Sabin 29 or 30), *Girl at the Window* (Sabin 25), and *Peeling Onions* (Sabin 26). Bacher helped Whistler print the "Venice Set" in its initial stages. The NGC's impression of *Carpenter Shop* (Sabin 38) was formerly in the collection of J.D. Smillie.

36. Mrs Lionel Birch, *Stanhope A. Forbes and Elizabeth Stanhope Forbes, A.R.W.S.* (London: Cassell & Company, 1906), p. 67.

37. Fox and Greenacre *op. cit.*, p. 78.

38. Getscher, *op. cit.*, p. 196.

39. Tyler *op. cit.*, p. xi; Peet *op. cit.*, pp. 65–75.

40. Gladys Engel Lang and Kurt Lang, *Etched in Memory: The Building and Survival of Artistic Reputation* (Chapel Hill and London: University of North Carolina Press, 1990). This book is highly recommended for its chapter dealing with women etchers. For a discussion on British art societies and membership policies pertaining to women, see Deborah

Cherry, *Painting Women: Victorian Women Artists* (London and New York: Routledge, 1993), pp. 65–77.

41. The Philadelphia Society of Etchers was an exception. Despite the local presence of some of the best American women etchers, Stephen Ferris' proposal to admit women to full active membership was defeated at their 7 Dec. 1880 meeting. "Minute Book," Philadelphia Society of Etchers Records, Bucks County Historical Society, Doylestown, Pa., Archives of American Art, roll 4408.

42. S.R. Koehler, *Exhibition of the Work of the Women Etchers of America* (Boston: Museum of Fine Arts/Union League Club, 1887), 1 Nov.–31 Dec. 1887. Also *Exhibition Catalogue of the Work by Women Etchers of America* (New York: The Union League Club, 1888), with an introduction by one of the chief commentators of the American etching revival, Marianna Griswold van Rensselaer. New York's first professional print curator, Frank Weitenkampf, wrote an article entitled "Some Women Etchers" for *Scribner's Magazine* XLVI:6 (Dec. 1909), pp. 731–39, using works from the Public Library's collection.

43. William Colgate, "Homer Watson: Artist Used Acid Pen as Critic," *London Evening News*, 9 Mar. 1946. Colgate cites a letter dated 27 Aug. 1887 from Watson to his Toronto dealer James Spooner.

44. Homer Watson, "My First Commission," in Jane VanEvery, *With Faith, Ignorance, and Delight: Homer Watson* (Kitchener-Waterloo: Homer Watson Trust, 1967). The Canadian was introduced to Whistler by two artist friends, not by Oscar Wilde, as is often mentioned. Watson relates a second meeting with Whistler at a preview of the Royal Academy's annual exhibition, where their paintings were hanging side by side. Whistler, however, ceased exhibiting with the RA in 1879, well before Watson began (1888). And as Whistler left off exhibiting with the Royal Society of British Artists in 1887, this meeting could not have taken place at either their 1888 or 1889 exhibition, as has been cited.

45. Homer Watson to Lorne, n.d. [1–7 Oct. 1889], as quoted in Muriel Miller, *Homer Watson, the Man from Doon* (Toronto: Ryerson Press, 1938), p. 37. I have dated the letter based on other correspondence.

46. James Spooner to Homer Watson, 31 Jan. 1885 and Apr. [1885], Homer Watson Papers, NGC Archives.

47. Spooner to Watson, 30 Nov. 1885, Homer Watson Papers, NGC Archives. It is not clear if Spooner was trying to encourage Watson to take up the medium or simply selling him some etchings.

48. J.W.H. Watts to Watson, Ottawa, 24 July 1888, Homer Watson Papers, MGIIE, coll. 25.1, Queen's University, Kingston, Ont.

49. "Painting Sir John A. Macdonald's Portrait," *Saturday Night* 42:32 (25 June 1927), p. 2; and Roxa Watson to Phoebe and Mrs Watson, 12 July 1888, Homer Watson Papers, NGC Archives.

50. The prints were made at the house of artist E.J. Gregory, at Cookham Dene near Windsor, which Watson rented primarly to have access to the press. Clausen lived nearby, and within a week of moving in Watson was receiving his first lessons. Roxa Watson to Phoebe Watson, Cookham Dene, between 7 and 20 Oct. 1889, reprinted in Muriel Miller *op. cit.*, p. 38; and Jane VanEvery *op. cit.*, p. 20.

51. Kerr-Lawson to Watson, n.d. [after 11 Jan. 1890], Homer Watson Papers, Queen's University, Kingston, Ont.

52. "Notes by George Clausen," in E.S. Lumsden, *The Art of Etching* (London: Seeley Service & Co., 1925), p. 334.

53. A set of Homer Watson etchings was reprinted by Nicholas Hornyanski in 1952. According to Mrs Hornyanski, editions of 5 to 10 impressions of each plate were pulled. (Information provided by Mrs Hornyanski to Ian Carter, McMichael Canadian Collection, Kleinburg, Ont., and

passed on to the author, 1 Mar. 1984.) All identifiable restrikes are signed directly below the plate mark with the title lower left, followed by "Hornyanski Impr." lower centre, and "Homer Watson Engr." lower right. The restrikes identified to date are: *Landscape with Oak Trees* (Hornyanski "The Oak Trees" or "Trees"), *Hay Ricks* (Hornyanski "Tree in the Meadow"), and *The Pioneer Mill*.

54. Most of those who were still alive in 1901 would not survive to the end of the decade. Watrous *op. cit.*, p. 28.

55. Joseph Pennell, *Adventures of an Illustrator, Mostly in Following His Authors in America and Europe* (Boston: Little, Brown, 1925), p. 101; and Watrous *op. cit.*, p. 33. See especially chapter 2, "The Constant Advocacy of Joseph Pennell," pp. 28–43. Pennell's contract with *Century Magazine* specified payment for travel expenses, $50 for an impression of each of ten etched subjects, and allowed Pennell to dispose of the remaining impressions in the edition as he wished.

56. The fad is best demonstrated by Pennell's own quest, recounted in Joseph and Elizabeth R. Pennell, "The Most Picturesque Place in the World," *Century Magazine* (July 1893), pp. 345–51. This *Baedeker*-style Europe began to obsess the second and third generation of painter-etchers. Certain towns and villages became so renowned for their wealth of picturesque subject matter that they were literally overrun with artists competing for the best vantage points. C.H. White described the competition in Bruges in his amusing 1909 article for *Harper's Monthly*.

57. In 1907, Cleveland Morgan, Gagnon's Montreal dealer, attempted to bring him together with a Dr Shearer, who was apparently writing a travel book. The artist intended to produce the etchings only upon receipt of Shearer's manuscript, as he did not want to go to the expense of a trip and making the prints without assurance that the project was a serious one. Gagnon to C. Morgan, 13 Feb. 1907, Gagnon Papers, McCord Museum Archives, Montreal. Also, *Century Magazine* apparently approached Edmund Morris, secretary of the Canadian Art Club, about using Gagnon's etchings for an unspecified article. Nothing came of this proposal. Gagnon to E. Morris, 27 Mar. 1913, Canadian Art Club Papers, AGO Archives, Toronto.

58. C.H. White, "In the Street," *Harper's Monthly* 110:667 (Feb. 1905), p. 365.

59. Frank Weitenkampf, *American Graphic Art* (New York: Henry Holt & Co., 1912), p. 41.

60. Florence Levy, ed., *American Art Annual*, vol. X (1913), p. 375.

61. C.H. White, "In the Street," *Harper's Monthly* 110:667 (Feb. 1905), p. 365. For a complete list of these articles, see White's references on p. 188. White was born in Hamilton, Ont., into a well-established professional family that included Thomas and Richard White, owners of the *Hamilton Spectator* and the *Montreal Gazette*. (Derived from information given to the author by the artist's relations, Patricia Mills and Nancy Castray.) White apparently left Hamilton around 1893, but kept in contact with the family, whose connections would have been useful in securing the patronage of *Harper's Monthly*.

62. Only after 1909 did White have some competition on the magazine's pages, when articles illustrated by other painter-etchers such as Pennell and J.O. Nordfeldt began to appear. See Harrison Rhodes, "New York, City of Romance," *Harper's Monthly* 119:714 (Nov. 1909), pp. 914–25, illustrated by Joseph Pennell and others; and Mary Heaton Vorse, "The Infidel City," *Harper's Monthly* 120:720 (May 1910), pp. 812–23, illustrated by J.O. Nordfeldt.

63. Instructor's Expense Book, Art Students' League of New York Papers, Archives of American Art, roll NY59–28.

64. Frank Weitenkampf, *American Graphic Art* (New York: Henry Holt & Co., 1912), pp. 39–40. See also

65. F. Weitenkampf, "New York in Recent Graphic Art," *Print Connoisseur* 1:1 (Oct. 1920), pp. 64–92.

65. J. Pennell to C. Zigrosser, Philadelphia, 12 Mar. 1920. Carl Zigrosser Papers, Special Collections, Van Pelt Library, University of Pennsylvania, Philadelphia.

66. [Carl Zigrosser], *Memorial Exhibition of the Complete Etched Works of Charles Henry White* (New York: E. Weyhe, 1920). (A second version was published by Goodspeed's Bookshop, Boston, in 1920.)

67. Receipt from *Cosmopolitan Magazine*, dated 29 July 1908, in the Milne Family Papers.

68. Rosemarie L. Tovell, *Reflections in a Quiet Pool: The Prints of David Milne* (Ottawa: National Gallery of Canada, 1980), cat. nos. 9 and 10.

69. It is interesting to note the article by Mildred Stapley, "City of Towers," *Harper's Monthly* 123:737 (Oct. 1911), pp. 697–706, illustrated with etchings by Henry Delville. Dated 1909 and 1910, they are similar in subject to Milne's skyscraper etchings.

70. For detailed information on Milne's New York etchings, see Tovell *op. cit.*, pp. 15–17 and cat. nos. 1–22.

71. Maude L.G. Oliver, "The Chicago Society of Etchers – Its First Exhibition," *Studio* 43:169 (Mar. 1911), pp. iii–vii.

72. Bertha Jacques to F. Weitenkampf, Chicago, 21 Oct. 1911. Frank W. Weitenkampf Collection, Manuscript Division, New York Public Library, Archives of American Art, roll N3.

73. Lang and Lang *op. cit.*, pp. 175 and 179.

74. This community of painter-etchers was not insignificant. By 1908 the *Gazette des Beaux-Arts* could speak of an "école d'aquafortistes américaine" existing in Paris, and identify Clarence Gagnon and Frank Armington among its members. "L'eau-forte américaine au Salon de la Société des Artistes Français," *Gazette des Beaux-Arts* 50:614 (Aug. 1908), pp. 120–21. In this article, Gagnon was identified as one of the best of the "school." *Studio* magazine was also reporting regularly on American painter-etchers in Paris.

75. The Association was founded in 1890, and in 1902 moved to 74 Rue Notre Dame des Champs. Its purpose was to provide "unconventional fellowship among artists, but also a common meeting place for students as well as for all interested in the development of American art." Non-Americans could only be associate members, without voting rights. The club contained a large library, a restaurant, a billiard room, and some exhibition rooms for the four shows held each year. Florence N. Levy, ed., *American Art Annual*, vol. 1 (1898) (New York: The Macmillan Company, 1899), p. 329; vol. 4 (1903–04), p. 229; and vol. 5 (1905–06), p. 231. Gagnon's letter announcing his arrival in Paris is written on American Art Association letterhead. Gagnon to James Morgan, 15 Feb. 1904, Morgan Papers, McCord Museum Archives, Montreal.

76. Records of the American Art Association are difficult to find. George C. Aid was a member as early as 1903 ("Studio-Talk, Paris," *Studio* 25:110, Apr. 1902, pp. 212–14), and Donald Shaw MacLaughlan was a member by 1903 ("Studio-Talk, Paris," *Studio* 28:120, Mar. 1903, pp. 142–44). In 1905, both Aid and Webster were exhibiting etchings at the AAA's annual exhibition, and in March 1906, MacLaughlan was given a one-man show of etchings in the Association's rooms. *American Art Association of Paris Catalogue of Annual Exhibition* (28 Jan.–18 Feb. 1905); and *Exposition d'eaux-fortes originales par Donald Shaw MacLaughlan* (24–31 Mar. 1906).

77. Webster is said to have begun to etch after studying Meryon's prints at the Bibliothèque Nationale in late 1904. However, Meryon's influence did not dominate Webster's work until after 1907. Webster had been a close friend of MacLaughlan's since 1900 and a devoted collector of his

prints. (The collection, dating from 1899, is in the NGC.) It is more probable Webster took up the art with MacLaughlan's encouragement. See "Some Etchings by Herman A. Webster," *Studio* 51:214 (Jan. 1911), pp. 283–89; Janet Flint, *Herman A. Webster, Drawings, Watercolors and Prints* (Washington, D.C.: National Collection of Fine Arts, Smithsonian Institution, 1974), p. 1; and Herman A. Webster to Pierre Dupuy, Canadian Ambassador to France, 14 Mar. 1960, typescript in Prints and Drawings curatorial files, NGC.

Clarence Gagnon made his first prints with W.S. Maxwell in Montreal, in 1903, when he was working for Maxwell's architectural firm. All the prints were rather crude drypoints, since neither Gagnon nor Maxwell had the expertise to work with acids. When Gagnon left for Paris on 9 Jan. 1904, he evidently took along the unsatisfactory plate for *Oxen Ploughing*, a print after his most important canvas to date. Close study shows the final state of the print is all etching, the subject entirely reworked as a "school piece." Gagnon is said to have taken lessons from a well-known etcher in Paris. The artist's close association with MacLaughlan at this time is documented in various papers. References: Maxwell's inscription on early drypoints in the MMFA collection; John Bland et al., *The Architecture of Edward and W.S. Maxwell* (MMFA, 1985), p. 49, note 26; Richard S. Lambert, *The Adventures of Canadian Painting* (Toronto: McClelland and Stewart, 1947), p. 190; and Gagnon Papers, Morgan Papers, McCord Museum Archives, Montreal.

78. Photograph in Gagnon photo album, private collection. The chronology of their development as etchers and the itinerary of their sketching trips between February 1904 and 1907 is too similar to be merely coincidental. See Lean McCauley, "Herman A. Webster – Painter-Etcher," *The Sketch Book* 7:1 (Dec. 1907), pp. 26-39.

79. *Ibid.* As well, *Porte de Bourgogne, Moret-sur-Loing* was a studio creation, with the view of the town plucked from a postcard sent to his brother in Apr. 1907 (Wilford Gagnon Papers, MG30 D384, National Archives of Canada, Ottawa); and *The Lake, Séminaire Saint-Sulpice, Montreal* of 1917 was based entirely on a photograph Gagnon took in 1909 (Gagnon photo album, private collection.) Photo sources for *La Salute, Venice* and *Street at Pont-de-l'Arche* have been noted by Carolyn W. MacHardy, "Clarence Gagnon's European Etchings, 1905–1909," *RACAR* XI:1–2 (1984), pp. 117–23; and René Boissay, *Clarence Gagnon* (Ottawa: Marcel Broquet Publishing, 1988). To date, with the exception of *Oxen Ploughing*, which probably shared the same photographic source as the painting, no one has identified any other kind of prepatory study for a Gagnon print.

80. Gagnon to Cleveland Morgan, Paris, 13 Feb. 1907, Gagnon Papers, McCord Museum Archives; Robert Pilot, *Clarence Gagnon, R.C.A.: Notes on the Artist's Technique, Palette, Conversations, etc.*, typescript, n.d., NGC Library, p. 5; and Caroline W. MacHardy, "The Rembrandt Plates and Donald Shaw MacLaughlan," *Print Quarterly* X:1 (1993), pp. 47–53. Pilot states that MacLaughlan and Gagnon only pulled six of Rembrandt's plates, but the number could have been greater. MacHardy cites impressions of two plates in the Art Institute of Chicago whose provenance can be traced to MacLaughlan. In the early 1980s, 14 of the 15 restrikes Gagnon received from MacLaughlan were brought into the NGC for expert examination by the author and Mimi Cazort. They were: *Supper at Emaus* (B 87), *Jews in the Synagogue* (B 126), *Joseph and Potiphar's Wife* (B 39), *Self-portrait with Saskia* (B 19), *Man at a Desk, Wearing a Cross and Chain* (B 261), *Studies of the Head of Saskia and Others* (B 365), *Rembrandt in a Flat Cap with Shawl over His Shoulders* (B 26), *Joseph Telling His Dreams* (B 37), *Rembrandt in a Velvet Cap and Plume* (B 20), *Adoration of the Shepherds: with Lamps* (B 45), *Christ and the Woman of Samaria* (B 70), *Circumcision*

in the Stable (B 47), *St. Jerome Kneeling in Prayer* (B 102), and *Landscape with Cow Drinking* (B 237).

In a letter to Cleveland Morgan, 13 Feb. 1907 (Morgan Papers, McCord Museum Archives), Gagnon indicates that his ownership of the prints had to be kept a secret, and thus does not mention the name of the "great friend" who gave them to him. By 1907 the Rembrandt plates were badly worn and reworked, and the impressions made by MacLaughlan were so poor that the project (similar to a controversial edition pulled in 1906) had to be cancelled. The publishers would no doubt have preferred to see none of these last pulls from the abused plates available to the market.

81. In his catalogue raisonné, *The Prints of Clarence Gagnon* (Victoria: Art Gallery of Greater Victoria, 1981), Ian M. Thom established a chronology based solely on Gagnon's erratic and inaccurate dating. For a more accurate dating based on archival references and exhibition history, the reader is referred to my chronology for Gagnon's published prints in *Canadian Art. Catalogue of the National Gallery of Canada*, vol. 2, ed. Pierre Landry (Ottawa: NGC, 1994), pp. 5–18. In addition, there exist first state impressions of unpublished prints: *Venice from the Lagoon, Rouen Cathedral from the Seine, A Rouen Street behind the Cathedral*, all from 1905; *A Lock-gate at Moret, Church at Moret* and *La Rance at Dinan* of 1907; and a view of Quebec City overlooking the St. Lawrence from 1917. In late 1917 or early 1918, he made a colour woodcut entitled "In the Northern Canadian Woods," of which he destroyed all existing impressions. The catalogue for the 1906 exhibition at the American Art Association lists "Jardin Boboli, Florence," "Église des Jésuites, Venise," and "Le Quartier juif," which cannot be accounted for.

82. Regarding Gagnon restrikes: until 1967, the plates remained with the artist's widow. That year they were sold to the Montreal Museum of Fine Arts. Each plate was cancelled with a small star scratched into the image. The MMFA pulled single impressions of the plates for which they did not have an artist's pull, with the star clearly visible in these impressions. Prior to the cancellation of the plates, a set of restrikes was made, on chine laid down on japan paper. A large, faint "X" was printed in light brown on the chine paper before the print was pulled from Gagnon's plates. The following examples of these restrikes are in the MMFA collection: *Old Windmill, Saint-Briac, Ripon Cathedral, Moonlight, Pont-de-l'Arche, View of Rouen, Rue des Petits Degrés, Saint-Malo, Canal du Loing, Moret*, and *L'orage*. It is not known when the restrikes were done or by whom. Neither is it known how many others were pulled or what the edition may have been.

83. Janet Braide and Nancy Parke-Taylor, *Caroline and Frank Armington, Canadian Painter-Etchers in Paris* (Brampton, Ont.: Peel Museum and Art Gallery, 1990), p. 20. Armington returned the favour by writing an article on Achener (b. 1881) which was published by *Studio* magazine: F.M.A., "Studio-Talk, Paris," *Studio* 53:222 (Sept. 1911), pp. 311–14. André Blum, *Exposition Maurice Achener: son œuvre gravé* (Paris: Galerie Marcel Guiot, 1927).

84. In 1939, Armington offered his library to the Art Gallery of Toronto (now the AGO). As might be expected, the Armingtons' library held many books on the most highly regarded printmakers of their day, including Whistler, Haden, D.Y. Cameron, Joseph Pennell, Frank Short, Meryon, Goya, Rembrandt, Anders Zorn, Frank Brangwyn, and James McBey, to mention a few.

85. James Laver, *A History of British and American Etching* (New York: Dodd, Mead & Co., 1929), p. 122. Laver was particularly drawn to *Henkersteg, Nürnberg*.

86. Preface to catalogue *Société de la Gravure Originale en Noir et en Couleur* (Paris: Éditeurs Manzie, Joyant & Cie, 1911), 9–29 Mar. 1911.

87. R.M. [Roger Marx], "Une Exposition d'aquafortistes américains," *Gazette des Beaux-Arts* 35:585 (Mar. 1906), pp. 244–45. The show ran from 4 to 17 Jan. 1906, with Gagnon exhibiting 17 prints. The prints of H.M. Luquiens were also on view.

88. Gagnon to James Morgan, 16 Jan. 1906, Morgan Papers, McCord Museum Archives, Montreal.

89. Émile Dacier, "Les Salons de 1906: La Gravure," *Revue de l'Art Ancien et Moderne* XX:112 (July 1906), pp. 47–56. In their review of the 1906 Salon, the *Gazette des Beaux-Arts* singled out Gagnon for more attention but did not illustrate his work. Paul Jamot, "Les Salons de 1906," *Gazette des Beaux-Arts* 36:589 (July 1906), pp. 60–61.

90. André Beaunier, "Les Salons de 1908," *Gazette des Beaux-Arts* 40:589 (July 1908), *La Tour de l'Horloge à Dinan*, restrike opp. p. 76; "Les Salons de 1913," *Gazette des Beaux-Arts* 43:673 (July 1913), *Rue à Caudebec-en-Caux*, restrike opp. p. 44.

91. Gagnon to Cleveland Morgan, 13 Feb. 1907, Morgan Papers, McCord Museum Archives, Montreal.

92. Gagnon to Cleveland Morgan, 27 Feb. 1907, Gagnon Papers, McCord Museum Archives, Montreal. The references to van Wisselingh and Colnaghi come from later correspondence with these dealers found in the same papers. Also Caroline W. MacHardy, "Clarence Gagnon's European Etchings, 1905–1909," *RACAR* XI:1–2 (1984), p. 120. MacHardy reports that the V & A purchased Gagnon's etchings from the Paris dealer Jacques Bramson.

93. F. Keppel & Co. to Gagnon, 24 Nov. 1915, Gagnon Papers, McCord Museum Archives, Montreal. Gagnon was selling through F. Keppel & Co. by 19 Jan. 1909. However, he may have sold through them as early 1906, when his Montreal dealer approached the New York firm. The prints were not part of Morgan's contract with Gagnon, and the artist was furious at this attempt to assume control over their sale and distribution. The incident precipitated Gagnon's break with Morgan. Gagnon to Cleveland Morgan, 27 Feb. 1907, Gagnon Papers, McCord Museum Archives, Montreal.

94. René Boissay, *Clarence Gagnon* (Ottawa: Marcel Broquet Publishing, 1988), p. 61.

95. As well, both Armingtons exhibited etchings at the Liverpool annuals in 1911 and 1912.

96. The Halifax venue was proposed by Lewis Smith, who received instruction in etching from Frank Armington in Paris that summer of 1910. "Minutes of Emergency Meeting, Nova Scotia Museum of Fine Arts," 26 Nov. 1910, *Nova Scotia Museum of Fine Arts Scrapbook*, Public Archives of Nova Scotia, Halifax.

97. Both Armingtons joined the Chicago Society of Etchers in 1913, and Caroline was a member of San Francisco's California Society of Etchers by 1916. For more on their membership in societies, see Braide and Parke-Taylor *op. cit.*, p. 89. In addition, by 1915 Caroline had joined the Société de la Gravure Originale en Noir. John D. Trask and J. Nilsen Laurvik, eds., *Catalogue to the Department of Fine Arts at the Panama-Pacific International Exposition*, vol. II (San Francisco: Paul Elder & Co., 1915).

98. E.D., "Bruges: Le quai long, gravure originale de M. F.M. Armington," *Revue de l'Art Ancien et Moderne* 25:142 (10 Jan. 1909), pp. 192–93.

99. "Some Etchings by Frank Milton Armington," *Studio* 51:212 (Nov. 1910), pp. 129–34.

100. Paul Chauvet, "Peintres-Graveurs contemporains: Frank M. Armington," *Gazette des Beaux-Arts* 8:662 (Aug. 1912), pp. 137–83. The published title was *Une Rue à Nuremberg*. F. Armington, "Book of Works 1906–1930," 86.0092M, no. 67, Region of Peel Archives, Brampton, Ont.

101. Gagnon to Cleveland Morgan, 13 Feb. 1907, Morgan Papers, McCord Museum Archives, Montreal. Gagnon describes the Dutch museum as simply "The Hague." His prints are not in the Gemeentemuseum as this reference would cause one to presume. Dr Josephus Jitta, Keeper of the Print Room, Haags Gemeentemuseum, to the author, 31 May 1994.

102. Gagnon to James Morgan, 24 Nov. 1906, Gagnon Papers, McCord Museum Archives, Montreal.

103. Gagnon to Edmund Morris, 13 June 1911, Canadian Art Club Papers, AGO Archives.

104. The best of the Canadian prints by Frank Armington is "Mount Sir Donald Glacier, Canada," illustrated in the British review of the 1912 Salon de la Société des Artistes Français. "Some Etchings from the Recent Salons in Paris," *Studio* 52:235 (Oct. 1912), pp. 16 and 18.

105. As quoted in Braide and Parke-Taylor *op. cit.*, p. xiv.

106. Lewis Edward Smith, Information Form, NGC Library, 1920. Smith probably became acquainted with Caroline Armington, née Wilkinson, when she taught art in Halifax during the 1890s ("France Adopts a Canadian Etcher," *Saturday Night* 44:21, 6 Apr. 1929, p. 17). Caroline Wilkinson's name does not appear in any of the annual reports for the Victoria School of Art and Design or the prospectus of the Halifax Ladies College (1892–98), where Lewis and Edith Smith taught from 1893 to 1895. The Sketch Club, founded in 1894, met once a week at the art studio of the Ladies College. It is very likely Caroline attended these sessions.

107. *Eighty/Twenty, 100 Years of the Nova Scotia College of Art and Design* (Halifax: Art Gallery of Nova Scotia, 1988); cat. no. 37 (illus.) is a smaller version of this print. The Boston Society of Etchers did not last beyond its inaugural year of 1917.

108. The Armingtons lived at 8 Rue de la Grande Chaumière, while the Académie de la Grande Chaumière was at no. 14. The Académie Colarossi was at no. 10 on this small, block-long street.

109. "Careers for Women: Dorothy Stevens Captures Personality in Painting," *Toronto Globe and Mail*, 30 May 1946.

110. A survey of *Studio* magazine from 1905 to 1913 shows a remarkable increase in the number and variety of printmaking classes begun at various public and private schools in Britain, including the London School of Art (1905, etching under Frank Brangwyn), Goldsmith College School of Art (1908, etching under W. Lee Hankey), Edinburgh College of Art (1908, etching under Ernest Lumsden, plus lithography and woodcut), and the School of Colour Printing (1911). The period also saw new facilities for the Westminster School of Art (1908) and the Central School of Art and Crafts (1908), with an expansion of the curriculum at both schools.

111. Beatty's earliest known prints are two etchings, *Swanston* and *Venice*, dated in the plate "1906."

112. In 1910, Short, who preferred classes of no more than 25 students, had 33 students. It was at this time that the Saturday class proved insufficient to accommodate all the students and the engraving studio had to go into operation at least two days a week. Royal College of Art, *The Year's Art for 1912* (report for the academic year 1911–12), p. 68; and Lang and Lang *op. cit.*, p. 160.

113. For a vivid description of Short's teaching methods and philosophy, see M.C. Salaman, "The Engraving School at the Royal College of Art," *Studio* 52:218 (May 1911), pp. 280–90.

114. The date of purchase is suggested by the instruction booklet that came with the box; Neilson signed his name with the date on the inside cover. Biographical information contributed by Jan Johnson, Montreal.

115. The date for the invention of lithography is variously given as 1796 or 1798, depending on what stage in Senefelder's invention is being credited as the true beginning.

116. Domenico Porzio, ed., *Lithography: 200 Years of Art, History and Technique* (New York: Henry N. Abrams, 1983), p. 16.

117. Douglas Druick and Peter Zegers, *La Pierre Parle: Lithography in France 1848–1900* (Ottawa: National Gallery of Canada, 1981), p. 98.

118. The subject of *Near Dordrecht* fits comfortably within Morrice's oeuvre. The only known impression comes from the collection of the artist's friend Robert Henri, who dated it as 1898. This dating must be given a great deal of weight, and stylistically the work does suit this period. However, there exist in two separate sketchbooks drawings which could be considered studies for the lithograph. Both drawings have the compositional elements of the sailboat with a windmill on the far shore to the left. One appears on sheet 14 recto in Sketchbook 13 (MMFA) dated 1893–95, and the other is on page 23 recto in Sketchbook 15 (MMFA) dated 1905–10/11. Charles C. Hill, *Morrice, A Gift to the Nation: The G. Blair Laing Collection* (Ottawa: NGC, 1992), p. 29. Hill points out that the date ranges of the sketchbooks have been attributed, but the dates of individual drawings within the sketchbooks remain problematic. The first sketch is the basis for an oil *The Estuary* (NGC) of 1892–96. The lithograph, while similar to all three of these other works, is not precisely like any of them. It is actually a transfer lithograph, which raises the possibility that Morrice took the transfer paper with him to Dordrecht. But when was that visit made? The leading Morrice scholars have given dates from between 1895 and 1898 for this visit. Nicole Cloutier, *James Wilson Morrice 1865–1924* (MMFA, 1986), p. 21; Lucie Dorais, *J.W. Morrice* (Canadian Artists Series) (Ottawa: NGC, 1985), p. 10; and Hill *op. cit.*, p. 29 and cat. no. 6, pp. 44–45.

119. Robert J. Lamb, *James Kerr-Lawson: A Canadian Abroad* (Windsor, Ont.: Art Gallery of Windsor, 1983), p. 24; see also Campbell Dodgson and Joseph Pennell, *The Senefelder Club* (London: Senefelder Club, 1922); and Joseph Pennell, "Cantor Lecture on Artistic Lithography delivered to the Royal Society of Arts, 16, 23 February 1914" (London: William Clowes & Sons, 1914); and Kemille Moore, "Lithography from c. 1875 to the 1920s," in Robin Garton, *British Printmaking 1855–1955* (London: Garton & Co., 1992), pp. 191–96.

120. "Art School and Gallery Notes," *Winnipeg Free Press*, 17 Apr. 1920.

121. Malcolm C. Salaman, *Modern Woodcuts and Lithographs by French and British Artists* (London: The Studio, 1919), pp. 123–24; and Sir Frederick Wedmore as quoted from the *Pall Mall Gazette* by Hector Charlesworth, "Praise for Canadian Painter," *Saturday Night* 27:51 (3 Oct. 1914), p. 3.

122. "Studio-Talk," *Studio* 52:234 (Sept. 1912), pp. 312–16; see also *Studio* 49:203 (Feb. 1910) p. 49; and *Studio* 55:227 (Feb. 1912), p. 47.

3 Erecting the Frame

1. Jean Grant, "Studio and Gallery," *Saturday Night* 12:11 (28 Jan. 1899), p. 9.

2. *Ibid.* The collections referred to were probably the ones then being amassed by John Ross Robertson and Sir Edmund Walker.

3. Jean Grant, "Studio and Gallery," *Saturday Night* 11:22 (16 Apr. 1898), p. 9.

4. Quiller, "Studio News," *Saturday Night* 15:4 (4 Dec. 1901), p. 14. The exhibition was held at Tyrrell's Gallery and consisted of the original drawings for the 1902 calendar. The calendars were published by the TASL and printed by the Toronto Engraving Co. and Alexander & Cable, both staffed by TASL members. In 1899, the publishing rights went to the local firm of Geo. Morang & Co.

5. William Colgate, *Canadian Art, Its Origins and Development* (Toronto: Ryerson Press, 1943), pp. 66 and 68.

6. Jean Grant, "Studio and Gallery," *Saturday Night* 12:52 (11 Nov. 1899), p. 9.

7. T.G. Greene, Information Form, NGC Library, c. 1912; and Jean Grant, "Studio and Gallery," *Saturday Night* 13:27 (19 May 1900), p. 9.

8. "Mahlstick Club," *Saturday Night* 14:27 (18 May 1901), p. 10 and illustrations p. 1; Lance, "Merry Mahlstickers," *Saturday Night* 15:26 (10 May 1902), p. 7; and Colgate *op. cit.*, p. 66.

9. The Mahlstick Club is never listed in the Toronto directories. Colgate (*op. cit.*) states that their first address was the St. James Building at Adelaide and Church, but no such building was listed at this address. The invitations and reviews for the three exhibitions held in 1900 to 1903 all note the address as the top flat of 75 Adelaide East.

 A comparison of a photograph of the Mahlstick Club, fig. 90 (Colgate Papers, Mu586, Ontario Archives, Toronto) with illustrations of the Toronto Art Students' League rooms (Robert Holmes, "Toronto Art Students' League," *Canadian Magazine*, vol. 4, 1895, pp. 172 and 184) shows that the Mahlstick Club took over the TASL rooms and all their specialized furnishings.

10. Lance, "Merry Mahlstickers," *Saturday Night* 15:26 (10 May 1902), p. 7.

11. John Bruce Cowan, *John Innes, Painter of the Canadian West* (Vancouver: Rose, Cowan & Latta Ltd., 1945); Toronto city directories 1900–09; *20th Annual Exhibition of the Royal Canadian Academy*, which opened at the AAM on 7 April 1899; and Henry James Morgan, ed., *Canadian Men and Women of the Time*, 2nd ed. (Toronto: William Briggs, 1912).

 Innes lived in Toronto from late 1898 or early 1899 until 1907, apart from a short absence in 1901 as a soldier/war correspondent in the Boer War. In Toronto, Innes worked for the *Toronto Mail and Empire* until 1905/06, and free-lanced out of a studio in the same building as Fred Haines. The set of five prints etched in 1900 and copyrighted in 1901 seems to be related to an article on the autumn cattle round-up Innes wrote and illustrated with photographs for the *Canadian Magazine*. ("A Visit to a 'Round-Up'," vol. 26, Nov. 1900, pp. 8–16). The etchings were printed with the assistance of a professional; the printer could have been W.W. Alexander, whose company's premises were in the same building as the *Mail and Empire*. An example of the complete portfolio, which includes its carefully conceived covers, can be found in the National Archives of Canada, Ottawa (hereafter cited as NA). The total number of the edition is not known, but the highest edition number currently located is 64.

12. Gemey Kelly and Scott Robson, *J.E.H. MacDonald, Lewis Smith, and Edith Smith in Nova Scotia* (Halifax: Dalhousie Art Gallery, 1990), p. 14 (citing Bob Stacey's unpublished manuscript "The Carlton Connection: The Art of Drawing for Profit: Graphic Design and the Group of Seven, the Association and Precursors").

13. "Canadienne," "At the Graphic Arts Club," *Saturday Night* 17:27 (14 May 1904), p. 11.

14. Robert Stacey, *Charles William Jefferys 1869–1951* (Kingston, Ont.: Agnes Etherington Art Centre, 1976), p. 14.

15. *Toronto City Directory* (Toronto: Might Directories Ltd., 1904).

16. "Canadienne," "At the Graphic Arts Club," *Saturday Night* 17:27 (14 May 1904). The review provides the best evidence to date of the identities of the early members; it

names: William W. Campbell, D.F. Thomson, A.H. Robson, C.M. Manly, Wallace Morgan, C.W. Jefferys, Robert Holmes, Arthur C. Goode, J.W. Beatty, F.H. Brigden, J.D. Kelly, W.W. Alexander, Owen Staples, Walter R. Duff, Jay Hambridge, J.E. Laughlin, Neil McKechnie, and Tom MacLean.

17. Estelle Kerr's studio was listed in 1907 Toronto city directory in the same building as the GAC, and her name first appears in the 1909 GAC exhibition at the CNE.

18. Augustus Bridle, "A Hot-Bed of Art," undated manuscript essay, Canadian Society of Graphic Art Papers, MG28 I381, NA.

19. *The Year's Art 1907: A concise Epitomy of all matters relating to the arts of painting, sculpture, engraving and architecture and to schools of design*, compiled by A.C.R. Carter (London: Hutchison & Co., 1907), p. 291; and J.E.H. MacDonald to Fred Housser, Thornhill, Ont., 20 Dec. 1926, copy in MacDonald Papers, McMichael Canadian Collection Archives, Kleinburg, Ont. MacDonald describes the "Canadian evenings" in which members, often visiting each other's studio, were asked to produce in thirty minutes, compositions of Canadian subjects.

20. Toronto city directories 1906–17. Discussions regarding the formation of the Arts and Letters Club began at the GAC sessions. See "Story of the A.L.C.," *The Lamps* (Jan. 1910), p. 2; and "Correspondence 1909 and 1910," ALC Archives. In October 1909, the ALC apparently took over the former rooms of the Graphic Arts Club at 36 ½ King St. East, which they rented for a year before moving 57 Adelaide East. The GAC moved on to Room J in the Toronto Arcade in 1909, remaining there until 1910. By 1911 they were back at 70 Victoria St. in new rooms, where they stayed through 1916. In 1917, the GAC, now called the Society of Graphic Art, was listed in the city directory at 70 Lombard.

21. *The Year's Art 1908: A concise Epitomy of all matters relating to the arts of painting, sculpture, engraving and architecture and to schools of design*, compiled by A.C.R. Carter. London: Hutchison & Co., 1908, p. 293.

22. In 1881, Staples worked for the Rochester Art Club (to which Horatio Walker belonged) and attended its art classes, including the wood engraving course. He was also present at Sir Francis Seymour Haden's lecture and demonstration on etching, given at the Club in early 1883. Returning to Toronto in 1885, Staples was befriended by ACE member Arthur Cox, who found him work as an illustrator in the publishing trade. Despite these connections, there is no evidence that Staples learned to etch at this early stage in his career.

23. Prospectus for private instruction issued by W.J. Thomson, 26 Oct. 1914, W.J. Thomson Papers, AGO Archives. As an experienced professional printer, Thomson could teach all branches of intaglio printing. His membership in the GAC can be dated from 1909. ("Graphic Art at the Exhibition," *Saturday Night* 23:48, 11 Sept. 1909, p. 7.) The review does not mention what Thomson exhibited, but in all likelihood it was prints.

24. In 1919, Laur left Toronto for Woodbridge, Ont., and adopted the nom de plume "Bridgewood."

25. Invoices in the Sir Edmund Walker Papers, Fisher Rare Book Library, University of Toronto, record purchases of Clarence Gagnon's etchings from the 1909 Canadian Art Club exhibition; prints by William J. Thomson were purchased directly from the artist, probably in 1910, the same year Walker, as a member of the Advisory Arts Committee to the National Gallery of Canada, was directing purchases of Thomson etchings to that body. For more information on Walker as a collector, see Katharine A. Jordan, *Sir Edmund Walker, Print Collector* (Toronto: Art Gallery of Ontario, 1975); and Katharine A. Lochnan, "The Walker Journals:

26. Dorothy Hoover to Rosemarie Tovell, interview 28 Oct. 1992. Dorothy Hoover recalls her father, Fred Haines, examining prints from Walker's collection.

27. "The Library," *The Lamps* 1:1 (Oct. 1911), p. 12.

28. Frank Newbolt, "The Art of Printing Etchings," *Studio* 39:164 (Nov. 1906), pp. 134–41.

29. Arthur Lismer, "Graphic Art," in *The Year Book of Canadian Art 1913*, compiled by the Arts and Letters Club of Toronto (London and Toronto: J.M. Dent & Sons, 1913), p. 240. Lismer's article makes first mention of the press being installed and seems to imply this was not done until 1912. Before the GAC purchased its own press, W.W. Alexander is said to have made the equipment at Alexander & Cable available to Club members. (Dorothy Haines Hoover in conversation with Rosemarie Tovell, 28 Oct. 1992.)

30. Both can be found in the William J. Wood Papers, McMichael Canadian Collection Archives, Kleinburg, Ont.

31. In 1898, Alexander showed a watercolour entitled "The Ramparts of Quebec" at the Toronto Industrial Exhibition (no. 30). It is not known what relationship this watercolour had with the print made some sixteen years later.

32. See "Notes by Sir Frank Short, R.A.," in E.S. Lumsden, *The Art of Etching* (London: Seeley Service & Co., 1925), pp. 339–40.

33. Florence Wyle, a young sculptor recently arrived from New York, was a friend of Duff's and Stevens'. Dorothy Stevens' etched portrait of Frances Loring ("The Brunette") may have been a companion piece.
 Newton MacTavish, *Ars Longa* (Toronto: Ontario Publishing Co., 1938), p. 30. MacTavish's portrait print (fig. 130) was worked up from a drawing. A portrait print of William Dummer Powell Jarvis (Royal Ontario Museum, 985.79.1) was commissioned by Jarvis' family following his death at Ypres in 1915. It is based on a photograph taken the year of his death. (ROM curatorial records.)

34. John D. Trask and J. Nilsen Laurvik, eds., *Catalogue to the Department of Fine Arts at the Panama-Pacific International Exposition*, vol. II (San Francisco: Paul Elder & Co., 1915), p. 421.

35. "New Brunswick and Quebec at the Graphic Arts Club," *Saturday Night* 18:20 (25 Mar. 1905), p. 2. Exhibition of works by C.M. Manly and C.W. Jefferys.

36. Titled the "Canadian Artists Sketch Exhibition," it was held at the King Edward Hotel, 5–8 Dec. 1907. Advertisement, *Canadian Courier* I:2 (8 Dec. 1907), p. 24.

37. Membership letter written by Augustus Bridle, 22 Mar. 1910, Arts and Letters Club Archives. Since many members of the GAC also belonged to the Arts and Letters Club, it is not surprising to find in the ALC Archives lists of exhibitions, including one-man shows, by GAC members.

38. Minutes of the meeting of the CNE Art Committee, 7 Mar. 1907, CNE Archives. From 1903 to 1914 it was known as the Art Committee; in Nov. 1914, the name changed to the Fine Arts Commission.

39. "Art and the Exhibition," *Canadian Courier* IV:14 (5 Sept. 1908), p. 6.

40. "Graphic Art at the Exhibition," *Saturday Night* 22:48 (11 Sept. 1909), p. 7.

41. Minutes of the CNE Art Committee, 17 Feb. 1910, CNE Archives. The Committee also agreed to pay for the expenses incurred.

42. W.W.A., "A Canadian Artist in Paris," *Toronto Globe*, 27 Aug. 1910; and Clarence Gagnon to Edmund Morris, Venice, 13 June 1911, Canadian Art Club Papers, "Edmund Morris Letter Book," vol. 1, AGO Archives. Alexander wrote an article on Frank Armington in Paris, which was

published after his return to Toronto. Gagnon sent his prints directly to Toronto, possibly on the advice of Canadian contacts such as Edmund Morris.

43. The print is based on an illustration, "Toiling in Mid Air," which Staples made from a photograph for the 4 Apr. 1910 edition of the *Toronto Telegram*. From the 1880s until his death in 1918, the *Telegram*'s owner, John Ross Robertson, wrote a regular column called "Landmarks of Toronto," and developed a large collection of illustrative material – paintings, drawings, prints, and photographs of historic interest (now in the collection of the Metro Toronto Library). Through their focus on history and urban landmarks, Robertson's articles instilled in Toronto's artists a sense of Canadian nationalism. He called on the services of many illustrators and artists over the years, including Jefferys and Thomson, but none as often as Owen Staples. The relationship between Staples' etching and his work for the "Landmarks" collection is perplexing. As staff artist for the *Telegram* from 1886, Staples supplied his employer with numerous drawings. From 1906 to 1918 the records show his etchings (many of which were reworkings of much earlier drawings) entering Robertson's collection. But while Staples clearly worked on subjects for his patron, the notoriously miserly Robertson did not always purchase the end results. *Steel Construction* may have been one such example; it entered the collection after Robertson's death.

44. Minutes of the CNE Art Committee, 27 Mar. 1911, CNE Archives; and GAC Secretary to J.O. Orr, Manager of the CNE, 17 Apr. 1911, CSGA Papers, NA.

45. GAC Secretary to J.O. Orr, CNE, 17 Apr. 1911, CSGA Papers, NA. Lismer's previous involvement with the Heeley Art Club of Sheffield, England, made it natural for him to take up an active role with the GAC so soon after his arrival in Canada. From 1911 to 1916, Lismer was central to the organization of the GAC/SGA's exhibitions and its representation at the CNE. He was secretary of the CNE's Graphic Arts subcommittee in 1915 and 1916.

46. From its inception, the CNE purchased art from its own exhibitions. These purchases were deposited with the Art Museum of Toronto, once it had a permanent home, and became the foundation of the AMT/AGT's print and drawing collection; they were officially gifted to the Art Gallery of Ontario in 1966. Linda L. Cobon, CNE Archives, to Charles Hill, NGC, 9 Jan. 1995. Information collated from AGO collection list and CNE record books.

47. "Neplus," "Black and White," *The Lamps* 1:1 (Oct. 1911), p. 8; "Art at Toronto," *Canadian Courier* X:12 (19 Aug. 1911), p. 6.

48. Report of the Deputy Minister, Department of Public Works, Sessional Papers (No. 19), A1913, pp. 16–17. The report on the NGC's acquisitions for 1911 states that purchases of Armington prints were made from the CNE's "black and white" section. This was the Armingtons' only Canadian venue in 1911. In several cases, the titles match prints exhibited at the CNE in 1910.

49. William J. Wood to Franklin Carmichael, Orillia, Ont., 7 Feb. 1912, as cited in Christine Boyanoski and John Hartman, *W.J. Wood, Paintings and Graphics* (Toronto: Art Gallery of Ontario, 1983), pp. 48–49.

50. Other members on the subcommittee were J.E.H. MacDonald, Arthur Heming, A.H. Howard, and C.W. Jefferys. Minutes of the CNE Art Committee, 15 Mar. 1912; and Minutes of the Graphic Arts Subcommittee, 6 and 18 Apr. 1912, CNE Archives. Although not on the subcommittee, Arthur Lismer was perhaps the most active GAC member for the CNE, serving on the Club's committee of management for the CNE from April 1911. GAC Secretary to J.O. Orr, Manager of the CNE, Toronto, 7 Apr. 1911, CSGA Papers, NA.

51. W.W. Alexander to Ivor Lewis, Toronto, 21 Feb. 1913, CSGA Papers, NA.

52. Lismer went to Antwerp in September 1906 to study at the Académie Royale des Beaux-Arts, where tuition was free and living was cheap. The cathedral's famous gothic doorway was one of the local subjects that caught his attention. The etching was pulled in 1909, when Lismer was back in Sheffield, England.

53. MacDonald is first recorded as a member of the GAC when he exhibited with the Club at the 1910 CNE. However, his close friendship with so many of the Club members dating back to Mahlstick Club days makes it logical to assume he entered its ranks upon his return from London in late 1907.

54. J.E.H. MacDonald signed very few of the impressions he pulled. After the artist's death, his son Thoreau MacDonald took to inscribing J.E.H. MacDonald's name and the title and date of the print in a manner which could be taken as the artist's inscription. This practice was further complicated in 1974 when, at Thoreau's request, David Blackwood pulled restrikes (on white BFK Rives wove paper) in an edition of 12 from two of J.E.H. MacDonald's plates. Thoreau signed and dated (variously as 1914 or 1915) the restrike impressions as if by his father, and titled them "Georgian Bay" and "Birch Canoe." (Information on restrikes generously supplied by David Blackwood.)

55. "Exhibition Pictures Sold," *Canadian Courier* XII:16 (14 Sept. 1912), p. 13. This article states that 42 prints were sold, but the numbers given for CNE and NGC purchases are not in accord with official records.

56. Etchings by Montreal artists Ethel Seath and Clarence Gagnon were on display at 1907 and 1910 RCA annuals held in Montreal.

57. The breakaway artists were discontented with the OSA's parochial view and low exhibition standards. For a detailed account, see Robert J. Lamb, *The Canadian Art Club 1907–1915* (Edmonton: Edmonton Art Gallery, 1988).

58. *Fifth Loan Exhibition: Catalogue of a loan collection of pen and ink, pencil and wash drawings and of etchings and engravings on wood, copper and steel*, compiled by Prof. James Mavor (Toronto: Art Museum of Toronto, 1912), 11 Apr.–11 May 1912.

59. M.L.A.F. "Art Gallery Has an Unusual Exhibition," *Toronto Daily Star*, 13 Apr. 1912; and "Splendid Picture Show," *Toronto Telegram*, 17 Apr. 1912. The two Canadians represented in the categories of reproductive printmakers were Hoppner Meyer and Daniel Wilson.

60. Walker to Morris, 5 Feb. 1912, Canadian Art Club Papers, "Edmund Morris Letter Book," vol. 1, AGO Archives. In this letter, he also gives Morris advice on Kerr-Lawson's lithographs. It is apparent Morris does not know of the Senefelder Club.

61. Canadian Art Club Papers, "Edmund Morris Letter Book," vol. 2, AGO Archives. All known correspondence relating to the organization can be found in these papers.

62. See "Art Notes," *The Week* 10:18 (31 Mar. 1893), p. 420, regarding the sale of "proof etchings" from the collection of Samuel E. Roberts; "Art Notes," *The Week* 12:23 (3 May 1895), p. 546, regarding engravings of Napoleonic subjects; and advertisement in 1909 CNE fine arts catalogue noting sale of 18th-century mezzotint portraits and engravings printed in colours.

63. "The Etchers of Canada," *Toronto Star Weekly*, 4 May 1912.

64. "Black and White Art and the Public," *Saturday Night* 25:30 (4 May 1912), p. 15; M.L.A.F., *Toronto Daily Star*, 13 Apr. 1912; and M.L.A.F., *Toronto Star Weekly*, 4 May 1912. In his introduction to the exhibition catalogue, James Mavor also paid tribute to the Association of Canadian Etchers, but neither he nor any of the reviewers knew the correct name

of the group or noted the remarkable similarities between the two exhibitions in the display of both historic and contemporary works.

65. Walker to S. Fisher, Acting Minister, Department of Public Works, 29 Mar. 1909; and Walker to Clarence Gagnon, Toronto, 17 Apr. 1909, Sir Edmund Walker Papers, Fisher Rare Book Library, University of Toronto.

66. Correspondence between Brown and Walker attests to their close cooperation when selecting works and negotiating prices. See "Sir Edmund Walker Misc. Correspondence 1912–," file 01.01, NGC Archives.

67. Eric Brown to Sir Edmund Walker, Ottawa, 8 Sept. 1912, "Sir Edmund Walker Misc. Correspondence 1912–," file 01.01, NGC Archives.

68. Brown to Walker, Ottawa, 28 Sept. 1912, "Sir Edmund Walker Misc. Correspondence 1912–," file 01.01, NGC Archives; *National Gallery Annual Report for 1912–13*, Department of Public Works, Sessional Papers (No. 19), A1913, p. 62; and Katharine A. Jordan, *Sir Edmund Walker, Print Collector* (Toronto: Art Gallery of Ontario, 1975), p. 15 and cover illustration.

69. Garry Mainprize, "The National Gallery of Canada: A Hundred Years of Exhibitions," NGC reprint from *RACAR* IX:1–2 (1984), nos. 15 and 17. In 1918, a second exhibition of Steinlin lithographs from the NGC collection was sent to the AMT (Mainprize, no. 20). A print show, also from the permanent collection, was sent to the AAM for the first time in 1919 (Mainprize, no. 23).

70. Jordan *op. cit.*, p. 22.

71. "Scrapbook," Arts and Letters Club Archives.

72. Undated draft minutes of SGA meeting held c. 3 Mar. 1914, CSGA Papers, NA. Notes for the minutes of the SGA meetings at this time were scribbled on the back of the secretary's copies of recent correspondence.

73. Irene B. Wrenshall, "The Field of Art," *Toronto Sunday World*, 22 Feb. 1914. The show would contain a strong didactic element.

74. T.G. Greene to E.R. Greig, Toronto, 12 May 1914, file A–3–9–5 #7, AGO Archives.

75. "Etchings by Toronto Etchers," file A–7–10–1, AGO Archives; "Toronto Art Gallery Purchases," file 2.12–T, NGC Archives. No catalogue for the exhibition was published. Partial contents of the show are known from E.R. Greig's handwritten list of the preliminary selection of works to be sent to the NGC for possible purchase. Wood's prints are not in this list, but his name appears on an address list. If his etchings were included in the exhibition, they would have been transferred from the Arts and Letters Club show.

76. Membership application, CSGA Papers, NA.

77. Titles and descriptions of etchings by Neilson and Maw are given in Irene B. Wrenshall, "The Field of Art," *Toronto Sunday World*, 5 Apr. 1914; and "A Display of Etchings," Toronto Telegram, 4 Apr. 1914.

78. "Pictures Shown by Local Etchers," *Toronto Mail and Empire*, 6 Apr. 1914. Neilson would enter his etchings in May at the Canadian Art Club's last annual exhibition.

79. "Pictures Shown by Local Etchers," *Toronto Mail and Empire*, 6 Apr. 1914; and Irene B. Wrenshall, "The Field of Art," *Toronto Sunday World*, 12 Apr. 1914. It is possible that Alexander gave the demonstration on etching for which Maw was scheduled. Newton MacTavish suggests Dorothy Stevens also gave an etching demonstration. "Notes on Some Canadian Etchers," *Studio* 58:262 (Jan. 1915), p. 256.

80. Irene B. Wrenshall, "The Field of Art," *Toronto Sunday World*, 10 May 1914.

81. Correspondence and hanging list, "Second Exhibition of Society of Canadian Etchers [sic]," file A–7–10–1, AGO Archives. The mislabelling of these files as "Society of

Canadian Etchers" has given rise to the assertion of a formal organization that never existed.

82. Eric Brown to E.R. Greig, Ottawa, 8 Apr. 1915, "Toronto Art Gallery Purchases," file 2.12–T, NGC Archives.

83. Dyonnet to Greig, Montreal, 18 Mar. 1915 and 22 Mar. 1915, "Correspondence 1913–17," file A–3–8–9 #2, AGO Archives.

84. Notes for minutes of the SGA meeting, early June 1915, CSGA Papers, NA.

85. Stevens demonstrated portraiture in two variant etching techniques. The demonstration pieces are in the collection of the Art Gallery of Ontario (nos. 1433 and 1434, "Head of a Boy," etching and soft-ground etching).

86. Texts may be found in "Second Exhibition of Society of Canadian Etchers," file A–7–10–1, AGO Archives.

87. Attendance record located in "Second Exhibition of Society of Canadian Etchers," file A–7–10–1, AGO Archives.

88. Irene B. Wrenshall, "The Field of Art," *Toronto Sunday World*, 25 Apr. 1915.

89. This was probably made at the request of Arthur Lismer of the SGA and secretary of the CNE's Graphic Arts subcommittee. Correspondence with Neilson, Raine, Gagnon, Seath, Simpson, and Barraud, "Second Exhibition of Society of Canadian Etchers," file A–7–10–1, AGO Archives; and Minutes of the Fine Arts Commission, 25 May 1915 and 12 May 1916, CNE Archives.

90. Ethel Seath to Greig, Montreal, 30 May 1915, "Second Exhibition of Society of Canadian Etchers," file A–7–10–1, AGO Archives.

91. The six wood engravings were an unprepossessing assortment by F.W. Sutherland, a commercial wood engraver in the Toronto publishing trade.

92. Hanging list, "Third Exhibition of Society of Canadian Etchers," file A–7–10–2, AGO Archives.

93. The annotated invitation is in "Third Exhibition of Society of Canadian Etchers," file A–7–10–2, AGO Archives. On this copy Greig amended the names of the artists giving demonstrations.

94. "Canadian Etching," *Toronto Globe*, 3 Apr. 1916; Estelle M. Kerr, "At-the-Sign-of-the-Maple," *Canadian Courier* XIX:22 (29 Apr. 1916), p. 17.

95. Hanging list, "Fourth Exhibition of Society of Canadian Etchers," file A–7–10–2, AGO Archives.

96. Greig to Brown, 20 Apr. 1917; and Walker to Brown, 22 Apr. 1917. Excerpted letters in "Toronto Art Gallery Purchases," file 2.12–T, NGC Archives.

97. "Art and Artists," *Toronto Globe*, 7 Apr. 1917; and "Toronto," *American Art News* XV:33 (26 May 1917), p. 3.

98. Britton B. Cooke, "Joseph Pennell, Etcher and Illustrator," *Canadian Magazine* 38:4 (Feb. 1912), pp. 333–40; "The Lights of New York," *Canadian Magazine* 38:5 (Mar. 1912), pp. 415–20; and "Art and Industry," *Canadian Magazine* 42:2 (Dec. 1913), pp. 131–37.

99. Archibald McMechan, "Changing Halifax," *Canadian Magazine* 41:4 (Aug. 1913), pp. 326–36.

100. MacTavish used eight of Stevens' etchings for single illustrations in *Canadian Magazine*: "The Coal Dump at Quebec," as "The Crane" (42:6, Apr. 1914, p. 602); "St. Jacques Cathedral, Dieppe" (43:4, Aug. 1914, p. 373); "The Jade Bracelet" (a self-portrait) (45:1, May 1915 p. 2); "The Brunette" (Frances Loring) (45:3, July 1915, p. 182); "The Black Muff" (45:5, Sept. 1915, p. 377); "Deborah" (45:6, Oct. 1915), p. 450); "The Japanese Fan" (a self-portrait) (46:1, Nov. 1915), p. 19); and "Apples" (46:3 Jan. 1916, p. 196). He also commissioned Stevens to illustrate two articles: Estelle M. Kerr, "Here and There in Belgium" (44:2, Dec. 1914), pp. 93–104, and Isabel Ecclestone MacKay, "The Curtain" (48:2, Dec. 1916), pp. 89–99.

57. F.H. Brigden to R.F. Gagen, Winnipeg, 31 Mar. 1915, OSA Papers, Ontario Archives. Wilson was the principal print collector in Winnipeg at this time, and the majority of prints on display at the 1913 exhibition likely came from his collection. He was a major supporter of the arts and a member of the Winnipeg Art Club. One must wonder if Wilson was the donor of a large portion of the prints sold at the Winnipeg Patriotic Fund in January 1915. See *Annual Report of the Winnipeg Industrial Bureau*, 1914, pp. 18–21.

58. L. Ruddell, Fine Arts Society Ltd., London, to James McDiarmid, 6 Dec. 1931. Copy of correspondence supplied by Virginia Berry. In 1931, the Fine Arts Society sent McDiarmid 105 prints by Brangwyn, Pennell, Brockhurst, D.Y. Cameron, McBey, Whistler, Zorn, and many others.

59. Winnipeg Museum of Fine Arts, *Western Canadian Artists' Exhibition ... and Loan Collection of Paintings Borrowed from Citizens...*, June–July 1913, nos. 247 and 248. McDiarmid immediately acquired two etchings by Barraud, which he lent to this exhibition. See also note 65 below.

60. For a detailed history of the Winnipeg School of Art, see Marilyn Baker, *The Winnipeg School of Art, the Early Years* (Winnipeg: Gallery 1.1.1., School of Art, University of Manitoba, 1984).

61. Barraud came to Winnipeg in May or June 1913, joining his brother Laurence, also an architectural draughtsman, at the office of David Bellhouse in the Canada Building. The offices of the J. McDiarmid Company were located in the adjacent rooms (Winnipeg city directories 1913–15).

62. Baker *op. cit.*, p. 29; and Information Form, 1928, NGC Library. Barraud's first dated prints were made in 1911. While it is not known where he learned to etch, there are several possibilities. Barraud's family was noted for artists and craftsmen. His uncle Francis J. Barraud was a trained artist with whom Cyril ran the family photography studio, Mayalls & Co., from 1896. Cyril Barraud was also a long-time member of the Gilbert-Garret Sketch Club associated with St. Martin's School of Art; and etching was a standard part of the curriculum at St. Martin's.

Musgrove claimed to have a "thorough knowledge" of lithography, etching, and block printing when he described his credentials to McDiarmid. Among his teachers, he counted D.Y. Cameron for etching. There is no indication that Musgrove made any prints in Canada prior to the mid-1920s, when he shared a studio with W.J. Phillips. His efforts at printmaking demonstrate an indebtedness to Phillips.

63. F.H. Brigden to R.F. Gagen, Winnipeg, 31 Mar. 1915, OSA Papers, Ontario Archives. Brigden writes of the initial meeting and describes the formation of the Club. Those present with Brigden at Mary Ewart's home were Barraud, Phillips, Valentine Fanshaw, and L.L. FitzGerald. According to Brigden, this group had already been meeting regularly every Saturday evening for informal life classes.

64. Although it is commonly stated that Fawcett arrived in Winnipeg in 1909, he does not appear in city directories until 1913. Given that he worked as a freelance commercial artist before joining T. Eaton Co. in 1917, he would surely have had himself listed immediately in order to obtain business. Furthermore, his name does not appear in connection with any artists' activities in Winnipeg until 1913. Phillips' arrival in June 1913, apparently only days after Barraud's, is already well documented in many publications on the artist.

65. The Barraud prints lent by McDiarmid to the 1913 *Western Canadian Artists' Exhibition* were "Tower Bridge" and "Westminster," which had won him a favourable review in "Art School Notes," *Studio* 56:231 (June 1912), pp. 82–83, when they were put on view at the Gilbert-Garret Sketch Club's members' exhibition. "Tower Bridge" was also shown at the Royal Academy's 1912 annual exhibition.

66. The lecture was possibly delivered in conjunction with the RCA exhibition which was about to open. "Club Notes," *Winnipeg Tribune*, 15 Jan. 1914. Previously, the Western Art Association had offered a lecture on commercial engraving by Edgar Ransom of Ransom's Engraving Company, who was also a charter member of the Manitoba Society of Artists. "Modern Engraving, Lecture before Western Art Association Yesterday," *Winnipeg Free Press*, 9 Dec. 1911.

67. Tape 4 of a series of taped conversations between Margery Dallas and W.J. Phillips, Nov. 1961–Spring 1962, Phillips Papers, Glenbow Alberta Institute, Calgary.

68. E.R. Greig to A. Lismer, Toronto, 8 June 1917, file A–3–9–5 #12, AGO Archives. During a visit to Winnipeg, Greig called on Phillips and Fawcett, and took in Phillips' one-man exhibition at the Winnipeg Art Gallery.

69. W.J. Phillips to Margery Dallas, 1961-62, tape 5, Phillips Papers, Glenbow-Alberta Institute, Calgary. Phillips commented on Fawcett's practice of drawing directly on the plate from nature. Fawcett worked rapidly, able to delineate the design for up to six plates on an afternoon's sketching trip. This hurried approach to etching may account for his lack of interest in the cuisine of the craft.

70. The subject is Elizabeth Sweatman, mother of Travers Sweatman, a prominent Winnipeg lawyer and locally respected amateur photographer.

71. W.J. Phillips, "Prints of Local Interest Shown" *Winnipeg Telegram*, 1 Nov. 1919. The CPE's first exhibition originated in Toronto in 1918 and travelled extensively across Canada.

72. For more information on Keagey and his prints, see *Canadian Art*, vol. 2 *op. cit.* (NGC, 1994), p. 364.
It has been thought that James Blomfield made etchings in Vancouver as early as 1900. However, his papers and lecture notes suggest he knew nothing about etching techniques until after his departure for Chicago in 1907. The prints commonly dated by historians to around 1900 are similar in style, size, paper type, and technique to those he pulled in Toronto during the 1920s and 30s. See Bloomfield [Blomfield] Papers, add. MSS 973, Vancouver City Archives; and Nicholas Tuele, *Printmaking in British Columbia 1889–1983* (Victoria: Art Gallery of Greater Victoria, 1984), n.p.

73. Ivor Lewis, draft letter reporting on the business meeting of the GAC, 12 Sept. 1912, CSGA Papers, NA.

74. Life classes were kept. The new program was approved at the annual meeting, 5 Oct. 1912. Ivor Lewis, undated fragment of letter to membership, CSGA Papers, NA.

75. One name proposed for the new national organization was the Canadian Society of Illustrators. Arthur Lismer, "Graphic Art" in *The Year Book of Canadian Art 1913*, compiled by the Arts and Letters Club (London and Toronto: J.M. Dent & Sons, 1913), p. 239.

76. Arthur Lismer, letter to membership, 16 Oct. 1913, "AMT Letters 1912–20–L," file A–3–9–5, AGO Archives. "The Exhibition at the Library," *Toronto Sunday World*, 8 Nov. 1913; "Art and Artists," *Toronto Globe*, 8 Nov. 1913; "Etchings and Watercolours at the Art Museum," *Toronto Daily Star*, 8 Nov. 1913; "In the World of Art," *Toronto Daily Star*, 13 Nov. 1913; and display illustrated in *Canadian Courier* XIV:26 (29 Nov. 1913), p. 13.

77. Ivor Lewis, letter to membership of Ontario Society of Architects, 28 Jan. 1914, CSGA Papers, NA.

78. Notes for minutes of SGA meeting, n.d. [beginning of June 1915], CSGA Papers, NA.

79. Despite misgivings, Greig forwarded the circular to the artists. E.R. Greig to Eric Brown, Toronto, 20 Apr. 1917, "Painter Gravers of America," file 04.3, NGC Archives.

80. Greig expressed his lack of faith in their joining an international society, and indicated his preference for Canadian etchers to form their own society which could then affiliate with an international printmakers association. E.R. Greig to

H. Ivan Neilson, Toronto, 2 May 1917, "AMT Letters 1912–20–N," file A–3–9–5, AGO Archives.

81. E.R. Greig to Lewis Smith, Toronto, 23 May 1817, "Fourth Exhibition of Society of Canadian Etchers," file A–7–10–2, AGO Archives.

82. E.R. Greig to Gyrth Russell, Toronto, 19 Jan. 1918, "Fourth Exhibition of Society of Canadian Etchers," file A–7–10–2, AGO Archives.

83. Fred Haines to E.R. Greig, Thornhill, Ont., 22 Jan. 1918, "AMT Letters 1912–20–A–M," file A–3–9–5, AGO Archives.

84. Thomson's and Haines' positions are recorded in various documents and CPE catalogues. Alexander noted his position on his biographical information form, n.d., NGC Library.

85. F.W. Jopling to E.R. Greig, Toronto, 2 Feb. 1918, file A–3–9–5 #10, AGO Archives.

86. Fred Haines to Eric Brown, Thornhill, Ont., 4 July 1918; and 24 Aug. 1918, "Society of Canadian Painter-Etchers," file 05.11, NGC Archives.

87. Fred Haines to W.J. Wood, Thornhill, Ont., 5 Jan. [1920], Wood/Ruby Papers, McMichael Canadian Collection Archives, Kleinburg, Ont. The actual itinerary is unknown. In his letter to Wood, Haines states that the tour went to fourteen venues outside Toronto.

88. W.J. Phillips, "Prints and Etchings of Local Interest Shown," *Winnipeg Telegram*, 1 Nov. 1919. The artists noted in the show were: Ernest Fosbery, E. Lane [likely a misspelling of E. Laur], George Fawcett, Phillips, Frank Carmichael, Dorothy Stevens, Fred Haines, E. Laur, George Chauvignaud, W.R. Stark, W.W. Alexander, Ivor Lewis, and John Cotton.

89. For an overall history of the CPE, see Andrew Oko, *The Society of Canadian Painter-Etchers and Engravers in Retrospect* (Hamilton: Art Gallery of Hamilton, 1981). Much of the research for this catalogue was based on the CPE's own archives. I have consistently found that the various histories they wrote of their origins ("CPE Scrapbook," AGO Archives) were based on memory rather than on documents, and in the short period I have covered, the CPE's own memory has proved to be extremely faulty. For example, they invariably gave their founding date as 1916.

90. For a full account of the Canadian War Memorials Fund, see Maria Tippet, *Art in the Service of War: Canada, Art and the Great War* (Toronto: University of Toronto Press, 1984).

91. Frances Carey and Antony Griffiths, *Avant-Garde British Printmaking 1914–1960* (London: British Museum Publications, 1990), p. 10. Beaverbrook commissioned British Senefelder Club member Frank Brangwyn to make a set of lithographs for the CWMF. He also acquired examples of lithography by Senefelder Club members C.R.W. Nevinson, Paul Nash, and G. Spencer-Pryse, made for the British Pictorial Propaganda Committee.

92. Sir Edmund Walker to Lord Beaverbrook, Toronto, 16 Nov. 1917, "Canadian War Art: Canadian War Memorials (General)," file 5.41–C, NGC Archives.

93. Beaverbrook to Walker, 10 Jan. 1918 (cable); and Walker to Beaverbrook, 12 Jan. 1918 (cable), file 5.41–C, NGC Archives.

94. Arthur Lismer to Eric Brown, Halifax, 12 Jan. 1918, file 5.42–L, NGC Archives.

95. Gerard de Witt enlisted in the Canadian Expeditionary Force at Halifax and was demobbed in Ottawa in 1919. He is not known to have made prints in Canada other than during his military service.

96. Lismer never mentions the firm by name, but this substantial establishment was the only lithographic firm listed in Halifax city directories of the time. Sources for the discussion of Lismer's lithographs are the correspondence between Eric Brown and Lismer, file 5.42–L and file 02.12, NGC Archives. See also Gemey Kelly *op. cit.* (1982).

97. Three of these prints were completed upon Lismer's return to Toronto in August 1919.

98. Correspondence between Eric Brown and C.W. Jefferys, file 5.42–J, NGC Archives.

99. Eric Brown to Arthur Lismer, Ottawa, 8 June 1918, file 5.42–L, NGC Archives.

100. *Canadian War Memorials Paintings Exhibition: 1920 New Series, the Last Phase* (Ottawa: National Gallery of Canada, 1920).

101. *Catalogue and Price List of War Etchings, Drypoints and Lithographs by British and Canadian Artists* (Ottawa: Canadian War Memorials, 15 Mar. 1920).

102. Brown to Walker, Ottawa, 20 Sept. 1918, file 01.01, NGC Archives.

103. Patricia Ainslie, *Images of the Land, Canadian Block Prints 1919–1945* (Calgary: Glenbow Museum, 1984).

Works in the Exhibition

W.W. Alexander
Toronto 1869 – Toronto 1948

1

Thames Traffic 1913 (see fig. 101)
Etching on wove paper, 15.2 × 22.7 cm (plate)
Inscriptions: below plate l.r., *W.W. Alexander 1913*; Verso: u.c., *Thames Traffic*
First Exhibited: Ontario Society of Artists, Toronto, 1913 (no. 92)
Art Gallery of Ontario, Toronto (51)
Gift of the Canadian National Exhibition Association, 1966

2

The Ramparts, Quebec c. 1914 (see fig. 102)
Etching in brown on wove paper,
15 × 17.6 cm (plate)
Inscriptions: below plate l.r., *W.W. Alexander,* l.l., *The Ramparts Quebec*
First Exhibited: First Exhibition of Canadian Etchers, Art Museum of Toronto, 1914, as "Cape Diamond, Quebec"
National Gallery of Canada, Ottawa (23903)

Caroline Armington
Brampton, Ontario 1875 – New York 1939

3

Ponte dei Sospiri, Venice 1912 (see fig. 80)
Etching in dark brown on wove paper,
35.7 × 25.5 cm (plate)
Inscriptions: in plate l.l., *CHArmington / 1912 / ponte dei Sospiri / Venice*; below plate l.r., *Caroline Armington,* l.l., *11/75*
First Exhibited: Panama-Pacific International Exposition, San Francisco, 1915 (no. 6071)
National Gallery of Canada, Ottawa (28248)

4

L'arc de triomphe, Saint-Jean-du-Doigt 1915
(see fig. 79)
Etching in dark brown on wove paper,
21 × 27.3 cm (plate)
Inscriptions: in plate l.r., *C H A. / 1915,* l.l., *L'arc de Triomphe / Saint-Jean du Doigt*; below plate l.l., *1st State 1/1*
First Exhibited: Panama-Pacific International Exposition, San Francisco, 1915 (no. 6072)
National Gallery of Canada, Ottawa (28247)

Frank Armington
Fordwich, Ontario 1876 – New York 1941

5

Henkersteg, Nürnberg 1909 (see fig. 81)
Etching in brown on laid paper,
34.5 × 27.5 cm (plate)
Inscriptions: in plate l.l., *A 09*; below plate l.r., *FrankMArmington 09,* l.l., *"Henkersteg, Nürnberg"*
First Exhibited: Canadian National Exhibition, Toronto, 1910 (no. 11)
Art Gallery of Nova Scotia, Halifax (10.1)

6

Albrecht Dürers Haus, Nürnberg 1909
(see fig. 78)
Etching in dark brown on wove paper,
34.7 × 27.6 cm (plate)
Inscriptions: in plate l.r., *A. 09*; below plate l.r., *Frank M Armington 09,* l.l., *"Albrecht Dürer's Haus, Nürnberg"*
First Exhibited: Johnson & Copping, Montreal, 1910 (no. 35)
National Gallery of Canada, Ottawa (322)

7

Portal im Rathaushof, Rothenburg 1909
(see fig. 77)
Etching in dark brown on wove paper,
34.6 × 27.7 cm (plate)
Inscriptions: in plate l.l., *A 09*; below plate l.r., *Frank M. Armington 09,* l.l., *"Portal im Rathaushof, Rothenburg, O.T."*
First Exhibited: Royal Society of Painter-Etchers and Engravers, London, 1910 (no. 8)
National Gallery of Canada, Ottawa (323)

J.M. Barnsley
**West Flamborough, Canada West 1861 –
Verdun, Québec 1929**

8

Study from Nature 1881 (see fig. 28)
Etching in brown on laid paper,
9.6 × 20.2 cm (plate)
Inscriptions: in plate l.l., *J. Barnsley. / '81*
From *Art and Music* I:4 (Dec. 1881)
National Gallery of Canada, Ottawa (773)

9

Entrance to Dieppe Harbour 1888
(see fig. 29)
Etching on buff japan paper,
11.2 × 16.6 cm (plate)
Inscriptions: in plate l.l., *BARNSLEY '88*; below plate l.r., *J.M. Barnsley*; Remarque: l.l., seagull flying
First Exhibited: W. Scott & Sons, Montreal, Oct. 1888
The Montreal Museum of Fine Arts
Purchase, Dr F.J. Shepherd Bequest
(GR.1965.394)

Cyril H. Barraud
Barnes, England 1877 – London 1965

10

J. McDiarmid's Yard c. 1913
(see fig. 157)
Etching in brown on wove paper,
12.5 × 19.7 cm (plate)
Robert and Margaret Hucal, Winnipeg

11

The Road to the Valley 1913
(see fig. 156)
Etching on japanese vellum,
46.4 × 29.5 cm (plate)
Inscriptions: below plate l.r., *Cyril H Barraud/13,* l.l., *6/50*
First Exhibited: Second Exhibition of Canadian Etchers, Art Museum of Toronto, 1915
National Gallery of Canada, Ottawa (1128)

12

Fort Garry and the Red River 1914
(see fig. 160)
Etching in brown on wove paper,
15.1 × 35.3 cm (plate)
Inscriptions: below plate l.r., *Cyril HBarraud /14,* l.l., *10/25*
First Exhibited: W.J. Phillips and C.H. Barraud – an Exhibition of Pictures, Richardson Bros. Gallery, Winnipeg, 1914 (no. 49)
Glenbow Museum, Calgary (61.21.199)

13
The Keewatin Channel 1915
(see fig. 161)
Etching in dark brown on japanese vellum,
21.4 × 37.6 cm (plate)
Inscriptions: below plate l.r., *Cyril HBarraud /15*
First Exhibited: Second Exhibition of Canadian
Etchers, Art Museum of Toronto, 1915
National Gallery of Canada, Ottawa (1129)

14
The Great Square, Arras 1917–18
(see fig. 170)
Etching and spirit-ground aquatint on japanese
vellum, 38 × 58.2 cm (plate)
Inscriptions: below plate l.r., *Cyril HBarraud*
First Exhibited: Canadian War Memorials
Exhibition, Royal Academy, London, January
1919 (no. 295)
Canadian War Museum, Ottawa (91082)

15
Evening on the Ypres-Poperinghe Road 1917–18
(see fig. 171)
Etching in brown on cream wove paper,
21.8 × 37.8 cm (plate)
Inscriptions: below plate l.r., *Cyril HBarraud*
First Exhibited: Canadian War Memorials
Exhibition, Royal Academy, London, January
1919 (no. 298)
Canadian War Museum, Ottawa (8045)

J.W. Beatty
Toronto 1869 – Toronto 1941

16
The Mill, Meadowvale 1908–09
(see fig. 97)
Drypoint in brown on laid paper,
17.5 × 22.5 cm (plate)
Inscriptions: below plate l.r., *J.W.Beatty*, l.l., *The
Mill Meadowvale*
First Exhibited: Canadian National Exhibition,
Toronto, 1922 (no. 364)
Art Gallery of Ontario, Toronto (216)
Gift of the Canadian National Exhibition
Association, 1966

17
St. Patrick's Market 1909
(see fig. 98)
Drypoint in brown on japanese vellum,
14.8 × 21.9 cm (plate)
Inscriptions: in plate l.l., *J.W. BEATTY 09*;
below plate l.r., *To my Friend. Eric Brown /
J.W.Beatty / 27.4.10*
National Gallery of Canada, Ottawa (7291)

William Brymner
Greenock, Scotland 1855 – Wallasey,
England 1925

18
Old Man Painting at the Louvre c. 1880–81
(see fig. 5)
Etching and watercolour on wove paper,
13.6 × 10 cm (plate)
Inscriptions: below image l.r., in pencil, *W.
Brymner*
The Montreal Museum of Fine Arts
(GR.1920.18)
Gift of W.S. Maxwell, 1920
Note: Impression pulled by Clarence Gagnon,
1903

John W. Cotton
Simcoe County, Ontario 1868 – Toronto
1931

19
Low Tide, St. Ives Harbour 1912 (see fig. 85)
Etching on japanese vellum,
22.5 × 30.1 cm (plate)
Inscriptions: below plate l.r., *JCotton / '12*
First Exhibited: Royal Academy, London, 1912
(no. 1529)
National Gallery of Canada, Ottawa (563)

20
Beeches, Epping Forest 1914–15
(see fig. 106 and pl. VII)
Colour etching and spirit-ground aquatint on
japanese vellum, 27.4 × 42.4 cm (plate)
Inscriptions: below plate l.r., *JCotton / 15*, l.l.,
No 17/50
First Exhibited: New Brunswick Provincial
Exhibition, Saint John Art Club, 1914 (no. 73)
National Gallery of Canada, Ottawa (1057)

21
The Lime Kiln 1915 (see fig. 105)
Etching on wove paper, 37.7 × 19.8 cm (plate)
Inscriptions: below plate l.r., *JCotton / 15*
First Exhibited: Chicago Society of Etchers,
1915 (no. 75)
National Gallery of Canada, Ottawa (1059)

Walter R. Duff
Hamilton, Ontario 1879 – Toronto 1967

22
Miss Florence Wyle c. 1915 (see fig. 110)
Drypoint in brown on japan paper,
27.7 × 17.5 cm (plate)
Inscriptions: below plate l.r., *WalterR.Duff.*
First Exhibited: Ontario Society of Artists,
Toronto, 1915 (no. 152)
National Gallery of Canada, Ottawa (1061)

Wyatt Eaton
Philipsburg, Canada East 1849 – Newport,
Rhode Island 1896

23
Trees in the Forest of Fontainebleau 1877
(see fig. 23)
Etching in brown on cream wove paper,
10.4 × 15.7 cm (plate)
Inscriptions: in plate l.l., *Wyatt Eaton 1877*
National Gallery of Canada, Ottawa (28304)

24
Haystacks at Barbizon 1877 (see fig. 24)
Etching in brown on cream wove paper,
10.6 × 16.3 cm (plate)
Inscriptions: in plate l.l., *Wyatt Eaton 1877*
National Gallery of Canada, Ottawa (28432)

25
Laure 1877 (see fig. 25)
Etching on cream wove paper,
13.2 × 9.5 cm (plate)
Inscriptions: in plate u.l., *Wyatt Eaton 1877*
National Gallery of Canada, Ottawa (37836)

26
Self-portrait 1879 (see fig. 26)
Etching in brown on cream wove paper,
15.5 × 10.8 cm (plate)
Inscriptions: in plate u.r., *Wyatt Eaton 1879*
National Gallery of Canada, Ottawa (28303)

George Fawcett
London 1877 – Miami, Florida 1944

27
The Blacksmith's Yard c. 1915–16 (see fig. 158)
Etching on japanese vellum, 23 × 21.3 cm (plate)
Inscriptions: below plate l.r., *George Fawcett*, l.l., *XI*
First Exhibited: Third Exhibition of Canadian
Etchers, Art Museum of Toronto, 1916
Robert and Margaret Hucal, Winnipeg

28
St. Boniface c. 1915–16 (see fig. 125)
Etching on wove paper, 19.9 × 17.9 cm (plate)
Inscriptions: in plate l.r., *George / Fawcett*; below
plate l.r., *George / Fawcett*, l.l., *St Boniface*
First Exhibited: Third Exhibition of Canadian
Etchers, Art Museum of Toronto, 1916
National Gallery of Canada, Ottawa (1207)

29
The Fort Garry c. 1917 (see fig. 159)
Etching on wove paper, 12.4 × 17.6 cm (plate)
Inscriptions: below plate l.r., *George Fawcett*, l.l.,
To W.J. Phillips
First Exhibited: Fourth Exhibition of Canadian
Etchers, Art Museum of Toronto, 1917
Glenbow Museum, Calgary (61.21.269)

Elizabeth Armstrong Forbes
Kingston, Ontario 1859 – Newlyn,
England 1912

30

The Reapers c. 1882–84 (see fig. 42)
Etching and drypoint in brown on laid paper,
15.2 × 20.2 cm (plate)
Inscriptions: in plate l.l., *EA* (monogram)
National Gallery of Canada, Ottawa (1300)
Gift of Mr Stanhope A. Forbes, Penzance,
England, 1916, and of 2nd Lieut. W.A.S. Forbes
of the Duke of Cornwall's Light Infantry, killed
in action at Guillemont, 3 September 1916

31

Dorothy, No. 2 c. 1883–84 (see fig. 40)
Drypoint in brown on laid paper,
19.8 × 12.3 cm (plate)
Inscriptions: in plate u.r., *EA* (monogram)
National Gallery of Canada, Ottawa (1303)
Gift of Mr Stanhope A. Forbes, Penzance,
England, 1916, and of 2nd Lieut. W.A.S. Forbes
of the Duke of Cornwall's Light Infantry, killed
in action at Guillemont, 3 September 1916

32

The Old Lady and Her Stick c. 1884–85
(see fig. 43)
Drypoint on wove paper, 17.5 × 10 cm (plate)
Inscriptions: in plate l.r., *EA* (monogram)
National Gallery of Canada, Ottawa (1307)
Gift of Mr Stanhope A. Forbes, Penzance,
England, 1916, and of 2nd Lieut. W.A.S. Forbes
of the Duke of Cornwall's Light Infantry, killed
in action at Guillemont, 3 September 1916

33

The Bakehouse c. 1886–87 (see fig. 41 and pl. II)
Drypoint in brown on wove paper,
26.3 × 20.2 cm (plate)
Inscriptions: in plate l.l., *EA* (monogram)
First Exhibited: Royal Society of Painter-Etchers
and Engravers, London, 1887 (no. 86)
National Gallery of Canada, Ottawa (1308)
Gift of Mr Stanhope A. Forbes, Penzance,
England, 1916, and of 2nd Lieut. W.A.S. Forbes
of the Duke of Cornwall's Light Infantry, killed
in action at Guillemont, 3 September 1916

Ernest Fosbery
Ottawa 1874 – Cowansville, Québec 1960

34

Spire of St. Andrew's Church, Ottawa 1914
(see fig. 140)
Etching in dark brown on laid paper,
12.4 × 9.8 cm (plate)
Inscriptions: below plate l.r., *Ernest Fosbery / May
19th 1914*
First Exhibited: Ontario Society of Artists,
Toronto, 1914 (no. 164)
National Gallery of Canada, Ottawa (1007)

35

Ottawa 1914 (see fig. 139)
Etching on laid paper, 15.6 × 42.9 cm (plate)
Inscriptions: below plate l.r., *Ernest Fosbery / May
21st 1914*
First Exhibited: Art Association of Montreal,
1914 (no. 137)
National Gallery of Canada, Ottawa (1009)

36

The Café c. 1918 (see fig. 138)
Mezzotint and drypoint on buff wove paper,
6.1 × 9.5 cm (plate)
First Exhibited: Royal Canadian Academy,
Toronto, 1918 (no. 219)
National Gallery of Canada, Ottawa (9755)
Gift of Mrs M.P. Kingsmill, Westmount,
Québec, 1961

Clarence Gagnon
Montreal 1881 – Montreal 1942

37

En novembre 1904–05 (see fig. 69 and pl. IV)
Etching in dark brown on japan paper,
13.7 × 20.9 cm (plate)
Inscriptions: below plate l.r., *Clarence A. Gagnon
05*, l.l., *En novembre*
First Exhibited: Salon de la Société des Artistes
Français, Paris, May 1905 (no. 4385), as "Journée
d'automne en Normandie"
National Gallery of Canada, Ottawa (3479)

38

Grand Canal, Venice 1905–06 (see fig. 67)
Etching in dark brown on japan paper,
18.8 × 25 cm (plate)
Inscriptions: below plate l.r., *Clarence Gagnon.07*
First Exhibited: American Art Association, Paris,
January 1906 (no. 11)
National Gallery of Canada, Ottawa (210)

39

Canal San Agostino, Venice 1905–06
(see fig. 70)
Etching in dark brown on japan paper,
20.9 × 15 cm (plate)
Inscriptions: below plate l.r., *Clarence A. Gagnon
06*, l.l., *Canal San Agostino*
First Exhibited: American Art Association, Paris,
January 1906 (no. 13)
National Gallery of Canada, Ottawa (196)

40

Canal San Pietro, Venice 1905–06 (see fig. 68)
Etching in dark brown on japan paper,
14.8 × 22 cm (plate)
Inscriptions: below plate l.r., *Clarence A. Gagnon
05*, l.l., *Canal San Pietro Venice*
First Exhibited: Salon de la Société des Artistes
Français, Paris, May 1906 (no. 4184 or 4185)
National Gallery of Canada, Ottawa (3467)

41

Rue des Cordeliers, Dinan 1907–08
(see fig. 66)
Etching in dark brown on japanese vellum,
19.8 × 24.7 cm (plate)
Inscriptions: below plate l.r., *Clarence A. Gagnon
07*, l.l., *Rue des Cordeliers, Dinan*
First Exhibited: Salon de la Société des Artistes
Français, Paris, May 1908 (no. 4350 or 4352)
National Gallery of Canada, Ottawa (211)

42

L'orage 1907–08
(see fig. 73)
Etching in dark brown on japan paper,
14.6 × 16.9 cm (plate)
Inscriptions: below plate l.r., *Clarence A. Gagnon
07*, l.l., *L'Orage*
First Exhibited: Salon de la Société des Artistes
Français, Paris, May 1908 (no. 4350 or 4352)
National Gallery of Canada, Ottawa (3477)

43

Mont Saint-Michel 1907–08
(see fig. 74 and pl. V)
Etching in dark brown on japan paper,
19.7 × 24.9 cm (plate)
Inscriptions: below plate l.r., *Clarence.A. Gagnon
07*, l.l., *Mont St Michel*
First Exhibited: Salon de la Société des Artistes
Français, Paris, May 1908 (no. 4350 or 4352)
National Gallery of Canada, Ottawa (207)

T.G. Greene
Toronto 1875 – Orillia, Ontario 1955

44

The Card Players, state I/II c. 1908–10
(see fig. 95)
Drypoint and plate tone on laid paper,
15.1 × 19 cm (plate)
First Exhibited: Canadian National Exhibition,
Toronto, 1910 (no. 120)
National Gallery of Canada, Ottawa (1063)

45

The Card Players, state II/II c. 1908–10
(see fig. 93)
Drypoint and plate tone on laid paper,
15.1 × 19 cm (plate)
Inscriptions: below plate l.r., *T.G.Greene*, l.l., *The
Game*
First Exhibited: Canadian National Exhibition,
Toronto, 1910 (no. 120)
National Gallery of Canada, Ottawa (23905)
Gift of Dr and Mrs Charles Comfort, 1980

46
The Fisherman c. 1911
(see fig. 96)
Drypoint and plate tone in brown on laid paper,
15 × 18.6 cm (plate)
Inscriptions: below plate l.r., *T.G. Greene*, l.l.,
The Fisherman
First Exhibited: Fourth Exhibition of Canadian
Etchers, Art Museum of Toronto, 1917
National Gallery of Canada, Ottawa (1423)

Fred S. Haines
Meaford, Ontario 1879 – Thornhill,
Ontario 1960

47
The Old Beech c. 1919
(see fig. 109)
Etching and aquatint in three shades of brown
on wove paper, 22.5 × 26 cm (plate)
Inscriptions: in plate l.c., *FH* (monogram); below
plate l.r., *Fred S. Haines*, l.l., *The Old Beech*
First Exhibited: Chicago Society of Etchers,
1920 (no. 65)
National Gallery of Canada, Ottawa (37170)

48
Dawn c. 1920 (see fig. 108)
Colour aquatint on wove paper,
20 × 16.6 cm (plate)
Inscriptions: in plate l.r., *FH* (monogram); below
plate l.r., *Fred S. Haines*
First Exhibited: Society of Canadian Painter-
Etchers, Toronto, 1920 (no. 50)
National Gallery of Canada, Ottawa (1711)

49
Indian Summer c. 1920 (see fig. 107)
Colour aquatint on wove paper,
19.9 × 24.2 cm (plate)
Inscriptions: below plate l.r., *Fred S. Haines*, l.l.,
FH (stamp) / *Indian Summer*.
First Exhibited: Canadian National Exhibition,
Toronto, 1920 (no. 219)
National Gallery of Canada, Ottawa (1806)

John Hammond
Montreal 1843 – Sackville, New
Brunswick 1939

50
Old and New Saint John 1882 (see fig. 35)
Etching in brown on wove paper,
25.2 × 18.6 cm (plate)
Inscriptions: in plate l.l., *JH* (monogram) *1882*
First Exhibited: Owens Art Gallery, Saint John,
1885 ?
Private collection

51
Dulse Gatherers on the Coast near Carleton,
N.B., state I/II c. 1882–83
 (see fig. 36)
Etching in dark brown on japan paper,
25.2 × 18.4 cm (plate)
Inscriptions: below plate l.r., *JHammond*
First Exhibited: Owens Art Gallery, Saint John,
1885 ?
New Brunswick Museum, Saint John (A51.104 A)
Gift of Constance Starr

52
Dulse Gatherers on the Coast near Carleton,
N.B., state II/II c. 1882–83
(see fig. 37 and pl. I)
Etching and plate tone on japan paper,
25.5 × 18.4 cm (plate)
Inscriptions: in plate l.l., *JH* (monogram); below
plate l.r., *JHammond*
First Exhibited: Owens Art Gallery, Saint John,
1885 ?
Winnipeg Art Gallery (G–65–127)
Gift of Mr Peter Dobush

53
Waiting for the Tide, Bay of Fundy 1883
(see fig. 33)
Etching in brown on japan paper,
15 × 25 cm (plate)
Inscriptions: in plate l.l., *JH* (monogram) *1883*;
below plate *J. Hammond*, l.l., *Waiting for the Tide,*
Bay of Fundy
First Exhibited: Owens Art Gallery, Saint John,
1885 ?
New Brunswick Museum, Saint John (A58.31)
Gift of Doris Murray

54
Fundy Coast 1883 (see fig. 31)
Etching in brown on japanese vellum,
15 × 25 cm (plate)
Inscriptions: in plate l.l., *JH* (monogram); below
plate l.r., *JHammond*
First Exhibited: Association of Canadian Etchers,
Toronto, 1885 (no. 108, as "Coast New
Brunswick" ?)
Private collection

55
Suspension Bridge, Saint John, N.B. c. 1884
(see fig. 34)
Etching in brown on wove paper,
20 × 30.3 cm (plate)
First Exhibited: Owens Art Gallery, Saint John,
1885 ?
National Gallery of Canada, Ottawa (29371)

Henry S. Howland, Jr.
Kleinburg, Ontario 1855 – Montclair, New
Jersey after 1925

56
Camp Scene, Georgian Bay c. 1884–85
(see fig. 8)
Etching in dark brown on japan paper,
12 × 16 cm (plate)
Inscriptions: in plate l.r., *H.S. Howland Jr.*; below
plate l.r., *Henry S. Howland Jr.*
First Exhibited: Association of Canadian Etchers,
Toronto, 1885 (no. 114); and Royal Society of
Painter-Etchers and Engravers, London, 1885
(no. 3)
National Gallery of Canada, Ottawa (37703)

57
The Grange, Residence of Goldwin Smith, Esq.
1887 (see fig. 9)
Etching on japan paper, 12.5 × 20.2 cm (plate)
Inscriptions: in plate l.l., *H.S. Howland. Jr. /*
Toronto 1887; below plate l.r., *Henry S. Howland*
Jr, with estate stamp of Stephen/Maxfield Parrish
First Exhibited: Ontario Society of Artists, 1887
(no. 101 and 102)
National Gallery of Canada, Ottawa (37706)

C.W. Jefferys
Rochester, England 1869 – York Mills,
Ontario 1951

58
Departure of the Siberian Battery from Petawawa
Camp 1919 (see fig. 169)
Transfer offset lithograph on wove paper,
57.6 × 48.2 cm (image)
Inscriptions: in image l.r., *C.W.JEFFERYS 19*;
below image l.l., *Charles W Jefferys*
First Exhibited: Canadian War Memorials, Art
Gallery of Toronto, 1919 (no. 18)
Canadian War Museum, Ottawa (8233)

F.W. Jopling
London 1859 – Toronto 1945

59
In a Toronto Shipbuilding Yard 1915
(see fig. 127)
Drypoint in dark brown on laid paper,
22.5 × 30.4 cm (plate)
Inscriptions: in plate l.r., *F.Jopling 15*; below plate
l.l., *FWJopling 1916*; beside plate l., *A Toronto*
Shipbuilding Industry (or Business as / usual)
First Exhibited: Third Exhibition of Canadian
Etchers, Art Museum of Toronto, 1916
National Gallery of Canada, Ottawa (1209)

60

Forging the 9-inch Shell 1918–19 (see fig. 172)
Mezzotint on heavy wove paper,
43.5 × 31 cm (plate)
Inscriptions: in plate l.r., *Fred Jopling*; below plate
l.l., *Fred Jopling 1918–19*, l.r., *5–10*
First Exhibited: Canadian War Memorials, Art
Gallery of Toronto, 1919 (no. 81)
Canadian War Museum, Ottawa (8330)

James Kerr-Lawson
Cellardyke (now Anstruther), Scotland
1862 – London 1939

61

Il Tempio e la Fontana, Rome 1908 (see fig. 88)
Lithotint on chine, mounted on card,
29.4 × 20.4 cm (image)
Inscriptions: below image l.r., *J. Kerr-Lawson del
et imp. / 08.*
First Exhibited: Dowdeswell Galleries, London,
December 1908 (no. 89)
National Gallery of Canada, Ottawa (751)

62

Il Colleone, Piazza Santi Giovanni e Paolo,
Venice 1908 (see fig. 89)
Lithotint on chine, mounted on card,
29.4 × 21 cm (image)
Inscriptions: below image l.r., *J. Kerr-Lawson del
et imp. / 08.*
First Exhibited: Dowdeswell Galleries, London,
December 1908 (no. 82)
National Gallery of Canada, Ottawa (754)

E.L. Laur
near Aylmer, Ontario 1867 – Woodbridge,
Ontario 1943

63

Evening 1908 (see fig. 99)
Mezzotint and engraving on buff wove paper,
19 × 25.4 cm (plate)
Inscriptions: in plate l.r., *LAUR / 08*; below
plate l.r., *ELLaur*
First Exhibited: First Annual Exhibition, Society
of Graphic Art, Toronto, 1913; or First
Exhibition of Canadian Etchers, Art Museum
of Toronto, 1914
National Gallery of Canada, Ottawa (992)

64

The River c. 1913–14 (see fig. 100)
Mezzotint on wove paper, 14.8 × 21.2 cm (plate)
Inscriptions: below plate l.r., *Laur*, beside plate l.,
only proof – plate destroyed
First Exhibited: First Annual Exhibition, Society
of Graphic Art, Toronto, 1913; or First
Exhibition of Canadian Etchers, Art Museum
of Toronto, 1914
National Gallery of Canada, Ottawa (991)

Arthur Lismer
Sheffield, England 1885 – Montreal 1969

65

The Transport, Halifax, N.S. 1917
(see fig. 150)
Lithograph on wove paper,
28.6 × 21.7 cm (image)
Inscriptions: in image l.r., *AL* (monogram);
below image l.l., *A. Lismer 1917.*, l.r., *The
Transport, Halifax, N.S.*
First Exhibited: Exhibition of Lithographs
Loaned by the National Gallery of Canada,
Nova Scotia Museum of Fine Arts, Halifax, 1917
National Gallery of Canada, Ottawa (1461)

66

The Little Drifter and the Big Freighter
1918–19 (see fig. 166)
Lithograph on calendered wove paper,
32.2 × 43.7 cm (image)
Inscriptions: in image l.l., *AL* (monogram);
below image l.l., *Alismer*, l.r. (by Kathleen M.
Fenwick), *The Little Drifter & The Big Freighter*
First Exhibited: Canadian War Memorials, Art
Gallery of Toronto, 1919 (no. 92)
Canadian War Museum, Ottawa (8374)

67

H.M.C.S. Grisle on Convoy Duty 1918–19
(see fig. 167)
Lithograph on wove paper,
38.5 × 55.2 cm (image)
Inscriptions: in image l.r., *AL* (monogram);
below image l.r., *A Lismer*, l.l. (unknown hand),
H.M.S. Grilse [sic] *on Convoy Duty*
First Exhibited: Canadian War Memorials, Art
Gallery of Toronto, 1919 (no. 96)
Canadian War Museum, Ottawa (8378)

68

Harbour Defence, Winter 1919 (see fig. 168)
Lithograph on cream wove paper,
40.4 × 55.5 cm (image)
Inscriptions: in image l.l., *AL* (monogram);
below image l.r., *ALismer*
First Exhibited: Canadian War Memorials, Art
Gallery of Toronto, 1919 (no. 102)
Canadian War Museum, Ottawa (8384)

J.E.H. MacDonald
Durham, England 1873 – Toronto 1932

69

Thunder Cloud, Georgian Bay c. 1912–13
(see fig. 117)
Etching and drypoint on laid paper,
16.8 × 23.5 cm (plate)
Inscriptions: below plate l.r. (by Thoreau
MacDonald), *J. MacD*
Art Gallery of Hamilton, Ontario (55.105)
Gift of D.C. Barber, Esq., 1955

70

A Georgian Bay Island c. 1912–13
(see fig. 118)
Etching and drypoint on japanese vellum,
17 × 23.5 cm (plate)
Inscriptions: below plate l.r., *J.E.H. MacDonald
'13*; l.l., *A Georgian Bay Island*
First Exhibited: First Annual Exhibition, Society
of Graphic Art, Toronto, 1913
Art Gallery of Hamilton, Ontario (53.57)
Gift of Thoreau MacDonald, 1953

71

Autumn Weather, La Tuque, Laurentians 1913
(see fig. 119)
Etching on buff laid paper, 17 × 23 cm (plate)
Inscriptions: below plate l.r., *J.E.H. MacDonald /
'13*, l.l., *Autumn Weather, La Touge* [sic],
Laurentians.
First Exhibited: First Exhibition of Canadian
Etchers, Art Museum of Toronto, 1914
Art Gallery of Ontario, Toronto (55/35)
Gift of Thoreau MacDonald, 1955

T. Mower Martin
London 1838 – Toronto 1934

72

Evening, Central Park, New York c. 1884–85
(see fig. 14)
Etching in brown on cream laid paper,
40 × 25 cm (plate)
Inscriptions: below plate l.r., *TMower Martin*
First Exhibited: Association of Canadian Etchers,
Toronto, 1885 (no. 159)
National Gallery of Canada, Ottawa (28475)

73

Island Creek c. 1884–85
(see fig. 15)
Etching in brown on german etching paper,
25 × 17.5 cm (plate)
Inscriptions: below plate l.r., *T Mower Martin*
First Exhibited: Association of Canadian Etchers,
Toronto, 1885 (no. 161)
National Gallery of Canada, Ottawa (36167)

74

The Untouched Forest c. 1884–85
(see fig. 16)
Etching in brown on japanese vellum,
60.5 × 40.5 cm (plate)
Inscriptions: below plate l.r., *TMower Martin*
First Exhibited: Royal Canadian Academy /
Ontario Society of Artists, Toronto, 1888
(no. 188)
National Gallery of Canada, Ottawa (28474)

S.H. Maw
Needham Market, England 1881 – Toronto 1952

75
Ely Cathedral, England (Interior, No. 1) 1913
(see fig. 121)
Etching in brown on laid paper,
22.7 × 11.3 cm (plate)
Inscriptions: below plate l.r., *S.H. Maw 13*
First Exhibited: Ontario Society of Artists, 1913
(no. 121, as "Ely Cathedral, Arch in Aisle" ?);
or First Exhibition of Canadian Etchers, Art
Museum of Toronto, 1914
National Gallery of Canada, Ottawa (1000)

76
Toronto Bay c. 1914 (see fig. 122)
Etching on japan paper, 30.2 × 11.3 cm (plate)
Inscriptions: below plate l.r., *S. Herbert Maw*
First Exhibited: First Exhibition of Canadian
Etchers, Art Museum of Toronto, 1914
National Gallery of Canada, Ottawa (1001)

77
The Lagoon, Venice c. 1917 (see fig. 124)
Etching in blue-black on wove paper,
10.3 × 15.3 cm (plate)
Inscriptions: below plate l.r., *S. Herbert Maw.*
First Exhibited: Royal Canadian Academy /
Ontario Society of Artists, Toronto, 1918
(no. 258)
National Gallery of Canada, Ottawa (1459)

78
The Olympic in Halifax Harbour 1918
(see fig. 149)
Etching in brown on cream wove paper,
20 × 15 cm (plate)
Inscriptions: below plate l.r., *S.H. Maw*, l.l.,
"Olympic" 1918 in Halifax Harbour
First Exhibited: Exhibition of Etchings by S.H.
Maw, Nova Scotia Society of Artists, May 1922
(no. 25)
Loan-collection Nova Scotia College of Art and
Design
Courtesy of the Art Gallery of Nova Scotia,
Halifax (61.02)

David Milne
near Paisley, Ontario 1882 – Bancroft, Ontario 1953

79
Madison Square: Spring 1911 (see fig. 63)
Etching on japan paper, 13.8 × 11.3 cm (plate)
Inscriptions: in plate l.r., *May 4 11*
First Exhibited: Philadelphia Water Color Club,
1911 (no. 634A)
Milne Family Collection

80
Ellis Island 1911 (see fig. 60)
Etching on japanese vellum, 10 × 15.1 cm (plate)
Inscriptions: in plate l.r., *July 8 11*
Milne Family Collection

81
Figure in the Sun c. 1911 (see fig. 61)
Etching on wove paper, 13.8 × 11.2 cm (plate)
First Exhibited: Chicago Society of Etchers,
1912 (no. 120)
Milne Family Collection

82
*Fifth Avenue from the Steps of the New York
Public Library* c. 1911
(see fig. 62)
Etching on wove paper, 13.8 × 14.8 cm (plate)
Milne Family Collection

James Wilson Morrice
Montreal 1865 – Tunis 1924

83
Near Dordrecht 1898
(see fig. 87)
Transfer lithograph on wove paper,
18.3 × 23.2 cm (image)
Inscriptions: in stone l.l., *Morrice*; Verso: l.l., *James
Wilson Morrice / Done in 1898*
Art Gallery of Hamilton, Ontario (64.391)
Gift of Mr and Mrs F.F. Dalley, 1964

H. Ivan Neilson
Quebec City 1865 – Quebec City 1931

84
Sous-le-Cap, Quebec 1911
(see fig. 135)
Etching in dark brown on chine,
15 × 10.2 cm (plate)
Inscriptions: below plate l.l., *H. Ivan Neilson.
1911.*, l.r., *"Sous le Cap, Quebec" Canada.*
First Exhibited: Royal Canadian Academy,
Ottawa, 1912 (no. 275)
National Gallery of Canada, Ottawa (565)

85
*Clark's Point, Valcartier, or Jacques Cartier
River near Valcartier* 1912
(see fig. 136)
Etching on chine, 15.2 × 20.3 cm (plate)
Inscriptions: in plate l.r., *HIN* (monogram) / *XII*
(reversed); beside plate l., *2nd Proof*
First Exhibited: First Exhibition of Canadian
Etchers, Art Museum of Toronto, 1914
National Gallery of Canada, Ottawa (28517)

86
The Deepening of the St. Charles River, Quebec
1913 (see fig. 132 and pl. VI)
Etching in dark brown on chine,
20.4 × 30.5 cm (plate)
Inscriptions: in plate l.r., *HIN* (monogram) /
H.Ivan Neilson / 1913.; below plate l.r., *H. Ivan
Neilson. 1913.*, l.l., *The Deepening of the Saint
Charles River*
First Exhibited: Royal Canadian Academy,
Montreal, 1913 (no. 369)
National Gallery of Canada, Ottawa (803)

87
Le Calvaire de Saint-Augustin, near Quebec
1916 (see fig. 137)
Etching in dark brown on chine collé,
35.5 × 28.3 cm (plate)
Inscriptions: in plate l.r., *Le Calvaire de Saint
Augustin near Quebec Erected / 1698 – 1916 HIN*
(monogram), l.l., *H. Ivan Neilson 1916*; below
plate l.r., *H. Ivan Neilson 1916*, l.l., *Le Calvaire de
Saint Augustin, Quebec*
First Exhibited: Third Exhibition of Canadian
Etchers, Art Museum of Toronto, 1916 ?
National Gallery of Canada, Ottawa (28512)

Walter J. Phillips
Barton-on-Humber 1884 – Victoria 1963

88
The Red River at Winnipeg 1915
(see fig. 126)
Etching on chine collé, 14.1 × 25.2 cm (plate)
Inscriptions: in plate l.r., *W.J.P. 15*; below plate
l.r., *W.J. Phillips*, l.l., *The Red River at Winnipeg*
First Exhibited: Third Exhibition of Canadian
Etchers, Art Museum of Toronto, 1916
National Gallery of Canada, Ottawa (1215)

89
The Lake 1916
(see fig. 163)
Etching on chine collé, 22 × 34.7 cm (plate)
Inscriptions: below plate l.r., *W. J. Phillips /16*
First Exhibited: Third Exhibition of Canadian
Etchers, Art Museum of Toronto, 1916
National Gallery of Canada, Ottawa (1378)

90
The Backwater 1917
(see fig. 162)
Etching on laid paper, 13.4 × 15.7 cm (plate)
Inscriptions: below plate l.r., *W.J. Phillips 1917*,
l.l., *Winnipeg River – No. III*
First Exhibited: Fourth Exhibition of Canadian
Etchers, Art Museum of Toronto, 1917
National Gallery of Canada, Ottawa (1413)

91

Mrs W.P. Sweatman 1917 (see fig. 164)
Etching on wove paper, 26.5 × 20.5 cm (plate)
Inscriptions: below plate l.r., *W.J. Phillips*
First Exhibited: Exhibition of Water-Colour
Paintings and Etchings by Mr Walter J. Phillips,
Winnipeg Art Gallery, 28 April 1917 (no. 17, as
"Portrait")
Glenbow Museum, Calgary (61.21.162)

Herbert Raine
Sunderland, England 1875 – Montreal 1951

92

Evening, the Canal, Montreal 1915
(see fig. 131)
Etching and drypoint in dark brown on japan
paper, 22.8 × 27.9 cm (plate)
Inscriptions: in image l.r., *Herbert Raine / 1915*
First Exhibited: Royal Canadian Academy,
Montreal, 1915 (no. 282)
National Gallery of Canada, Ottawa (1189)

93

Old Houses on the Hill, Beaupré, P.Q. c. 1917
(see fig. 153)
Etching in brown on japan paper,
19 × 28 cm (plate)
Inscriptions: below plate l.r., *Herbert Raine*, l.l.,
"Old Houses on the Hill, Beaupré, P.Q.
First Exhibited: Art Association of Montreal,
1917 (no. 293)
Art Gallery of Nova Scotia (29.2)

94

The Pilgrims, Sainte-Anne-de-Beaupré, P.Q.
1917–18 (see fig. 154)
Etching and drypoint in dark brown on japan
paper, 14.1 × 21.5 cm (plate)
Inscriptions: below plate l.r., *Herbert Raine*, l.l.,
"The Pilgrims," St. Anne de Beaupré, P.Q.
First Exhibited: Royal Canadian Academy /
Ontario Society of Artists, Toronto, 1918
(no. 267)
National Gallery of Canada, Ottawa (1501)

95

Old Houses in a Courtyard, St. Vincent Street,
Montreal, P.Q. c. 1918 (see fig. 152)
Etching and drypoint in dark brown on japan
paper, 25 × 28.8 cm (plate)
Inscriptions: below plate l.r., *Herbert Raine*, l.l.,
Old Houses in a Courtyard, St. Vincent Street,
Montreal, P.Q.
First Exhibited: Art Association of Montreal,
1918 (no. 304)
National Gallery of Canada, Ottawa (36957)

Gyrth Russell
Dartmouth, Nova Scotia 1892 – Penarth,
Wales 1970

96

Bedford Row (The Old Street, Halifax) 1912
(see fig. 147)
Colour aquatint on wove paper,
17.3 × 12.4 cm (plate)
Inscriptions: below plate l.r., *Gyrth Russell 1912*,
l.l., *Old Street Halifax*
First Exhibited: Nova Scotia Provincial
Exhibition, 1912 (no. 152, as "Bedford Row")
Scott Robson, Halifax

97

Winter Scene, Halifax 1912
(see fig. 146)
Colour aquatint on wove paper,
12.4 × 17.4 cm (plate)
Inscriptions: below plate l.r., *Gyrth Russell 1912*,
l.l., *Winter Scene Halifax*
First Exhibited: Ontario Society of Artists, 1913
(no. 131)
Scott Robson, Halifax

98

The White Barn, Montarlot 1916
(see fig. 129 and pl. VIII)
Colour aquatint on wove paper,
12.7 × 17.1 cm (plate)
Inscriptions: below plate l.r., *Gyrth Russell 1916*,
l.c., *R.A. Winter 1917*, l.l., *The White Barn,*
Montarlot
First Exhibited: Fourth Exhibition of Canadian
Etchers, Art Museum of Toronto, 1917
National Gallery of Canada, Ottawa (1418)

99

Mine Crater, Vimy Ridge 1918
(see fig. 174)
Drypoint on laid paper, 12.8 × 18 cm (plate)
Inscriptions: below plate l.r., *Gyrth Russell*
First Exhibited: Canadian War Memorials
Exhibition, Royal Academy, London, January
1919 (no. 248)
National Gallery of Canada, Ottawa (18836)

Henry Sandham
Montreal 1842 – London 1910

100

In Boston Public Gardens 1884
(see fig. 18)
Etching on buff laid paper, 24.9 × 39.1 cm (plate)
Inscriptions: in plate l.r., *Hy Sandham / 1884*
First Exhibited: Association of Canadian Etchers,
Toronto, 1885 (no. 234)
National Gallery of Canada, Ottawa (28266)

101

Osprey 1888 (see fig. 27)
Etching in brown on wove paper,
8 × 16.5 cm (plate)
Inscriptions: in plate l.r., *Hy Sandham*
From Dean Sage, *The Restigouche and Its Salmon*
Fishing, Edinburgh, 1888
Webster Collection, New Brunswick Museum,
Saint John

Lewis E. Smith
Halifax 1871 – Rockingham, Nova Scotia
1926

102

Barges at Hammersmith, London 1913
(see fig. 82)
Etching on wove paper, 19.9 × 14.9 cm (plate)
Inscriptions: below plate l.r., *Lewis ESmith 1913*,
l.l., *Barges at Hammersmith London / 25/50*
First Exhibited: Nova Scotia Provincial
Exhibition, 1913 (no. 73, as "Barges, Low Tide,
Hammersmith")
National Gallery of Canada, Ottawa (1410)

103

Old House, Sharon, New Hampshire c. 1917
(see fig. 83)
Etching and drypoint on wove paper,
15.7 × 21.6 cm (plate)
Inscriptions: below plate l.r., *LewisESmith*, l.l.,
13/50 Old House Sharon New Hampshire
First Exhibited: New Brunswick Provincial
Exhibition held at the Saint John Art Club, 1920
(no. 142)
Art Gallery of Nova Scotia, Halifax (31.6)

Owen Staples
Stoke-sub-Hamdon, England 1867 –
Toronto 1949

104
Self-portrait 1906 (see fig. 94)
Etching and drypoint in brown on wove paper,
14 × 12 cm (plate)
Inscriptions: in plate l.r., *Owen Staples 1906*;
Verso: *Wishing you all / A Merry Xmas / Owen & Lil*
Baldwin Room, Metropolitan Toronto
Reference Library (E1–3k)

105
Steel Construction 1910 (see fig. 113)
Etching on wove paper, 16.3 × 19.7 cm (image
plate); 21.4 × 27.3 cm (second plate)
Inscriptions: in plate l.r., *Owen / Staples*; below
plate l.l., *Owen Staples*
First Exhibited: Canadian National Exhibition,
1910 (no. 95, as "Evolution of a Skyscraper")
Art Gallery of Ontario, Toronto (576)
Gift of the artist, 1915

Dorothy Stevens
Toronto 1888 – Toronto 1966

106
Fiesole c. 1910 (see fig. 84)
Etching on laid paper, 24.8 × 24.5 cm (plate)
Inscriptions: below plate l.r., *Dorothy Stevens*, l.l.,
Fiezole [sic]
First Exhibited: Salon de la Société des Artistes
Français, Paris, 1910 (no. 4998); or Philadelphia
Water Color Club, 1911 (no. 611D)
National Gallery of Canada, Ottawa (36946)
Gift of Diana M. Schatz, Toronto, 1993

107
The Gamine c. 1912 (see fig. 111)
Drypoint on japan paper, 20.8 × 13.5 cm (plate)
Inscriptions: in plate l.l., *Stevens*; below plate l.r.,
Dorothy Stevens
First Exhibited: Fifth Loan Exhibition, Art
Museum of Toronto, 1912 (no. 543)
National Gallery of Canada, Ottawa (995)

108
Sortie de l'église 1913 (see fig. 128)
Etching on japan paper, 25.3 × 30.2 cm (plate)
Inscriptions: below plate l.r., *Dorothy Stevens–*
First Exhibited: Chicago Society of Etchers,
1914 (no. 207)
National Gallery of Canada, Ottawa (999)

109
King and Yonge Streets c. 1915 (see fig. 133)
Etching on japan paper, 25.1 × 17.5 cm (plate)
Inscriptions: below plate l.r., *Dorothy Stevens–*
First Exhibited: Ontario Society of Artists, 1916
(no. 167)
National Gallery of Canada, Ottawa (36885)

110
British Forgings 1919 (see fig. 173)
Etching and drypoint on japanese vellum,
30.2 × 34.5 cm (plate)
Inscriptions: below plate l.r., *Dorothy Stevens*, l.l.,
2 British Forgings
First Exhibited: Canadian War Memorials, Art
Gallery of Toronto, 1919 (no. 168)
Canadian War Museum, Ottawa (8828)

111
Building the Freighter 1919 (see fig. 175)
Etching on japanese vellum, 30 × 25 cm (plate)
Inscriptions: below plate l.r., *Dorothy Stevens*, l.l.,
Shipbuilding – The Freighter
First Exhibited: Canadian War Memorials, Art
Gallery of Toronto, 1919 (no. 170)
Canadian War Museum, Ottawa (8830)

William J. Thomson
Guelph, Ontario 1858 – Toronto 1927

112
Grand River, Galt 1884 (see fig. 12)
Etching in dark brown on wove paper,
12.4 × 24.9 cm (plate)
Inscriptions: in plate l.l., *W. Thomson / 1884*; below
plate l.r., *WJ Thomson*, l.l., *Grand River Galt 1884*
First Exhibited: Association of Canadian Etchers,
Toronto, 1885 (no. 254)
National Gallery of Canada, Ottawa (356)

113
King Street, Toronto, 1884 1885 (see fig. 11)
Etching in dark brown on japanese vellum,
20.6 × 19.2 cm (plate)
Inscriptions: in plate l.r., *W.J. Thomson / 1885*;
below plate l.r., *WJ Thomson*, l.l., *King St Toronto
1884*
First Exhibited: Association of Canadian Etchers,
Toronto, 1885 (no. 252, as "View on King Street")
National Gallery of Canada, Ottawa (1011)

114
Niagara River, Queenston 1886 (see fig. 13)
Drypoint in dark brown on japanese vellum,
9.5 × 18 cm (plate)
Inscriptions: below plate l.r., *WJ Thomson*, l.l.,
Niagara River Queenston
National Gallery of Canada, Ottawa (334)

115
Railroad Station, Hamilton 1896 (see fig. 20)
Drypoint in dark brown on japanese vellum,
12.6 × 20.9 cm (trimmed within platemark)
Inscriptions: below image l.r., *W.J. Thomson*, l.l.,
R R Station Hamilton
First Exhibited: Fifth Loan Exhibition, Art
Museum of Toronto, 1912 (no. 569, as "G.T.R.
Station, Hamilton")
National Gallery of Canada, Ottawa (332)

116
Fisherman's Harvest, Vancouver 1913
(see fig. 104)
Drypoint in dark brown on japanese vellum,
18.9 × 25.7 cm (plate)
Inscriptions: in plate l.r., *Fresh Fish / Vancouver /
July 1913 / W.J. Thomson*; below plate l.r.,
WJThomson 1913, l.l., *Fishers Harvest Vancouver*;
Verso: u.c., *Fishermans Harvest / Vancouver/ Dry
Point Etching / by William J. Thomson / 11 Bleeker
St. / Toronto*
First Exhibited: First Exhibition of Canadian
Etchers, Art Museum of Toronto, 1914
National Gallery of Canada, Ottawa (1004)

Homer Watson
Doon, Ontario 1855 – Doon, Ontario 1936

117
Hay Ricks 1889
(see fig. 46)
Etching on wove paper, 9.9 × 14.8 cm (plate)
Inscriptions: in plate l.r., *H.W.*; below plate l.r.,
Homer Watson
National Gallery of Canada, Ottawa (7901r)

118
Faggot Gatherer 1889
(see fig. 45)
Etching on wove paper, 10 × 8.8 cm (plate)
Inscriptions: in plate l.r., *HW*; below plate l.r.,
Homer Watson
First Exhibited: Fifth Loan Exhibition, Art
Museum of Toronto, 1912 (no. 603)
National Gallery of Canada, Ottawa (7902)

119
Landscape with Oak Trees 1889–90
(see fig. 47)
Etching in brown on wove paper,
9.8 × 15.2 cm (plate)
Inscriptions: in plate l.r., *HW*
Jim A. Hennok, Toronto

120
The Pioneer Mill, state I/III 1890
(see fig. 48)
Etching in dark brown on wove paper,
30.1 × 41 cm (plate)
Inscriptions: below plate l.r., *Homer Watson*
National Gallery of Canada, Ottawa (37239r)

121
The Pioneer Mill, state II/III 1890
(see fig. 49 and pl. III)
Etching in dark brown on wove paper,
30.1 × 41 cm (plate)
Inscriptions: below plate l.r., *Homer Watson*
National Gallery of Canada, Ottawa (7899)

122
The Pioneer Mill, state III/III 1890
(see fig. 50)
Etching in dark brown on wove paper,
30.1 × 41 cm (plate)
Inscriptions: below plate l.r., *Homer Watson*, l.l., *By
Kind Permission of Her Majesty*, l.c., *The Pioneer Mill*
First Exhibited: Fifth Loan Exhibition, Art
Museum of Toronto, 1912 (no. 602)
Tom and Linda Humphries

J.W.H. Watts
Teignmouth, England 1850 – Ottawa 1917

123

Elgin Street, Ottawa 1880
(see fig. 3)
Etching on wove paper, 14.9 × 10.2 cm (plate)
Inscriptions: in plate l.r., *J. W H WATTS*, l.c.,
ELGIN ST OTTAWA, l.l., *1880*
First Exhibited: Royal Canadian Academy,
Ottawa, 1880 (no. 256, as "Parliament Buildings,
Ottawa" ?)
National Gallery of Canada, Ottawa (28528)
Gift of Isabel Pike, Ottawa, 1979

124

Montebello on the Ottawa, Residence of
L.J. Papineau 1880
(see fig. 4)
Etching on wove paper, 15.1 × 20.3 cm (plate)
Inscriptions: in plate l.l., *JWW80* (in reverse), l.r.,
J.W.H. WATTS; on mount (now gone), *Montebello*
on the Ottawa / Residence of / L.J. Papineau
First Exhibited: Royal Canadian Academy,
Halifax, 1881 (no. 149 or 150 ?)
Baldwin Room, Metropolitan Toronto
Reference Library (X7–2)

C.H. White
Hamilton, Ontario 1878 – Nice, France
1918

125

New York East Side Set: The Boiler Works
1902
(see fig. 55)
Etching in brown on japanese vellum,
18 × 25.3 cm (plate)
Inscriptions: in plate l.l., *White*; below plate l.r.,
White imp / –03– / The Boiler Works, New York,
l.l., *Second state*
First Exhibited: Exhibition of Etchings by
Charles Henry White, Montross Gallery, New
York, 1907 (no. 7)
National Gallery of Canada, Ottawa (23765)

126

New York Fulton Market Set: Fulton Market
1904–05
(see fig. 54)
Etching on laid paper, 18.4 × 22.9 cm (plate)
Inscriptions: in plate l.r., *White*; below plate l.r.,
Fulton Market, N.Y., l.l., *4th State*
First Exhibited: Exhibition of Etchings by
Charles Henry White, Montross Gallery, New
York, 1907 (no. 18)
National Gallery of Canada, Ottawa (1749)

127

The Condemned Tenement 1906
(see fig. 58)
Etching on laid paper, 12.1 × 16.7 cm (plate)
Inscriptions: below plate l.r., *CHWhite del et imp-*
Condemned Tenement, NY, l.l., *3rd State*
First Exhibited: Exhibition of Etchings by
Charles Henry White, Montross Gallery, New
York, 1907 (no. 15)
National Gallery of Canada, Ottawa (1752)

128

Chicago Set: The Bascule Bridge 1908
(see fig. 56)
Etching in brown on japan paper,
18.4 × 24.9 cm (plate)
Inscriptions: below plate l.c., *CHWhite del et imp*,
l.r., *The Bascule Bridge, Chicago*, l.l., *6th State*
First Exhibited: Salon d'Automne, Paris,
October 1909 (no. 1762)
National Gallery of Canada, Ottawa (1761)

129

San Remo Set: Medieval San Remo 1913
(see fig. 57)
Etching on laid paper, 23.9 × 17.8 cm (plate)
Inscriptions: below plate l.l., *3rd State CHWhite*
del et imp., l.r., *Mediaeval San Remo*
First Exhibited: Chicago Society of Etchers,
1914 (no. 229, as "Old San Remo")
National Gallery of Canada, Ottawa (23818)

W.J. Wood
Ottawa 1877 – Midland, Ontario 1954

130

The Artist Painting in the Country 1912
(see fig. 141)
Etching on wove paper, 10.2 × 13.6 cm (plate)
Inscriptions: in plate l.r., *W.J. Wood / 1912*;
below plate l.r., *W.J. Wood*
First Exhibited: Canadian National Exhibition,
Toronto, 1912 (no. 722, as "A Holiday")
Art Gallery of Ontario, Toronto (L69.89)
Gift of R.W. Finlayson, 1969
Donated by the Ontario Heritage Foundation,
1988

131

At Whitsuntide 1917
(see fig. 142)
Etching in brown on wove paper,
17.6 × 25.1 cm (plate)
Inscriptions: in plate l.r., *Virginia Water /*
W.J.Wood / 28/5/1917; below plate l.r., *Wm J*
Wood 1917, l.c., *At Whitsuntide*
First Exhibited: Canadian National Exhibition,
Toronto, 1917 ?
McMichael Canadian Collection, Kleinburg,
Ontario (1981.192.8)

132

Still-life 1919
(see fig. 143)
Etching and lavis on wove paper,
17.2 × 12.5 cm (plate)
Inscriptions: in plate l.l., *W.J. Wood / 23–6–19*;
below plate l.r., *W.J. Wood 1919*
First Exhibited: Society of Canadian Painter-
Etchers, Toronto, 1920 (no. 126)
McMichael Canadian Collection, Kleinburg,
Ontario (1981.192.5)

Selected References

W.W. Alexander

"Art Notes." *The Week* 12:12 (15 Feb. 1895), p. 281.

Bingham, John McKenney. "Picturing Canada on Copper." *Bridle and Golfer* (Nov. 1933), pp. 26–28.

Hulse, Elizabeth. *A Dictionary of Toronto Printers, Publishers, Booksellers and the Allied Trades, 1798–1900*. Toronto: Anson-Cartwright Editions, 1982.

Oko, Andrew. *The Society of Canadian Painter-Etchers and Engravers in Retrospect*. Hamilton: Art Gallery of Hamilton, 1981.

AGO: artist's file, Library; CPE Papers, Archives.

CNE Archives: Minutes, Fine Art Committee, 1911–12.

McMichael Canadian Collection Archives, Kleinburg, Ont.: William J. Wood Papers, collected by A. Walling Ruby.

NA: CSGA Papers.

NGC: artist's file, Library.

Archives of American Art: Minutes, Committee of Instruction, 1887, Pennsylvania Academy of Fine Art Papers, roll P47.

1881 Census, Ontario, Toronto, St. Patrick's Ward, subdiv. no. 4, p. 3.

Toronto city directories from 1892.

Caroline and Frank Armington

Braide, Janet, and Nancy Parke-Taylor. *Caroline and Frank Armington, Canadian Painter-Etchers in Paris*. Brampton, Ont.: Peel Museum and Art Gallery, 1990.

Brockman, A. McKenzie. *Caroline and Frank Armington*. Montreal: Montreal Print Collectors Society, 1985.

Canadian Who's Who, vol. 2. London: Times Publishing Co., 1936.

Catalogue of Artist's Proof Etchings, the Work of Mr and Mrs Frank Armington. Montreal: Johnson & Copping, 1910.

"France Adopts a Canadian Etcher." *Saturday Night* 44:21 (6 Apr. 1929), p. 17.

Hoffmann, Eugène. *Le Livre d'or des peintres exposants, Morts pour la France pendant la Grande Guerre (1914–1918)*. Paris: Bureaux du Livre d'or des peintres exposants, 1921.

Laver, James. *A History of British and American Etching*. New York: Dodd, Mead & Co., 1929.

Salaman, Malcolm C. *Fine Prints of the Year: An Annual Review of Contemporary Etching and Engraving*, vols 1–3 and 5. London: Halton & T. Smith, 1924–26, 1927.

AGO: artist's files, Library and Archives.

NA: CSGA Papers.

NGC: artist's file, Library; Canadian War Memorials (General), file 5.41–C; Misc. Correspondence with F. and C. Armington, file 7.1–A, Archives.

Region of Peel Archives, Brampton, Ont.: Frank and Caroline Armington Papers, reels 84.0002M, 86.0092M, 91.0041M, 91.0049M RG13.

Archives of American Art: Frank W. Weitenkampf Collection, Manuscript Division, New York Public Library, roll N3.

J.M. Barnsley

"An Art Reception Day." *New York Recorder*, 7 Mar. 1891.

Canadian Art, vol. 1, eds. Hill and Landry. Ottawa: NGC, 1988, pp. 40–48.

Lord, J. Barry. *J.M. Barnsley (1861–1929), A Retrospective*. Vancouver: Vancouver Art Gallery, 1964.

O'Brien, Maureen C., and Patricia Mandell. *Nineteenth Century American Etchings in the Collection of the Parrish Art Museum*. Southampton, N.Y.: The Parrish Art Museum, 1987.

MMFA: artist's file, Library.

Cyril H. Barraud

"Arts and Crafts Officials." *Winnipeg Tribune*, 5 Feb. 1914.

"Art School Notes." *Studio* 56:231 (June 1912), pp. 82–83.

Baker, Marilyn. *The Winnipeg School of Art, the Early Years*. Winnipeg: Gallery 1.1.1., School of Art, University of Manitoba, 1984.

Barraud, E.M. "Artists of the Barraud Family." *Country Life* (Oct. 1965), pp. 1030–31.

Barraud, E.M. *Barraud: The Story of a Family*. Greenwood, S.C.: The Attic Press, 1967.

Barraud, E.M. "Miscellanea: I. Brief Notes on the Barraud Family." *Proceedings of the Huguenot Society* 20:6 (1972), pp. 673–75.

Berry, Virginia. *Vistas of Promise, Manitoba 1874–1919*. Winnipeg: Winnipeg Art Gallery, 1987.

Catalogue of Pictures by Cyril H. Barraud and W.J. Phillips. Winnipeg: Messrs Richardson Bros., 27 Oct. 1914.

Catalogue of War Etchings by Lieut. Cyril H. Barraud, Lieut. Gerard de Witt, and Caroline Armington, and Drypoints by Lieut. Gyrth Russell. London: Canadian War Records Office, 1919.

"Club Notes." *Winnipeg Tribune*, 15 Jan. 1914.

Glover, Patricia. *Manitoba Etchings 1910 to 1940*. Winnipeg: Winnipeg Art Gallery, 1973.

Tippett, Maria. *Art in the Service of War: Canada, Art and the Great War*. Toronto: University of Toronto Press, 1984.

CNE Archives: Minutes, Fine Art Committee, 1921–34.

McMichael Canadian Collection, Kleinburg, Ont.: William J. Wood Papers, collected by A. Walling Ruby.

1881 Census, Ontario, Grey County, St. Vincent Township, Meaford, p. 2.

Toronto city directories, 1897–1912.

John Hammond

Macaulay, Marian Braid. *John Hammond (1843–1939)* (Lives and Works of Canadian Artists, no. 4). Toronto: Dundurn Press, 1977.

Nesbitt, J. Aird. *A Short Biography of Canada's Oldest Artist, John Hammond, R.C.A.* Montreal: Jas. A. Ogilvy's Ltd., 1929.

"The Owens Art Gallery." *Saint John Daily Telegraph*, 15 Apr. 1885.

"The Owens Art School." *Saint John Daily Telegraph*, 15 Apr. 1887.

"Queen's Jubilee Art Exhibition." *Saint John Daily Telegraph*, 23 June 1887.

Reid, Dennis. *Our Own Country Canada.* Ottawa: NGC, 1979.

[Rombout, Luke]. *John Hammond, R.C.A. 1843–1939.* Sackville: Owens Art Gallery, 1967.

Smith, Karen. *Stephen Parrish and Charles A. Platt, Nova Scotia and New Brunswick Views.* Halifax: Dalhousie Art Gallery, 1985.

AGO: Third Exhibition of Canadian Etchers, file A–7–10–2, Archives.

NGC: artist's file, Library.

Archives of American Art: S.R. Koehler Papers, roll D186; "Stephen Parrish Account Book 1880–1889," Parrish Family Papers, Free Library of Philadelphia, roll 4409.

Private collection, U.S.A.: "Stephen Parrish Record of Paintings and Etchings 1877–1915," p. 337.

Saint John city directories, 1879/80–1883/84.

Henry S. Howland, Jr.

Canadian Art, vol. 2, ed. Pierre Landry. Ottawa: NGC, 1994, p. 154.

"Literary Gossip." *The Week* 1:22 (1 May 1884), p. 350.

Share, Rita. "The Howland Homestead," in *Binder and Twine Festival* (booklet). Kleinburg, Ont., 1971.

Archives of American Art: S.R. Koehler Papers, roll D186; "Diaries of James D. Smillie 1865–1910."

1881 Census, Ontario, Toronto, St. Thomas Ward, Pt. 2, p. 21.

Toronto city directories, 1878–95.

C.W. Jefferys

Stacey, Robert. *Charles William Jefferys 1869–1951.* Kingston: Agnes Etherington Art Centre, 1976.

Stacey, Robert. *C.W. Jefferys.* Ottawa: NGC, 1985.

Stacey, Robert. *Western Sunlight: C.W. Jefferys on the Canadian Prairies.* Saskatoon: Mendel Art Gallery, 1986.

Arts and Letters Club Archives, Toronto: Scrapbook 1908–25.

CNE Archives: Minutes, Fine Art Committee, 1909–18.

NGC: Canadian War Artists: C.W. Jefferys, file 5.42–J; Canadian War Memorials (General), file 5.41–C, Archives.

Archives of American Art: Student Register 1893–94 and 1894–95, Art Students' League of New York Papers, roll NY59–20.

Toronto city directories from 1888.

F.W. Jopling

Canadian Art, vol. 2, ed. Pierre Landry (Ottawa: NGC, 1994), p. 352.

Cooke, W. Martha E. *W.H. Coverdale Collection of Canadiana.* Ottawa: Public Archives of Canada, 1983, pp. 141–42.

Murray, Joan. "Early Canadian Printmakers." *Canadian Antiques Collector* 4:8 (Aug. 1969), pp. 22–25.

Oko, Andrew. *The Society of Canadian Painter-Etchers and Engravers in Retrospect.* Hamilton: Art Gallery of Hamilton, 1981.

AGO: artist's file, Library; AMT Letters 1912–20: F.W. Jopling, file A–3–9–5 #10.

NA: CSGA Papers, Archives.

NGC: artist's file, Library; Canadian War Artists: F.W. Jopling, file 5.42–J; and Canadian War Memorials (General), file 5.41–C, Archives.

Archives of American Art: Student Register 1882–83 and 1883–84; Student Ledger 1883–84, Art Students' League of New York Papers, rolls NY59–20 and NY59–22.

1881 Census, Ontario, district no. 134, East Toronto, St. David's Ward, subdiv. no. 3, p. 16, no. 66.

Toronto city directories from 1877.

James Kerr-Lawson

Lamb, Robert J. *James Kerr-Lawson: A Canadian Abroad.* Windsor: Art Gallery of Windsor, 1983.

Salaman, Malcolm C. *Modern Woodcuts and Lithographs by French and British Artists.* London: The Studio, 1919, pp. 123–24.

"Studio-Talk." *Studio* 49:203 (Feb. 1910), p. 49.

"Studio-Talk." *Studio* 55:227 (Feb. 1912), p. 47.

"Studio-Talk." *Studio* 52:234 (Sept. 1912), pp. 312–16.

NGC: Print Purchases: J. Kerr-Lawson, file 2.12–K; Canadian War Memorials (General), file 5.41–C, Archives; curatorial file, Department of Prints and Drawings.

Queen's University, Kingston: Homer Watson Papers.

E.L. Laur

"Canadian Artist Prospers / Finds Opportunity at Home." *Toronto Star*, 26 July 1930.

Canadian Etchers 1910–1935. Ottawa: Sandringham's, 1–31 Dec. 1982.

Oko, Andrew. *The Society of Canadian Painter-Etchers and Engravers in Retrospect.* Hamilton: Art Gallery of Hamilton, 1981.

NGC: artist's file, Library.

Toronto city directories, 1896–1920.

Arthur Lismer

Kelly, Gemey. *Arthur Lismer: Nova Scotia 1916–1919.* Halifax: Dalhousie University Art Gallery, 1982.

Lismer, Arthur. "Graphic Art," in *The Year Book of Canadian Art 1913.* London and Toronto: J.M. Dent & Sons Ltd., 1913.

Toobey, Michael. *Our Home and Native Land, Sheffield's Canadian Artists.* Sheffield: Mappin Art Gallery, 1981.

AGO: Arthur Lismer Papers; AMT Letters 1912–20: Lismer, file A–3–9–5 #12; Fourth Exhibition of Canadian Etchers, file A–7–10–2, Archives.

CNE Archives: Minutes, Fine Art Committee, 1915–19.

NA: CSGA Papers.

NGC: Print Purchases: A. Lismer, file 2.12–L; Canadian War Artists: A. Lismer, file 5.42–L, Archives.

J.E.H. MacDonald

Duval, Paul. *The Tangled Garden.* Toronto: Cerebrus/Prentice Hall, 1978.

Kelly, Gemey, and Scott Robson. *J.E.H. MacDonald, Lewis Smith, Edith Smith in Nova Scotia.* Halifax: Dalhousie University Art Gallery, 1990.

Reid, Dennis. *The Group of Seven.* Ottawa: NGC, 1970.

Robertson, Nancy E. *J.E.H. MacDonald, R.C.A. 1873–1932.* Toronto: Art Gallery of Toronto, 1965.

AGO: artist's files, Library and Archives.

Arts and Letters Club Archives, Toronto: Scrapbook 1908–25.

CNE Archives: Minutes, Fine Art Committee, 1912.

McMichael Canadian Collection Archives, Kleinburg, Ont.: J.E.H. MacDonald Papers.

NA: CSGA Papers.

NGC: artist's file, Library.

Private collection: Hunter Bishop Papers.

Hamilton city directories, 1888–91.

Toronto city directories, 1892–1908.

T. Mower Martin

Auction Sale of Oil and Water Color Paintings by T. Mower Martin R.C.A. Montreal: M. Hicks & Co., 17 Nov. [1888].

Auction Sale of Original Water-Colors, Oil Paintings and Etchings by T. Mower Martin R.C.A. Montreal: M. Hicks & Co., 6 Dec. 1889.

Catalogue of Oil Paintings and Water Color Drawings by T. Mower Martin R.C.A. Ottawa: I.B. Tackaberry, 3 Apr. [1886]. The annotated copy in the OSA Papers, Archives of Ontario, Toronto, lists 8 etchings.

Catalogue of Oil Paintings, Water Colours and Etchings by T. Mower Martin R.C.A. Toronto: Coolican & Co., 20 Nov. [1886].

Catalogue of Water Colour Drawings and Etchings by T. Mower Martin R.C.A. Toronto: Messrs Jones and Wall, 7 May [1886].

O'Brien, Maureen C., and Patricia Mandell. *Nineteenth Century American Etchings in the Collection of the Parrish Art Museum.* Southampton, N.Y.: The Parrish Art Museum, 1887, nos 445 and 446.

Reid, Dennis. *Our Own Country Canada.* Ottawa: NGC, 1979.

"Venerable Artist Kindled Spirit of Art in Toronto." *Toronto Daily Star,* 20 July 1927.

Metro Toronto Library: Newspaper Clipping Scrapbook (Canadian Art, 1907–25).

NGC: artist's file, Library.

Private collection, Calgary: T. Mower Martin Papers.

S.H. Maw

Catalogue of Etchings. Halifax: Nova Scotia Society of Artists, [May 1922].

"City Artists Form Association and First Exhibition Given." *Halifax Echo,* 5 May 1922.

Hamilton, Ross, ed. *Prominent Men of Canada,* vol. 1. Montreal: National Publishing Co. 1932, p. 57.

Biographical Dictionary of Architects in Canada, 1800–1950, Toronto: documentation file.

Dalhousie University, Killam Library, Halifax: D.C. MacKay Papers.

NA: CSGA Papers.

NGC: artist's file, Library; Misc. Correspondence S.H. Maw, file 7.1–M; and Canadian War Artists: A. Lismer, file 5.42–L, Archives.

Royal Institute of British Architects, London: R.I.B.A. records.

David Milne

Carney, Lora Senechal. "David Milne's New York," in Ian M. Thom, ed. *David Milne.* Vancouver: Douglas & McIntyre, 1991, pp. 37–61.

O'Brian, John. *David Milne: The New York Years 1903–1916.* Edmonton: Edmonton Art Gallery, 1981.

Tovell, Rosemarie L. *Reflections in a Quiet Pool: The Prints of David Milne.* Ottawa: NGC, 1980.

NA: Milne Papers.

Private collection: Milne Family Papers.

James Wilson Morrice

Cloutier, Nicole. *James Wilson Morrice 1865–1924.* Montreal: MMFA, 1986.

Dorais, Lucie. *J.W. Morrice* (Canadian Artists Series). Ottawa: NGC, 1985.

Hill, Charles C. *Morrice, A Gift to the Nation: The G. Blair Laing Collection.* Ottawa: NGC, 1992.

Johnston, W.R. *J.W. Morrice.* Montreal: MMFA, 1965.

Modernist Canadian Prints. New York: Associated American Artists, 1986.

H. Ivan Neilson

Caw, J.L. *Scottish Painting, Past and Present, 1620–1908.* Edinburgh: T.C. & E.C. Jack, 1908.

Désilets, Alphonse. "Les Beaux-arts à Québec." *Le Terroir* 10:2–3 (July–Aug. 1930, pp. 27, 30.

"Ivan Neilson's Etchings." *Saturday Night* 33:23 (20 Mar. 1920), p. 12.

Johnson, Jan. "Henry Ivan Neilson," in Denis Martin, *Printmaking in Québec 1900–1950.* Quebec City: Musée du Québec, 1990, pp. 110–13.

Kerr, Estelle M. "The Etcher's Point of View." *Canadian Magazine* 48:2 (Dec. 1916), pp. 152–59.

Lesage, Jules-Siméon. "Henry Ivan Neilson," in *Notes et esquisses québecoises.* Quebec City: Ernest Tremblay, 1925, pp. 74–79. The article on Neilson is dated 1910.

MacTavish, Newton. "Some Canadian Etchers." *Studio* 58:262 (Jan. 1915), pp. 256–64.

Morgan, Henry J. *Canadian Men and Women of the Time.* Toronto: William Briggs, 1898.

"A New Venture in World of Art." *Quebec Chronicle Telegraph,* 18 Oct. 1928.

"Quebec Artist's Exhibit in Toronto." *Toronto Mail and Empire,* 23 May 1919.

Wrenshall, Irene B. "The Field of Art." *Toronto Sunday World,* 8 Mar. 1914.

Archives nationales du Québec, Quebec City: Collection Neilson.

MMFA: artist's file, Library.

Musée du Québec, Quebec City: artist's file, Library.

NGC: artist's file, Library.

Private collection, Hudson, Qué.: Neilson Papers.

C.H. White

American Art Annual, vols 10, 15 and 17, ed. Florence N. Levy. New York: American Federation of Arts, 1913, 1915, 1917, 1919.

Articles by C.H. White for *Harper's Monthly*: "In the Street" (110:667, Feb. 1905, pp. 365–76); "The Fulton Street Market" (111:664, Sept. 1905, pp. 616–23); "In Up-town New York" (112:668, Jan. 1906, pp. 220–28); "Philadelphia" (113:673, June 1906, pp. 42–52); "Boston Town" (113:677, Oct. 1906, pp. 666–74); "New Orleans" (114:679, Dec. 1906, pp. 121–30); "Richmond" (114:683, Apr. 1907, pp. 706–12); "Charleston" (115:690, Nov. 1907, pp. 852–61); "Salem" (117:697, June 1908, pp. 20–28); "Pittsburg" [*sic*] (117:702, Nov. 1908, pp. 901–08); "Chicago" (118:707, Apr. 1909, pp. 729–38); "Queer Folk at the Capital" (120:716, Jan. 1910, pp. 253–60); and "Some Votaries of Bruges" (121:722, July 1910, pp. 281–92).

Articles in *Harper's Monthly* illustrated by C.H. White: Bessie Dean Cooper, "A Hilltop in Paris" (120:715, Dec. 1909, pp. 72–83); and Harrison Rhodes, "Baltimore" (122:729, Feb. 1911, pp. 407–18).

Catalogue of an Exhibition of Selected Examples of Original Etchings by the Foremost American Etchers. Chicago: Albert Roulier's Art Galleries, 9–13 Mar. 1914.

"Charles Henry White." *Print Collector's Bulletin, No. 9*. Chicago: Albert Roulier, [c. 1909 ?].

Exhibition of Etchings by Charles Henry White. New York: Montross Gallery. 13 Nov.– 7 Dec. 1907.

An Exhibition of Selected Examples of Original Etchings by the Foremost Living American Etchers. Chicago, Albert Roulier's Art Galleries, 10–13 May 1916.

Laver, James. *A History of British and American Etching*. New York: Dodd, Mead & Co., 1929.

Salaman, Malcolm C. *Fine Prints of the Year: An Annual Review of Contemporary Etchings and Engravings*, vols 1–5. London: Halton & T. Smith, 1924–27.

Weinberg, H. Barbara. *The American Pupils of Jean-Léon Gérôme*. Fort Worth: Amon Carter Museum, 1984.

Weitenkampf, Frank. *American Graphic Art*. New York: Henry Holt & Co., 1912.

Weitenkampf, Frank. "American City Views in American Prints." *The Print Connoisseur* 5:1 (Jan. 1925), pp. 25–47.

Weitenkampf, Frank. "New York in Recent Graphic Art." *The Print Connoisseur* 1:1 (Oct. 1920), pp. 64–92.

[Winslow, Henry]. "Charles Henry White." *Fine Arts Journal* (Feb. 1909), pp. 86–90.

[Zigrosser, Carl]. *Memorial Exhibition of the Complete Etched Work of Charles Henry White*. New York: E. Weyhe, 1920. A second version was published by Goodspeed's Bookshop, Boston, 1920.

NGC: Print Purchases: C.H. White, file 2.12–W, Archives.

Archives of American Art: Student Register 1896–97 and 1897–98; Instructors' Expenses 1904–08 and 1908–11, Art Students' League of New York Papers, rolls NY59–20, NY59–21, and NY59–28.

University of Pennsylvania, Van Pelt Library, Philadelphia: Special Collections, Carl Zigrosser Papers.

W.J. Wood

Boyanoski, Christine, and John Hartman. *W.J. Wood, Paintings and Graphics*. Toronto: AGO, 1983.

Hartman, John. *W.J. Wood (1877–1954), A Retrospective Exhibition of Etchings*, typescript, n.d., McMaster University Art Gallery, Hamilton, Ont.

Arts and Letters Club Archives, Toronto: Scrapbook 1908–25.

McMichael Canadian Collection, Kleinburg, Ont.: General Correspondence; William J. Wood Papers, collected by A. Walling Ruby.

NGC: artist's file, Library.

Index

This selected index contains the names of key persons and organizations, as well as titles of works of art, exhibitions, and manuals of instruction. Page numbers given in bold type refer to illustrations.